# When Movies Were Theater

FILM AND CULTURE

JOHN BELTON, EDITOR

FILM AND CULTURE

*A series of Columbia University Press*

EDITED BY JOHN BELTON

For the list of titles in this series, see page 423.

# When Movies Were Theater

## ARCHITECTURE, EXHIBITION, AND THE EVOLUTION OF AMERICAN FILM

## William Paul

COLUMBIA UNIVERSITY PRESS   NEW YORK

COLUMBIA UNIVERSITY PRESS

*Publishers Since 1893*

NEW YORK   CHICHESTER, WEST SUSSEX

cup.columbia.edu

The author and publisher wish to thank the College of Arts and Sciences, Washington University in St. Louis, as well as its Program in Film and Media Studies for contributing to the cost of this publicaiton.

Library of Congress Cataloging-in-Publication Data

Names: Paul, William, 1944– author.
Title: When movies were theater : architecture, exhibition, and the evolution of American film / William Paul.
Description: New York : Columbia University Press, [2016] | Series: Film and culture | Includes bibliographical references and index.
Identifiers: LCCN 2015044943| ISBN 9780231176569 (cloth : alk. paper) | ISBN 9780231176576 (pbk. : alk. paper) | ISBN 9780231541374 (ebook)
Subjects: LCSH: Space and time in motion pictures. | Motion pictures and architecture. | Motion picture theaters. | Theater architecture.
Classification: LCC PN1995.9.S668 P38 2016 | DDC 791.43/095693-dc23
LC record available at http://lccn.loc.gov/2015044943

Columbia University Press books are printed on permanent and durable acid-free paper.

Printed in the United States of America

c 10 9 8 7 6 5 4 3 2 1
p 10 9 8 7 6 5 4 3 2 1

**Cover art:** Commercial painting of the Olympia Theatre, Miami (John Eberson, architect)

To my wife Rafia,

with love and admiration

# CONTENTS

*List of Illustrations*   ix

*Acknowledgments*   xiii

INTRODUCTION
An Art of the Theater   1

1. MAKING MOVIES FIT   21

2. STORE THEATERS
A Radical Break   62

3. PALATIAL ARCHITECTURE,
DEMOCRATIZED AUDIENCE   95

4. ELITE TASTE IN A MASS MEDIUM 122

5. UNCANNY THEATER 186

6. THE ARCHITECTURAL SCREEN 230

CONCLUSION
Ontological Fade-Out 275

Appendix 1: Stage Shows and Double Features in Select Markets Outside New York City 299
Appendix 2: Feature Films Based on Theatrical Sources, 1914–2011 303
Appendix 3: Filmography 309
Appendix 4: List of Theaters 313
Abbreviations Used for Citations in Notes 317
Notes 319
Selected Bibliography 399
Index 413

# ILLUSTRATIONS

Figure 1.1    Side boxes at the Strand Theater, New York (1914)   6
Figure 1.2    A 1914 sketch of the proposed Duplex Theater in
              Detroit   9
Figure 1.1    The movie screen framed like a picture at the premiere
              showing of the Vitascope (1896)   35
Figure 1.2    A mid-nineteenth-century tiered horseshoe theater,
              New York   39
Figure 1.3    The horseshoe form of Koster and Bial's Music Hall   40
Figure 1.4    The Olympia Music Hall (1896)   55
Figure 2.1    A 42nd Street façade theater, New York (1903)   70
Figure 2.2    A typical configuration for a store theater (Chicago,
              1909)   73

Figure 2.3      An early acknowledgment of distortion problems in larger theaters   75

Figure 2.4      The American Theatre, Salt Lake City (1913)   91

Figure 3.1      The large open balcony of the Strand, New York City (1914)   106

Figure 3.2      Mezzanine promenade for balcony patrons at the Strand   109

Figure 4.1      *The Big Parade* nears its 90th week at one New York theater   148

Figure 4.2      The Embassy Theatre, New York (1925)   150

Figure 4.3      Trade journal advertisement for *The Patriot* (1928)   151

Figure 4.4      Advertisement for the premiere of *Sunrise* (1927)   157

Figure 4.5      Advertising *Sunrise* for its artistic achievement   158

Figure 4.6      Advertisement for the premiere of *The Student Prince* (1927)   159

Figure 4.7      Unlike "programmers," "specials" often relied on critical response to attract audiences   161

Figure 4.8      A teaser campaign for *Life Begins* (1932)   162

Figure 4.9      Advertising critical response for *Life Begins* in advance of any actual reviews   163

Figure 4.10     Only one critic cooperates with the advertising campaign for *Life Begins*   164

Figure 4.11     Advertisement for the artistically distinctive film, *The Crowd* (1928)   166

Figure 4.12     MGM makes "motion picture history" by its choice of venue   167

Figure 4.13     *The Crowd* seeks entry into "the key legitimate motion picture house of the world"   168

Figure 4.14     After an extended run, *The Big Parade* starts an engagement "at popular prices"   170

Figure 4.15     *Strange Interlude* touts voice-over as a "next step" innovation   173

Figure 4.16     *The Power and the Glory* combines voice-over narration with a jumbled chronology   175

Figure 4.17     *Don Juan*'s Vitaphone soundtrack provides big city performance to smaller venues   178

Figure 4.18     *Annie Get Your Gun*'s "Special Pre-Release Engagement"   183

Figure 5.1    Picture setting for the New Willis Wood Theater in
              Kansas City, Missouri (1914)   196

Figure 5.2    Picture setting for the Majestic in Cleveland
              (1914)   197

Figure 5.3    Picture setting for *The Clansman* in Los Angeles (1915),
              before its New York premiere   198

Figure 5.4    Picture setting for *Broken Blossoms* in Portland,
              Oregon, with Chinese costumes for the ushers   200

Figure 5.5    The presentation of *Broken Blossoms* in Spokane   201

Figure 5.6    A trade journal advertisement (1926) for Novelty Scenic
              Studios   202

Figure 5.7    A trade journal advertisement (1926) for Tiffin Scenic
              Studios   203

Figure 5.8    A fanciful stage treatment in a North Carolina theater
              (1925)   204

Figure 5.9    *Motion Picture News*'s suggestion (1927) for a picture
              setting for an atmospheric theater   205

Figure 5.10   A seasonal setting for Christmas at the Hippodrome in
              Buffalo (1920)   205

Figure 5.11   Picture setting for an atmospheric theater in Miami
              (1926)   206

Figure 5.12   Picture setting for the Vitagraph Theater, New York
              (1914)   209

Figure 5.13   The Strand Theatre, Newark (1916)   211

Figure 5.14   The Strand, New York, with its elevated style of
              architecture (1914)   212

Figure 5.15   Advertisement for a 1920 Chicago engagement of *In
              Old Kentucky*   220

Figure 5.16   Stage set design for a 1925 Boston engagement of *The
              Lost World*   225

Figure 5.17   The opening title of *The Lost World*, with background
              painting   226

Figure 6.1a   James Cagney in *Footlight Parade* comes to see a "B"
              western "talkie" with John Wayne   248

Figure 6.1b   A "flesh show" follows the "B" western "talkie" in
              *Footlight Parade*   248

Figure 6.2    *Saboteur*'s accurately rendered studio re-creation of
              Radio City Music Hall   249

Figure 6.3–16b   Comparison images from the 10mm and 35mm
                 versions of *The Big Trail*   257–266
Figure C.1       The Cinemas I–II (1962), the "first theater building
                 with an open façade in New York City"   284
Figure C.2       Philharmonic Hall (1962) at Lincoln Center   284
Figure C.3       Advertisement for the Cinemas I and II theaters in
                 New York   285
Figure C.4       Schlanger's auditorium in gun-metal gray could fully
                 integrate the Synchro-Screen into the architectural
                 space   287
Figure C.5       An architectural design that created different spaces for
                 different kinds of films   288
Figure C.6       Feature films based on theatrical sources
                 (1914–2011)   289
Figure C.7       A highly symmetrical environment obscures a hidden
                 threat in *2001: A Space Odyssey*   296

# ACKNOWLEDGMENTS

THIS BOOK BEGAN AS A STUDY OF 3-D MOVIES IN THE EARLY 1950s, a topic that appears nowhere in this volume. Because so many newly implemented technologies of the period—Cinerama, CinemaScope, Todd-AO—were referred to as "stereoscopic," even though not truly three-dimensional, I wanted to look at the discourse around Hollywood's initial short-lived move to wide-gauge filmmaking in 1929–1931. The research led to a discovery I had not anticipated: early wide-gauge film was seen in part as a solution to the problem of showing movies in the voluminous spaces of the movie palaces that had been built over the previous decade and a half, a problem that contradicts the predominantly nostalgic view of this exuberant architecture. Further, because wide-gauge films could offer a differing stylistic practice, it began to seem that the limitations of

palace exhibition might have played a constitutive role in the development of American film style. At the invitation of Tom Gunning, I presented this material at a class he was teaching on film exhibition, after which he made the fateful suggestion, "You might want to take a look at the opening of the Strand," Thomas Lamb's 1914 Broadway theater that became a model for the boom in palace construction that followed.

I guess I could curse Tom for this because it led to about seven or eight years of reading issue-by-issue, often week-by-week, in technical and trade journals over a five-decade period, sending me back in time to the development of store theaters in the first decade of the twentieth century, then into the nineteenth century for film showings in vaudeville theaters, and ahead to changes wrought by the introduction of sound and subsequently to new architectural approaches that supplanted the palaces. Ultimately, I have to thank Tom because it made the central concern of this book something I have directly experienced in my own lifetime of moviegoing but had never really articulated before: the surprisingly varied ways in which the moving image has been situated in architectural space and how that relationship between image and space has affected our understanding of what a movie is.

Over the years that I have presented this material in lectures and conferences and in everyday conversation, I have received insightful and challenging comments from friends and colleagues, most especially Richard Allen, Charles Barr, John Belton, Stefan Block, Phil Blumberg, Colin Burnett, David Callon, Todd Decker, Eric Dienstfrey, Pete Donaldson, Ellen Draper, Ira Konigsberg, Rob and Mary Joan Leith, Julie Levinson, Adam Lowenstein, Martin Marks, Roger Midgett, Michael Moore, Susan Ohmer, Kevin Sandler, Shawn Shimpach, Ed Sikov, Jeff Smith, Gaylyn Studlar, Judith Thissen, David Thorburn, and Johannes von Moltke. As I was embarking into a mostly unknown territory for me, I am particularly grateful to three theater historians: P. A. Skantze convinced me to look more generally at theater history; Julia Walker gave valuable suggestions on specifics of American theater; and Pannill Camp led me to key sources on theater architecture, providing me with his unpublished writings on architecture and staging, and graciously reading drafts of chapters to help me avoid egregious mistakes on theater history. Philip Sewell also read early drafts of most of the final chapters and helped push me toward greater clarity. I am indebted to my research assistant Courtney Andre for the quantitative work she did compiling numbers of

play adaptations as well as the progressive disappearance of stage shows in the sound era.

The research staff at the University of Michigan Library tracked down bound copies of old trade journals and seemed to turn interlibrary loan into something of an express train. The photographic services staff at Harvard Library provided excellent reproductions of the odd staging practices in silent era movie exhibition. I was able to make good use of the resources at the Avery Architectural & Fine Arts Library at Columbia University; especially helpful were Nichole Richard, who guided me through the archives for architects Andrew Geller and Thomas Lamb, and Margaret Smithglass, who facilitated permissions to use publicity photographs prepared for the opening of Cinema I-II.

I want to thank Susan White for decades of friendship and collegiality, and particularly for inviting me to give a keynote address at a University of Arizona conference, a lecture that became the foundation for chapter 4. A portion of chapter 6 originally appeared in different form in the *Michigan Quarterly Review*, where I received valuable editorial advice from Larry Goldstein. Michael Arnzen provided the germ for an essay that would become the source for chapter 5 by asking that I contribute to a special issue on the uncanny for *Paradoxa*. His initial request that I write about comedy and/or horror in relation to the uncanny led to a productive back-and-forth, which made me realize there was an aspect of the uncanny in the silent era practice of "staging the picture" that was work exploring. That article was subsequently transformed into a memorable occasion by Russ Collins, the director of the Michigan Theater in Ann Arbor, who drew on my research to "stage" a performance of Charles Chaplin's *The Circus* (1928), complete with live action prologue. Witnessing a rediscovered piece of lost history brought back to life was a rare experience for a scholar.

I would like to end with a number of personal appreciations. I thank my wife for indulging my obsessive interest in theater architecture over such a long period, and my son for putting up with my eccentric behavior of inspecting the spatial dimension of every last auditorium whenever we happened to see a movie at an unfamiliar multiplex. My last two personal thanks conjoin someone I've never met with someone I've known my entire life. My mother has always claimed credit for my fascination with movies, but she also inspired my interest in the spaces in which movies were shown. The most obvious way she accomplished this was by preferring a neighborhood theater that required a two-mile drive

from city to suburb over one to which we could walk. One of the surprises of my research is that this theater, the Whitney in Hamden, Connecticut, was designed by architect Ben Schlanger, who figures prominently in this book. And not just the Whitney: as it turned out, I had the good fortune of growing up in a city with three Schlanger theaters, all familiar venues to me. As a child I was in awe of the magical spaces of the palaces, most especially a theater by another architect important for this book, Thomas Lamb, who designed the 3,000-seat Loew's Poli in downtown New Haven. Nevertheless, even as a child I felt that somehow movies looked better at the modest Whitney than the imposing Poli. And in spite of his repeated demands for "neutral treatment" of the auditorium, Schlanger's own designs were hardly cold and uninviting places: the burnished bronze interior of the Whitney remains as luminous to me as any palace interior. In reading countless Schlanger articles, I found myself looking in memory at his beautifully simple theater, seeing in it what I saw as a child, but understanding as an adult why this theater worked so well. The best of the other theater architects loved theatricality, something Lamb's designs had in abundance, but Schlanger loved movies, which is why he sought to make the image itself the most dramatic element in cinema architecture. And so I am grateful to this man I did not know, yet encountered through designs that helped shape my view of both movies and architecture.

# When Movies Were Theater

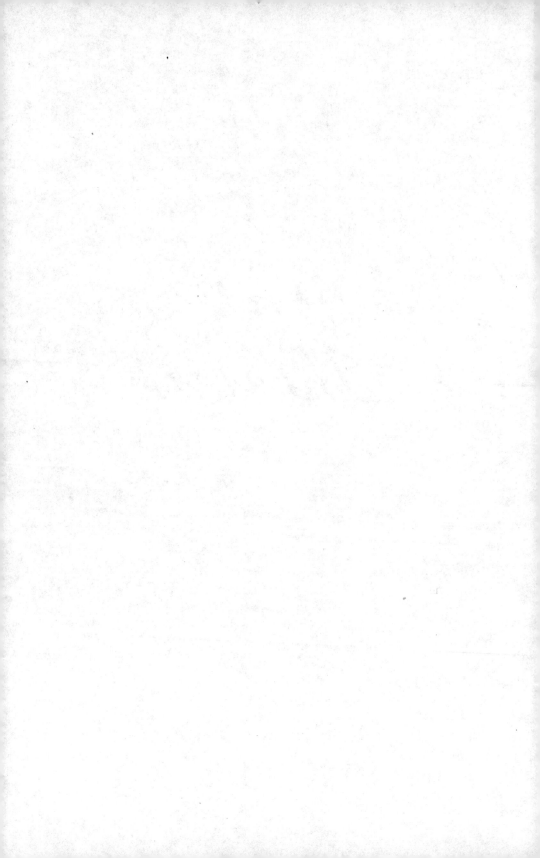

# INTRODUCTION

## An Art of the Theater

As revealed to the public at the Broadway Theater in New York, Cinerama is spectacular affirmation of the fact that *the motion picture is distinctly an art of the theater*—the theater of today and of the future—and not an art of the house.
—*Motion Picture Herald* (1952)[1]

The Times Square throng was thinning on a recent, about-to-be-rainy Sunday evening when the JumboTron outside the W Hotel sparked to life. "Film Festival in a Box," it announced. And then the movies, short films with titles like "Laundry" and "Pete's Beach" and actors the crowd had never heard of, started. The effect was immediate: Tourists actually lowered their cameras. Theatergoers stopped checking prices at the TKTS booth. The lost looked up from their street maps. They watched. They tried to listen. They madly dialed the 800 number they were told would provide audio. Failing that, they even talked to one another.
—*New York Times* (2010)[2]

## TEXT AND CONTEXT

What does it mean to say, "I saw a movie last night"? When I first began teaching film studies about four decades ago, students and I shared a common understanding of this phrase. Nowadays, I'm uncertain. Where my imagination still determinedly conjures up visions of a theater at night, lights, lobbies, crowds, the student was more likely domestic, snugly ensconced in a dorm room with, in the not too distant past, a VCR, a DVD player, or, most recently, a laptop, tablet, or even a phone. Previously, the actual experience of seeing a movie always meant something more than just seeing the film itself. In first-run theaters in the United States, it meant a luxurious waste of space, ornamentation and opulence in excess; it meant a full proscenium stage and curtains; and it meant balconies, loges, sometimes second balconies, and a sea of seats. In short, viewing a

movie in the past was also an experience of architecture, an experience of both the film image and the grand theatrical space that contained it.

If going out to the movies still means an experience of theatrical space, the space itself has taken on a minimalist quality. The last few decades have witnessed a thoroughgoing transformation in the physical plant of American movies, so much so that going to the movies in the 1970s might seem to have more in common with going to the movies in the early 1930s than going to the movies today. The luxurious waste of space in theaters of the past has given way to the architecture of efficiency in the multiplex theater of today: its chief aim is to give you the screen and sound entertainment with no room for distraction. Now, pretty much all we have left from past opulence are the screen itself and the black velveteen cloth surrounding it.

In an even more radical transformation, the theater has ceased to be the primary venue for moving images. When *Motion Picture Herald* defiantly declared in 1953 that cinema "is distinctly an art of the theater . . . and not an art of the house," it was making a claim for architectural location, not dramatic vocation. Anxiously responding to the threat of television, it sought to keep the motion picture image anchored to the primary space it had inhabited for the previous five decades. Certainly such technologies as Cinerama and CinemaScope were innovated to provide visual experiences appropriate to a theatrical space and beyond the capabilities of television, and for a while they did do this. But now moving images, regardless of what technologies were used to produce them, are so much with us in so many places that they seem as inescapable as Muzak in an elevator—in classrooms, airline and train terminals, restaurants, museums, libraries, shopping malls, banks, in virtually any public space imaginable, and sometimes even private spaces like bathrooms. In noting these developments as a prelude to looking at movies in the theater, I am not setting the ground for a sentimental journey to a lost past of better times.[3] In many ways, truth be told, the grand palaces of Hollywood's Golden Age were terrible places in which to view movies, as I hope will become apparent in subsequent chapters. But my goal in this book has less to do with rating the quality of specific filmgoing experiences than addressing a larger issue that might be best evoked by the following question: If movies are no longer inescapably an art of the theater, have we lost an understanding of the art form that seemed self-evident to past audiences?

Simply asking this question posits a connection between text and context that we need not automatically assent to, and the fact that people now willingly consume moving images in a seemingly infinite variety of settings suggests at least a possible indifference on the part of spectators, or, more radically, a sense that context has little to do with how we understand text. But the seeming malleability of the object, its chameleon-like ability to fit into a wide variety of settings, should not mean context ceases to matter. Let me briefly shift the object on view to painting and consider how context might condition viewing in this case: a Baroque gilt frame on a Jackson Pollack painting, say, would alter the way we look at the object as much as a plain polished metal frame would impact on a painting by Raphael. I have chosen the two examples because each seems so egregiously inappropriate, but still leaves open the question of how we arrive at a sense of what makes a context appropriate. Context is itself a matter of convention, so the unconventional context I've posited for each painting would likely make us reject any alteration to conventional ways of viewing each.[4] The context, then, does in part determine the object, but context itself is often a historically determined convention. Our view of the object will change with changes in the context, and conversely changes in context can lead to changes in our understanding of the object.

So, although the theater as a site for viewing a film is no longer inevitable and recent times have decisively untethered movies from their theatrical context, we cannot conclude that there is such a thing as an unencumbered text. The image always appears to us in the context of a larger space, and, if viewed in an interior, within a specific architectural space. Whether we view the image outside or in, surrounded by a natural or a built environment, the space in which we are located frames both our understanding and our vision because the space invokes connotations and references that exist independently of the image. In the first decade of the twentieth century, new theaters began to be purpose-built for motion pictures. If motion pictures became an art of the theater, it was in part because the spaces it inhabited derived from existing theatrical models. But, crucially, these models did not exist in a void. Rather, there was an architectural context developed over centuries for what theatrical spaces could be.[5] And in the history of theater architecture there had been changes in the arrangement of space sufficiently radical to affect performance practices. So, for example, we would inevitably find a different theatrical experience in identical performances of, say, Aristophanes's

*The Birds* if it were staged at the ancient amphitheater and circular performing area of the Theater of Dionysus in Athens, the sixteenth-century Teatro Olimpico in Vicenza, Italy, with its amphitheater seating indoors facing a proscenium stage, the Globe Theatre of Elizabethan England with its thrust stage, the late-eighteenth-century La Scala with five tiers of loges arranged in a horseshoe shape and four tiers of private boxes directly flanking the extended apron stage, Richard Wagner's late-nineteenth-century reworking of the opera house that drastically altered the audience's relationship to the stage image, the average Broadway picture-frame theater of the early twentieth century, or the 1950 theater-in-the-round of the Playhouse Theater in Houston, one of many mid-twentieth-century rebellions against the picture-frame theaters.

My single staging of *The Birds* in all these varied locales is of necessity a fantasy example since, as a practical matter, theater professionals working in such a wide range of spaces would inevitably seek to change the performance in response to the space. The context in these cases would impact on the content in ways that are more than a matter of how a frame might shape the spectator's perception. Motion pictures, of course, are different to the extent that the performance stays pretty much the same, regardless of spatial frame.[6] In fact, the apparently infinite reproducibility of the same performance was early on considered one of the great advantages of movies since they could provide audiences all across the United States with performances once only available to a limited number in New York or major cities on a road tour. Did this early observation of the object's constancy lead to a constancy of the space surrounding it? There was, in fact, early on a sense of a correlation between the construction of the image in terms of camera distance and constancy of screen size, as I will detail in chapter 2. But at the birth of the movies, architectural space was variable to the extent that movies had to fit into preexisting spaces. And with the advent of purpose-built film theaters, how that space should be configured was not an uncontested issue.

A projector on one end, a screen on the other, seats in between. How different can forms of movie theater architecture be? In writing of architecture, I need to make one distinction upfront because I am approaching this subject in a very particular way: where most writing of movie theater architecture emphasizes decorations, particularly with an almost nostalgic longing for the exuberantly complex decorative schemes of the old palaces, my concerns here are with architecture of *form*, specifically

addressing the issue of how the image is situated in architectural space. While there have been wildly different approaches to the *look* of the theater over the past hundred years or so, on the issue of form we are most likely to think there is not much room for variation. In fact, before the multiplex and subsequent megaplex revolutions, all moviegoing might seem similar at first glance because it took place in the same venues for the most part. When the Strand, the first dedicated movie palace, opened in 1914, it became a major influence on theater-building and screen presentation throughout the country. But, while it survived until 1987, it looked very different at the time of its demolition; in fact, it would not be too much to say that it underwent continual transformations throughout its lifetime.

In its initial incarnation with a fully equipped stage sufficient for a vaudeville theater, the Strand interspersed its screen entertainment with both live performances and a symphony orchestra located on the stage. The movie screen was placed upstage behind the live performers, set within a secondary stage that had its own curtain. The orchestra and occasionally chorus and soloists remained a visible presence directly in front of the screen throughout the showing of the movies. With the introduction of sound in the late 1920s, the secondary stage disappeared, and the screen moved into a downstage position, nearly at the curtain line. Some theaters in the biggest cities, including the Strand, kept live performances as part of the show, but most eliminated them. Compared to later palaces, the Strand was definitely looking to the past since it not only had balcony boxes, which continued to show up in later palace construction, but also orchestra boxes (fig. I.1). With the decreasing importance of stage shows or their outright elimination, side boxes lost their rationale of bringing spectators close to live performers and, so, ceased to be used for seating.

In 1953, the Strand, which had changed its name to the Warner in 1951, became the premiere New York theater for the new Cinerama technology and, in the process, reconfigured the space of the theater: the enormous arcing screen that extended into the space of the auditorium necessitated blocking the stage and its surrounding proscenium arch, the key architectural elements that related this auditorium to the space of conventional legitimate theaters. Also invoking live theater, the side boxes, already reduced to mere decoration, were now completely obscured, in part by the screen, with the rest covered over by curtains, which also concealed

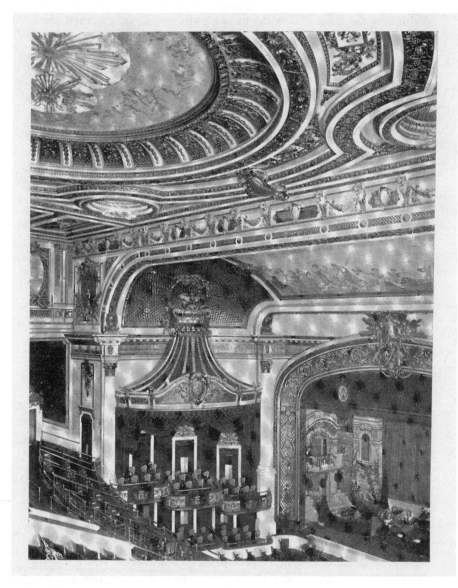

FIGURE I.1
Side boxes at the Strand Theater, New York (1914), at both the balcony and orchestra levels sold at a premium price because of the closeness to live performers.

Adamsesque detail throughout the front of the auditorium in order to give the theater a more "modern" look. In effect, the screen, once defined by architectural space, now itself defined that space, so much so that the name of the theater was changed once more, this time to the Warner Cinerama, in the early 1960s. Cinerama might have marked motion pictures as an art of the theater, as the *Motion Picture Herald* hopefully claimed, but changes this new technology wrought on the theatrical space attenuated the conventional associations of the past; if the original Strand could invoke live theater, most certainly vaudeville, the changes in architectural space created a very different kind of theater and signaled that this new technology represented a kind of theatrical entertainment the world had never seen before.

Subsequently, with the fading of Cinerama as an attraction and the decline in audiences for downtown theaters, the Strand/Warner/Cinerama became the first Times Square house to become "duplexed," having its balcony transformed into a separate theater with a separate name, the Penthouse. The two resulting theaters were themselves quite different architecturally since the original balcony utilized very steep raking, as was common practice for balconies in twentieth-century theater architecture.[7] As a result, the ground floor theater, which kept the enveloping Cinerama screen, had a gently sloping floor, while the upstairs theater, which placed its flat screen in the upper reaches of the old proscenium, offered a fortuitous anticipation of the stadium-style seating that would begin to dominate movie theater architecture in the late 1990s. Even this duplexing left room for additional modification: into the large stage and backstage area necessary for live performance, now simply empty space, was shoehorned a shoebox theater, the Orleans, for niche-audience films (the kind of film a reflection of its size) and, eventually, hard-core pornography.[8] Even in this one famous Broadway theater, without any modification of the building shell, there were very great differences in how films were presented to audiences over the seventy-plus years of its existence.

The past, then, was not all the same, and it is not just in the expanded media universe of recent times that expectations of what it means to say, "I saw a movie" have changed. Rather, expectations have been changing constantly over the history of exhibition, and sometimes changing in radical ways as a consequence of the kinds of movies being made, audience demographics, fashion, and technology, among other factors. Consider the example of the Duplex Theater in Detroit. As much as it is possible to

designate anything a first, this theater might well be the first multiplex. But the reason for twinning this theater space was very different from the purpose of multiple screens in late-twentieth-century theaters; as a result, without specific historical knowledge of its rationale, the Duplex Theater presents an architectural form that can only seem peculiar to us, and, when examined closely, perhaps even bizarre, almost to the point of being incomprehensible. Although it has some familiar structural and decorative elements, there is no precedent in the history of theater architecture for its idiosyncratic form:

> In duplex theaters [*note*: the Detroit theater was intended as a template for future designs!] the auditoriums are separated as to sound but not as to a view of each auditorium from the other one. In effect, they constitute what might be termed a single auditorium transversely divided near its center by a proscenium arch faced by seats on each side of the arch. Those seated on either side of the arch look through it at a picture screen behind those facing them. . . . Connecting the sides of the proscenium opening at its bottom is the usual orchestra pit, stage front and footlights, the arch, orchestra pit, stage front and footlights all being double, or two-faced, having the same appearance in both first and second auditoriums. The effect in a duplex theater is therefore that of two auditoriums facing each other and separated by a shallow stage, at the back of which is the picture screen, the screen and the opposite auditorium being viewed through a stage setting of scenery of the usual type at the sides and top of the proscenium arch.[9]

This remains such an unusual design to this day that it is difficult to imagine what it might actually look like from description alone. Furthermore, at first glance, an actual illustration, as provided by a sketch from *Moving Picture World*, might seem to contradict the description to some degree (fig. I.2).

Where exactly are the proscenium arch and stage with footlights and orchestra pit mentioned in the description? And while the central location of the projection booth (a feature highlighted in the caption as "Operating Rooms") might make this an efficient design for a duplex theater in the 1970s, why the plate glass underneath it? Both questions can be answered by what must seem the oddest feature of the design. Look closely at the seats in the auditorium on the right and you will discover that the

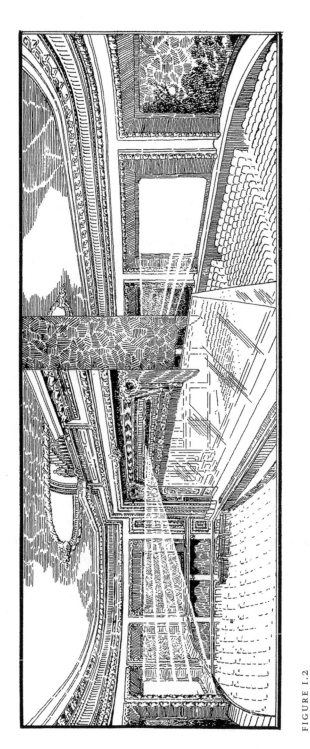

FIGURE I.2

A 1914 sketch of the proposed Duplex Theater in Detroit, which opened in 1916, seems to have the seats in both auditoria facing in the wrong direction, *away* from the screen.

spectators cannot possibly be looking at the screen in this auditorium for the simple reason that the seats are facing *away* from it. Rather, the intention is that spectators look at the screen in the opposite auditorium, *through* the soundproof plate glass, represented by the translucent triangular shape in the center of the image, halfway between the two sets of seats that seem to face each other. Now look more closely at this soundproof glass and you should be able to make out the proscenium arch (surmounted by organ pipes), a very shallow stage, and the orchestra pit arrayed around the glass.

What is particularly confusing here is that the film image is viewed by people sitting in the *opposite* auditorium; spectators are spatially separated from the film screen, allowed access to it only by an imperceptible glass. Accordingly, the orchestra in the pit of one auditorium accompanied the film image at the back of the *other* auditorium. The reason the central plate glass was soundproof was to ensure that patrons in the opposite auditorium would not hear the music intended for the image being projected *behind* them. The fake proscenium arch concealed the projection booth (hence the light rays that seem to emerge from the top of the proscenium on both sides) and provided a surrounding frame for the plate glass to create a *trompe l'oeil* illusion that the movie image was located on an actual stage, not against the back wall of the opposite theater. Seats on either side were located below the level of the fake stage so that spectators in one auditorium would not be visible to those in the other, even though they faced each other. In the darkness, spectators received the impression of a screen located far upstage behind the proscenium arch, the preferred placement for the screen in this period. The darkened space of the opposite auditorium effectively became the space of a nonexistent stage. There's one last point that might be a source of confusion in trying to understand this design: films for each auditorium were being run *simultaneously*, which means as an audience in one auditorium viewed the film image on a screen in the opposite auditorium, a different image ran on the screen in the auditorium situated behind them. There are no reports that the rearview screen was regarded as a distraction.

Strange as this design may seem now—and it is hard to imagine anything stranger—six months after the theater's opening, a movie trade journal referred to Detroit as "Home of the Famous 'Duplex.'"[10] If the Duplex had indeed become famous in exhibition circles, it is because its

seemingly incomprehensible design offered a *function* contemporary viewers could easily understand: "the remedy of an objectionable element in motion picture exhibitions . . . duplex theaters afford those entering after a long photoplay has started an opportunity of witnessing several short picture plays until the long one starts again." While waiting for "the beginning of a long play," one may "be entertained by short productions *such as he would otherwise see at its conclusion instead of as a preliminary.*"[11] The theater might have had two orchestra pits, but they were utilized by only one orchestra, which played solely for the feature film. When patrons arrived, they were sent into the theater showing short films, which had an organ accompaniment. The program was set up so that the shorts matched the duration of the feature, each running simultaneously with the other. When the shorts playing in theater one ran their course, the orchestra, having finished playing for the feature in theater two, would trod an underground passageway into the other pit and would play, once again, for the feature, which would now unspool only in theater one. At the same time, the organ loft would close for theater one and open for theater two so that the organist could play for the shorts there. Patrons arriving at this time would be shown into theater two.

Why this complicated strategy of showing all the same films in a bifurcated theater? If the films were all the same, why not one theater with a simpler architectural form? The Duplex was built during a period of transition in film exhibition. In the preceding nickelodeon era, film showings consisted primarily of a vaudeville-like program of short films, which meant that patrons could drop in at any time and understand what they were seeing. With the move to the feature film in the early teens, such casual attendance became more difficult, a fact that raised concerns in the film industry and offered one reason for resistance to the feature film.[12] *Exhibitors Herald* took note of the advantage of the Duplex Theater in this context:

> The experiment of the Duplex Theater, Detroit . . . is of striking interest to the trade at large. One of the most widely circulated criticisms from the patron's standpoint has to do with the breaking in on the long feature some time after the preliminary incidents of the story have been unfolded, leaving the film fan a very unintelligent observer of the remaining portions of the picture. . . . It has been argued that time schedules drive patrons away.[13]

There was some thought in the period that different modes of production would continue, with even the possibility of different audiences gravitating toward different theaters, one kind for short films, the other for features. And each kind of film did suggest a specific architectural context: small-capacity theaters would continue to show programs of short films since their limited seating demanded frequent turnover, while longer features would require larger theaters with greater capacity.[14] The Duplex Theater offered a solution to the two contrasting architectural spaces with a theater design that accommodated audience habits and expectations: you could arrive at any time of the day as you had previously and not be as disadvantaged as you would be with single screens that were showing features. But the Duplex Theater also served to condition new expectations: this strange architecture *required* the combination of a feature film and short subjects playing simultaneously opposite each other. Without such programming, the architecture would seem a needlessly elaborate configuration of space. Had the theater become the successful template for future movie theaters that its developers had intended, the architecture would likely have had an impact on production, making production of short films in large numbers more of an ongoing necessity.

I have used Detroit's Duplex Theater as my first example because it suggests an almost schematic connection between theater architecture and the *kinds* of films being shown in those theaters. This architecture was clearly designed to integrate two contrasting modes of film exhibition that drew on the differing models of "legitimate" theater and vaudeville, a contrast in exhibition models that would be a central concern for the industry over the next several decades. But there are also other elements of the design and programming here that might seem odd, which I have not yet commented upon. While the architectural decoration might make the Duplex Theater look similar to the movie palaces of Hollywood's Golden Age, it nonetheless displays striking features that would seem foreign to moviegoers of the sound era: the fairly remote positioning of the screen, enforced by a literally unbridgeable distance, the gilt picture frame surrounding the film image, the reference in the description to "a stage setting of scenery of the usual type at the sides and top of the proscenium arch," the two large paintings, also in gilt frames, that surround the movie screen in the sketch. In terms of programming, the description above states that it is common to show shorts *after* the feature, not before. While these elements might seem unusual, none is idiosyncratic

and unique; in fact, each represents a convention of film exhibition at the time, a number of which remained conventions until the introduction of sound film.

## A Reciprocal Relationship

The history of the stage in the twentieth century is also the history of film. Which is to say, it is impossible to separate stage and screen and still understand the history of American theater. Tied together in various ways, each contributed substantially to the other's aesthetic and economic development.
—Thomas Postlewait[15]

My analysis of the Duplex Theater centered on the relationship between art object and architectural context, considering how architectural form in this instance responded to conventions that had developed around the art object, but also how the resulting architecture could in turn define the object. Given that the architecture was so overtly novel, meeting the needs of a new art form, it might seem surprising that specific elements in the Duplex theater—the use of proscenium, stage, stage settings, and orchestra pit, all elements unnecessary for actual film showings—were in fact commonplace elements in other film theaters of the silent period. I will consider the reasons for these architectural details in future chapters, but for now let me suggest that movie theater architecture in this period inevitably points to two other interconnected contexts: the larger history of theater architecture itself and, as a consequence, the history of theatrical *performance*. Looking at the context of performance conventions can help to explain another seemingly oddball example of early movie theater architecture, this one from the late silent period, a structure that deliberately turned its back on precisely all those features of conventional theater architecture that did figure in the otherwise idiosyncratic Duplex Theater.

The Film Guild Cinema, which opened in New York in 1929, sought "to bring before a public not otherwise attracted to motion pictures, what is best in cinema art"[16] in part by looking different from any theater of the time and, in the process, as a poster announced, serving as "The first 100% cinema—unique in design—radical in form—original in presentation—conceived—executed by Frederick Kiesler."[17] Viennese émigré architect Kiesler had been on the programming committee of the Film Guild, an organization intended to exhibit films that might not survive

in the marketplace. Unlike the Duplex Theater, it did not seek to ally itself with contemporary theater by appropriating its architectural trappings; rather, it rejected every trace of commercial theater in order to claim the uniqueness of cinema, and particularly a brand of cinema that vaunted art over commerce. From our current perspective, we might expect the art policy of a theater to dictate a kind of purity in exhibition, something that would give us direct access to the film text without distraction.[18] Kiesler seemed to be promising precisely this with a note that appeared in the Film Guild Cinema's program at the premiere showing: "The function of a building determines its form, color, material. Architecture is function materialized in space." For this reason, Kiesler sought to create an architecture specific to the cinema: "the interior design is intended to assist the witness in concentrating on the screen . . . by the elimination of the proscenium arch and the orchestra pit, by a color scheme in which black predominates and by a decided pitch to the floor, downward toward the screen."[19] Further, beginning with the façade, Kiesler sought an insistence on black and white because it "typifies the black and white of the motion picture, and is therefore not a mere whim of decoration."[20] Everything about this theater seemed to aggressively reject conventions of live theater, including the implied criticism of decoration based on whim. In this manner, Kiesler's architecture seems very much in line with an impulse of early film theory by seeking to set film in opposition to theater, not something derived from it. Motion pictures called for a radical form because this was a radically different art. The stage, the curtain—these belonged to live theater and had no place in a film theater. And yet there were ways in which Kiesler's design was responding to contemporary theater, even perhaps in dialogue with it.

If the function of the form is to display a motion picture image in the most advantageous manner, to lead all eyes to the screen, as Kiesler claimed, Kiesler's most radical departure seems to lead in the opposite direction.

The auditorium has many surfaces of projection and is *the main feature of the house*. The medium of this new projection is called a "screenoscope." The screen proper is circled with a giant wooden ring, from proscenium arch to floor, a fixture said to correct the angle of vision for a person seated in any part of the house. Behind the ring is a curtain which opens in four directions and which can

be manipulated so that a screen of any size or shape is mechanically obtainable.

Picture yourself a dwarf inside a giant camera, for that is what the auditorium of this theatre most resembles. The floor is 38 feet wide, with a pitch of one inch in ten slopes down for 91 feet to the bottom of the ring framing the screen. By means of two sliding silver shutters, this ring, or lens, of the camera closes between the presentations.

The ceiling, which has a silvery surface, is flat for ten feet from the projection booths, then it too slopes down to the "lens." The lower side wall, lined with blue leather, also appears to diminish as it approaches the focal point. It goes up for about ten feet, then projects slightly over the edge of the audience, and then is continued, this time in black satin, to the ceiling. The under side of the overhang is cream colored. The projection booths have six sides, and all the wall and ceiling surfaces can be flooded with color, given some special design, or can be used as *a screen for supplementary motion pictures*, thus lending atmosphere to the piece that is being played on the regular screen. For example, if a religious film were being shown, *the house could be transformed into a cathedral by means of this side wall lighting*. If "Jeanne D'Arc" were being played, the whole auditorium could be bathed in flames during the scene in which the heroine is burned at the stake by her British captors.

There are 38 projection holes to facilitate this process, which is said to be uniquely adapted to imbue the audience with the mood of the picture.[21]

Nowadays, we might be inclined to call this a multimedia show, while bathing the whole auditorium in flames would perhaps seem more appropriate to a rock concert than a somber art film by Carl Theodor Dreyer. Yet this article from a prominent trade journal presents Film Guild Cinema's scheme as a real advance in film exhibition as a way of promoting film art.

In the end, all these projections around the auditorium were never in fact used, but we can still wonder at the desire to employ them.[22] Some of this has to do with the ways in which the screen image was "staged" during the silent period, a practice I will be analyzing in chapter 5. But there are also two very specific references to contemporary legitimate theater

here, one in the implicit invocation of a famous stage production, the other in the name of the theater itself, and these two references help explain the design of the theater. Seen in the context of theater history, and most especially recent contemporary theater, one detail in the above description of the Film Guild Cinema would likely stand out for a contemporary reader and help make clear what was special about this theater. The proposal to transform the theater "into a cathedral by means of this side wall lighting" for a film with a religious subject would likely call to mind the celebrated Max Reinhardt production of *The Miracle* in New York (1924): "For the American opening, Norman Bel Geddes decorated the [Century] theatre interior as a gothic cathedral, and used the aisles for processions. The audience was within the place depicted and did not view it as a separate picture."[23] Kiesler's motion picture theater effectively proposed having film do something similar to what Reinhardt had accomplished with set design, utilizing projected images rather than a built environment. Further, using architecture to invoke Reinhardt, a Viennese stage director who worked in Berlin, made particular sense here in the way that using a Viennese architect and set designer who had worked in Berlin made sense: the Film Guild existed before it opened this particular theater as its permanent home, and from the beginning its programming gave particular emphasis to German film of the 1920s as cinema's most artistically advanced works, with Soviet films as a close runner-up.[24]

Further, the names of Reinhardt, Bel Geddes, and Kiesler all invoke movements in live theater that are pertinent here, a pertinence that can be recognized by considering the actual name of this movie theater. Bel Geddes himself was as much or more involved in designing experimental theater architecture as Kiesler, but these designs belonged to a particular kind of theater that represented in drama what the Film Guild programming sought with film. The Film Guild, originally the International Film Arts Guild, founded in 1926, "was modeled after New York's 16,000 member Theatre Guild, the largest little theatre organization in the United States" (Guzman, 266). The Theatre Guild was founded to produce the most "advanced" plays that could not survive within the commercial Broadway theater. In the 1920s, these plays were most often from Europe, but the Theatre Guild also provided a home for experimental work by Elmer Rice and Eugene O'Neill, premiering, for example, O'Neill's *Strange Interlude* (which I will have reason to discuss in chapter 5).[25] In

similar fashion, the Film Guild presented a mixture of advanced European movies, meritorious American works, and experimental films. And the Film Guild was also a key player in the growth of the "Little Film Theater" movement, a term that like the Film Guild Cinema itself invoked the legitimate theater, namely the Little Theater movement, which began in the early teens.[26]

The Little Theater movement did not solely signify more experimental playwriting; important for my concerns here, it also sought out different architectural forms and experiments in staging practice. Kiesler, who had worked primarily in live theater, designed the Film Guild Cinema precisely at a time when the most advanced writing on live theater was calling into question conventional relations between spectator and spectacle, even to the point of calling for a new architecture of the theater that would eventually find its greatest fruition in new theater-building of the post–World War II period. Changes in theater architecture after World War II as well as staging practices would have some impact on film theaters as well, which I will address in a separate volume. But for now we can best understand Kiesler's movie theater design by reference to advanced live theater of the period. In an article on designing the Cinema Guild Theater, Kiesler wrote, "The first radical step toward the creation of an ideal cinema is the abolition of the proscenium and all other stage platform resemblance to the theatre which we find in motion picture houses."[27] But rejecting the proscenium would hardly create a distinctive architecture for the cinema in this period. In point of fact, there is a good deal of writing at the time that attacked the proscenium in architecture for live theater.[28] In this regard, Reinhardt's *Miracle* production might have taken place in a commercial theater, but it announced its avant-garde status not only by obscuring the proscenium arch of the Century Theatre but also by moving the production out into the space of the audience.

There is something of a paradox in Kiesler's claim for the "first 100% cinema." If the proscenium in theater history has a connection to the development of the "stage picture" in performance practices, then film as a dramatic medium offered its most complete realization; here the stage was literally a picture.[29] By its very nature as a projected image, film would always have to limit the space of its performance to the space of the screen, with the screen going far beyond any stage in creating an absolute separation between performers and audience, one of the most common complaints against the proscenium theater. This context can make us understand

Kiesler's multiple projections as a way of overcoming the limitation of a pictorial screen, but the absolute boundary of the screen was an aspect of the film image that could be seen as limiting only by comparison to what was happening in avant-garde theater of this period, a theater that Kiesler himself had worked in. With his thirty-eight supplemental projectors, Kiesler turned virtually the entire surface of the auditorium into a screening space, much as Bel Geddes had turned the interior of the Century Theatre into a cathedral.

Contemporary commentary on the premiere of the Film Guild Cinema did understand this difference in ways that seemed to reference experiments in contemporary theater. A writer in the *New York World* noted that the various projection surfaces around the theater were intended "to allow of the 'spectators' being suddenly and literally immersed in the drama."[30] Further, the *New York Times* observed, "By flashing pictorial matter upon the side walls the management hopes to create in the audience more of an illusion of three dimensions than the flat-screen can hope to give."[31] This concern with giving film the three dimensions that theater has naturally, making the performing space a continuation of rather than in opposition to the viewing space, would surface again in the 1950s, when new technologies seemed to fulfill ideas about breaking down barriers between audience and image. I will have more to say about these new technologies and changing relationships between image and architecture in another volume. For now, I want to draw a more general conclusion from my two examples of unusual film theaters, one that will guide my investigations through this book: the cinema might have presented a new kind of dramatic art, but as a dramatic art it could never be an island unto itself. Much as theatrical movies in the twenty-first century exist in an expanded media universe that has helped to redefine them, in their early history movies were effectively expanding the *theatrical* universe, and this expanded theatrical universe had the power to shape expectations and create understanding about the cinema itself.

I have tried to explain some of the striking features in Kieseler's architecture by reference to contemporary live theater, but this cannot account for everything. As with the Duplex Theater, there are other elements brought forward by the description that might not be entirely comprehensible to us, but are not in fact unique to the Film Guild Cinema. Without knowledge of the extensive writing on film theater architecture that began in the teens, we are likely to overlook the significance of key features here.

In a period when the great movie palaces could have widths over 100 feet, why the concern with "correct angle of vision" in a theater only 38 feet wide? Why might the screen need to change shape "in four directions"? Why the diminution of surfaces as they approach the screen? Since the writer does not feel the need to specify why any of these aspects are virtues in a motion picture theater, there is clearly a context here that we have lost. To understand why particular architectural forms were chosen, I will have to chart an *internal* history as well, looking at how film and architecture professionals arrived at the varying styles and forms for movie theaters that evolved over a roughly fifty-year period.

My aim here is not chiefly descriptive, however, since ultimately I hope that looking at the container can also offer a way of understanding its contents. If movies in the early fifties could still seem an art of the theater, then charting the varying ways in which those theaters were designed should condition our very understanding of what a movie is. Does a movie ever exist as a thing onto itself? Much academic criticism in all the arts over the past several decades has said decisively not, paying great attention to the economic, cultural, and political contexts in which works of art appeared. Yet with film, little attention has been paid to the most immediate context for each text, the movie theater itself. Today we know that *Motion Picture Herald* was on the losing side of its argument as a seemingly existential bond between movies and theaters has been permanently severed. Now most films intended for theatrical exhibition receive the majority of their income from post-theatrical video release or digital distribution. But we also cannot ignore the extent to which films in the past were bound to the architectural spaces in which they were shown. In order to understand the consequences of this bond, this book will consider a convergence of different histories—theater history, architectural history, and motion picture history, encompassing both production *and* exhibition—in order to present a history of movies *in* the theater, a history that seeks to determine the cross-fertilizing influences of theater architecture, staging practices, and film technology. In doing this, I want to propose an ongoing reciprocal relationship between movies and theaters, between text and context, that has shaped both our expectations and our actual experiences of what a movie is.

# 1. MAKING MOVIES FIT

If any building embodies Louis Sullivan's principle that form follows function, it is the theater. . . . No American architect, not even Louis Sullivan, was predisposed to experiment with the interior arrangement of the playhouse.
　　　　　　　—Mary C. Henderson[1]

One of the best-kept secrets in the theatre is the frequency with which architectural design totally frustrates the intentions of artists for whom such work is ostensibly undertaken. It is one of the theatre's greatest ironies that those who design its stages and auditoria, no matter how distinguished they may be as architects, are very often baboons when it comes to creating a space in which actors and audiences can happily cohabit.
　　　　　　　—Charles Marowitz[2]

Performance spaces, once built, tend to outlast their creators. Miscalculations made in one generation may haunt the users of the facilities through many subsequent generations.
　　　　　　　—Martin Bloom[3]

For fifty years our theatre has been steadily and slowly working over from the bizarre operatic structure set upon the drama of Europe by the bursting luxuriance of seventeenth century Italian courts towards a reticent auditorium which should display, upon an illusively lighted stage within a frame, a realistic representation of life. At last . . . we have reached a form appropriate to the purposes of the nineteenth century drama.
　　　　　　　—Kenneth Macgowan[4]

THE THEATER BUILDING LITERALLY HAS AN ANCIENT HISTORY, one that goes back far before anyone could even imagine the technological developments that would lead to movies for the theater. But the theater building as an architectural form also has a varied history. On the face of it, the function of live theater would seem to dictate a specific use of space as much as film theater does: the very nature of the event requires a performing area and a viewing area. But in live theater this requirement is even more indefinite than with film since performing and viewing areas may, in fact, occupy the same space. I have begun this chapter with a colloquy of four voices to suggest the following: the function of live theater might always be clear, as theater historian Mary Henderson has it, but only if we define theatrical function in the most generalizing

way of spectators encountering performers. If the function were so simple, how could so many "distinguished" architects become baboons as dramatist-director Charles Marowitz claimed in 1997? Clearly, Henderson's understanding of function, based on a fairly restricted notion of theater, is too vague to imply, let alone dictate architectural form.

But if the nature of the theatrical entertainment were more specifically defined—with possibilities ranging from, say, the circus to naturalistic drama—then function would become more varied and potentially call for a variety of forms. Further, what constitutes theatrical entertainment can change with time, as is very much the case with the appearance of motion pictures within late-nineteenth-century theaters. Such changes can give rise to the "miscalculations" of past theater architecture surviving long after the original designers, as architect Martin Bloom has it. Although Bloom has in mind flaws inherent in the original design, miscalculation can also mean a past function for theatrical space that no longer conforms to current practice, a change in performance style that earlier architects could not have anticipated. This problem of a mismatch between architecture and staging is evident in stage and film producer Kenneth Macgowan's ironic praise for contemporary theater architecture finally arriving in 1921 at a form appropriate to dramatic styles of the previous century, an irony lost on us if we are not aware of the changes taking place in the most advanced theater productions when Macgowan wrote this, an irony that should be apparent from the book's title, *The Theatre of Tomorrow*.

In the United States, motion pictures first appeared in theatrical spaces designed for other purposes. My concern in this chapter is with how well motion pictures actually fit within those spaces and, complementarily, the extent to which those spaces helped condition an understanding of motion pictures. Crucial to this consideration is an understanding of the function of theatrical space, an understanding that does in fact change with history, even if we limit theater to mean a dramatic form usually centered on a preexisting text. The function of the spaces in which movies first appeared in 1896 has a precise historical determination. To complicate matters, the understanding of the function of theatrical space was itself undergoing a change in precisely this period, with changes in staging practices and the audience-performer relationship. Following up on his ironic praise for the new theater architecture, Macgowan notes isolated exceptions of the previous century that were becoming more of a

trend at the time of his writing: "For a hundred years scattered artists, architects and directors have been fighting both the court opera house and the modern peep-show theatre in an endeavor to create still another form of playhouse—a structure neither as absurd as the opera house nor as limiting as the picture frame stage . . . a theatre for the future as well as the past; a theatre for the drama that grows tired of the limitations of realism" (186–87). In Macgowan's formulation, theater architecture effectively expresses a preference for kinds of staging as well as kinds of drama, so, for example, the "picture frame stage" evinces a preference for realistic staging. Taking a cue from Macgowan, then, I would like to reverse Sullivan's familiar dictum and use form as a means to arrive at function.

Let me begin with Sullivan himself by considering the Dankmar Adler–Louis Sullivan Auditorium Theatre in Chicago (1889), "the most important and influential theater building of the nineteenth century after Bayreuth Festspielhaus," a building roughly contemporaneous with the invention of cinema and possibly an influence on subsequent movie palace architecture.[5] There are a number of striking features in the design of this building that we are no longer likely to see in a new theater: side boxes, which were perpendicular to the hall, not facing the stage; an arrangement that allowed covering the orchestra seats with wood planking; and, finally, one of its most innovative architectural features, "hinged ceiling plates, which could be lowered to close off two upper balconies."[6] What precisely was the theatrical function of these architectural forms?

The first two items actually had little to do with theatrical entertainment. Of the man who commissioned the building, Sullivan wrote, "he wished to give birth to a great hall within which the multitude might gather for all sorts of purposes, including grand opera."[7] "All sorts of purposes" might well be an understatement since the first use to which the hall was put, a year before its formal opening, was the 1888 Republican National Convention. After the space officially opened as a theater, it also functioned as a concert hall for the Chicago Symphony Orchestra, which made the Auditorium its home until it moved to a dedicated concert hall in 1904. In both these cases the side boxes that did not directly face the stage could make sense: facing the orchestra is not necessary for a concert, while facing the interior could make sense for a convention. Covering the orchestra seats with wood planking was necessary for the convention as well, but it also allowed for the possibility of gala balls, which

were indeed held in this theater. The one item here that actually has to do with theater was the hinged ceiling since it allowed for "reducing capacity to about twenty-five hundred for dramatic presentations." At the time of its construction, the theater "was designed to seat over forty-two hundred for operatic, choral, or orchestra performances."[8] As an architectural matter, then, "dramatic presentations" clearly stood in opposition to these other entertainments and called for a different *kind* of architectural space. The different configuration of space should provide insight into contemporary understanding of, say, the function of grand opera as different from that of dramatic presentations.

Writing of the move toward "the large, pictorial, and essentially Romantic style of stage production" in the nineteenth century, theater historian Donald C. Mullin has observed, "Whether the design change dictated by fashion influenced playwrights or whether the changes in dramatic entertainments ran parallel to those in architectural practice is not clear."[9] Architectural space will inevitably place constraints on what may be exhibited within it, but to what extent may performance determine architectural space? At the beginnings of Western theater there seems to have been a fairly direct connection between theater design and performance. In the enormous outdoor theaters of ancient Greece, performance space was contiguous with audience space, with both performers and audience utilizing the same *paradoi*, the walkways to enter seating and performing areas.[10] The consequent emphasis on theater as communal experience, with playing and seating areas constituting a continuous space, finds its literary reflection of community in the onstage chorus. Further, the very size of the theaters necessitated the use of masks with built-in miniature megaphones and something like platform shoes for all performers to make them more visible and audible to the widely scattered audience. This, in turn, had to have an impact on the way the plays were written.[11] Still, these were structures that were being erected at the same time as the plays being written for them. In later centuries, however, economics could be as important a factor in determining architectural form as theatrical function, most especially in theaters built on speculation in a commercial market.

For example, the advent of the unroofed theaters in Elizabethan England staged dramas within structures "undoubtedly derived from the bull and bear baiting yards."[12] The reason for the architecture was both economic and political, "so that the buildings could readily be adapted to

gaming houses should their use for plays be restricted at any time by the authorities, thus insuring the owners against loss by the multi-purpose nature of their building design" (ibid.). Would the design have been different had the sole function been presentation of plays? The design of contemporaneous interior court theaters, based on a rectangle, was certainly different, so it seems likely the rectangular shape could have provided a model for unroofed theaters as well, one that might look more familiar to us. But the court theater did not face the economic constraints of the commercial theaters. The resulting dual-purpose architecture of the unroofed theater consequently acted as a limiting factor on how plays were presented, its circular form requiring a platform that extended from one end of the circle toward its center. At the least, there could be no question of extensive scenery, which is why Shakespeare's plays often call upon our imaginations to provide settings for the staged action. Further, the extremely varied views of the performing area created by the circular shape were certainly a factor in determining a style of playwriting that favored the expressivity of language over spectacle.[13]

Architecture, then, could affect the composition of a play, and I will argue in later chapters that it would eventually have an impact on film production as well. But in its earliest appearance in a theater, film might seem more of an immutable object that merely had to be fit within an existing space willy-nilly, not able to change in any fundamental way as staging practices in live theater could change in response to architecture. Nevertheless, *how* the film image was presented to an audience within a given architectural space turns out to have required a good deal of forethought and could be surprisingly varied, even in its earliest exhibition. This is to say that the theaters themselves did affect how the first motion pictures were perceived by the American public, literally in terms of how the screen was spatially located in relation to the spectators. But there was also a metaphorical meaning fostered by the connotations of the theatrical space as well as the manner of presentation, both in theatrical format and in issues of staging, which inevitably invoked other theatrical presentations.

Once a theater is built, the very expense of its construction makes tearing it down the last option to allow for any novelty in theatrical presentation. For this reason, architecture is generally the most conservative element of theater. As economic necessity determined the form of the Elizabethan theater, it also determined the venue for motion picture

exhibition: the sense that cinema might be little more than a novelty as well as the very brevity of the films themselves could not warrant new structures. Further, as much as motion pictures were a novelty, they also operated within a context of visual novelties that were a striking feature of nineteenth-century entertainments, not least of which was the development of photography itself.[14] I want to look at two that had strong associations with theater and may be seen as precursors of the motion picture: panoramic paintings and *tableaux vivants*. Both appeared in a period that seemed to increasingly value illusionism, both paralleled each other in periods of popularity, and both were effectively supplanted by motion pictures as a popular entertainment. Finally, each allows us to consider how an illusionist object would depend upon a specific architectural space to create its illusion. Panoramic paintings with their *trompe l'oeil* ambitions aimed at fooling the eye into accepting pictorial representation as reality are of interest because they required special buildings that looked nothing like conventional theaters, and yet they were seen as theatrical entertainments and ultimately did have a direct impact on theater practice.[15]

First popular in the late eighteenth century, panorama painting saw a major revival in the few decades preceding the first exhibition of motion pictures. In both periods, the panorama painting brought with it the dedicated buildings of the earlier period. These buildings could seem at an extreme remove from theater buildings: spectators were led up a stairway to a central viewing platform where they found themselves surrounded by a wraparound painting. But even if the buildings themselves did not provide an architectural connection to conventional theater, the paintings were viewed as a form of theatrical entertainment: for example, a 1903 historical survey of the "New York Stage" lists "The Colosseum," a building which opened in 1874 specifically to display a panorama painting, "London by Day."[16] This painting was enormously successful for three months, after which time, much as a new play might open, a new painting, "Paris by Night," was installed. When business fell off (reportedly because of competition from P. T. Barnum's circus at the Hippodrome, the cavernous space that would become the first Madison Square Garden), the show closed and the building was taken down.[17] Similarly, the panoramic painting "The Battle of Gettysburg" was exhibited in a special building, "The Cyclorama." As plays in this period would travel to different cities, the painting was moved to Washington, D.C., after a two-

year run; subsequent paintings of "The Falls of Niagara" and "The Destruction of Babylon" carried through to the 1893–94 season.[18]

Finally, if not actual theater itself, panorama painting had a direct impact on theatrical practice in two ways.[19] After the first period of popularity, moving panoramas (paintings of great width that moved by being wound along two rollers) began to be used in stage productions in the 1820s.[20] Subsequently, the moving panorama effectively bridged the connection between the panorama painting and the stage theater and had a direct influence on late-nineteenth-century scenography: "The moving-panorama backdrop became an indispensable part of nineteenth-century theatrical productions, whereby it should be noted that it was panorama painting that influenced stage design and not the other way around."[21] Along with the moving panorama, the 360-degree panorama painting had an impact on late-nineteenth-century scenography because the painting had to be *staged* for its illusion to work: the building guaranteed that the viewer stood in the center of the painting so that it became the entire environment and at a sufficient distance from the painting to ensure its illusion. The distance also provided the possibility for creating an environment in front of the painting with three-dimensional objects that would enhance the painting's realism.[22] The first use of the manufactured environment dates to a Frenchman, Jean Charles Langlois, for a rotunda he built in Paris in 1831: "between the viewing-platform and the canvas he introduced a *faux terrain*—three dimensional scenery which blended with the picture on the canvas. When organized skillfully it would be impossible for spectators to tell where three-dimensional elements ended and two-dimensional canvas commenced. For Langlois' first panorama, 'The Battle of Navarino,' he purchased a ship that had distinguished itself in the engagement—the *Scorpio*—and incorporated a section of it into the rotunda" (Hyde, 59). The use of a portion of an actual ship anticipates the kind of large-scale illusionism that characterized nineteenth-century spectacle theaters.

With the panorama revival in the 1870s, "The *faux terrains* became as important as the paintings themselves" (Hyde, 169), a shift in emphasis that was significant for live theater, reflecting a change in the pictorial theater itself. Their direct impact on theatrical staging is evidenced by an 1881 observation cited by theater historian Martin Meisel: "A new system of scenery has lately been introduced in pieces like 'Michael Strogoff'

(1871) which consists of grouping living persons and bits of still life with pictorial background into a picture. This is borrowed from the panoramas."[23] Meisel considers this development a "late achievement of a fully pictorial theater, in which actor and crowds were fused with the setting in a sustained and atmospheric unity" (44). As such, this "innovation" not only anticipates the move toward more fully three-dimensional scenography in the theater but also presages the combination of film image with built sets that I will discuss in chapter 5. These changes in set design would eventually lead to changes in theater architecture. Still, they were possible to employ within existing theaters. On the other hand, panorama paintings required a very precisely determined space to achieve their effect, and single-purpose buildings were economically limiting: when the panorama's popularity declined, the buildings were demolished.

Something as novel as motion pictures could well have called for a distinctive building type, as did panoramas. And something like this did in fact happen with some early attempts to combine motion pictures with panoramic exhibition in buildings erected for this purpose.[24] Within a decade, after they clearly established themselves as a lasting primary attraction, motion pictures would find their own buildings, but in the interval, the panorama buildings could serve as a warning: movies could prove to be a transient fad like panoramas. Further, the motion picture image could be more easily made to fit within existing spaces because it did not place the same kind of constraints on architecture as panoramic painting. Since the motion picture was an object that could be exhibited to large groups of people at any time and seemingly at any place that could be suitably darkened, the theater might well seem to be the most obvious choice among existing spaces.

Must movies be shown in theaters? Before the age of television, the very technology would seem to require the elaboration of a theatrical space for exhibition. But the earliest showings of motion pictures in the United States were in arcades rather than theaters, and it was something of a solitary experience, with individuals watching the film through a viewer like Thomas Edison's Kinetoscope. The technology was fairly simple, relying on the viewer for energy, and celluloid could be dispensed with entirely, as with the Mutoscope machine that flipped cards of still photographs. Edison himself had only made "half-hearted efforts to develop a projecting machine," and so the apparatus his company put out under the Edison name was invented by others, Thomas Armat and C. Frances

Jenkins.[25] In France, the Lumière brothers from the outset seem to have regarded their development of motion pictures as something to be exhibited in a public space, although not necessarily a theater per se: the first showing of their cinématographe was at a June 1895 scientific conference in Lyons, with the setting clearly influencing the kinds of film shown. This was perhaps most obvious in the case of footage which showed attendees of the conference to themselves shown on the very day the film had been shot, a presentation which stressed the marvelous in this scientific marvel by transforming time and space.[26] A subsequent showing in Paris led the Lumières to plan for a New York opening. It was only the promise of the New York cinématographe premiere that led the sales agents for Edison's Kinetoscope to prompt Edison to move his moving images onto a screen and into a theater.

As the Lumiére exhibition makes clear, a theater need not have been the inevitable choice for first-time exhibition in the United States. Since the Kinetoscope presented an image isolated in a spatial void, the invention of the motion picture not only did not presuppose a specifically theatrical space, it seemed to exist outside of architectural space entirely. Displacing the image from an individual viewing machine filled in that void, providing a specific context for the image that had to impact on a sense of the image itself. What kinds of places were available for exhibiting motion pictures in the United States? At the time motion pictures moved into theaters, the most obvious possibilities were the opera house, the vaudeville theater or music hall, and the straight dramatic theater. To this, I should add the lecture hall as a possible space since it was precisely a lecture hall within a New York wax museum, the Eden Musée, which began showing films in late December 1897 and provided cinema with one of its most important early venues in the United States. But this does not offer an architectural departure since the shape of this lecture hall reflected dominant styles in theater architecture of the period.

As far as theaters go, generally, the opera house and the vaudeville theater were among the largest theaters in a given city, with the great space of the auditorium considered appropriate to spectacle-oriented performances. This is not to say that straight plays were never given in opera houses or music halls, but the general orientation of these theaters was toward spectacle.[27] Although this distinction between spectacle theaters and dramatic theaters would prove important for motion picture exhibition with the advent of the feature film in the teens, initially motion

pictures found their home in spectacle-oriented vaudeville theaters. The kinds of movies being produced at the time could, in fact, fit easily into a vaudeville theater because they could conform to the aesthetic purpose of the overall program.[28] Since early films ran less than a minute, vaudeville, itself presenting a series of discrete performances, offered a theatrical context that could accommodate a modular presentation. This is to say that early motion picture presentations effectively echoed this modular form in miniature, in the process helping to define variety as an important aspect of movie exhibition.

The choice of vaudeville theaters for the first showing of motion pictures in the United States, and especially the specific vaudeville theater Koster and Bial's Music Hall, seems overdetermined in retrospect, something that grew out of the films themselves. Many of the short films that the Edison company had made for use in the solitary viewing machine, the Kinetoscope, featured vaudeville stars who had been filmed in excerpts from their acts at Edison's New Jersey studio. The use of vaudeville acts, some of which had appeared at Koster and Bial's, in fact, would seem to inscribe motion pictures as an extension of vaudeville in contrast to the initial demonstration of the Lumiére films in Paris.[29] Furthermore, film historian Robert Allen has argued that motion pictures fit very neatly into vaudeville because visual entertainments had a fixed place in the standard vaudeville bill: "the endless procession of visual novelties . . . were always an important part of vaudeville. Vaudeville absorbed, in slightly altered form, both melodrama and pantomime, and provided a forum for several other pre-cinematic novelties, the popularity of most of which reach a high point on the eve of the introduction of the movies" (Allen, 52).

The Vitascope fell in line with previous music hall pictorial presentations in one very specific way: "Kilanyi's Glyptorama" premiered at Koster and Bial's in December 1895 and ran pretty much until the Vitascope premiere in April 1896. The Glyptorama was a mechanized variation on "living pictures," an entertainment which "rose to a pinnacle of popularity at the close of the nineteenth century, with numerous productions competing for public favor in New York's major variety theatres" and "a remarkable variety of tableau acts in the United States."[30] Living pictures consisted of "live models [who] represented static scenes from painting, sculpture, and other sources. Through elaborate stagecraft, these scenes were made to appear as much like the original work as possible" (Mc-

Cullough, 25). As an entertainment they could fit very neatly into a vaudeville show because even when they were presented as part of the entertainment in a legitimate play, they worked like a mini-vaudeville show in themselves: a series of individual "acts," most recalling a familiar artwork, but otherwise generally unrelated, and seemingly chosen for their variety, ranging from comic to pastoral to spectacular to religious to melodramatic.[31] Edward Kilanyi, a German producer who had begun his career as a scene painter, had previously toured with a troupe to present "living tableaux" in Germany, France, Spain, and England; his performances in London set off a fad for tableaux at variety theaters. He subsequently brought them to the United States, first as intermission entertainment for a dramatic stage performance, a "burlesque" entitled *1492*; the entr'acte was called "Queen Isabella's Art Gallery," with the women outnumbering men since the basis in famous artworks allowed hints of nudity that were a prime attraction of the entertainment. The great success of this entr'acte had an effect comparable to his London showing, leading to a competition at vaudeville theaters, first with a series of "Living Pictures" "devised" by Oscar Hammerstein which premiered at Koster and Bial's in May 1894, where they "proved a genuine hit," leading to *tableaux vivants* shows at Proctor's in New York and in Boston among other cities; Kilanyi responded with a new series of living pictures for the *1492* entr'acte.[32] For contemporary audiences the early uses of motion pictures had to suggest a parallel with living pictures: both functioned as an act in a vaudeville show, where they presented a series of discrete views, and both were used as entr'acte entertainment in stage dramas, with motion pictures eventually usurping *tableaux vivants* in both instances.[33] Perhaps the most obvious connection between the two for contemporary observers was signaled by terminology: early motion pictures were occasionally referred to as "living pictures."

In the competitive climate that began to emerge around living pictures, the Glyptorama sought to distinguish itself by a novelty that conjoined them to machinery, making use of the moving panorama, which, as noted above, had become a common device in theaters of the time. With this addition of mechanical movement, the Glyptorama effectively carried living pictures in the direction of motion pictures, making the premiere of the Vitascope in retrospect a logical successor, one that would eventually displace the Glyptorama itself. It was the practice in earlier living picture entertainments to draw a curtain between individual tableaux

as a way of both concealing the change to a new picture and heightening the illusion of stillness in each tableau. The Glyptorama countered this discreteness with a flow from one "picture" to the next, maintaining a continuous visual field by mechanically moving already staged models into position as the new background unrolled behind them on a moving panorama. This shift from concealment to revelation was no modernist *avant la lettre* "baring of the device": the 20-foot-wide stage picture set in a proscenium 42 feet wide was surrounded by a black drop curtain to hide the elaborate mechanism required for the movement. Not being able to see how the change was managed made the transformation itself seem marvelous, as marvelous as the rendering of a flat object in three dimensions by living subjects. The Glyptorama thus heightened a paradox inherent in living pictures, itself a paradoxical term, by simultaneously setting the movement of real-life foreground and painted background against the stillness of the posed figures.[34] It also set the three-dimensionality of the performers and props against the flatness of a painted background, although the distance from the audience might have lessened this difference. ·

This opposition between movement and stillness would be further underscored by the occasional movement of inanimate objects or change of lighting effects within the picture. For example, in response to a picture entitled "The Deluge," a reviewer remarked, "the light and scenic effects were superb, and the real rain, falling upon the six shapely maidens grouped on the mountain top, in all sorts of picturesque attitudes, was *a triumph of stage realism*."[35] This was, however, a very odd realism because the only living beings on the stage held the stillness of inanimate objects, while the inanimate objects themselves moved; the realism, then, was actually in the setting and the illusions created by lighting effects and "real rain," which, of course, was not real at all. As we will see, setting had become a crucial defining feature for stage realism in this period, a notion that in turn had an impact on the early reception of motion pictures. While the stillness of the human figure in living pictures was remarkable because it made a familiar painting or statue (sources for individual pictures were always listed in the program) seem as if it were about to spring to life, the illusion and realism of motion pictures worked in an opposite direction, taking something frozen and magically granting it movement. In this regard, consider the early Lumière showings, which would always begin with a single frame that would then slowly transform

into lifelike motion as the projectionist move the hand-cranked machines up to full speed.[36] The stillness of living pictures is effectively a freezing of time: the image made up of real people looks as if it should spring to life at any moment, and yet it does not. Time stands still. As such, motion pictures effectively resolved the tension implicit in living pictures by adding a temporal dimension to the realistic pictorial representation.

The fate of the Glyptorama offers perhaps the strongest evidence of a connection between living pictures and motion pictures in contemporary reception: "The tableau vivant reached its zenith as an independent popular entertainment during the time of Kilanyi's flamboyant presentations. Its days were numbered, however, for within four months the Glyptorama was replaced by a new novelty, one far better equipped to satisfy the nineteenth century thirst for verisimilitude and one which became an even stronger influence upon the destiny of the theatre. This new curiosity was 'Edison's Vitascope,' precursor of the cinema" (McCullough, 39).[37] If early motion picture projection could seem to follow directly from the Glyptorama performance, it is likely because both invoked stereopticon shows for contemporary viewers, a visual entertainment that also proceeded through a series of discrete images. Commentary in the *New York Times* compared the Glyptorama to stereopticon shows—"As in the changes of slides in a stereopticon, one picture will dissolve into another"[38]— even dubbing the show a "stereopticon–living picture exhibit," with the "dissolve" anticipating a key filmic device.[39] Similarly, a *Times* review of the Vitascope premiere compared the show to a stereopticon: "a projection of his kinetoscope figures, in stereopticon fashion, upon a white sheet in a darkened hall."[40]

As the successor to the Glyptorama at Koster and Bial's, the Vitascope borrowed from both its format and its physical staging. The Glyptorama featured fourteen separate "pictures"; the actual duration of the picture was likely not much longer than a Vitascope "view" since it was held "as long as the models were able to hold their poses without moving" (McCullough, 28). Subjects ranged from "Roman Bath" to "Football," from "Slave Market" to "The Bay of Naples." The Vitascope premiere at Koster and Bial's also consisted of a series of briefly glimpsed pictures with "twelve views" listed in the program, although in the end only six were shown at the premiere (albeit multiple times as the brief films were set up on the projector in a loop). As with the Glyptorama, variety was an object of the programming, with subjects ranging from dancers to a seaside setting,

from a burlesque boxing match to "a comic allegory called 'The Monroe Doctrine'" to a scene from a familiar farce.[41] One of the short films, the burlesque boxing match, was excerpted from the play 1492, which had provided the first American showing for Kilyani's living pictures and set off the craze.

If variety was a defining feature of both the Glyptorama and Vitascope programs, from these initial showings a concern with variety would attach itself to motion pictures as if it represented an essential quality. But this was not just a variety of subject matter: perhaps the salience of the Glyptorama for movies lay in its making setting a key element of variety. In a sense, the Glyptorama was something of a throwback to the earlier practice in live theater of effecting scene changes in full view of the audience, a practice that was progressively abandoned with the move toward more realistic and three-dimensional scenery, which necessitated the use of a curtain as living tableaux exhibitions did as well. But the Glyptorama made possible the visible change of an entire setting complete with three-dimensional objects, in the context of late-nineteenth-century stagecraft a seemingly magical transformation. If a rapid change of the setting could be a source of astonishment, then motion pictures had to seem even more astonishing in making change instantaneous and almost a defining feature of motion pictures. In the context of the move toward three-dimensional sets which effectively limited setting, with many realistic plays restricting their action to one elaborate set, film's variety aesthetic would give rise to the notion that realistic plays had to be "opened up" when turned into film.

Most strikingly, the Glyptorama established a visual presentation borrowed for the Vitascope premiere. Living pictures were "usually presented on a stage or in a box-like enclosure, viewed through a large, often elaborately decorated frame, like a picture frame" (McCullough, 28). Contemporary reviews provided specifications for this frame that would be echoed in reviews of the Vitascope: "The most important production of the season so far at Koster and Bial's took place last evening. It is called Kilanyi's Glyptorama, and consists of a series of immense living pictures shown in a frame fourteen feet high by twenty feet wide."[42] For the living pictures, the gilt frame made sense since famous works of art were the most common source for the pictures. This was not the case for early Edison "views," which, as I had noted, most often reproduced moments

from vaudeville acts of the kind that appeared at Koster and Bial's. Nevertheless, the manner of presentation was similar: the *New York Times* review of the Vitascope premiere noted, "The white screen used on the stage is framed liked a picture" (see fig. 1.1).[43] A subsequent article gave the specifics: "Figures appear to be a trifle over life-size on the screen, which is about 20 by 12 feet."[44] Given the strikingly similar size of the framed "pictures" in the Glyptorama and the Vitascope, it is likely the moving pictures would recall the frozen pictures for a contemporary audience. Further, how much this reflects contemporary understanding of early motion pictures may be signaled by the fact that this manner of presentation had a lasting effect: as we will see, the image within a gilt frame became a standard way of situating the motion picture screen in the nickelodeon era.

There was one important difference in the exhibition of living pictures compared to motion pictures that can possibly help us further determine how contemporary audiences received motion pictures. Koster and Bial's had a proscenium opening 42 feet wide, so the relatively small size of the Glyptorama frame in relation to the proscenium was likely determined

FIGURE 1.1
The movie screen framed like a picture at the premiere showing of the Vitascope (1896).

by the limited sight lines, but why place it upstage at all?[45] Similar to the enforced distance of panorama paintings, this location was desirable to preserve the illusions of living pictures, the uncanny representation of a preexisting object, since the greater distance would make deceptions less perceptible. So, for example, in response to the American premiere of Kilanyi's living pictures, shown between Acts II and III of *1492*, a *New York Times* reviewer noted that some figures "by a clever arrangement of the stage and lights were made to resemble marble sculpture closely enough to be taken for such by the naked eye from the midway seats of the orchestra and the balcony. The most notable was the 'Venus of Milo,' where the arms of the woman personating the armless figure were draped in sleeves of the same color and texture of the background. The illusion was so perfect as well-nigh to defy detection.'"[46]

The Vitascope, on the other hand, did not need distance to maintain its illusion, and so it was brought downstage to the proscenium area.[47] There is nothing natural or automatic about this location for a film image: by the teens, this positioning of the screen would in fact be rejected. But in the context of the Glyptorama, the illusions offered by the Vitascope could only seem more miraculous by being moved closer to the audience; the downstage position effectively announced the superiority of the Vitascope. In the context of a vaudeville show, the downstage position also offered the advantage of having the screen function like a drop curtain behind which the next act might be prepared, and this use likely accounts for "curtain" becoming a synonym for "screen," a usage that would last into the teens.[48] Nevertheless, while downstage position was convenient for the flow of the vaudeville show, and it could serve to announce the superiority of motion pictures to both panoramic paintings and living pictures, this positioning of the screen actually created problems. Up to this point, my focus has been primarily concerned with what was *on* the stage of the theater, whether living pictures or photographic pictures, and how this might have impacted on the initial reception of motion pictures in a vaudeville format. But if we look more closely at theater architecture in this period, it turns out that the space of the theater was as much an issue for motion pictures as it was becoming for late-nineteenth-century staging practice. Architectural space turns out to be a crucial factor in early motion picture exhibition: how the audience was situated in relationship to the object had a profound effect on that object.

## The Space of the Theater

The horseshoe type of plan . . . is not particularly applicable to motion picture theaters, although in many theaters existing to-day this seating arrangement may be encountered. It is difficult with this type to secure proper sight lines; the seats at the extreme sides of the house receive such a distorted view of the pictures on the screen that they are practically useless. . . . [The "rectangular plan"] is the one most frequently found in the motion picture theater world and is the one best suited to motion pictures as a general rule. The depth, however, may be so excessive as to render vision and audibility difficult; but given a house of this type of reasonable proportions the results secured are almost certain to be satisfactory.
*Architectural Forum* (1917)[49]

In an influential study of theater architecture published the same year as the first U.S. exhibition of projected motion pictures, British architect Edwin O. Sachs articulated a relationship between spectacle and spectator that should dictate the space of the auditorium: "the planning of the theatre, especially in regard to the size of the auditorium and the setting out of the stage, depends on the performance to be produced."[50] Although Sachs is displeased to note frequent attempts to turn different kinds of theatrical spaces into multipurpose halls, generally for him opera calls for large spaces in both auditorium and stage dimensions, where room is needed for "elaborate scenery, choruses, and ballets," while straight drama requires a space that will place the audience in "closest touch with the actors; every gesture should be seen, every whisper heard" (4). Clearly, a similar understanding led Sullivan and Adler to devise the hinged ceiling that would reduce the size of the Auditorium Theatre. Since movies at the time did not have spoken language, they need not be subject to the size restrictions of straight dramatic theaters Sachs proposes here. And the enormous capacity of the movie palaces that began to be built in the teens was likely predicated on the initially silent status of movies. But if the average vaudeville theater was larger than dramatic theaters, how that space was configured was problematic even for silent film exhibition. Movies might have fit comfortably into the context of a vaudeville show, but the architectural space offered by vaudeville theaters of the period was an entirely different matter.

The general shape of the theaters available to motion pictures in the 1890s looked very different from the theaters that would be built for films a little over a decade later. But it was not just a matter of film-specific theaters leading to a change in architecture; by the teens and twenties,

theater design for live performance was markedly different from what dominated at the turn of the century. Theater historian Donald Mullin has commented, "By 1914 the new theaters were almost unrecognizably different from those of a century before."[51] As products of nineteenth-century theater architecture, the vaudeville theaters that exhibited early motion pictures were most likely to draw on a form that was established about two centuries earlier: a roughly U-shaped auditorium facing a proscenium stage with a large apron extending in front of the proscenium. "Horseshoe" was the most common name for the seating area, but the general shape could range from a more gently curving semicircle to banks of seats on three sides of a rectangular hall (in the manner of the side boxes I had noted in the Adler-Sullivan auditorium), a form that may still be seen in some concert halls such as Symphony Hall in Boston and even as recently in the Nashville Symphony concert hall built in 2006.[52] This form evolved from early indoor theaters of the seventeenth century, where the space in front of the stage could operate as a playing area for moments of spectacle, or even serve, as we saw with the Auditorium Theatre, as the dance floor for a ball.[53] As action moved further back and onto a stage, seats could be placed in the orchestra, or this area could continue to be used for such spectacles as processions, masques, or dances, as they would be well into the nineteenth century. For example, a sketch of "an equestrian version of *Richard III*" from a London theater in 1856 shows a conventional tiered horseshoe theater but with something on the order of a circus ring in the orchestra area and, simultaneously with action on stage, action involving performers and horses in the ring.[54]

There were a number of advantages to the horseshoe design that kept it viable into the early twentieth century, although not all had to do with the primary function of theatrical performance. Before the advent of massive cantilevered balconies, which made it possible to build back rather than up, the stacked horseshoe rings facilitated enlarging capacity while maintaining a relatively close proximity to the stage for most viewers (fig. 1.2). From the late eighteenth century on, there seems an understanding that distance from the stage should be somewhere between 55 and 70 feet to keep dialogue intelligible. Richard Leacroft cites a *Treatise on Theatres* from 1790 which puts the distance at less than 75 feet, while American architect Arthur Meloy came up with the same distance in 1916: "The depth of any theatre where speaking parts are to be given should not exceed 75 ft. from the curtain line to the rear seats, as the human

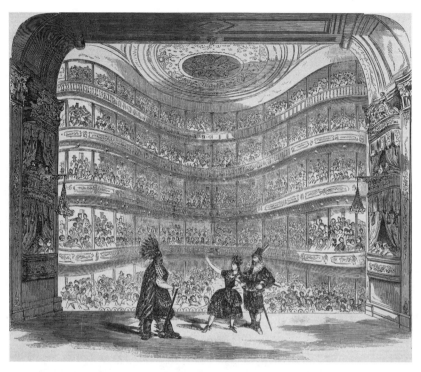

FIGURE 1.2

A mid-nineteenth-century tiered horseshoe theater, New York, kept the audience in close proximity to the stage.

voice will not carry more than that distance without straining."[55] With the development of the enormous movie palaces in the teens and the twenties, building back (as well as up!) became a norm, and the palaces far exceeded these distances. They did have live performances, but they were generally connected to music so distance seemed less of an issue than it was in live drama.

There was one additional advantage to the U-shape worth noting here: it could create a greater sense of intimacy in the audience as people were arrayed in a way that made them always aware of other viewers, marking the communal nature of the theatrical experience as central to its social function.[56] Conversely, the sense of display coupled with the stacked tiers emphasized separating the audience according to class distinctions; the hierarchical nature of the seating areas had a specifically class function, often reinforced by a separate entrance for the uppermost ring.

Subsequent movie palaces would challenge these class divisions explic-
itly, but the element of display proved an advantage for the first film exhi-
bitions: in early showings the screen itself was not the only object of in-
terest. Because the technological novelty could itself provide spectacle, at
the first showing of the Vitascope at Koster and Bial's, the performance
effectively began with the shrouded projectors as evidenced by this con-
temporary response: "In the center of the balcony of the big music hall is
a curious object, which looks from below like the double turret of a big
monitor. In front of each of it are two oblong holes. The turret is neatly
covered with the blue velvet brocade which is the favorite decorative mate-
rial in this house."[57] In this instance, the horseshoe shape was ideal since
it allowed many viewers the possibility of dividing attention between the
apparatus and the image (fig. 1.3). This practice was common enough
and continued long enough that a writer in 1914 could recall "the earlier
days" when projectors were usually placed in balconies and "the opera-

FIGURE 1.3
The horseshoe form of Koster and Bial's Music Hall provided much of the audience
a view of the Vitascope projectors in the second tier (slightly left of center and draped).

tors, always the center of all eyes, often wore dress suits"; the operator was called, he noted, "the professor" as if he were a character in this drama of technological progress.[58] If, by 1914, there was a clear understanding that motion pictures required a different orientation between spectator and spectacle, that was in part because theater architecture itself was undergoing a marked transformation in this period, a transformation that occurred in conjunction with changes in theater lighting practices.

It is a testament to the conservative impulses of theater architecture that the horseshoe shape lasted as long as it did with little challenge because it presented problems even for live theater in creating a wide range of ways to view the stage, although some of this might be mitigated by staging practices.[59] This is to say that problems with the shape of the viewing area may be directly related to staging in any given period. So, for example, as painted flats utilizing perspectival drawing came into being together with the proscenium theater, the further in front of the flats the performer appeared, the easier it was to maintain an illusion of three-dimensional space.[60] With the advent of the "picture-frame" stage in seventeenth-century Europe, "logic might seem to demand that the auditorium should adapt itself to the new requirements by making all seats face forward. This did not happen. Long after the action had retreated behind the picture frame, the seats continued to be arranged as if it were still out in front of it" (Tidworth, 72). The wide variety of viewing positions in a horseshoe theater is not a problem if actors perform primarily in the proscenium area or on the forestage in front of the proscenium, the common practice in early proscenium theaters and one that continued well into the nineteenth century, when it was still possible to find theaters with seating areas flanking the apron stage as stage boxes. The nature of the vaudeville show possibly helped keep the horseshoe form alive because much of the action could take place in the downstage area. But changes in straight dramatic performances in the late nineteenth century decisively rendered the horseshoe form old-fashioned for live drama as well in spite of its longevity up to that point. Why this was the case had to do with issues around realism for both live theater and motion pictures, but the perception of realism differed markedly in each instance. Nevertheless, realism on the stage and realism in motion pictures were oddly connected for contemporary viewers, a point I can get at by looking at reaction to the earliest film showings.

Most of all, contemporary reaction to motion pictures was struck by the reality effect, albeit in a very particular way. Charles Musser has observed about the Vitascope premiere, "as ROUGH SEA AT DOVER dramatically demonstrated, scenes of everyday life were often greeted with much greater enthusiasm than excerpts of plays and vaudeville acts" (*Emergence*, 118). This was evident in the *Times* report on the premiere, which noted, "it was the waves tumbling in on a beach and about a stone pier that caused the spectators to cheer and to marvel most of all. Big rollers broke on the beach foam flew up high, and weakened waters poured far up the beach. Then great combers arose and pushed each other shoreward, one mounting above the other, until they seemed to fall with mighty force and all together on the shifty sand, whose yellow, receding motion could be plainly seen" ("Edison's Latest Invention"). Although waves striking a beach would seem the most ordinary of occurrences, the writer thought it worth the most thorough and precise description, a way of conveying to his readers the wonder of what he was seeing. Certainly, the vaudeville acts and play excerpts that Edison had reproduced were familiar enough entertainment at Koster and Bial's, so that the one piece of actual nature represented by "Rough Sea at Dover" could seem all the more novel.

The Lumière films made it to New York about two months after the Edison premiere at Koster and Bial's and impressed viewers in a number of ways: late in the run, a note in the *New York Times* described them as "exhibiting moving views as real as nature's self."[61] Lumière projection further distinguished itself by a steadier image[62] and even added sound effects to heighten its reality: for "one scene representing an actual battle between two troops of cavalry," there was a promise of "the flash of sabres, noise of guns, and all the other realistic theatrical effects."[63] One curious aspect of this description is the claim not simply of realism, but, rather, of "realistic *theatrical* effects" (emphasis added). This does suggest another response to the reality effect that did not see it as the latest development in a line of visual novelties that aimed to fool the eye. Rather than visual novelty, it is possible to see an evolution that placed the reality effect of the moving image in relation to aesthetic trends of late-nineteenth-century theater. This effectively pointed to a very different direction for motion pictures than the simple representation of reality. Consider the response of the well-known theater producer Charles Frohman, who had attended the Vitascope premiere:

"That settles scenery," said Mr. Frohman. "Painted trees that do not move, waves that get up a few feet and stay there, everything in scenery we simulate on our stages will have to go. When *art can make us believe that we see actual living nature,* the dead things on the stage must go." ("Edison's Latest Invention," emphasis added)

The most striking aspect of Frohman's response is that he does not see movies in terms of the various ninteenth-century visual tricks, but rather immediately ties it to art and the stage: it is art that can make us believe in the reality of the image. Given his own background, it is perhaps not surprising that he immediately saw possibilities for movies in terms of theater, and indeed he himself would eventually become involved with theatrical exhibition of movies. But his connecting it to art seems to me the crucial difference here.

If the *Times* report is accepted, Frohman's singling out "Rough Sea at Dover" reflects the general appreciation for this film at the premiere. But this is not necessarily what might have been anticipated prior to the first showing. In an article the *Times* ran in advance of the premiere, Albert Bial of Koster and Bial stated the following: "I propose to reproduce in this way at Koster and Bial's scenes from various successful plays and operas of the season and well-known statesman and celebrities will be represented, as, for instance, making a speech or performing some important act or series of acts with which their names are identified."[64] In other words, Bial proposed having on screen what Koster and Bial's might well be able to present onstage. If these people could in fact be seen onstage "making a speech," would not the stage appearance be superior because we could hear as well as see? Frohman effectively answered this question in a remark that echoed Bial's promise; the simple act of recording famous performers, even if reduced to pantomime, would be a means of preserving the performance: "And so we could have *on the stage* at any time any artist, dead or alive, who ever faced Mr. Edison's invention" (emphasis added). Much as the film should have implied a someplace elsewhere, strikingly Frohman still located the action on a stage. And as wonderful as he found this possibility, he still returned to theatrical setting as the key attraction of film: "That in itself is great enough, but the possibilities of the vitascope as successor of painted scenery are illimitable" ("Edison's Latest Invention").[65] When others were looking elsewhere, either considering the possibility of preserving a performance or

enjoying the illusion of the reality effect, why did Frohman focus primarily on setting? I believe this was a consequence of both theater architecture and changing practices of staging.

Within a couple of decades of the introduction of projected motion pictures, the architectural form for live theater with frontal seating and a proscenium stage that pushed all action behind the proscenium in a box set as if behind a fourth wall, this form became dominant, replacing the previously dominant horseshoe form. So, for example, as New York's theater district at the beginning of the twentieth century moved into Longacre Square, subsequently Times Square, virtually all of the theaters built in the teens and twenties abandoned the horseshoe, opting for frontal seating instead.[66] And this form seems in large part a response to the rise of realistic drama and realistic staging.[67] In general, this was a period that found increasing value in the ability to create the illusion of a *three-dimensional reality* on the stage, a reaction against the stylization that was inherent in painted flats.

Painted flats, the dominant mode of stage scenery in the late nineteenth century, limited the use of the stage depth, most especially if the flats drew on perspectival lines and ever diminishing objects. Put simply, painted objects could grow smaller, but actors could not as they moved into the depth of the stage. The rise of three dimensional objects and settings might have limited the *implied* depth of the setting, which perspectival drawing could always elongate, but realistic set design effectively expanded the playing areas onstage: actors were now free to move across the entire width and depth of the stage. An immediate consequence of this is that the setting itself began to take on greater dramatic importance. But the horseshoe theater played against the importance of the setting: in this architectural space, the downstage position, effectively divorced from the setting, would be preferred by actors for the simple reason that this position, moving out in front of the proscenium, ensured being seen by most spectators. By the time the feature film began to establish itself as a theatrical entertainment, realistic staging practices increasingly made the limitations of the horseshoe form outweigh its virtues for live theater. In *The Theater of To-day*, first published in 1914, Hiram Kelly Moderwell specified the limitations of contemporary theater architecture:

All of us who are obliged to take cheap seats in the theatre have realized many times that most theatres of the old style are built in

utter contempt of the man with a small income. One feels that the architect thought he was doing us a favour to let us in at all. Many seats in the ordinary "horseshoe" theatre make the stage partly or wholly invisible. Very frequently the back of the balconies is so ill ventilated that the evening is torture. The acoustics of such caves are often wretched.[68]

The objection to acoustics here refers to the tendency to build the final balcony very deep, something that was structurally easier to do than with lower rings, creating the kind of "well" that Edwin O. Sachs writing in 1896 repeatedly objects to.[69] Except for these balconies, which always contained the least expensive seats in the theater, the virtues of proximity to the stage and the individual theatergoer's ability to see other audience members facilitated by the horseshoe design were offset by the vice of restricted views beyond the proscenium.

The horseshoe theater could not have become so prevalent and survived as long as it did had it truly produced as many bad seats as Moderwell claims: every theater but one illustrated in the three volumes of Sachs's *Modern Opera Houses and Theatres* (1896) draws on the horseshoe form, and that one, the Bayreuth Festspielhaus, looked ahead to twentieth-century theater design (Sachs, 1:29). There is no comparable survey of American theaters, but the evidence is that most also employed tiered horseshoes, with the Adler-Sullivan Auditorium Theatre in Chicago cited as the first significant departure from the form.[70] The fact that the horseshoe form would be so thoroughly rejected makes the timing of the shift significant. Not coincidentally Moderwell defines the "theatre of to-day" by Ibsen and other naturalist playwrights, although the first performances of Ibsen's naturalistic plays date to the 1880s, when they were unsuccessful. By 1914 Moderwell could dismiss horseshoe theaters as "theatres of the old style" precisely because they had too many bad seats *for the kind of staging* that came to seem appropriate for naturalistic drama, staging that exposed the limits of the horseshoe form. What Moderwell considered the "modern" theater effectively re-oriented the viewer's relation to the stage, requiring a more frontal arrangement of seats. The change in architectural form most evident in New York's new theater district could nevertheless be contested, but in order to do so dominant staging practices would have to be contested as well. The terms of a 1914 argument in favor of the horseshoe

shape, the same year as Moderwell's argument against old style theaters, are striking:

## THE FORM OF THE THEATRE

In an interesting article in a contemporary [sic], the form of theatre design is discussed and the criticism made that the shape of our present houses is an anachronism, as it has grown up through the fact that the stage originally was pushed out into the center of the house so that an effective view could be obtained of the acting from the tiers of the curved seating, whereas at present the stage is confined within the proscenium arch. This has rendered many of the seats in the older theatres useless for purposes of seeing from, and the writer goes on to urge that the ideal form of theatre is a rectangle with the seating arranged in straight lines from side to side. The conservation of the theatrical profession, and, we gather incidentally, of the architectural profession, is, in the author's view, to blame for this failure to recognize practical facts; but *we think it must be borne in mind that the audience of many theatres go in no small measure to see the audience as well as the piece*, and the traditional form of the theatre meets this requirement admirably. Then, too, in the newer theatres, modification of levels and slopes are skillfully dealt with so as to meet many of the objections to which we have referred, while the horseshoe form enables us to accommodate many in galleries without overshadowing and making the center of the house gloomy. The horseshoe form also has considerable merits acoustically over the rectangular form suggested, and brings a larger number of the audience nearer the stage, so there is another side to the question which has been overlooked by our contemporary. We very much doubt if the wedge-shaped theatre such as Bayreuth would be an improvement on the whole, with [sic] aesthetically it could not be as well treated. Perhaps the best solution would be in the adaptation of some form of apron stage, as has been tried by Mr. Granville Barker.
                    —*The Builder* (London)[71]

This is nearly forty years after Richard Wagner recognized at Bayreuth that differences in staging practice would require architectural differences as well. But rather than reject the nineteenth-century architecture as old-fashioned, like Moderwell writing the same year, the writer of this article responds by asking for new approaches to staging, which would effectively return to earlier methods.

Wagner's Bayreuth Festspielhaus in 1876, referenced in this article, was the first strong challenge to the horseshoe design, and it was very much a response to contemporary changes in *staging*: featuring a wide auditorium all on one level and tiered rows of seats arranged along a gentle arc facing the stage, it provided a full view of the stage for all spec-

tators. The importance of this theater for subsequent developments is that it makes clear the connection between staging and architecture. Wagner did not simply move action away from the proscenium area; he provided no forestage of any kind, eliminating even the *possibility* of performing in front to the proscenium. A double proscenium helped move the action deep into the stage, creating a deliberate distance between spectator and performance where the horseshoe design always sought closeness.[72] In designing his theater, Wagner recognized that radical differences in staging practice, making use of an area of the stage previously ignored, would require radical architectural differences as well.[73] This movement back into the proscenium might have found its most extreme example in Wagner, and it did not spawn much in the way of imitation initially. But the sense of separation from performance space, a complete world cut off from the world of the theater auditorium, became an ongoing feature of theatrical staging in the late nineteenth century and had to make the dominant architectural form of theater less acceptable.

The Bayreuth Festspielhaus was sufficiently unusual in the extremity of its departures, that it took a while for its influence to be felt with the singular exception of the Adler-Sullivan Auditorium Theatre.[74] Otherwise, the transformation was gradual, marked by a number of interconnected developments throughout the nineteenth century, each one signaling a shift in the way stage space was handled:[75] the advent of the box set, the framing of the proscenium arch and the elimination of the forestage, new technologies for illumination that allowed for a radical shift in the way the space of the stage related to the auditorium, all of these, as it turns out, important developments for motion pictures as well. "From the 1860s, greater realism in plays was reflected in the scenery, and wing and border setting began to be replaced by box settings representing 'real' rooms with side walls and ceilings."[76] With the seemingly self-contained space represented by the box set, the stage setting appeared more cut off from the auditorium. The separation was made definitive when English actor Squire Bancroft and his wife Marie took over management of the Haymarket Theatre in 1879 and had it remodeled, installing one feature that was much imitated: the proscenium was rendered as "a massive and elaborately gilded frame complete on all sides, the lower part forming the front of the Stage and concealing the Orchestra which is placed underneath."[77] Richard Southern notes that it is not

clear how the orchestra was concealed, but perhaps the submerged orchestra was intended to suggest Bayreuth. Although it looked different, this gilded frame shared a common attribute with the Bayreuth proscenium and perhaps invoked the Wagnerian Gesamtkunstwerk by its invocation of another art form: it was an absolute boundary forcing action to take place behind it.

If the proscenium as boundary cut off an area of action by eliminating any forestage, the box set effectively expanded it toward the back of the stage which had previously been limited by perspectival set design. In the past, lighting had also created a problem: in earlier indoor theaters, lighting was initially primarily by candlelight, subsequently by oil lamps, with the wing-and-backcloth system allowing for some light from the wings, but with a good amount of light coming from the auditorium itself, along with footlights, making the forestage area the most fully illuminated. Gaslight was introduced in English theaters in 1815, United States theaters in 1816, and Parisian in 1821. In the definitive study of theater lighting, Gösta M. Bergman notes the key advantages that gaslight brought: greater flexibility because "intensity could be varied at will by throttling the gas supply," the "regeneration of the stage picture" because of the variety of kinds of light available, an overall increase in illumination both in the auditorium and onstage and, commensurately, "new possibilities of locating the action to the rear part of the stage, thus making it more mobile and realistic."[78] Improvements in lighting, then, were a necessary precondition for the box set, and the two together effectively opened up the expressive potential of the upstage area.

The final transformation, occurring around the same time the Bancrofts had the proscenium frame created for the Haymarket Theatre, came with the introduction of electricity. Thomas Postlewait has observed, "Electric light would radically change stage lighting and the principles of scenic design" (129). Most important for its impact on staging, "the maximum value of light on the stage increased strongly in the 1880s and -90s at most theatres. . . . At many theaters, this worship of light led to excesses. They virtually drowned the stage in light from the permanent lighting systems and arc lamps. Not the least was this true of American theatres" (Bergman, 295–96). This meant, of course, that the audience could see more of the set, but that in itself created a new problem: "The illusionary built-up pieces appeared as puerile deceptions" (Bergman,

294–96). So, the lighting called attention to background in a way that it never had before, but then led to an expectation that the background be more convincing in its realism.

This issue of background warrants more consideration, but to do so I first have to look at the lighting of the theater itself. Before the introduction of gaslight, the lighting in the auditorium could be changed only with difficulty, and so generally for indoor theaters illumination levels in the auditorium and onstage stayed constant throughout the performance. Gaslight provided the possibility of altering light levels during the performance, but initially the auditorium light was only lowered when stage light was lowered to depict a nighttime scene. The Bayreuth Festspielhaus once again looked ahead to future conventions when it "introduced the darkening of the auditorium in 1876. At the inauguration the public was greatly shocked when, all of a sudden, the lights went out."[79] Near-total darkness in the auditorium is, of course, a necessary precondition for motion pictures, but, as it turned out, not without contestation in early film theaters. Further, it is likely that the continuous nature of vaudeville performances as well as the need to look at a program in the course of the performance kept the twilight level of the theater somewhat brighter than in straight dramatic theaters, but by the late nineteenth century darkening the theater in some fashion did become a convention marking the beginning of a performance. There are two crucial things I want to take away from this. The brilliantly illuminated stage in a darkened auditorium escalated the sense of the stage as a self-contained world cut off from our world that had begun with the Bayreuth Festspielhaus and entered the commercial theater with the Bancrofts' proscenium frame. The second change was in the auditorium itself: individuals became shadows, an undifferentiated mass. With this development, the horseshoe form lost its last surviving rationale.

Keeping these factors in mind, I want to return to the Vitascope premiere with one last point about the "new" approaches to lighting and set design. Bergman cites a negative response to the new lighting styles from Percy Fitzgerald, a contemporary (1885) observer, worth quoting here: "Again, the system of *intense* lighting has operated seriously to the enfeebling or overpowering of dramatic effect. . . . The abundance of light now shed upon the scene diminishes the relief of the figures, whereas the comparative shade [of the old system], or indistinctness of the background,

throws out the figures."[80] For Fitzgerald, then, the dimness of the back of the stage was an advantage for it served to make the performers stand out more from the setting. Although Martin Meisel ultimately makes something very different of it, his analysis of the effect of the Haymarket proscenium frame also notes a shift in how human figures related to background setting: " 'Tableau' in drama meant primarily an arrangement of figures, not a scene and its staffage . . . before [English actor-theater manager] Irving and the Bancrofts the actor was not yet so bounded and contained by the picture, so much *within* it, that his 'least exaggeration destroys the harmony of the composition.' It is rather to the point that the conventions of academic portraiture at least through [Sir Thomas] Lawrence encouraged a similar disjunction between figure and ground, the latter, even as landscape, often suggesting theatrical scenery" (Meisel, 44). This then is the change that takes place in the last couple of decades of the nineteenth century: a transformation in the relationship between figure and ground, a transformation that had to affect how early motion pictures were perceived in their theatrical context.

On the face of it, this kind of figure-ground opposition would seem less of an issue for a film image that reproduces a reality in which all elements, transferred to film, have an identical ontological status, something made all the more emphatic by monochromatic film stock. And yet, because of production necessity, the films shown at the Vitascope premiere did have a distinctive way of handling figure and ground. This can be difficult to determine precisely because at most only one of the five Edison films appears extant, the "skirt or serpentine dance," which is likely "Annabelle Serpentine Dance" (1895).[81] But as with most of the early Edison shorts of performers, the performance was shot in the "Black Maria" studio, a structure whose interior had a small stage against a black background with an opening on the roof to use sunlight as the only light source (Musser, *Nickelodeon*, 35). As a result, the serpentine dancer was brightly illuminated along with some of the dance floor and banisters on the side. The rest of the image is entirely black, providing an almost complete separation between performer and background.[82] Whether or not all the other Edison films had the same background-figure relationship, it is very likely that the one that began the show, "Umbrella Dance," did.[83] And this is the film that immediately preceded "Rough Sea at Dover." In determining how the first film might have conditioned the second, it is worth keeping in mind that each film ran about twenty seconds, but was

on a loop that was run multiple times, so that the figure against a black background would really be imprinted on the spectator's vision with the abrupt shift to a very different kind of image.[84] "Rough Sea at Dover" is extant, and it presents a richly detailed image, enough to have inspired the extensive description reprinted above from the original review: a pier on the left cuts across the image on a diagonal up toward the top center, the composition serving to emphasize the depth of the space as great breakers splashed against the pier and move directly toward the camera. The depth did strike one contemporary observer: "One could look far out to sea and pick out a particular wave swelling and modulating and growing bigger and bigger until it struck the end of the pier. Its edge then would be fringed with foam, and finally, in a cloud of spray, the wave would dash upon the beach."[85] While background-foreground movement is crucial to this film, there is no figure-ground aspect here since it is all setting, which makes the opposition to the previous film particularly stark. Finally, the elaborate means necessary to change realistic settings in contemporary theatrical practice had to make this abrupt shift from the black background of "The Umbrella Dance" to the fully detailed natural world of "Rough Sea" seem truly startling.

It is in this context, then, that Frohman could understand the reality effect of motion pictures primarily in terms of setting. Movies effectively operated within a larger theatrical context and were in part defined by it, and for Frohman this meant a period in which the very sense of a theatrical setting was changing. I want to emphasize that this transformation was a process and not a straight-line development. Change rarely happens without resistance, and there were certainly economic forces that would promote continued use of wing-and-backcloth scenery. Indeed, until the teens many theaters and many early narrative films continued to use painted flats even for practicables like a clock on the wall or flats that had lighting effects painted on them, a procedure that had already begun to look archaic on the stage under the hard electric lighting of the 1880s. But in narrative film by the teens, "interiors were beginning to be constructed and painted so that they appeared to be actual rooms in real buildings— not stage sets."[86] With the subsequent rise of the feature film in this period, the alliance between screen and setting that Frohman imagined at the Vitascope premiere would help determine how films were exhibited, as we will see. But in a horseshoe theater, setting was perforce a secondary part of the theatrical performance because a large part of the audience had

limited access to it. In live theater an approach to staging that gave more and more expressive value to scenography would finally render the horseshoe theater obsolete. In similar fashion, the film image exposed the limitations of the horseshoe theater much as the development of motion pictures would be limited by the space in which they were exhibited, a space that inevitably made them isolated pieces of entertainment dependent upon novelty.

## SPEEDING TRAINS, SCREAMING LADIES, AND THE FOURTH WALL

As a visual novelty like the Glyptorama, motion pictures could fit within the entertainment paradigm offered by vaudeville, and the architectural form of the vaudeville theater need not be the problem that it became for realistic staging in live drama. However, while moving the image closer to the audience could make the realism of moving pictures all the more astonishing by comparison to *tableaux vivants*, it could also effectively undermine that realism. The screen's flat surface and its downstage location, a position that movie theater practitioners would reject by the teens, meant that objects on its surface would become easily distorted the further the viewer moved away from a perpendicular view. And quite a few of the audience in a horseshoe theater did in fact depart from the perpendicular. This is to say that the realism of the motion picture image, as powerful as it might have been for contemporary observers, is not automatic: it is in part a function of the architectural space in which it is placed and the concomitant vantage point of each individual spectator.

To get some sense of how the image might appear to contemporary viewers seated in a horseshoe theater, I would like to look at a couple of observations from contemporary reviews of the Biograph premiere in Hammerstein's Olympia Music Hall in New York in 1896 six months after the Vitascope premiere. Although the Biograph used a larger-format film in the taking, contemporary evidence suggests it was projected onto a similarly sized screen as the Vitascope: what distinguished it for contemporary observers was its greater sense of detail as well as both the steadiness and the brightness of the image, which were seen as enhancing its realism.[87] The startling quality of the realism was evident in a number of reports on one film in particular, the "Empire State Express,"

reports that seem to echo reaction to the showing of a Lumière film, "Arrival of a Train at La Ciotat," in France from the previous year. Of particular interests to my concerns is that two of the contemporary reports of the Biograph premiere implicitly locate the viewer in the auditorium, providing us the rare instances of firsthand contemporary experience that specifies the spatial relationship between viewer and screen. I'll begin with the most dramatic description, a review that ran in the *New York Mail and Express*:

> The Empire State Express, with its startling reproduction of the size and speed of the famous flyer, is almost the best picture even thrown upon a screen. The other night two ladies in one of the boxes on the left-hand side of the horseshoe, which is just where the flyer vanishes from view, screamed and nearly fainted as it came apparently rushing down upon them. They recovered in time to laugh at their needless excitement. The right-hand boxes are better for nervous folk.[88]

A *New York Times* review singled out the same film for praise, but did so in somewhat different terms, a difference very much worth noting:

> The finest of all these pictures was one of the Empire State Express going at sixty miles speed. The train is seen coming out of a distant smoke cloud that marks the beginning of a curve. The smoke puffs grow denser on the vision, and soon coach after coach whirrs to the front, and it seems as though the entire left-hand section of the house would soon be under the wheels that are racing for New York. The cheers that greeted the picture and its repetition were as great as those for McKinley . . . [this last item refers to a film showing William McKinley in front of his house while the auditorium held "many leaders of the Republic Party in conspicuous boxes"].[89]

The initial advertisement for the Biograph did not mention any of the individual titles, but subsequent advertisements contained a complete list with only "McKinley" and "Empire State Express" listed in capitalized letters for emphasis.[90] The obvious difference in these two reports is that one of the observers of the "Empire State Express" heard screams,

while the other heard only cheers. But each description points to both writers sharing a vantage point from the center of the house, where it might well seem as if the train were speeding toward the left side of the auditorium. Neither writer felt threatened himself, and both qualify the possibility of the train actually rushing off the screen with "apparently" and "it seems as though . . ."[91] But the architectural arrangement of the auditorium means the two writers saw something very different from what the two women in the first report saw, and their position is more explicitly defined: "just where the flyer vanishes from view" would mean the last box down the arm of the horseshoe on the left. This location of the two women also makes it evident that the Biograph followed the Vitascope's manner of presentation by locating the screen downstage, close to the proscenium itself.[92] Since photographs of Olympia's interior show that the last box directly abuts the proscenium, the downstage location of the screen means the women were viewing the image at the most extreme angle possible (see fig. 1.4). From this vantage point, the threat would have had to seem less apparent and less real than to viewers in the center of the auditorium as both the severe distortion of objects and the very apparent flatness of the image would have had to play against the depth cues of perspective and relative object size.[93]

But let's suppose the women did in fact scream, even if only one observer seems to have heard them. Why the scream? The one observer who heard the scream noticed that laughter followed, suggesting that the response had a playful quality. And perhaps with good reason since, more than others, the viewers on the left side could both acknowledge the reality effect and at the same recognize the illusion as an illusion. But there is another way of looking at this that can return us to the larger context of live theater in this period. In an extensive survey of the "panicked audience" response to early film showings, Stephen Bottomore concludes that many of the reports exaggerated the responses, but nonetheless conjectures a foundation for the reports that is of interest here. Drawing on experimental psychology research, he notes, "There is considerable evidence to believe that animals and humans may have a neural organization and even particular neurons 'specifically sensitive to changing size' in perceived visual images, a change sometimes known as 'looming.' . . . An image which is growing rapidly in size may have a powerful, psychological effect. Enlarging images seem to trigger avoidance and flinching and a defensive head movement instinct in certain

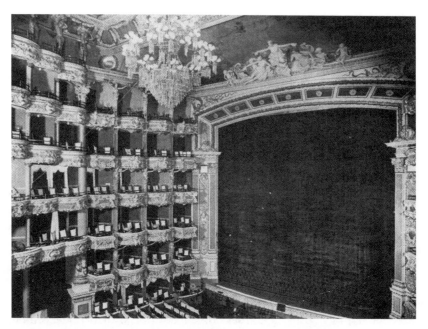

FIGURE 1.4
The Olympia Music Hall (1896), showing the boxes abutting the stage, site of the
women screaming in terror at an approaching train.

animals and in humans."[94] Noting that the flinching response was not
universal, Bottomore surmises that there must be an unexpected element
as well as proximity to the screen. The unexpected element is most evi-
dent in the continuing use of a familiar trope in the horror film: the sudden
appearance of a surprise element, usually the monster, looming large in
the foreground of the image, continues to startle audiences in the twenty-
first century. I use this example because it suggests that size is as impor-
tant as surprise. There is obviously no surprise in an enlarged object in
the foreground that we first saw in the background, although most re-
ports on the "Empire State Express" did emphasize the speed of the
train. But in the context of contemporary stage practice, size itself could
offer an unexpected element here that would make the image startling.

Consider the description of a different film, one showing a parade,
that was part of the Biograph premiere:

The paraders . . . will advance down the stage, apparently to walk
across the footlights; they will march across and back, then turn

and march back until they seem to be lost in the distance, and so deep will be the vista that it will look as though the entire back of the stage had been taken out.[95]

The theatrical context clearly shaped expectation, as this description is presented entirely in terms of live theater: the paraders march "down the *stage*," rather than the filmed location and they seem about to "walk across the *footlights*." But if context determines perception of the film, the film reciprocally alters the architectural space in which it was exhibited, extending the depth of the stage far beyond its actual dimensions. I had previously noted that changes in staging practice granted more dramatic expression to the depth of the set, so it's appropriate that a contemporary observer would be attuned to the expansion of depth afforded by the image. Any stage was always limited by its physical dimensions: the Olympia Music Hall, where the Biograph premiered, had a distance from "footlights to back wall" of 46 feet, although only a portion of that would be used for settings, so any actual set would likely be less than 35 feet, which would be fairly expansive for the period.[96] The film image by contrast was only limited to what reality could present and lenses could capture, and in this regard, as the description suggests, film astronomically extended the depth of the stage along its perpendicular. In the context of realist set design, the almost infinite space afforded by the film image could make depth itself a source of spectacle.

Still, if film seemed to expand the space of the stage, exhibited on a stage the film image also exposed a crucial difference in the way it handled perception of depth. Even in a stage set 35 feet deep, if real-world three-dimensional space could be reduced to flatness, an object moving from upstage to downstage might be seen to grow somewhat larger. But in an actual living space, the reverse might happen as the greater amount of space around the object could paradoxically make it seem smaller. Either way, the change in object size is sufficiently minor that we tend not to think of it. With the film image, the reverse happens: as with any representational art that creates a sense of depth on a flat surface, object-scale is a key indicator of depth. And relative object-scale in film is even more striking than in painting or a still photograph precisely because film presents movement: depending upon the lens used, a person walking merely ten feet toward a camera could readily move from long shot to close-up.[97] Of course, neither of these terms existed in the early years

of film, but it might be worth keeping in mind that an early term for close-up—a "big head"—stressed size over distance.[98] In the context of a theatrical stage, the way the film image portrayed depth, and particularly depth in motion, could itself be startling.

Returning to the screaming and/or fainting women, we can certainly question if they were afraid of being run over since in the architectural space of a horseshoe, which placed a large portion of the audience at odd and distorting angles toward the screen, and most especially for those sitting far down the horseshoe, the flatness of the image would be as apparent as its evocation of depth.[99] It is really only from the center of the auditorium, the position of the two observers, that it might seem as if the spectators on the left side of the auditorium would be run over. For those sitting on the left, I would like to posit that the cries, if they did indeed occur, may have been out of something other than fear of being run over, perhaps, say, astonishment at the rapid change in relative object size, with the apparent flatness of the image making size more crucial than depth. In this architectural context, then, the most powerful aspect of the moving image for contemporary audiences, its reality effect, could only register as a novelty in a long line of similar novelties. After all, the novelty of the Vitascope usurped the novelty of the Glyptorama.

There are two other aspects of the film image that should have played against its realism, or, perhaps more accurately, should have highlighted a tension between apparent realism and its contrary status as illusion. The first is almost never mentioned in all the reception of early cinema I have come across: while some films had color from hand painting, "Rough Sea at Dover" most likely did not, which means the seemingly real world the movie image presented on screen often lacked color.[100] Why should a black-and-white image, deficient in one of the key signs of the real world, seem the height of realism, as so much early commentary asserted?[101] There is potentially a disturbance in film's ability to make a world of shadows seem like a reality. Another disturbance had to do with the width of the screen in relation to the stage: while the film image might have expanded the depth of the stage, it actually reduced width. The proscenium opening at the Olympia was smaller than the 42-foot-wide proscenium at the Vitascope premiere, only 31 feet wide (Cahn, 61). But it still created a discrepancy with the likely 20 foot or so width of the Biograph screen. If we keep in mind that this novelty appeared within the context of visual entertainments that attempted to trick the eye into

accepting a reality that was not in fact there, we have to note that the width of the image also exposed the limits of that reality. The Empire State Express looked as if it were going to ride over spectators, but what happened when it didn't? Where did it go?

One other observer of the first Biograph films noted a similar phenomenon in the film featuring McKinley:

> There he stood on his much-betrampled lawn at Canton, talking with his son. Leisurely he read a telegram of congratulations, and then turning he came toward the excited audience, until it seems as though he were about to step down into their very midst. But at that moment came the edge of the curtain [i.e., the screen], and he vanished round the corner to address a delegation of workingmen.[102]

As the moving image allowed movement toward the camera, it created a sense of depth that exceeded that of still photography. But even from the perspective of a spectator in the center of the auditorium, the illusion of depth would seem to self-destruct at the moment when McKinley disappears instead of stepping off the screen or when the Empire State Express, having grown to an overwhelming size, simply vanished. Could this paradoxical play on perception be as startling as the realism? At the least, by instancing movement seemingly into the space of the spectators, but actually into what we would come to call offscreen space, both "McKinley" and the "Empire Express" made clear that the screen restricted movement at the same time that it seemed to expand it. In the final analysis, by representing an unbridgeable space between its self-enclosed world and our reality, the screen created a dramatic space analogous to what had become a dominant live theater aesthetic with the rise of realistic scenography, the self-enclosed world revealed to us through an invisible fourth wall.

Crucial to an understanding of contemporary response to motion pictures is understanding how much viewers saw the film image *in theatrical terms*. Consequently, in the above quotation I needed to note that "curtain" means motion picture screen, not an actual curtain. Although "screen," derived from stereopticon shows, would remain the most common term subsequently, early descriptions of motion pictures also use the word "canvas" in addition to "curtain." *Canvas* likely derived from the actual material used, but it also signifies the way in which the screen was situated on a vaudeville stage: "The vitascope projects upon a large area

of canvas groups that appear to stand out from the canvas and move about with great facility and agility, as though activated by separate impulses. In this way the bare canvas before the audience becomes instantly a stage upon which living beings move about."[103] In theatrical parlance, "canvas" could be another term for "flat," so the screen became theatricalized by being likened to a flat.[104] The screen is like a flat, but the photographic image seems to create a three-dimensionality, making characters "stand out from the canvas." The use of the word *canvas*, then, points to the play between three-dimensionality and flatness that I am writing about here.

The optics of the motion picture image might have made the decisive move away from the horseshoe theater a matter of necessity. But as a matter of architecture, cinema in becoming a dramatic medium *at this historical moment* seemed to effectively cast its lot with naturalistic theater, requiring the same kind of frontal organization as that required by realistic staging. Without actually using the term, the assumption of a fourth wall underlies the comparison between the movie theater and the contemporary legitimate theater in a series of articles on "The Modern Moving Picture Theatre" that ran in *Moving Picture World* in 1909:

> the aim of the stage producer is to create an effect of illusion—the effect of looking upon a scene or play in progress through an aperture or opening. In other words, the assumption is that the wall of a room or the side of an outdoor scene is removed and gives one, as it were, a privileged view of what is taking place, whilst those who are enacting their parts on the scene are unconscious of being under observation.
>
> It is precisely this effect which the moving picture was designed to create. . . . It cannot be too strongly insisted upon that the moving picture at its best, in respect of the sensuous impression which it creates, is, allowing for the absence of the spoken word, an almost perfect substitute for a stage play, and that therefore it demands exactly the same treatment in the theater as does an ordinary play.[105]

The easy assumption underlying this statement that fourth-wall aesthetics is the defining aspect of live theater suggests how prevalent this attitude was at the time, even though fourth-wall staging stood in opposition to a good deal of staging practice in past theatrical performance.

In this architectural and dramatic context, then, the screen represented a culmination of moving the action behind the proscenium since the screen located at the proscenium effectively puts everything behind it. And, most importantly for the contemporary aesthetic understanding, the screen itself represented a boundary that could never be breached. By 1921, writing about advanced movements in the theater, Kenneth Macgowan could title a chapter, "The Movies—The Curtain Becomes the Stage," and confidently state, "We have made the curtain the fourth wall of realism."[106] Seeing the screen itself as a fourth wall makes sense of the repeated exhortation from the period that actors should not look at the camera, should, in effect, pretend that they are not being filmed. By comparison to live theater, this might seem an unnecessary injunction since actors on screen do not in fact possess the power of sight: even if they look out of the screen, they still are unable to see us. Nevertheless, if the moving picture at the time seemed "an almost perfect substitute for a stage play," then screen actors must ignore the fourth wall as much as stage actors did. And the seeming ontological realism of the film image created by the reality effect made this all the more imperative.

But if film drew on the aesthetic assumptions of mainstream theater of its period, there was one striking way in which it could handle realistic space differently. In 1909, the same year as the above quotation, D. W. Griffith directed a short film, "The Drunkard's Reformation," that made extensive use of reverse-angle cutting.[107] In the film's penultimate scene, an alcoholic takes his young daughter with him to view a play that, as it turns out, is about the dangers of alcoholism. As the play unfolds, we are alternately given shots of the play from the perspective of the audience and shots of the father and daughter as they progressively get caught up in the personal meaning the play has for them. In the process, the camera effectively creates a 360-degree space *at the same time* that each individual shot operates as if we were viewing the action through an invisible fourth wall. The fact that the key actors in this film *do* look directly at the camera without breaking the illusion of reality is facilitated by the fictional world they inhabit and the reverse-angle cuts that assure us they are looking at a stage through their own invisible wall.[108]

Film, then, could exceed the realism of mainstream staging practice by delineating a 360-degree playing area, at the same time that this playing area was even more inviolate than the space of the stage in live theater. Only the pretense of a fourth wall, subscribed to by both actors and

viewers, kept the boundary unbridgeable in live theater. But, as we've seen with McKinley and the Empire State Express, moving beyond the fourth wall would cause individuals and objects to disappear. If film increased the realism of the naturalistic stage by creating a fully self-contained world, it also created an element of magic in the way that world related to ours, an issue I will deal with more directly in chapter 5. But even if film could surpass naturalistic theater in creating the illusion of a 360-degree space, the contemporary theatrical context in which film was introduced inevitably made the screen seem the culmination of the theater's ambitions. In this context, the moving image effectively embraced a seeming destiny as the ultimate fourth-wall medium, or, as *Moving Picture World* put it, "precisely this effect which the moving picture was designed to create."[109] In the context of the proscenium theater and the fourth-wall staging of realistic drama, the screen had to seem, after all, the one fourth wall that could never be entered. And architecture would have to be called upon, reciprocally, to maintain the notion of the screen as an inviolable space.

# 2. STORE THEATERS

## A Radical Break

### Vaudeville in a Box

Fourth among the great commercial interests of the United States, Kinematography, or the art of making motion pictures, and the several co-related branches of industry each contributing its portion to the harmonious whole, has shown a development that hitherto has not been equaled in the annals of business and that may well be termed the marvel of the Century. . . . It is generally agreed that it was somewhere 'round about the year 1896 that motion pictures began to show commercial possibilities in this country. . . . It was not until the year 1905, however, that the motion picture business hit its present slant towards prosperity. . . . Most everyone in the picture business today has witnessed the development of the exhibition business from the "store show," which is rapidly passing, to the large and comfortable houses where the finest pictures are now shown. It was the multiplication of the "store show" that gave the motion picture business its impetus.

—*Moving Picture World* (1914)[1]

FROM ROUGHLY 1905 TO THE EARLY YEARS OF THE DEPRESSION, more theaters were built across the United States than at any other time in American history. While it could be traced back to the 1890s, the "store theater," as it was generally called in the trade press, kicked off the building boom in 1905: between 1905 and 1910, the store theater saw a rapid rise in popularity and installations and, with this rise, the beginnings of movies as a primary form of entertainment for a majority of Americans. In this period claims were heard of the seemingly metastasizing growth of store theaters—in 1906 alone "thousands of store shows" ("Kinematography," 176). There is no way to prove these numbers, not least because claims of exactly how many theaters were built in the first decade of the dedicated motion picture theater and concomitant numbers of increasing patronage are often contradictory, sometimes even from the same sources.[2] Writing in 1910, Robert Grau, a theatrical producer, wildly claimed that motion pictures created "30,000 new places of amusement."[3] By 1916, the *Exhibitors Herald* would claim the more modest— and more likely—total of 18,000 theaters with a daily attendance of 16 million people.[4] If there is exaggeration in this breathless boasting of numbers, it speaks to the genuine sense of excitement about something new happening.

A key expression of this excitement is one of the most repeated myths of the nickelodeon era, the seemingly improvised nature of the store theater, which served to explain its rapid proliferation: putting together a film theater was often portrayed as just a matter of hanging up a bedsheet at one end, positioning a projector at the other, and putting some chairs in-between. A 1914 *Moving Picture World* review of the development of the motion picture offered a typical description: "In the beginning stores could be rented at a low figure and the cost of two or three hundred folding chairs, a few yards of muslin and a projecting machine did not exceed five hundred dollars."[5] A more recent history of early exhibition claims, "A storefront theater could be set up almost on impulse."[6] If this ever were the case, and there are reasons to doubt it, this period did not last long. The novelty of the store theater lay in its architecture, but as a theatrical entertainment it was building on an existing form that required a degree of planning and deliberation.

Concurrent with but running counter to the origin myth was the great acclaim granted to Samuel Rothapfel, later famous as "Roxy," in the trade press, which from early on presented him as someone to imitate.[7] In

1910, *Moving Picture World* printed a brief story about the career of "Mr. S. L. Rothapfel," whom it termed "the ideal exhibitor," although he ran his theater "in a little city of 7,000 inhabitants situated in the coal mining region of Pennsylvania." The *World* was so impressed with the fact that "out of this 7,000 Mr. Rothapfel gets 1,000 in his theater every day of the week," that it gave him the opportunity of writing a couple of columns on exhibition in subsequent issues.[8] While Roxy was emphatic about the need for fine projection—"Everybody work toward the screen" was his "motto"[9]—his greatest interest was in programming: "A very important item in careful management is the arrangement of programs. By this I mean the order in which the respective reels and songs are run." He proposed an "ideal program" of three reels: first an "industrial," a leisurely introduction to the entertainment; some escalation in vitality with a song (not specified, but likely accompanied by stereopticon slides following contemporary practice); "a splendid dramatic reel," increasing the intensity of the program; and, finally, a comedy, so that the "audience will leave their seats all smiles and satisfaction." As varied as this program is, Roxy finds a sense of unity in music: "Another thing I want to call attention to is that fact that *not one minute during the entire performance should your music cease.* Open with a waltz in a lively tempo and use the same during small intermissions, swinging into score arranged for pictures on signal from the operator [i.e., projectionist]."[10] Clearly this was not slapdash exhibition, and Roxy even called for "a careful rehearsal of your show," although film might seem to obviate such a need ("Observations by Wide-Awake Exhibitors," 373).

If programming required such deliberation, it was because the store theater did not emerge as something different from vaudeville, but rather as an offshoot of it, a series of discrete acts arranged to create a sense of unity. Writing a laudatory response to Rothapfel's articles, another exhibitor claimed that, like Rothapfel, he achieved "popularity" by "the care I always took in selecting a well balanced program," an ability he derived from "many years' experience in show business before moving pictures came around." His final exhortation—"Remember, there are a lot of different tastes to please"—is a succinct statement of a vaudeville principle.[11] The store theater effectively extended the reach of variety entertainment by putting it in a can and exhibiting it in a box, all of which could be accomplished without actual performers having to travel a circuit of cities and towns across the United States and without the elabo-

rate architecture required to present them. If the store theater established vaudeville as a guiding principle for dedicated movie theaters, it was a principle that carried over into the movie palace era as well. This consistency was reflected in Rothapfel's career: as he progressed from his small town to big city, from modest store theater to grand palace, the vaudeville aesthetic continued to guide his sense of what a movie show should be.[12] The vaudeville inheritance, then, was not left behind when movies moved from the vaudeville theater into a different home: rather, it is key to the development of motion pictures and proved as central to the growth of the palace as it was to the store theater. However, as an architectural matter, the store theater was something very different, and aspects of that difference would impact on subsequent movie palace design.

## A NEW ARCHITECTURE

Films of the store theater era have received intense scholarly scrutiny because it is a period of such extraordinary change in the films themselves. But since this is also a period of great change in the venues where movies were shown, we should at least consider if there was a connection between the spaces surrounding the screen and what was unreeling on the screen. Certainly, most commentators have correlated the sharp rise in production with the extraordinary number of store theaters, with their "daily change" policies, and this change is easiest to document empirically since it fits nicely in a supply-and-demand model. As *Moving Picture World* observed in 1914, "During the year 1906 thousands of store shows were opened and the demand for pictures was theretofore unheard of."[13] *Moving Picture World* did not see supply begin to keep up with demand until 1907, but that lag only serves to underscore that exhibition helped drive production.[14] Other important changes were taking place in this period as well, and it is worth asking if exhibition could in any way influence these changes. Robert Allen has seen a correlation between the ascent of the nickelodeon and the rise to dominance of the narrative film: "Between 1907 and 1908, a dramatic change occurred in American motion picture production: in one year narrative forms of cinema (comedy and dramatic) all but eclipsed documentary forms in volume of production."[15] And Tom Gunning has located the beginnings of the "narrator system," crucial to the development of American film style, in this period.[16] I do not want to claim one-to-one causation, but it is likely not mere coincidence that all this was happening

when the whole theatrical plant for exhibiting motion pictures underwent a radical change. At a minimum, we can say the advent of the store theater was a response to the kind of movies that were being made and the places they were being shown. But, once established, the store theaters made demands on the kinds of films being produced—and established limitations as well that, ultimately, led to their own demise.[17]

Most obviously, the period from the rise of the store theater to the rise of the movie palace coincides with the growing perception of motion pictures as a new and distinctive way of telling stories, effectively a form of theater available to an audience much larger than ever before, but also an audience that generally did not have access to theater previously. At a minimum, the store theater helped condition this new view since it was the store theater which proved film alone could be a primary attraction for audiences at very low cost. And it was here that the motion picture finally came into its own as a new art form. In a 1915 interview, Cecil B. DeMille "stated his belief that the photoplay, which he described as picturization of a dramatic theme, was developing into one of the great branches of world literature," a claim that would have been inconceivable only a decade earlier.[18] For example, in 1908, a *Moving Picture World* article stated that most people did not see motion pictures as art: "That the moving picture drama is an art, is a proposition as yet not well recognized by the public at large. That it has a genuine technique, *largely in common with the acted drama* yet in part peculiar to itself, is a proposition which seems not to be well recognized within the moving picture field itself."[19] Movies in the period of the store theater had begun to be seen as a new dramatic art. Whether consequently or coincidentally, new configurations of theatrical space accompanied this new art.

In 1906 *Billboard* commented on the rapid expansion of motion picture exhibition as something more than the store theater: "Store shows *and* five-cent picture theatres might properly be called the jack rabbit of the business of public entertaining—they multiply so rapidly."[20] Two *kinds* of theaters are instanced here, flagging a distinction not observed by histories of early exhibition, which tend to use "store theater," "nickel theater," and "nickelodeon" interchangeably. A focus on architectural form can explain this difference: following the rapid growth of the store theaters and very much as response to their success, existing theaters, both vaudeville and legitimate, were repurposed as nickelodeons. Why is this distinction significant? For one, the store theaters became the first

dedicated film theaters.[21] More radically, while the repurposed nickel theaters offered familiar theatrical spaces, the store theaters upended centuries of architectural conventions. In the process, they provided a way of thinking about movie theaters that would have a lasting impact on architectural form. The significance of the store theater, then, was three-fold: as the first dedicated motion picture theater, it established cinema as a magnet in the urban landscape; it created a distinctive architectural form responsive both to the requirements of film viewing as well as the restrictions of its urban setting; and it radically altered spatial conventions, making theater less exclusive by demonstrating that virtually any interior space could be made theatrical.

In 1913, an architecture magazine, *The Brickbuilder,* announced a design contest for motion picture theaters. It revealed the winners in a 1914 issue with a supplement, "The Moving Picture Theatre Special Number," entirely devoted to movie theaters.[22] The contest specifications made clear that "A Moving Picture Theater" for *The Brickbuilder* meant in its dimensions and location a store theater, one occupying a double lot: "The building lot has a frontage of 50 feet and is 100 feet deep, bounded on either side by existing buildings. The building is to occupy the entire lot."[23] The store theater was acknowledged as a specific architectural form. Consequently, it received increasing attention as a distinctive *theater* building in trade journals and architecture magazines.[24] *Motion Picture News* noted in 1914, "The permanency of motion pictures in the amusement field has resulted in specialization on photo play theatres by architects."[25] As early as four years before, an issue of *Architect's and Builder's Magazine* ran the first article on requirements for movie theater architecture, "The Moving Picture Theatre."[26] Throughout the decade, articles on movie theater architecture appeared with increasing frequency in all major architectural journals, although the movie palace would eventually effect a shift away from design principles developed from the store theater. The year 1916 saw the first book on motion picture theater architecture, *Theatres and Motion Picture Houses* by Arthur Meloy. In 1917, a second appeared, *Modern Theatre Construction,* by Edward Bernard Kinsila, who had begun a column the previous year under the same name in *Moving Picture World,* which claimed, "Mr. Kinsila has established a considerable reputation as a builder of theaters."[27]

As the example of Kinsila demonstrates, it was not just architecture journals that had begun to recognize movie theater architects. In 1910,

*Moving Picture World* inaugurated a column by John M. Bradlet, "The Construction and Conduct of the Theater" (subsequently known as "Construction Decorations"), which dealt with the problems facing movie theater design and construction.[28] In 1913, Bradlet moved over to *Motion Picture News*, where he wrote the "Motion Picture Theatre Construction Department" for the next year.[29] He was succeeded by Nathan Myers, "the well-known architect and specialist in motion picture theatre construction," a description significant for simply recognizing the movie theater as an architectural specialty.[30] In announcing his appointment and the beginning of a new column, "Architecture and Construction," the *News* noted, "There is scarcely a town of any consequence throughout the country but already has, or is expecting, the building of at least one pretentious theatre devoted exclusively to motion pictures."[31] In 1916, latecomer *Exhibitors Herald*, which had only begun publication in 1915, inaugurated the column, "Theater Planning and Building," whose author was listed as "W. T. Braun, Architect."[32] Announcing the architectural bona fides for their writers established respectability for this new architectural form to reflect the respectability of a new dramatic art. Respectability was a crucial issue because the store theaters in their earliest incarnations frequently had a disreputable taint that was often associated with class which, in turn, was a consequence of its architecture. But by the teens store theaters appeared in the pages of major architectural journals alongside extended photo-essays on the manses of the very wealthy.

Much of the early writing on store theaters that appeared in exhibition journals tended to focus on façades, and this is a tradition that continues today in contemporary commentary on old movie theaters.[33] While photos of interiors are rare, one of the most frequently reprinted images of a store theater from this period is the spectacular front of Milwaukee's Butterfly Theater with the wings of its large goddess butterfly soaring above the third floor of the façade. In her study of the sources of early movie theater architecture, Charlotte Herzog has stated flatly, "The front of the nickelodeon was its most important part."[34] This, however, is not what made the store theater unique: even as it might have moved toward something more garish with façades covered by an excess of electric lights— and exhibition journals frequently boasted of the number of bulbs—its treatment of the exterior actually served to ally the store theater with straight dramatic theaters of the time: the concentration on the façade was an important issue for both because both often had a small urban

footprint. Theater historian Marvin Carlson has noted commercial theaters in Paris, London, and New York had façades integrated into a streetscape, often as narrow as a storefront, that opened onto a passageway leading to an auditorium placed behind neighboring buildings.[35] This was particularly true of legitimate theaters built in the decade or so after the arrival of the store theater along 42nd Street in New York.[36] While the width of its auditorium in the store theater was no greater than that of the façade, the façades often followed a pattern Carlson notes for legitimate theaters, a pattern that could "identify the building possessing them, with reasonable certainty, as a theater. . . . The façade is normally divided into three horizontal units, the lowest containing entrances . . . the second containing the most impressive architectural elaboration . . . and the third offering much more modest fenestration, often topped by a pediment or other roofed elements" (Carlson, 118; see fig. 2.1).[37] While never as garish as some store theaters, the entrances of legitimate theaters could be quite eye-catching in spite of their small size, relying on awnings, vertical stanchions, and illuminated signs to stand out from their streetscape.

Within a few years, the exuberant façades of the store theaters began to get disapproving notices within the trade press and more concern was directed to interiors: for example, F. H. Richardson wrote, "Too many owners, in erecting and finishing their fronts, seem to have in mind only something flashy to catch the eye, rather than something dignified and beautiful."[38] It was in the interior that a distinctive architectural form emerged since the image, granted an architectural dimension, became the defining spatial element. That the image was the key element in a theater's architecture is evident in repeated assertions that the motion picture image could triumph over the stage by taking the whole world for its setting. The store theater lacked the defining element of live theater, a stage, but it offered something better in its stead. As a trade writer noted in 1908, "The picture parlor of to-day is nothing more than a small theater, where, instead of the elaborate and costly stage settings that the big theater had to pay for before the advent of the motion pictures, we have it all on the film; and we can go further than the setting of a drama or comedy on the stage and bring in nature's own setting and background."[39] As Charles Frohman predicted at the Vitascope premiere, the crucial achievement of motion pictures *in the context* of contemporary drama lay in what it did for settings. The point was echoed after the

FIGURE 2.1
A 42nd Street façade theater, New York (1903).

establishment of the feature film by playwright and subsequent film director William DeMille in 1918, who accurately saw an inverse influence on the theatrical set design: "in the setting and the treatment the theater will become more suggestive and less imitative. The necessity for physical realism is going to disappear from the theater because that function will be taken care of in a better way by the photoplay."[40]

The plentitude of the film image, its seeming ability for contemporary observers to go beyond anything live theater could offer, seemed to dictate a simplicity in the rest of the auditorium, a simplicity that eventually would be rejected by the movie palaces that supplanted the store theater. But in the store theater, to paraphrase Roxy, all elements of the architecture had to work toward the screen. How did store theater architecture do this? Discussion of the store theater interior in trade and architectural journals focused repeatedly on a number of interconnected issues: the actual shape of theater; building code restrictions; seating; lighting; ventilation; location and handling of the projector; and framing, location, and size of the screen. In all these aspects, the store theaters offered at least some departures from previous theatrical forms, departures that reflect both external demands and demands of moving image presentation. By far, the greatest departure was a radical alteration of theatrical space, a rejection of spatial hierarchy that was a key feature of virtually all previous theater architecture. Along with concerns of how best to show a moving picture image, it was this disavowal of spatial distinction that drove much of the discussion. The image defined the space around it, not the composition of the audience, which could be diverse or homogeneous.

## THE SPACE OF THE IMAGE

A long and narrow auditorium [is] the best disposition to insure a good projection.
    —*The Motion Picture News* (1913)[41]

About ninety per cent of the small motion picture theatres to-day are long and narrow.
    —*The Motion Picture News* (1914)[42]

Because of the desirability of presenting as nearly a direct view of pictures as possible to the audience *to avoid distortion*, motion picture theaters are often built long and narrow.
    —*Moving Picture World* (1915)[43]

All art operates with some external constraints, but this is possibly more evident with architecture than any other art form, since architecture must always deal with an obvious set of external constraints: available space, preexisting aspects of the chosen site, available building materials, demands of designated function, municipal building codes, and so on. The earliest store theaters did in fact have fairly pronounced limitations: many beginning as Kinetoscope parlors simply sought to add some space for projection or, ultimately, transform the arcade space into a theater space. Conventions on how to handle interiors established themselves fairly quickly in part because they had to operate within realistic constraints. These were never quite as rigid as initial attempts to convert an existing arcade, but there were a number of external factors that encouraged the long and narrow shape typical of the store theater era.

As the name suggests, the store theater had fairly severe space limitations placed on it—the space of a store within an urban block, generally a narrow frontage of 25 to 30 feet extending back 50 to 100 feet.[44] Even if a wider lot were economically practicable, which was the case for larger theaters that were more common outside of the big Eastern cities, building codes would encourage the long and narrow shape by requiring alleyways along the width of the theater for quick and easy egress in case of fire.[45] Exits in the front of the auditorium that led into alleys would also place limits on how the screen was situated, presenting an architecturally defined frame that could take up half the front of the auditorium. While mandated by fire codes, this tripartite division of the front of the theater was one area where the store theaters did have an influence on subsequent movie palace design: locating the screen between two architecturally defined elements set a pattern for situating the screen that would pervade exhibition throughout the silent era (fig. 2.2).[46]

As early as 1910, John M. Bradlet, author of an architectural column for *Moving Picture World*, thought theaters were getting too long. The shapes could indeed reach extreme proportions. Certainly, one can understand this complaint with a theater like one in New Haven, Connecticut, which arrived at its 766-seat capacity by extending a 27-foot width along a 200-foot depth.[47] Bradlet recommended a balcony to improve the shape of the theater: "The absence of a gallery forces the builder to make the most of the floor space to accommodate enough seats. In the majority of the narrow houses we find not over 12 chairs in a row and, to seat 300 persons, we must have 25 rows, or a hall not less than 100 feet long. If a

FIGURE 2.2

A typical configuration for a store theater (Chicago, 1909), with the tripartite division of the front of the auditorium.

gallery was provided to seat 75 or 100 persons, we would gain a space in the hall of about 25 feet."[48] Still, even the occasional addition of a balcony did not necessarily change the preference for long and narrow: for example, a theater built in 1912 in Wichita, Kansas, seating 900, with 250 in the balcony, was 25 feet wide and 140 feet long.[49]

External circumstances might have promoted the long and narrow shape, but, once established, it was also seen as the most suitable for the projected image, as indicated by the progression in quotations at the head of this section from simple observation to endorsement. The long, narrow theater represented a functional style born of necessity, not theory. But, however arrived at, the form was subsequently seen as the most functional for the motion picture image. In 1910, when he recommended shortening the length of theaters, Bradlet stated that films look better in small towns than in big cities because auditoria were not as narrow nor as deep. By 1913, he reversed himself and stated a preference for the long

over the wide theater.[50] The most likely reason for his change of mind was the increased prominence of motion pictures in older vaudeville theaters, which were wide, and the advent of small-time vaudeville in similarly sized theaters—in 1910, for example, Keith and Proctor "turned six of their seven theaters in the Manhattan district into moving picture theaters."[51] With conventional theatrical spaces being utilized more and more for motion picture exhibition, the optical problems of wide theaters became increasingly recognized in a way they were not when film was exhibited in horseshoe theaters.

In 1910, when Bradlet was advocating wider auditoriums, another writer for *Moving Picture World* summed up the problems of projection in large theaters: "I do not consider the arrangement of many of the larger theaters the best possible for moving picture projection. The relation of the projecting machine to the screen is not by any means ideal, and the pictures show it. There are too many unfavorable seats: too many near the screen, and too many at the sides, where the picture is viewed at an angle, causing foreshortening."[52] A 1914 *Motion Picture News* article on screens noted a need for a special screen to disperse light in such theaters: "otherwise the picture could hardly be seen from all seats, owing to the horse-shoe shape of the old theatres." But "if your theatre is long and narrow, all screens will suit your purpose."[53] The problem of wider theaters was acknowledged by the development of a curved screen that claimed to solve the problem. An advertisement for the "Perfection Concave Screen" asked the questions, "**Do your patrons avoid your front and side seats?** When they are compelled to occupy those seats, do they leave your entertainment **wearied** and **dissatisfied**, feeling that they do not care to come again? **Is it worth anything to you** to know that with a 'PERFECTION CONCAVE SCREEN' you can correct that defect so that the front and side seats will be just as desirable as the center seats?" (fig. 2.3).[54] This ad copy treats all the answers as self-evident, suggesting that problems of distortion were common knowledge among film practitioners. Quoted testimonial from a Manhattan exhibitor in a subsequent advertisement suggests audiences were perfectly aware that some seats were better than others: "The pictures are now equally distinct and the characters and outlines in exact proportion as viewed from all parts of my theatre. In addition, the side seats in the theatre, which formerly were shunned by patrons because of the blurred appearance of the characters, are occupied with satisfaction."[55] However successful this screen might have

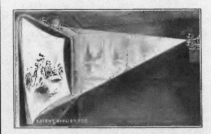
FIGURE 2.3
An early acknowledgment of distortion problems in larger theaters with an early attempt, often repeated, to solve the problem with a curved screen.

been, it was the space of the auditorium that determined the need for it. On the other hand, *all* the submitted entries in the 1914 *Brickbuilder* design competition showed a long and narrow auditorium. This was clearly understood as the optimal shape before the advent of the movie palace.

The actual size of the image, one of the raging concerns of the store theater period, was also a factor in how well the projected image appeared in the narrow long house. Initially, there was a very strong sense of what size the screen should be. An early issue of *Moving Picture World* (1907) reported the following conversation at a motion picture supply house: " 'What size picture do you want at a distance of sixty feet?' 'Life size,' " with "life size" specified as 13 feet wide.[56] "Life size" is a phrase that turns up repeatedly in the trade press as a recommendation for what the image should look like, and the recommended screens generally range between 11 and 13 feet. In 1910, a *Moving Picture World* writer stated categorically, "In most pictures, the proportions of the actors are such that they would be very nearly life-size on a screen about 9 x 12 feet" (C.Y., 744). How could the writer be sure that a 12-foot image would be

life-size? This particular problem provides the strongest correlation be-tween projection and production practice because the expectation that a constant screen size would produce a "life size" image could only happen if there was a constant camera distance in production.

There had in fact been a common distance in American film estab-lished by the "twelve-foot line," which generally placed the camera twelve feet away from the human subject. But it was precisely in the store period that this began to change, eventually reestablishing itself as the "nine-foot line" somewhere around 1909–1910.[57] This did not happen without contestation as there were complaints about the camera being too close in 1909. By 1911, an editorial in *Moving Picture World*, complaining about "unnecessarily large and, therefore, grotesque proportions," issued a "fundamental rule . . . no figure should appear larger than life-size to the eye."[58] Although the *World* was specifically talking about production prac-tice ("Too Near the Camera"), they were actually addressing a problem that had begun to appear in both production *and* exhibition.

Strikingly the terms of the arguments against closer camera distances are explicitly echoed in arguments against larger screens that had begun to appear in the larger—and longer—houses. So, for example, the writer who defined a 9-ft. x 12-ft. screen as life size in 1910 complained about the 14-ft. x 18-ft. screen at the Orpheum Theater in Chicago as "far too large" by noting: "the actors appear like giants, which is unnatural," add-ing, "Not all films are of such photographic quality as to bear this ex-treme magnification," a claim not without warrant (C.Y., 744). A *Moving Picture World* editorial from the previous year complained of actors too close to the camera in almost identical terms: "The consequence was that the people in the theater had the idea that the film showed a story that was being enacted, or had been enacted, rather, by a race of giants or giantesses . . . natural size [is] more agreeable to the audience."[59] For a contemporary viewer, then, similar results could be accomplished and similar complaints generated on either the production or the exhibition end: unnatural giants.

Writing in 1911, John M. Bradlet made this connection between pro-duction and exhibition explicit in an article that segued from a complaint about screen size to a complaint about close camera distances. Bradlet criticizes the image on the larger screen for not showing things in "their natural sizes." When he advises an exhibitor against a large screen, the exhibitor replies, "The public demands a large picture." Rather than ac-cept this, Bradlet assumes it is the complaint of a few filmgoers with bad

eyesight and advises them to use opera glasses! This suggests the preference for life-size images is not grounded in a desire to reproduce reality in general, but rather a specific desire that the screen should reproduce the experience offered by live theater. If you feel the camera distance has limited your ability to see, then use the same solution you would use for live theater! Finally, he makes a connection between parallel developments in exhibition and production: "Well, the exhibitor is not the only one to blame, as the manufacturer is also guilty. There is nothing more absurd on the part of a manufacturer, nothing which destroys the art and beauty of a scene more than showing us greatly enlarged faces of the leading actors." By current standards, we would not consider these figures "greatly enlarged" since Bradlet further specifies "these enlarged figures, with the head touching the very upper part of the frame, and the feet missing."[60] Keeping in mind the fact that the screen at the 140-foot long theater in Kansas City noted above was 15 ft. 4 in. x 11 ft. 6 in., I would argue that the change in figure size Bradlet ascribed to the manufacturer in this description is not at all unlike what would be experienced by enlarging from a 12-foot wide screen to 15 feet in a long theater. If 13 feet wide was considered life-size at a distance of 60 feet in 1907, how would it subsequently appear at 100 or 140 or 200 feet?[61]

The increasingly long viewing distances of the larger theaters inevitably conditioned a more flexible understanding of screen sizes. F. H. Richardson wrote a handbook for motion picture theater operators in 1910, subsequently the standard projection reference book.[62] One of the most astute observers of motion picture theaters throughout the teens, he proposed a more relativistic approach to screen size in 1909, even while giving voice to the standard preference for a "life-size" appearance: "The curtain [screen] should be of size to accommodate a picture in which the figures will be at least life size. Nine by twelve will do nicely for a small house, but for a house of ample dimensions the picture should be at least fifteen feet in width. It must be remembered, however, that every foot added to the picture size adds enormously to the necessary light intensity to produce equal brilliancy."[63] Richardson would always remain concerned about the loss of image quality with a larger screen ("Better have a good small picture than a bum large one"), but in 1910 he could expand his recommendations up to 18 or 20 feet, albeit preferring 18 feet, for a theater 120 feet deep.[64] If "life-size" remained a continuing concern in this period, and larger theaters made the 12-foot wide image geared to the 12-foot line in production actually appear less than life-size, then it is

reasonable to assume that the larger screens necessitated by the longer theaters were paralleled by the closer camera distances that became more common in the same period. The long, narrow house in effect became one condition of creation for film producers.[65]

## ANTI-HIERARCHY ARCHITECTURE

Now for the first time in history a new art is being born that is more democratic than the drama—and the drama always has been the fundamental democrat of the arts.

—William DeMille[66]

Placing seats in front of a screen would seem like a fairly simple matter since the seats all need to be arranged in relation to a fixed object, ranging anywhere from about 12 to 15 feet across. But the simplicity itself contained a problem. Live theater was presented on stages that averaged between 30 and 40 feet at their proscenium opening; further, the stage existed in a three-dimensional space. These two facts made live theater effectively more forgiving since the broader expanse and the actual depth multiplied the number of vantage points for any audience member: if any individual was not able to see the whole stage, they would nonetheless be able to see a significant part of it. This opposition was understood early on as the following from *The Brickbuilder* in 1914 indicates:

People will attend grand opera or a performance given by a great actor and be satisfied with seats from which they can see only a portion of the stage so long as they can hear the voices or see part of the acting. In a picture theatre the interest is focused on a small part of the stage as compared to the area covered by the actors in a legitimate production. It is therefore vitally essential that the sight lines be so arranged that each person may have a good view of the whole screen.[67]

I want to linger over this point now because it will play an important role in a theoretical understanding of movie theater architecture that emerged in the 1930s. Clearly, the long, narrow hall, ideal for the film image, would have been a disastrous shape for live theater. But even with this shape, perfect visibility of that narrow space of the screen placed restrictions on how the seats were to be arranged. Furthermore, these restrictions com-

peted with economic demands as well as the dictates of emerging build-ing codes, and these were concerns that carried over into the movie pal-aces as well. For example, staggered seating, so that each seat was not directly behind another, is the simplest way of improving visibility for each movie spectator. Yet it actually took quite a while for staggered seat-ing to become a norm because it generally meant a loss of seats every other row to carry it out. Optimal seating arrangements often lost out to exhibitor demands for higher seating capacities, most especially in the period under consideration as the store theaters grew larger and larger until they were finally supplanted by the palaces. The competing inter-ests could be most clearly seen in how aisles were situated. In 1911, John M. Bradlet complained that architects were following the pattern of the opera house by placing an aisle directly in the middle of the auditorium: "If these architects were students of motion pictures, they would know that the best seats are the ones directly in front of the screen, while the picture, viewed from the side seats, always appears more or less dis-torted."[68] But the central aisle need not be attributed to the model of the opera house. It's often hard to determine exactly what the arrangement in the earliest store theaters were like because there are no actual archi-tectural plans and photographs of interiors are rare. There are isolated early photographs that do show seemingly wall-to-wall people, indicating at best very narrow aisles on the ends of each row. But the disadvanta-geously located central aisle seems more common, and for the good reason that one aisle enables more seats per row than two aisles on the end. There were variations in building codes throughout the country, but there was enough similarity for *Motion Picture News* to publish general rules for seating in 1914: "Chairs between two aisles should not number more than thirteen, and between an aisle and the wall not more than seven."[69] A central aisle, then, could gain one seat per row. Maximizing the num-ber of seats was the same reason for center aisles in the small multiplexes built inside shopping malls in the 1970s and 1980s, once again removing the best seats for film viewing.

Another factor that had an economic dimension to it was the floor slope, but here theory seems to have won out over expense. The earliest store theaters likely had flat floors, as low-cost conversions would con-tinue to have been a determining factor. A 1910 article on the problem of seeing over the oversized hats women preferred in this period recom-mended that women could keep their hats on, "if all moving picture

theaters had their floors constructed on a slant."[70] By the teens, a slope seems to have become a mandatory feature: all of the illustrated entries in the *Brickbuilder* competition show sloped floors in their longitudinal sections.[71] The sloped floor was hardly unique to the store theaters, however, since it is commonplace in nineteenth-century theaters, but the historical precedent likely helped it become even more of an imperative when coupled with the distinctive sighting requirements of motion pictures. Especially in the absence of staggered seating, the slope helped individuate each viewer's perspective.

Much as it took over the sloped floor, the sloping actually pointed to something very different from live theater, although not without precedent: as every seat putatively provided a good view of the screen, there was a widely held belief that the motion picture theater democratized theatrical spectatorship. There was some limited concern with making spectatorship more democratic in late-nineteenth-century theater, but it was really with the store theater that the democratic nature of viewing became an issue, as indicated by the William DeMille quote at the head of this section. Following his complaint about the center aisle in the store theaters, Bradlet attacked architects for one other area of ignorance: "Some architects, not knowing the requirements of motion pictures, and believing that every theater should have side boxes, near the stage, have provided many such boxes in moving picture theaters, and the managers, who had an idea that they could increase their receipts by having reserved seats in the boxes, have been badly deceived" (Bradlet, Jan. 21, 1911). Even Adler and Sullivan had to give in to a demand for side boxes at the Auditorium Theatre. But when side boxes did appear in the store theaters, their poor vantage points ultimately transformed them, creating new functions such as a screen "flanked by two private boxes, reserved for the use of the lecturer and singer" (who were intended to accompany the film showings in a 900-seat theater in Milwaukee, billed as "High Class in Every Detail") or rendering them "purely ornamental" (a 600-seat theater in Detroit trying to appear "pretentious," generally a favorable adjective for theater architecture in this period).[72] Omitting, removing, or transforming the side boxes effectively rid these spaces of the most overtly antidemocratic aspect of seating in live theaters.

There has been much debate in film studies over the composition of the store theater's audience, whether it was primarily working class, working class in just major urban centers (with guilty-pleasure visits paid by

middle- and upper-class slummers), or a mix of all classes.[73] Indisputable, however, is the fact that the very low cost brought in people who either did not often go to the theater or people who at most could afford the cheapest seats in the upper balcony of live theaters. Calling moving pictures "a sort of people's forum," *Moving Picture World* writer Stephen Bush claimed they had abolished price and class distinctions along with the old belief that the poor must be segregated: "Much of the hostility against the motion picture abroad is due to its enlightening and leveling influence."[74] Theatrical producer Daniel Frohman, Charles's brother, attributed the success of movies to a combination of price, product, and seating:

> There is much to be said for an amusement which a poor man can have for ten cents. The galleries [i.e., the second balcony] of the regular theatre, that portion of the house from which a large part of the profit is derived, are being emptied, not because of the price of the seats, but because the average theatre-goer has always objected to paying a disproportionate price for a poor seat and poor play together, when for ten or twenty-five cents he could sit down stairs in a moving picture house and get something in which he may be really interested.[75]

For both Bush and Frohman, seating was the crucial issue: if the poor could now sit where the rich normally sit, the rich would have to sit next to the poor to enjoy the spectacle. In effect, store theater architecture in doing away with spatial segregation in seating did away with class distinctions that had been inscribed in theater architecture for centuries.

This would change somewhat with the reascension of the vaudeville theater as a venue and the building of the palaces, but the belief in the democratic nature of movie-viewing that began with the store theater became a factor in palace architecture as well because of the way in which spectators related to film spectacle. If early film theory was centrally concerned with locating the differences between film and theater, I would claim it is precisely—and paradoxically—because most contemporary viewers saw a continuity between the two. That continuity made film practitioners equally concerned with difference: one was close enough to the other that differences had to impact on practice, such as the design of the theater, as we've seen. A technical writer for *Exhibitors Herald* noted a difference in 1916 that was crucial to contemporary understanding of

motion pictures as the more democratic of arts, "One is viewed on a flat screen which viewed from all positions is always the same—a picture; the other is composed of people on an actual stage, with a perspective, which changes to every seat. People in various parts of the house see it differently because of the angle of vision."[76] This difference in viewing experience made movies more democratic because movies effectively had the power to override the inevitable *hierarchization of space* in theater architecture. This belief was in fact a myth, as would be acknowledged by theater architecture several decades later, but it was sufficiently accepted as truth at the time to guide the development of motion picture theater design.

Further, that this was a distinctly American view of movies can be seen by a 1910 report on "A London Moving Picture House De Luxe" in *Moving Picture World*. Although it was fairly small, it nonetheless had differential pricing, "the balcony being reserved for the highest-priced seats. . . . The front seats are priced at 3d., the back seats 6d., and those in the balcony are 1s."[77] The fact that even the larger theaters that grew out of the store theaters in the United States continued to be called nickel theaters made clear the admission price was the great leveler. While a 1910 *Moving Picture World* editorial recommended that "it is perfectly possible to conduct a house on the differential price system," and the presence of vaudeville in the bigger theaters could lead to some pricing differences, in general American movie theaters tended to shy away from this.[78] Further, outside of an important regional exception in the South, American theaters never attempted an architectural distinction found in the London movie theater and common to European theaters and opera houses, the creation of lounges segregated by seating area: "one being reserved for threepenny seat-holders, and the other two for sixpenny and shilling patrons" ("A London Moving Picture House").

## ARCHITECTURE AND ANXIETY: ODOR, LIGHT, FIRE

The democratic nickel theater had its downside for some observers in the range of patrons it could attract. Much like the repeated calls for higher ticket prices as a way of attracting a higher class of patrons, addressing the disreputable status of the early store theaters, making these undifferentiated spaces amenable to all classes, animated the chief architectural concerns repeatedly addressed in trade journals: ventilation, light-

ing, and physical safety. The spatial separation by class of the traditional theater could operate as a form of social control. So, for example, the second balconies could be home to the lower classes as well as prostitutes looking for customers. The decampment of these customers for the store theater made it a new business address for prostitutes, since indecorous activities could and did take place in the dark. In this context, lighting instead of spatial separation could serve as a form of social control, which is how it often ended up allied with ventilation. Thus, a 1909 *Moving Picture World* article moved directly from a discussion of lighting to the importance of ushers "in excluding undesirable visitors, the better for the reputation of the house." And this led directly to the following: "Too much attention cannot be given to the cleanliness of the house; to its proper ventilation, and, then to the preservation of quiet and order amongst the audiences."[79] Light, cleanliness, ventilation, order— for contemporary observers who sought to improve the reputation of store theaters, these were interconnected concerns necessitated by the democratic audiences: the theaters had to be kept safe from their audiences of unwashed masses, whose odors and indecorous behavior necessitated both the elevated light levels as well as the circulation of fresh air.

The store theaters seemed to have been a magnet for concerns about dirt, whether dirty air or actual dirt dragged in from the street by presumably dirty patrons. A theater in 1907 was praised for its "ventilating system [which could] draw out the foul air and replace it with sterilized fresh air."[80] Another theater in 1910 was cited not only for its good ventilation, but for having "an obliging usher who meandered up and down the aisles spraying [the audience] with some sweet scented liquid," a not uncommon practice.[81] Smell signaled dirt, and dirt was dangerous: "The great amount of disinfectants sold yearly to moving picture theaters shows the unsanitary conditions of the present floors, absorbing and retaining all the filth carried from the street."[82] And dirt was clearly connected to class: in an article advocating raising ticket prices beyond a nickel, *Moving Picture World* columnist W. Stephen Bush boasted that theaters with high prices "are making far more money by charging more and are in addition blessed with a *better and cleaner* patronage."[83] In this formulation, "better" meant people who washed.

From the perspective of a century later, the strangest aspect of the discourse on the new dedicated movie theaters is the repeated insistence

that light levels should be kept bright enough during the show to read a newspaper:

> As much light as may be furnished without interference with the picture on the screen should be supplied at all times, as an audience is much more affected by panic when in almost total darkness. (1908)[84]

> As we took our seats we could see to read a newspaper that we carried. The effect of this unnecessary volume of light was to degrade the brilliancy of the picture on the screen, which appeared to the audience to have somewhat of a misty look. (1909)[85]

> The house [the Auditorium Theater, Dayton] is well lighted, in fact you can read a paper in almost any part of the house. (1910)[86]

> The lighting of the [Coliseum Theater, Seattle] is very good; a newspaper can easily be read at any time during the show. (1911)[87]

> The [Orpheum Theater, St. Joseph] is so lighted that one can read a newspaper in any part of the house while the picture is being shown. (1912)[88]

But why would you want to read a newspaper while watching a movie? An Englishman visiting a New York movie theater for the first time in 1909 did wryly report a counterpoint to the tension he felt viewing a melodrama, "Then the clouds began to gather [i.e., on-screen], the man on my right opens a book and begins to read."[89] American lighting practices were distinctive, as European theaters tended to be dark, something of a flaw from an American perspective.[90] A 1914 *Motion Picture News* article entitled "America First in Picture Theatres," for example, cited Samuel Rothapfel's disapproving comment, "All the European houses are pitch dark while the pictures are being shown."[91] Why the difference? The lighted theater certainly addressed concerns about safety: nitrate film was explosive, and there had been dangerous fires in store theaters. But the fact the European theaters could function safely in the dark suggests other concerns as well.[92]

There was very likely a correlation between light levels and the practice of continuous performance through a very long day. The modular

nature of the standard store theater's program, comprising a number of short films, ensured that audiences could arrive at any time and take any seats available. The resultant constant traffic would require light levels sufficient for people to find their way to empty seats. Much as the modular nature of the store theater's program was a direct imitation of vaudeville, the continuous performance practice likely derived from vaudeville, where it had been originated by B. F. Keith. And it is likely that vaudeville did not use a fully darkened auditorium either: in 1910, Samuel Rothapfel was hired by the Keith and Proctor chain to improve the lighting in their theaters so that the screen image could be sharp while the auditoria remained light.[93] Light in vaudeville theaters was directly connected to reading, albeit not newspapers: playbills identified individual acts for viewers. Furthermore, the kind of performance offered by the vaudeville theater made light levels in the auditorium of lesser importance than they would be in straight dramatic theaters, where the advent of the fourth-wall aesthetic was in part dependent upon the possibility of a darkened auditorium. Even as the movies had cast its lot with fourth-wall aesthetics, the theaters embraced a vaudeville aesthetic in their lighting procedures because they embraced vaudeville programming.

Although it began with the store theaters, the call for lighted houses was not limited to small theaters with disreputable clientele; it continued even as motion picture theaters grew larger and the class range of the audience expanded. As late as 1914, when Vitagraph took over a legitimate theater and changed its name to the Vitagraph Theatre in order to promote its product, the theater was praised because "a complete lighting system, calculated to make it possible for one to read a newspaper at any time, has been installed."[94] The fact that this was still an issue might reflect continuing concerns about safety, but by this point the booth was fully separated from the audience. On the other hand, this was also in response to city ordinances, which were likely prompted by concerns about social control. In 1910, "All of the Chicago theaters are lighted houses, being required by city ordinance."[95] And in New York City in 1911, "recent ordinances compell[ed] the owners of theaters to illuminate their theaters at all times."[96]

All this had to have an impact on theater design. The mutual exclusive aims of image visibility and an illuminated house could be accomplished in two ways: by forms of illumination that would keep the area of light relatively restricted; and by manipulating how the image was situated.

A dose of sensibleness was also needed, which was finally provided by F. H. Richardson in 1912: "That considerable light is desirable in a theater auditorium, or other place where large numbers of people assemble, no sane man would deny," Richardson conceded. But when he asked, how much light, he answered somewhat differently from his contemporaries: "Just sufficient to enable one, after being seated long enough to become accustomed to the semi-gloom, to see clearly objects in one's immediate vicinity and to dimly discern objects all over the house. It is not necessary to be able to read a newspaper. One doesn't go to a theater to read papers while the show is on." Finally, although the darkened theater was only a phenomenon of the late nineteenth century, Richardson suggested a similarity between the two theatrical forms by claiming, whether it was stage or screen, "Too much light detracts from the interest of the show."[97] Richardson's prescription for "semi-gloom" pretty much carried the day in subsequent theater design, whether store theater or palace.

One solution to the illumination problem in the store theater did provide a lasting contribution to motion picture theater design: downlighting. The earliest example I have found of this is in the 1910 description of a Chicago theater, "in which the lamps, located on the ceiling, are enclosed in deep cone shades, which confine the light to the place where it is needed, and protect the screen at the same time."[98] Several months later, in his regular column Richardson drew a sketch of a similar method.[99] Downlighting would become a standard fixture in small theaters, where the ceiling is close enough to keep the circle of light fairly contained, or under the balcony overhang in larger theaters. But downlighting arrived in a period when motion picture theaters began to take on gargantuan proportions. In these very large spaces, other solutions had to be found, some involving light and some involving the actual situation of the screen. How the screen was situated in the auditorium directly related to anxiety over light levels because of the potential for degrading the screen image. Following the fourth-wall aesthetics of naturalistic theater, which sought to make the space of the setting distinct from that of the theater, store theaters evolved a number of approaches to setting the space of the film image, seemingly so different from our space, off from the rest of the theater.[100] Because store theaters either didn't have a stage or only had a shallow one, they borrowed the picture frame from vaudeville theaters to create a de facto proscenium: the frame was either made part of

the screen—some manufacturers would in fact ship the screen enclosed by a gilt frame—or made an integral element of the architecture surrounding the screen. In 1909, F. H. Richardson acknowledged both approaches with his recommendation for situating the "curtain," i.e. the screen: "A neat, heavy moulding around the curtain adds very much to the effect, but better yet is a 'flare' from eighteen inches to two feet in depth such as one sees in the proscenium arch of a theater."[101]

But the lighted house of the store theaters presented a problem not seen in live-performance theater where the stage could be illuminated at a much higher level than the auditorium: the gilt frame around the screen could pick up the light from the theater, sending distracting reflections back to the audience, or reflecting light onto the image itself. To lessen the effect of reflections, store theaters began utilizing a dead black border, really the first instance of black masking, which could be achieved either by painting directly on the screen or by layering black cloth around it. As an added bonus, contemporaries thought the black border could heighten the apparent brightness of the image by creating a sharp contrast. In the same column in which he recommended a frame for the image, Richardson also recommended a black surround: "It will be found that much brilliancy will be added to the picture by painting all the curtain except the space actually occupied by the picture a dead black." Another commentator thought a "black cloth border . . . enhanced the value of the picture by giving it perspective or greater 'depth.'"[102] There was some experimentation to heighten the brilliance of the picture by contrast in ways that might seem odd to us now, such as having colored lights play around the image[103] or another for black masking which would then be surrounded by an illuminated colored-glass frame to achieve a greater sense of depth and relief in the image.[104] Since its success was founded in a stark contrast between dark and light, the use of black masking, like the illuminated house itself, effectively called for a light film image with a relatively flat lighting style. A key reason for this is that the image itself was not very bright. The black masking might have helped boost the visibility of an image in a lighted theater, but it also offered a way of compensating for the relatively low projection-light levels allowed in a number of U.S. municipalities. Where there were reports of carbon arcs running in Australia at 90–100 amps and in England at 80–90 amps, New York City law set limits at 25 amps.[105]

To compensate for such low illumination levels, screens were developed that could take advantage of the store theater's narrow widths by reflecting light back at the same angle it hit the screen, rather than a more diffuse dispersal of light needed for wide auditoriums. Ads for such highly reflective screens appeared with some frequency in trade journals from 1909 on and always made claims about their properties in relation to the illumination in the theater, thus connecting screen illumination itself to a concern for social control. A 1909 promotional article for the "Mirror Screen" noted, "it is not easily affected by other light, therefore it allows more light to be had in the theater."[106] And an advertisement for a metallic screen coating the same year boasted, "After using it on your curtain your house can be light enough to read the finest print and you'll have a better picture than you had before with your house in pitch darkness. No more reason for your patrons to be stumbling over themselves in the inky darkness. . . . Your house can be light as day; You can open your doors and windows wide and allow free ventilation and have no fear of a dimmed picture. Outside light has no effect."[107] In effect, the ad promised that light, fresh air, and a brilliant image—the very things needed to keep the theater safe and attract all kinds of patrons—could be had with the right screen.

If lighting and ventilation were in part issues of public safety, the location of the projector would seem to be entirely that, and entirely beyond contestation. Noting that motion picture film will ignite in about three seconds if it stops moving, a 1908 article considered it "most important" that "the picture machine be enclosed in a thoroughly fireproof, and as far as possible smoke proof, operating room."[108] While there was continued debate into the 1910s about whether or not to have an open booth in vaudeville theaters, in the store theater there was never any reason to show the operator or the apparatus. Typical of the understanding of theater architecture in the period, concerns with illumination could lead to concerns about fire: "the laws of some states require that picture theaters be illuminated every 15 minutes during the show. The reels are highly inflammable, and panics occasioned by their conflagration have more than once caused grave loss of life."[109] Concealed projection booths seem to be an early fixture in architectural design, perhaps as much for dampening the sound of the projector as for concerns about fire safety. Given this necessity, an architectural form very quickly emerged in the store theater that was a deft and economical use of space: the booth was centrally located

over the entryway, generally with entrances into the auditorium on either side of it. It might also be located on stilts over seats at the back of the auditorium, although this seems primarily a design of the earliest store theaters that got dropped from later, more luxuriously appointed interiors. In either way, space taken away from seating was minimized.

More rigorous building and fire codes in the teens did finally demand a separate, and fireproof, "operating room," as it was generally called, as a matter of public safety. But the common booth of the room at the back of the theater also created a problem by placing the source of fire right in the path of exodus from the fire. There were some suggestions for reversing the auditorium, placing the screen near the entrances, but the more common solution was additional fire exits placed near the screen. The operating room remained a fixture chiefly at the back of the auditorium, aligning audience movement in toward the screen with its own trajectory.[110] Given the concerns about panic, however, there was another possibility rarely explored in the United States. Jean-Jacques Meusy has noted it was not exceptional for Paris theaters to locate projectors behind a transparent screen, "the most famous being the Gaumont-Palace," the largest and most luxurious theater in Paris devoted to motion pictures (Meusy, 84). For fear of audience panic in case of fire and smoke, rear-screen projection offered the best solution for keeping danger fully isolated from the audience, yet this was in fact an exceptional procedure in U.S. theaters.

In the case of the store theaters, either the lack of a stage or a limited stage might have been the reason for not using back projection, but ample stage area was offered by the vaudeville theaters, and even they eschewed rear-screen projection.[111] Promoting an awareness of the projection booth was a kind of assurance of safety, a way of preventing the kinds of "panics" that a "conflagration" might cause. The apparatus might be partly concealed, but the activity of image-making, its separate points of origin and destination, were generally evident to U.S. audiences. As much as later theories of spectatorship can construct a naïve spectator absorbed by the image, the very structure of the theater essentially exposes how the image is created, with a beam of light emerging from a back wall until it strikes a surface in front. Compared to this kind of moving image-making, television technology is completely opaque: we simply have an image with no sense of how it arrived on its screen. The preferred manner of situating the moving picture image in the architectural

space of American theaters followed from the earliest showings with the visible projectors: the nexus of anxieties in store theater architecture might have dictated the enclosed booth, but the technological production of the image was always made evident.

## THE STORE THEATER IN THEATER HISTORY

By the middle of the teens, stories of store theaters becoming stores again began to appear.[112] Increasingly, "large" and "pretentious" were adjectives attaching themselves to movie theaters: "There is scarcely a town of any consequence throughout the country but already has, or is expecting, the building of at least one pretentious theatre devoted exclusively to motion pictures."[113] With the rise of the feature film, the store theater ceased being economically viable, so that one architect could note in 1916: "very few of the remodeled store buildings still house moving picture exhibitions" (Braun, May 6, 1916, 23). They would soon disappear entirely from the urban landscape, existing primarily in memories of the "nickelodeon," the name itself taking on a kind of quaintness. Does the store theater, then, have no lasting contribution to the architectural and theatrical forms that succeeded it?

As an architectural form the store theater could well have been a model for dedicated movie theaters that followed with the rise of the feature film. I would like to consider one example that suggests how the store theater might have evolved. The American Theatre opened in Salt Lake City in July 1913 and was billed as "America's Biggest Picture Theatre" (fig. 2.4). It would be eclipsed within a year in size and with a very different design, but before then, *Moving Picture News* thought it worth noting that "it is hard to realize that the building is dedicated exclusively to the photoplay. Its capacity is nearly twice that of the majority of New York's legitimate theatres."[114] Although the invocation of legitimate theaters is meant to advance the claims of this theater to quality, the design of the American grew more out of the store theater: it lacked a stage and it situated the screen within a gilt frame surrounded by black masking and a larger frame outside of that. This was a dedicated movie theater, with no live performance other than what accompanied the film showings: "The program is uniformly composed of five reels of pictures. Sometimes a five-reel feature will be the evening's entertainment. At others, single reels, with a two or three-reel subject, will be offered." The theater

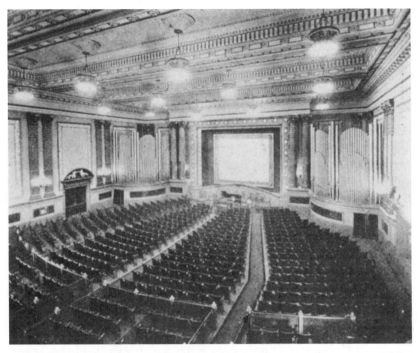

FIGURE 2.4
The American Theatre (1913), Salt Lake City, a large theater that evolved from the store theater, lacked a stage and kept the screen encased in a gilt frame.

was also something of a departure in ignoring the demands for variety: a feature film could suffice as entertainment on occasion.

The actual size of the auditorium was 165 feet deep by 90 feet wide. The depth, then, approached the longest store theaters, but the American was nearly twice as wide. Still, the shape was substantially longer than wide, so that it could nicely accord with contemporary understanding of movie theater form. But in contrast to the one admission price at store theaters, the American offered a range of prices that implicitly acknowledged a limitation in the sight lines. Next to a small block of 300 seats in the orchestra, the second most expensive seats were in the 500-seat balcony, "a block of two hundred seats, on either side of the operating-room, and in a direct line with the screen."[115] This differential pricing, then, pointed to another departure from live theater by offering a different rationale for what determined a good seat. Essentially, seats that would fit within the then dominant long and narrow shape of the

dedicated motion picture theater would fetch the highest price; the more seats departed from it, the lower the price. This way of looking at seats would not last long, however. While the motion picture did indeed triumph as a popular theatrical form, the American Theatre, nonetheless, proved to be more the last of its kind rather than a promise for the future. For all the big theaters that emerged in the United States following it, a full stage was called for and a different shape took hold.

This is not to say, however, that the store theater had no impact on later developments. There are two areas I need to address here. The first takes up an ongoing dialogue that film theaters were having with live theaters. If the format of the store theater drew on vaudeville, the kinds of work it presented nevertheless invoked dramatic theater, its limited size dictating playlets rather than full-length plays because of the need for constant turnover. It was precisely the connection to live drama that made contemporary writers see a democratic aspect in movie theaters. The extraordinary proliferation of store theaters in a fairly short time frame meant that dramatic narratives were suddenly available to everyone at low cost and under the same conditions: the store theater transformed theater by removing it from the theater. This new understanding is reflected in the observation from 1915 cited earlier that the "picture parlor of to-day is nothing more than a small theater." Up to this point, I have looked at influence in one direction, from live theater to movie theater. But the sudden ubiquity of a theater of dramatic performances staged in the unlikely precinct of a store suggests the possibility of a reciprocal influence.

To my knowledge, histories of American theater rarely if ever acknowledge the store theater or the nickelodeon. But if we look at theater history from the perspective of *motion picture theater history*, then it has to seem more than coincidence that the first substantial challenge to the dominant commercial theater in the United States occurs in the context of store theater proliferation. The emergence of the Little Theater movement in 1912 reflects an understanding that theater did not require the elaborate physical resources of commercial theaters to provide compelling dramatic entertainment, an understanding that had to be conditioned by the success of the low-cost store theaters.[116] If the movie store theaters chose unlikely spaces for conversion, the Little Theater movement distinguished itself by "mounting plays in what might now be called 'alternative spaces.' "[117] One of the best known, the Provincetown Players, for example, set its first theater in Massachusetts in a converted fish-storage

facility on a wharf and subsequently opened a theater in New York City in a stable. The Little Theater movement also represented a challenge to the dominant realistic mode of commercial drama, and in this regard it effectively challenged what was becoming the dominant mode of filmed drama. But the influence does not end there; rather, it takes a cross-fertilizing route, returning once again to the film theater. The subsequent emergence of the motion picture art theater, which was specifically called the Little Film Theater movement, is the one place you can see a continuity from the store theater, although it came about in a circuitous manner, first taking a detour back into live theater. Commensurately, as the Little Theater movement in live theater often countered dominant naturalistic staging, the Little Film Theater movement opened up a space for motion pictures that went against the dominant realist aesthetic as well.

Where the simplified style of the art theater sought to give unimpeded access to the dramatic text, the little film theaters in the 1920s followed the store theaters in aiming for unimpeded access to the motion picture image and generally did so with the familiar long and narrow hall. The Film Guild Cinema was unusual in employing a modern architect for its experimental design, but the relatively unadorned quality of the store theaters, even if not displaying an overtly modern aspect, shared a similar purpose: as Barbara Wilinksy has written in her study of art cinemas, "the simple, modern design of a theater like the Film Guild provided what some cinéastes believed to be the proper environment for film viewing, in which all lines directed the eye to the screen, discouraging audience distraction."[118] As we have seen from contemporary observers, it was also the richness of the image that licensed the limited architecture: there was no need for elaborate settings since the images could provide so much, all the more so since they now had the label of advanced art. Looking at the development of movies in terms of the architecture used to display the image makes all the more evident how much interaction between movies and live-performance theater is central to the development of movies. Later movie theaters thrived on elaborateness of decoration; the store theater might seek a degree of "pretentiousness" by importing a few classical elements into its interiors, but for the most part elaborateness was restricted to façade. No doubt, a pared-down look was in large part a consequence of economics, but this does not mean the theaters were slapped together. How they would function still had to be thought about, as there is ample evidence in the trade press.

The store theater was a dead end to the extent that it was founded on an exhibition format that disappeared with the rise of the feature film. But it did effectively look ahead to the feature film by helping to establish the popularity of narrative film, film as a dramatic art, not simply a novelty element in the context of a vaudeville show. And as an architectural form, the first dedicated motion picture theater, it did have an impact on later film theaters in a number of specific areas: black masking around the image (although the rationale for doing this was lost); downlighting; rectangular form; frontal seating; light levels and continuous performances with a sit-anywhere policy that complemented the "democratic" seating plan; "pretentious" elements in decoration as a positive quality, a way of elevating the status of the object displayed by elevating the environment itself; a central concern with ventilation as a way of defining the environment. It is also in the store theater that the architectural screen emerges, a feature of neither the vaudeville theaters before them, nor the movie palaces after them. The notion that the screen might determine architecture was lost in the excitement over the movie palaces of the teens, but it would eventually emerge again in the sound period.

The "nickel theaters" that repurposed existing theaters, most often marginal vaudeville theaters, faced the familiar problem of how to make movies work within existing architectural spaces. In this context, the store theater had to be important because it represented the first sustained thinking about how the film image should be situated in architectural space, and it did so by challenging conventions of theatrical space. And even if the constricted space of the small theater and the great open spaces of the palace might seem to make the two polar opposites, the democratization of space in the store theater did have an impact on palace design. This, then, is the lasting achievement of the store theater: it convincingly demonstrated that virtually any interior space could be turned into a theater and achieve commercial success even as it undercut the hierarchical organization of space that was an essential feature of earlier theater architecture. Comfort, decorum, an architecturally pleasing environment, even a sense of luxury, all the things the trade press was calling for in order that a more refined setting could elevate a product aspiring to be art, none of this was needed if the play, or photoplay, really was the thing. I suspect the enduring myth of the accidental nature of the store theater lies in its impact outside of movie history, that it offered a model for all dramatic arts.

# 3. PALATIAL ARCHITECTURE,

## DEMOCRATIZED AUDIENCE

### THE FORM OF THE PALACE: THE GUIDING MYTH
### OF PEOPLE'S ARCHITECTURE

*. . . theaters create not only their dramas, but their audiences as well.*
—Stephen Orgel[1]

Although architectural writers by the mid-teens had begun to refer to the motion picture theater as if it were a specific form, the period from the rise of the store theater through to the dominance of the movie palace in the late teens–early twenties actually saw a multiplicity of forms. As a number of scholars have demonstrated, the growth of motion picture exhibition was not an unbroken line from vaudeville to store theater/ nickel theater to picture palace, with each new form wiping out the last.[2] Rather, echoing the general history of live-performance theaters, there

was frequent overlap that promoted an evolution of form and occasionally unexpected crossbreeding. Further, perhaps because movies first successfully appeared in architectural spaces not specifically designed for them, there seems to have been a sense that just about anything could be pressed into service as a movie theater, ranging from the smallest stores to the cavernous Madison Square Garden and Ebbett's Field, home of the Brooklyn Dodgers.[3] The movie palace, which would finally become the dominant form for first-run exhibition, did not emerge as an inevitable development. Its emergence was conditioned by a number of factors, some of which had to do with the conception of motion pictures at the time.

This multiplicity of architectural forms can be confusing because often enough they had little to do with theater function. Adding to the confusion, past writing on early motion picture theaters has generally used function to classify theaters and ignored architectural form. For example, Robert C. Allen's claim that "small-time vaudeville provided the important link between the primitive nickelodeon of 1906 and the palatial movie theatre of the 1910s" suggests an evolution of theatrical spaces, although what he is describing is, in fact, more an evolution of performance practices.[4] Early on some nickel theaters, to distinguish themselves in a fiercely competitive market, added an act or two of vaudeville to their shows; parallel to this, by 1908 low-performing vaudeville theaters improved their profitability by making movies the main attraction, Of these changes, Allen has argued, "What evolved from this movement toward spacious, middle-class oriented theatres and away from the converted storefront was small-time vaudeville: the showing of a mixed program of film and vaudeville acts in large capacity theatres for between ten and thirty-five cents."[5] This programming was small-time because it had fewer and less expensive acts than big-time, but in the realm of motion picture exhibition, it was big-time because it offered far more and more varied entertainment than store theaters and at not much greater cost. If small-time vaudeville seemed to advance motion picture exhibition, it was also retrograde to the extent that it was a logical outgrowth of nickel theater programming and not really conducive to feature-length films.[6] But if we look at the emergence of the feature-length film as the true harbinger of exhibition's future, then we have to look elsewhere and consider the importance of legitimate theaters, the primary venue for early features. And legitimate theaters were architecturally very different

not only from store theaters and most vaudeville theaters, but they were different from the future movie palaces as well. I will consider the crucial role played by legitimate theaters in the next chapter because it was of lasting importance in the growth of American exhibition.[7]

For now, I want to consider the theaters in which small-time vaudeville appeared. In mixing live performance with movies, small-time did establish a performance strategy that was adapted by the movie palaces emerging in the teens and twenties. But the multiplicity of architectural forms embodied by small-time vaudeville is ultimately of greater consequence because the forms exposed the limitations of existing architectural models for the vaudeville-movie mix the palaces would purvey. Ultimately, the movie palace had to create its own form. Consider one of Allen's key examples of small-time:

> One of the first and most ambitious schemes for building large capacity theatres for vaudeville and motion pictures was developed by Philadelphia motion picture producer/distributor Sig Lubin. . . . [In 1908 in Philadelphia] he constructed an eight-hundred seat theatre for vaudeville and film costing $132,000, called the Palace of Delight (usually referred to simply as the Palace). When it opened the first week of September 1908, *Moving Picture World* called it the largest and most elaborate motion picture theatre in the world. The Palace gave four shows each day, using six "first-class" vaudeville acts daily and charging ten cents. . . . In January 1909, *Moving Picture World* claimed that Lubin's new venture was competing with the established high-class vaudeville theaters in Philadelphia.[8]

That this theater directly competed with established vaudeville theaters might make it seem as if it looked like them as well. But, in fact, it looked more like an extension of the store theater, utilizing the standard long and narrow form, described in a book on Philadelphia theaters as " 'bowling alley' architecture"[9]—and with good reason since the overall dimensions of the theater were 48 feet wide by 190 feet deep.[10] With a fairly small stage and lobby areas and forty-seven rows of seats, the actual depth of the auditorium was likely somewhere between 140 and 150 feet.[11] This is a bit shorter than the 163-foot depth at the 6,200-seat New York Roxy, built eighteen years later, but at its broadest point, the auditorium of the Roxy was approximately 189 feet wide, nearly four times the width of

Lubin's theater. For all of the Palace's narrowness, the distance from stage to farthest seat was about 30 to 40 feet greater than that in the biggest opera houses in Europe, where distance is measured from stage to last seat in the uppermost ring.[12] Such a distance, then, would have been far beyond anything most architects at the time would have considered optimal for a live-performance theater, and yet this theater was used as much for vaudeville as for motion pictures.

At the other extreme, because older theaters could be pressed into service for this new exhibition format, however imperfectly, small-time vaudeville could also end up looking like big-time vaudeville as far as theatrical space was concerned. Here's another example from Allen, in the very same city and around the same time: in April 1913, New York–based exhibitor Marcus Loew "leased the Metropolitan Opera House in Philadelphia, described by *Variety* as 'the largest and most modern place of entertainment in the city.' Loew used the 3,482 seat theatre, built by Oscar Hammerstein in 1907 at a cost of $1.2 million, for small-time vaudeville in opposition to a Keith big-time house just across the street" (Allen, *Vaudeville*, 285). *Variety* might have called this theater "modern," but it was a tiered-ring horseshoe theater typical of the kind of house Hammerstein had been building in the previous century. In 1928, the two upper side rings were removed to put in an organ loft for a dedicated movie theater, which failed within five months (Glazer 1986:169), likely because there were many, many bad seats in this theater from a motion picture point of view. If we keep in mind the half-movie, half-live-performance nature of small-time, we could say that each of these Philadelphia theaters presented a good show about half the time for about half the audience. Given the extreme distance of many of its seats from the stage, Lubin's Palace likely worked better for movies, while the high number of side seats at the Metropolitan would make it work better for live performance. In sum, neither could provide a template for the movie palaces that were soon to become a key force in motion picture exhibition. There was no evolution.

Because the palaces of the teens and twenties were so impressive in size, I want to stress that even before their advent, people were well aware that there were problems with seeing movies in a large theater, with "large theater" generally meaning vaudeville theater. But why did this insight only appear in 1910, why was this not a consideration in the previous fourteen

years that motion pictures were being shown in vaudeville theaters? The advent of the store theater itself had to be the crucial element because it reoriented the audience's relationship to the screen. The recognition of sight-line problems for movie exhibition was an insight that was only really available *after* the introduction of an alternative that privileged vision of the image. But even with this understanding, the very economy of theater-building meant that older forms could continue alongside newer spatial arrangements. So, while some theaters with horseshoe interiors were gutted and completely rebuilt on the inside, others continued to be used without modification well into the era of wide screens and stereophonic sound. This context helped make the palace architecture seem like a break with and an improvement on the past: large theaters that rejected architectural conventions of the vaudeville theater by reorienting the audiences toward the space of the spectacle.

While the feature-length film was emerging at precisely the same time, there was a demand for larger and larger theaters that existed independently of the feature. Greater seating capacity was considered desirable for a number of reasons. Importantly, size could clearly correlate with status since the largest and most expensive theaters were often those intended for grand opera. It is for this reason that exhibition journals were always concerned to track capacity of new houses, proclaiming each new landmark in theater capacity as if it were a major advancement for the art of motion pictures. The sizes began to get truly impressive, regularly setting landmarks, beginning to overtake all but the largest opera houses. They would soon be surpassing opera houses as well, so that a new kind of economy was introduced, one that was still dependent upon turnover, but at much longer intervals. By 1914, architect Nathan Myers could write, "We have seen the picture first thrive in the three-hundred-seat house. . . . To-day those houses, yes, and those of five hundred seats are gradually being pressed to the wall by the larger and more fit competitors." Myers noted that already 2,000-seaters were common in larger cities; he recommended 1,000 as the proper size for a smaller city.[13] Both these figures were far below the theatrical plant that would be built over the next fifteen years or so.

As audiences grew larger and films grew longer, the long and narrow hall began to reach its limit. If theaters were to get larger, they had to find ways of doing this beyond expanding the depth. A logical outgrowth of

the expanded store theater would be to increase the width, but keep the dominant rectangular form, a possibility we saw in the previous chapter with the American Theatre in Salt Lake City. But in less than a year, the American Theatre found its status eclipsed by the opening of the Strand Theater on Broadway in New York on April 18, 1914. Billed as "the largest theatre in this country devoted exclusively to the projection of motion pictures," the Strand had a reported capacity of approximately "3,500 people—1,500 downstairs, the remainder in the single balcony," although 3,000 is the likelier figure.[14] How did it achieve this size?

Like the American, the Strand exceeded the dimensions of the largest European opera houses to the extent that the distance from curtain line to last seat in the balcony was approximately 135 feet. But its shape departed from the rectangular shape the American was still following by adopting a square, with the seating area of the orchestra approximately 112 feet deep by 112 feet wide.[15] It would take a couple of decades before this shape would be subject to critical scrutiny; for now, it was clearly the shape of the future, generating sufficient excitement to blind contemporary observers to faults that would seem obvious decades later—and had seemed to be obvious before the Strand's premiere. Within a year, in a series of articles on theater architecture for *Moving Picture World*, Edward Bernard Kinsila provided architectural plans for a large theater and a medium-sized theater; in each, the auditorium is square.[16] It is only with a plan for "An Ideal Type of Small Motion Picture Theater" that he draws a narrow, rectangular auditorium.[17] How much things had changed may be seen by a 1921 article in the *Architectural Record* on a new C. Howard Crane theater in Cleveland: "The auditorium is unusually long in proportion to its width and the effect of length is greatly increased by the fact that it narrows gradually toward the stage."[18] The actual ratio of the auditorium was approximately 1:1.75, width to depth, which, if anything, was on the shallow side when compared to the earlier dedicated movie theater form, where ratios of one to four were not unusual. Thus, 1:1.75 could only seem unusual by reference to a square.

Although the Strand established a policy of "very popular prices," it followed the American Theatre in posting a range of prices.[19] But the basis for the differential pricing is revealing: "Admission prices will be 10 cents, 15 cents and 25 cents for seats in the body of the house. Box and loge seats will be 50 cents."[20] Where the top prices at the American seemed to invoke earlier store theaters by making distance from the

screen a desirable value, the top prices at the Strand followed the proce-
dure of the vaudeville theater by privileging proximity to the stage, even
if, in the case of box seats, it offered a distorted view of the projected im-
age.[21] The problem of extreme side views, often noted in earlier writing
in both exhibition and architecture journals, got swept aside in the en-
thusiasm for the achievement of this theater. One review of the opening
noted that William Farnum, star of *The Spoilers*, the feature film for the
premiere, "saw himself as others see him, sitting in a box not far from
the screen."[22] In fact, Farnum's extreme angle toward the screen had to
offer a view of himself quite unlike what most of the audience saw. The
box seats were of sufficiently negligible value that they would eventually
become primarily a decorative feature for the auditorium, but contempo-
rary commentary could ignore their limitations in the great enthusiasm
for the achievement in sight lines: "There are no bad seats in any part of
the house" ("Opening of the Strand," Apr. 18, 1914).

The reception of the Strand frequently portrayed it, either overtly or
implicitly, as democratizing theatrical space. This response links the
Strand to a democracy discourse on theatrical space that dates back at
least to the mid-nineteenth century, a discourse explored by Joseph M.
Siry in his richly nuanced view of the social and political history sur-
rounding the Adler-Sullivan Auditorium Theatre in Chicago. Siry traces
the beginnings of this discourse to the Academy of Music in New York
(1854), which was built in response to "repeated indications of popular
demand for Italian opera at moderate prices." But it deliberately sought
*not* to simply follow European models: "Even the name *opera house*, with
its elite and foreign associations, was replaced by the term *academy*, which
conveys emphasis on musical education as an institutional purpose." Fol-
lowing aesthetic concerns around staging practices in late-nineteenth-
century American theater discussed in chapter 1, the democracy dis-
course turned on two key issues, seating and sight lines. Since the
auditorium would require a high capacity (5,500) to "achieve the goal of
affordable opera, meaning low prices for individual seats," the architect
was asked to provide "tiered balconies of open seating rather than private
boxes." Allowance was made for a number of proscenium boxes "to be
showcases for members of Manhattan's wealthy families" who supported
the Academy. But as open and seemingly unrestricted as the seating space
was, the basic form of the European opera house was followed nonetheless,
which meant a problem with sight lines: "Many of these seats had either

no view or only a partial view of the stage. . . . Thus the conventional horseshoe plan proved ill adapted to the democratic ideal of relatively few boxes."[23]

The Auditorium Theatre was intended as Chicago's response to New York's Metropolitan Opera House, which opened in 1883. "The Metropolitan's concept of audience shaped its architecture," much as the concept of audience for the Auditorium Theatre would shape *its* architecture. Following European models, the Met had rings of tiered boxes, with the purpose of the boxes succinctly stated by its architect: "Its boxes afford a rare opportunity for the display of beauty and toilet[te]s." By turning the horseshoe into something of a lyre so that the boxes would flare out as they approached the stage, the architect attempted to deal with the sightline problem, but with little success: "the social demands of the patrons had resulted in a functionally compromised hall" (Siry, 79, 82). By contrast, businessman Ferdinand Peck, who commissioned Adler and Sullivan to design the Auditorium, sought "a public hall where a broad audience could have access to high culture."[24] Because of changes in staging toward the end of the century, other theaters sought to improve sight lines, but always keeping something of a U-shape seating arrangement, if not a full horseshoe. Adler and Sullivan understood the only solution was in a rejection of the Italian opera house model.[25] The space of the opera house was hierarchical not just in its tiered structure but also in its sight lines, something that was becoming increasingly obvious by mid-nineteenth century. Iain Mackintosh quotes a complaint from 1865 in a journal "of the building trade in Britain": "the arrangement of our theaters, is and is likely to continue to be, such that the stage decorations can be seen—as far as seen at all—only to a very great disadvantage by a very large proportion of the visitors."[26]

To improve sight lines and, in the process, create a greater equality for all spectators, Adler and Sullivan drew on a different European model, one that came complete with an ideological meaning that complemented its aesthetic aims, the Bayreuth Festspielhaus: the theater's "deemphasis on boxes in loges or tiers fulfilled Wagner's aim of shaping a democratic and unified experience for the audience. He felt that Europe's ruling classes, with their box-filled theaters, had removed musical drama from its popular origins in antiquity and that partial restoration of ancient theater architecture signified the public's reappropriation of musical drama"

(Siry, 107). Nevertheless, likely in a concession to the aristocracy, Bayreuth did include a row of boxes behind the last row of seats, and although Peck had been strongly opposed to boxes of any kind, the Auditorium did eventually have a double tier of boxes on either side of the steeply raked orchestra, arranged so that the top tier was level with the back row of orchestra seats. Following Bayreuth, rows in the body of the auditorium were set on a curve so that every viewer faced the stage, a procedure followed in the Strand as well as most of the theaters built in New York's new twentieth-century theater district.

There are some important differences I will discuss, and I don't think it would be possible to determine a conscious influence on the Strand's architect, Thomas Lamb, but one can certainly draw a line from the Auditorium to the Strand in both its architecture and the discourse around it. The Strand raked the orchestra seats, not as sharply as the Auditorium, but to a point that that last row was above stage level. And the squarish shape of the Strand was remarkably close to the Auditorium, which was 92 feet wide by 110 feet deep. According to the Auditorium's first manager, "This space being nearly square brings the main body of the audience within easy reach of the stage and does away with all the disagreeable features of a long and narrow room" (Siry, 204). At approximately 3,000, the Strand's capacity was less than the Auditorium, which held 4,000 with another 237 seats in the boxes, but both were exceptional in the sheer number of people they accommodated, which was central to their democratic ambitions.

Whether or not the Auditorium Theatre was an influence, the Strand itself became a familiar reference point for subsequent movie palaces. By 1918, the *Architectural Record* could describe a new movie theater in the following way: "its plan and equipment necessarily follow, in a general way, the precedents established by the earlier houses, of which the Strand Theatre, New York City, is a familiar and worthy example."[27] If there was in fact an influence from the Auditorium to the Strand, the Strand featured one crucial difference that itself became influential. The Auditorium achieved its high capacity by building up, the one element it kept in common with conventional opera houses: it featured three balconies. The first balcony was similar to the Strand's balcony: it was steeply raked, of sufficient depth to extend over a lobby area, and with greater capacity than the orchestra, 1,600 seats to the orchestra's 1,400, which is similar

to the Strand's seat distribution. But above it there were two more balco-nies, each with a capacity for 500, although, as I noted in chapter 1, these could be closed off for more intimate performances. Furthermore, the width of the Auditorium "necessitated rows of columns to support the main balcony and upper galleries." It was only with their next two major theater projects—the Grand Opera House in Pueblo, Colorado (1890) and the Schiller Theater in Chicago (1892)—that Adler and Sullivan used cantilevers, making them, according to a *Chicago Tribune* article quoted by Siry, the only two theaters "in the country without pillars" (Siry, 348). At 1,200 and 1,275 seats respectively, these two theaters were much smaller than either the Auditorium or the Strand. These capacities are worth keeping in mind when gauging the impact of the Strand's expan-sive balcony on contemporary observers. With the Strand, architect Lamb helped establish the single high-capacity balcony as a key feature of movie theater architecture.

Up to this point, even those theaters which exchanged the horseshoe for frontal seating achieved their capacity through two balconies. And it was fairly common through the first decade of the twentieth century for those balconies to have columns. The move away from support columns began with an increasing use of cantilevering in this period. Iain Mack-intosh traces "the first major use" of the steel cantilever to "1891 at the D'Oyly Carte's English Opera House," seating 1,400. Although this was a year after the Pueblo Grand Opera House, it does indicate that the trend toward the use of cantilevers extended beyond the United States (Mack-intosh, 38). In 1903, the New Amsterdam opened on 42nd Street with a decidedly modern look in a stylish art nouveau interior. Even more mod-ern, its architects "employed the largest steel cantilevers ever used in the-atres to bear the weight of the balconies. . . . The cantilevers also did away with the support posts that obstructed the view of the stage from many seats."[28] The balcony held 500, with the "gallery" (i.e., second balcony) above it another 500. Cantilevers increasingly became the standard for legitimate theater buildings in this period, but what they could accom-plish was really put to the test with the construction of large movie theaters. The year before the Strand opened on Broadway, in February 1913, the Regent Theatre, also designed by Thomas Lamb, debuted on 116th Street in New York with 1,794 seats, roughly 754 in a balcony.[29] The balcony was the architectural feature to receive most attention in a con-

temporary description: "There are no pillars to hold up the balcony; an unobstructed view may be had of the picture from any angle of the seating plan. The balcony is supported on the cantilever plan."[30]

It was in this architectural context, then, that the balcony turned out to be a central focus in the enthusiastic reception given the Strand. The key point was recognized by a contemporary observer, who noted an aspect of the seating that differentiated the Strand from many large theaters: "There is not an obstruction from one end of the house to the other which can possibly interrupt the line of vision to the screen. There is not one post either upstairs or down." As noted, other theaters in the previous decade had done away with posts and columns, but nothing on the scale of the Strand, which made its cantilevering something of a technological marvel in its scale. At the time, the cavernous Hippodrome, designed for large-scale spectacles, complete with water tank onstage, was the only New York theater of any kind larger than the Strand. And the Strand was directly compared to the Hippodrome in terms of its stage, "as commodious as any theater in New York aside from the Hippodrome" (*MPW*, Apr. 18, 1914). But the Strand bested this larger theater in its seating arrangement since the Hippodrome's capacity of 4,678 could only be arrived at by means of supporting pillars placed throughout the house and creating many obstructed views.[31] Thomas Lamb would go on to prove even higher capacities did not require pillars when he designed the Capitol (1919), three blocks north of the Strand on Broadway, with 5,230 seats. I cannot say if cantilevering to this extent was ever put to use in other kinds of buildings, but Lamb appears to have been breaking new ground in theaters, and its use here was perhaps the most direct impact the Strand had on subsequent movie palace design.[32] It was a defining feature of subsequent new theaters, but it also figured in remodeling of older ones.

As impressive as the sheer scale of the cantilevering at the Strand was, it was not just the lack of posts that made for a good seat. The opening night observer who said there were no bad seats was more specific about what made a good seat: "I was conducted to what a distinguished committee of reception alluded as the worst seat in the house, and I have never sat in a better. As one stands in the aisle dividing the first from the second balcony, one realizes how close the stage is even to the furthest away seats" ("Opening of the Strand," Apr. 18, 1914). Figure 3.1 provides

FIGURE 3.1
The large open balcony of the Strand (1914), New York City, equaled the capacity of
the orchestra, but seemed close to the stage because of adjacent boxes.

some sense of the closeness since the first row is adjacent to the three
boxes flanking the stage. The description requires some explanation, in
particular the reference to a second balcony. As often happens in this
period, live theater is the main point of reference. Following a pattern he
had first tried out on a smaller scale at the Regent, Lamb divided the bal-
cony into three sections, each separated by what the writer calls an aisle,
but designated "crossover" in Lamb's floor plans: loges in front, then two
seating areas, all steeply raked in the style of an amphitheater.[33] In the
live theater, the worst seat should have been at the back of the second
balcony because of its distance from the stage. In a movie theater, the
worst seat should have been a box seat, as would be implicitly acknowl-
edged when these eventually fell into disuse. So how did the worst seat in
a live-performance theater become a good seat in a movie theater?

It had been possible in the past to build the final balcony, often called
the gallery, both up, even above the ceiling of the main auditorium, and
deep because of support from built-up areas beneath it. In chapter 1,

I noted complaints about these balconies because they created a kind of "deep 'well,'" a claustrophobic space that seemed cut off from the rest of the theater (see p. 45). This then is the context to consider in understanding contemporary reception of the Strand. Its balcony was a model not just because it was cantilevered and without obstruction but also because its expanse and location provided a radical sense of openness. Lamb's design of the balcony made possible what would become a standard feature of the palaces, namely, its seating capacity could equal or surpass that of the orchestra. In the process, not only did the capacity exceed that of the largest "caves" in old theaters, but the cantilevering effectively made it possible to push the cave forward and bring it into the light of day, that is, into the main portion of the auditorium. It was as if Lamb had reintegrated an exiled second balcony back into the auditorium.

The very openness of the architectural space was particularly striking for contemporary observers because something on this scale had never been tried before, but also because it endowed the space with a symbolic value that was realized in the frequent claims that every seat was a perfect seat. In the past, the second balcony had been literally a segregated area, a full story higher than the first and often only accessible through a separate entrance, not through the main public spaces of the theater, and in the southern United States, it was also racially segregated.[34] But in spite of contemporary commentary, there *were* columns in the Strand's capacious balcony: look closely at the illustration and you will see there is indeed a column at the far left of the image three rows from the back wall, complemented by one outside our field of vision further to the left, with a couple of rows of chairs (only two each) on either side of the column. It is a testimony to how overwhelming the great expanse of space seemed that it was all that our contemporary viewer noticed, overlooking this apparent leftover from earlier theater architecture. The power of the space lay in its meaning: by making the transition from loge to first balcony to second balcony continuous, the vast flowing space promoted a sense of community, unifying the audience in opposition to the hierarchical deployment of spaces in conventional theater design. The limited space of the store theater made it easier to overturn distinctions of conventional theater. The Strand's vastness of space inevitably leads to divisions within that space, and yet the expansiveness of the architecture seeks to override hierarchy.

With the sense of continuity, unifying distinct spaces, an ideological signification emerged that perfectly suited the understanding of motion

pictures as the art form that democratized drama. In like fashion, the motion picture palace itself would now democratize viewing. If the technology of mechanical reproduction could produce something that was "more democratic than the drama," as William DeMille put it, advanced technology in the form of massive cantilevering could effectively situate that drama in a more democratic space. An important difference between the Strand and the Auditorium is that the Auditorium was intended to present opera to the masses, while the Strand was intended for an emerging art form that had its own claims to democratizing art. The familiar notion that movies democratized viewing because they presented the same view to every member of the audience was itself a myth, but it dovetailed perfectly with the myth of the people's palace.

The symbolism of the balcony as a democratic viewing area carried over to the public areas and another novelty of the Strand, a mezzanine rotunda, that architecturally tied orchestra to balcony. At this rotunda, a promenade built around an open well looked through a rectangular opening onto the rear seats of the orchestra and also fed into the ramps that led directly into the balcony (fig. 3.2). There are also stairs at the back going to the upper reaches of the balcony, but the ramps were visually rich since they seemed to be on the same level as the mezzanine, but in a gradual slope, barely noticeable, that led up a level to the first aisle of the balcony. Aside from its symbolic significance of visually connecting balcony to orchestra, the promenade promoted an actual interaction between different members of the audience, a feature singled out by *Motion Picture News*: "This allows patrons of both the balcony and orchestra to walk around ad lib during the intermission."[35]

If the auditorium democratized viewing, the rotunda democratized the public spaces. The Strand's rotunda was also a deft design since it employed the large space made available by the steep raking of the balcony. Contemporary observers saw the rotunda itself as derived from European opera houses, but put to different use in that the direct connection of orchestra to balcony accentuated the democratic quality of the seating: the architecture drew the attention of orchestra sitters to the upper areas of the theater rather than keeping it discrete.[36] The rotunda was much imitated in later theaters, although one variant, most common in theaters designed by Rapp and Rapp, actually made possible a higher-priced seating area that was spatially separated.[37] While Lamb had made the higher-

FIGURE 3.2

This mezzanine promenade for balcony patrons at the Strand unified spatially distinct areas through an open well offering a view of the orchestra.

priced loge seats continuous with the rest of the balcony, Rapp and Rapp placed them on a separate level, a mezzanine roughly where the promenade was in Lamb's designs. But if the mezzanine loge seemed to reinstate the hierarchical space of earlier theater architecture, this was countered by the fact that it was entered through a promenade it shared with the balcony and the promenade looked directly down on the main lobby, visually joining all the public spaces outside the auditorium. Even into the 1950s, New York palaces with mezzanine seating took advantage of the spatial separation by allowing smoking in this area.

By visually connecting orchestra and balcony, Lamb's rotunda had the further advantage of minimizing distances, an important issue at the time. A 1917 *Architectural Forum* article noted, "Theater managers nowadays are insistent upon keeping the people as close to the ground as possible, as they say it is almost impossible to make the patrons climb stairs. For this reason a large number of the more modern motion picture houses have been constructed with but a single balcony instead of the usual two balconies."[38] Keeping this stricture in mind, we can understand *Moving*

*Picture World*'s praise for how the Strand's balcony was situated in relation to the orchestra: "No matter for what parts of the house you buy your ticket, you never have to climb until you are tired" (Apr. 18, 1914, 371). This deployment of space then became another way of equalizing differences among audience members: space was visually constructed so that no location within the auditorium appeared very far from any other location. In a sense, the equality promoted by the square itself took on an ideological dimension: the rectangle promoted differentiation, the square similarity. Walkways establishing a fluid connection among all levels of the house visually minimized distances, even if the farthest seat at the Strand was outside the dimensions of the largest European opera houses. The desire to have walkways that connected all the public spaces offers the starkest contrast to the earlier practice of segregating audiences.

Describing the event as "far more suggestive of a night at the opera than a motion picture entertainment," *Moving Picture World* did single out the audience for special attention in its report on opening night at the Strand:

> The quality of the audiences at motion picture entertainments has been improving, as everybody knows, for the last three or four years, but the demonstration of the fact was never made more complete than Saturday night. Consciously and unconsciously the world of amusement and of art in amusement has been looking forward to the palatial home of the quality picture and consequently the lobby of the theater and other portions as well looked at times like an animated edition of "Who's Who in Society." . . . While a large sprinkling of the first-nighters knew but little of what can be done with motion pictures and had only imperfect notions gained, perhaps in cheap theaters, the majority of the vast audience consisted of enthusiasts to whom the motion picture is the only and favorite amusement.[39]

As the final comment indicates, the presence of "Who's Who" patrons does not mean that the movies had suddenly taken over the opera house audience to the exclusion of the masses. *Moving Picture World* had been editorializing for years about expanding the movie audience by expanding the class appeal, so the mixed nature of this audience is what made it particularly compelling. With this great inclusiveness came a rhetoric of

uplift that goes back to the nineteenth century, where the concern for expanding the audience turned in the opposite direction, moving downwards along the class scale in order to promote social harmony by exposing the working classes to elevated works of art.[40] With movies, uplifting the masses required uplifting the medium, so that for contemporary industry observers the architectural achievement of the Strand embodied that uplift, making it stand in for the growth of motion pictures in general: the movies had come up in the world both in artistic achievement and in social status. *Motion Picture News* saw in the Strand's premiere "a signal proof of the prestige that motion pictures have won during the last year."[41]

Because it could directly challenge legitimate theater as a collection of shorter films could not, the feature-length film was crucial for this prestige. It is for this reason that the very long evening of entertainment on the Strand's opening night had to end with a feature, and most specifically a feature that, at over two-and-a-quarter hours, ran longer than most of the features at the time. Nevertheless, at the time of the Strand's opening there was real uncertainty about how much features could sustain the operations of large-scale theaters, especially given the fact that there was only one company at the time, Famous Players–Lasky (Paramount Pictures), that was dedicated to feature film production exclusively. Even after other companies joined in and the major studios established themselves, the concern about quality would linger into the sound period, and for reasons that were evident this early. About six months after the Strand opened, *Moving Picture World* posed the question, "Is it possible to provide all these theaters with films of a uniform standard of excellence?" One possible answer was bleak: "If it is impossible now, or at any time hereafter, to guarantee features of undoubted quality, once a week or once a month or at any other interval of time, then it will be far better all around to discontinue the feature as a regular and indispensable part of the motion picture entertainment."[42]

The Strand offered one solution to this dilemma by trying to brand the theater itself. One of the curiosities of the opening night performance was a comedy short in which "we saw the Mutual Girl paying a visit to the Strand and being entertained by Rothapfel."[43] S. L. Rothapfel, already a celebrity in the trade press as "Roxy" or "Roxie," was the first manager of the Strand. His theater, like himself, would become celebrated in its own right and something of an attraction, a place that was

on the list of things to see for any visitor to New York, like the Mutual Girl. Even at its opening, it was observed that the Strand was "intended . . . to be a Mecca for exhibitors from all parts of the country . . . to make the house a model of motion picture theatre operating, so that Strand methods and Strand ways will become a national standard."[44] In this regard, it clearly succeeded. By the late summer, the claim that it was a "true national theater" acknowledged this influence: "I choose the term national rather because the theater has already become a recognized pattern for the presentation of motion pictures. One cannot go to the Strand Theater without meeting one or more exhibitors from different parts of the country anxious to witness the performances and eager to profit by the advice as well as by example of the management."[45]

What exactly were "Strand methods and Strand ways" that proved so influential? I've indicated the architectural elements that were imitated in subsequent theaters. But the Strand was also a model in presentation and programming, both of which had an impact on architecture, creating a stage-within-the-stage that was much copied. Drawing on strategies he had developed elsewhere, manager S. L. Rothapfel emphasized the live musical performance by placing the orchestra onstage in front of the movie screen, something he had first tried in 1911 in Minneapolis. As at the Regent the year before, Roxy's first theater in New York, the screen itself was located on a separate stage behind the orchestra with singers standing in decorative boxes flanking the screen, imitating the tripartite division of the architectural space around the screen I noted in the previous chapter as a feature of the store theater. Finally, a series of one-reel films interspersed with live performances led into a multi-reel film, *The Spoilers*, as the highlight of the evening's entertainment. From a contemporary perspective, the location of the orchestra on stage in front of the screen might seem one of the oddest features of the Strand methods. While we are likely to imagine it as a distraction from the screen image, the onstage orchestra was valued at the time for its foregrounding, literally, the musical aspect of the performance, providing the audience with a sense of fullness that had to seem an exceptional value compared to other theatrical performances; here was truly something for everybody and at a price everyone could afford. Such was the influence of the Strand that the orchestra and singers onstage quickly became a commonplace in movie theaters, even in small theaters. By late 1915, the architecture columnist for *Moving Picture World* complained of the practice, providing

obvious reasons for eventually moving the orchestra back into a pit in front of the stage: "In most picture theatres the bands are placed on the stage before your very eyes so as to constantly distract your view from the scenes on the stage" (Kinsila, *MPW*, Dec. 25, 1915, 2349–50). Finally, while vaudeville programming is the model here, the multi-reel film assumed its place as the primary attraction among a varied series of short films and live performances, with the key ambition for Roxy, as always, a well-balanced program. As is evident from the many pieces he wrote, even though it was made up of disparate pieces, he attempted to give the overall show a shape that was not unlike a narrative arc.

Important for my concerns with film image and architecture was the upstage position of the screen within a second stage: while the orchestra and singers during the performance would eventually depart the stage, the screen would always remain upstage throughout the silent period, and for reasons that give the lie to the claim that every seat was a perfect seat. Architect Edward Bernard Kinsila noted in 1915, "Because of the desirability of presenting as nearly a direct view of pictures as possible to the audience to avoid distortion, motion picture theaters are often built long and narrow. It is better, if possible, to straighten the line of sight by providing a stage and placing the screen about twenty feet towards its rear."[46] Kinsila echoes earlier writers by noting that the long, narrow shape was a response to limitations imposed by the moving image, but since he elsewhere states he prefers a film theater that looks more like a live theater, he sees the upstage position of the screen as a better solution to the problem of distortion. The reason for this is simple: placing the screen further away reduces the sight-line angles for seats on the sides of the auditorium. The upstage position of the screen, then, offers an implicit recognition that there was in fact a problem with some seats in the palaces, and perhaps even, as would be later recognized, a good number of seats. Placing the screen upstage proved to be a partial and ultimately temporary solution to a problem that would be exacerbated after the introduction of sound.

How pervasive the Strand's influence was may be seen in a 1917 advertising campaign that ran in both the *Saturday Evening Post* and the *Ladies' Home Journal*, both magazines aimed at a mass market, not the trade. Beginning with the headline "You can have 'The Strand' in your own town," the advertisement, run by Paramount Pictures, sought to conjoin the prestige of the Strand with the movies made by Paramount: "Last

time you were in New York you went to 47th Street and Broadway and joined the big crowd of good-looking, well-dressed people that passed through the gay entrance of the Strand. . . . You have the Strand in your town if you have Paramount Pictures!"[47] Paramount Pictures meant feature-length films exclusively, but showing solely these features would not give "your town" a Strand. Rather, the feature could anchor the "recognized pattern for the presentation of motion pictures," which meant the feature was one element of a show made up of a mix of films and live performances. Much as the feature film was becoming central to what people meant by "the movies," the Strand was important in establishing conventions for succeeding movie theaters, in architecture as well as in programming. It was only with the rise of television in the 1950s that the movie theater became more fully divorced from live theater so that an architecture could finally emerge that made no reference to live theater. But in the teens and twenties, movie theaters had to keep architectural ties to live-performance theaters because live performance remained a key element of film presentation.

## SOMETHING FOR EVERYONE: THE VAUDEVILLE LEGACY AND THE VARIETY DEBATE

The moving picture theatre has practically developed into a vaudeville house, and the term is, therefore, in most cases improperly applied. While, for example, there are in Greater New York over 500 so-called moving picture houses, and in Philadelphia over 300, comparatively few of them are without scenery and variety performances of some kind. (1911)[48]

Then came the super features with their many reels, that practically were an evening's entertainment. The country suddenly went feature mad. (1916)[49]

By 1914, when the Strand opened, it had become clear to many industry observers that the future of the movies lay with the feature-length film. In 1912, *Moving Picture World* announced, "One of the greatest achievements—indeed, it is the greatest—of the year is the successful introduction of the more-than-one-reel film."[50] The following year, *Moving Picture News* prophesied, "The feature film will become one of the principal items of merchandise, and depending upon the quality of the feature film, so will the people receive good or bad impressions of the industry."[51] The programming at the Strand's premiere would seem confirmation of these claims by the pride of place granted to *The Spoilers.*

Nevertheless, initially, the feature itself was seen as antithetical to such an elaborate program, giving rise to what *Moving Picture World* in 1915 dubbed the "battle of 'Feature versus Program,'" the "program" meaning a complete entertainment comprising a collection of short films: "The feature men predict the gradual but certain elimination of the program, while on the other hand the program men are very sure that what they call the 'feature craze' is nearing its end."[52] The distinction put forth here derives from the fact that the companies committed to the feature film sent the film out as a single entity, while those committed to short films sent out a complete program in a variety format, and "a standard program might include a western, a slapstick comedy, a drama, and a newsreel."[53] For the most part, individual exhibitors generally faced the choice of either one or the other.

The sheer size and high return of the Strand granted it more clout with distributors, so that Rothapfel could combine a feature with a series of short films from different distributors and even add in live performance.[54] The program was in fact so overstuffed that it is difficult to imagine a twenty-first-century audience sitting through all of it with pleasure: an orchestral performance of the national anthem accompanying an Edison short, "The Star-Spangled Banner," complete with lighting effects and a surprise reveal of the stage decorations around the movie screen; the orchestra playing Liszt's Second Hungarian Rhapsody; a solo "by a well trained soprano"; "A Neapolitan Incident," a "scenic" (what we would now call a travelogue) depicting "the beauties of Italy" as a tenor sang ("a collaboration of motion picture and singing" according to the *New York Times*); "Our Mutual Girl," a comedy short; the quartet from *Rigoletto* sung by the Strand Quartet; "Pathé's Weekly," a newsreel; "The Bathing Beauty," a Keystone comedy; and, finally, for the entire second half, the 145-minute *The Spoilers*.[55] Presumably, the audience was sufficiently entranced and possibly exhausted by the amount of entertainment in the first "half" (likely about an hour, judging from contemporary reports), that they were quite happy to immerse themselves in the extended drama of the much longer second "half."

The program at the Strand's premiere was deliberately excessive as a way of highlighting the theater's significance. Subsequent programs would be shorter and less elaborate, but the programming principle would remain the same. As Rothapfel claimed, "As far as conditions allow we simply have to delve in and pick our own programs, *making variety the*

*chief attraction.*"[56] From the days of his store theater in rural Pennsylvania, Rothapfel was praised for a seeming instinct on how best to order a program, and his principles were repeatedly cited in the trade press, as we saw in the last chapter. Rothapfel did not rely on distributors for a complete program; he sought distinction for his new theater by his own creativity in putting together a program. With theaters growing larger and performances growing longer, the principles behind the ordering of the program became more complex. But why should Rothapfel seek distinction in this manner? Framing the great period of movie palace construction with the opening of the Strand in 1914 and the opening of Radio City Music Hall in 1932 foregrounds a striking connection between the two theaters: both were originally intended for vaudeville.[57] The Strand would be transformed into a movie palace while it was under construction, while Radio City would find itself financially compelled to make motion pictures the dominant entertainment in its first year of opening. But in both instances, the first and last palace, more or less, vaudeville underlay their status as movie theaters. Movies might have been the chief entertainment at the opening of the Strand, but as *Motion Picture News* pointed out, "Variety and quality ruled in the selection of the opening program."

Beginning in vaudeville theaters, motion pictures in the United States seemed inescapably tied to a vaudeville aesthetic for many contemporary observers. In spite of the pride of place given *The Spoilers* at the Strand's premiere, William N. Selig, president of the company that produced the film, could write a few months later, "That the single reel photo-drama is the keystone of the motion picture industry becomes more apparent daily. Patrons of the film drama want their programs as diversified as possible. A program offering four or more productions is more apt to please an entire audience than is a program offering one photo-play of four or five reels."[58] Selig was hardly alone in finding the appeal of the feature film limited. In spite of the over three-and-one-half-hour entertainment the Strand presented, Carl Laemmle, president of Universal Pictures, set a narrow time frame for most movie shows: "One hour and ten minutes is about as long as many of the patrons wish to spend in the theaters and I think this time is best spent giving them a diversified program." For Laemmle, the kind of entertainment the Strand offered meant audiences could no longer drop in at any time and have fun.[59] Even as late as 1916 and after his own company had committed itself to feature film produc-

tion, George K. Spoor, cofounder of Essanay, stated categorically, "Strong one, two and three act photoplays mean the backbone of the motion picture industry. . . . While many theaters will do well with the large features, the vast majority will do best with variety programs."[60]

Spoor's remark might make sense if we understand that the original use of the word "feature" generally signified a film with distinctive attributes, not necessarily longer than one reel; Spoor purposely uses the phrase "large feature." And in fact, there was an important distinction here: three to five reels (approximately 50 to 80 minutes) was becoming the standard feature length, with a number of companies (Mutual, Warners) pledging to produce three-reel features on a regular release pattern. At these lengths, the feature film would allow time for a variety of shorter films and even live performance. And for all these contemporary observers, "variety" was the key issue. One could answer, as W. Stephen Bush did, that a feature by itself might offer a good deal of variety: "it is not altogether clear why the more expensive offering cannot furnish both substance and variety."[61] But old hands in a young industry did not necessarily believe that. A year after the Strand opened, a manager at the Edison company observed, "The varied program is what has made the Strand theatre, New York. The Strand shows a drama, a comedy, a travel picture, an educational subject and a topical or news film on every program. Of course the Strand plays a feature every week."[62] Although the feature rapidly continued its ascent as the dominant movie attraction, variety in programming remained an aesthetic goal of the movie palace. Even five years after the opening of the Strand, Rothapfel, who was then managing both the Rialto and the Rivoli in New York City, could say, "Don't depend entirely on so-called features for all pictures cannot be perfect. . . . Variety is the spice of the show business as well as life."[63] This was a simple business proposition: since regularized production of features inevitably meant uneven quality, successful exhibition had to search for solutions elsewhere.

While many contemporary observers thought the feature film was supplanting live drama, movie palace programming had a direct impact on the shape of the feature by subsuming it within a variety presentation. This is most evident in the seeming consensus on the length of the feature that emerges from 1913 to 1916. By 1915, Horace G. Plimpton, the Edison manager cited above on the importance of variety for the Strand's success, noted that "most adaptations" of stage plays run "around 4,000

and 5,000 foot length," that is, approximately 72–90 minutes, a running time that, quite remarkably, would be taken as standard through much of the classical period, at the least for what would be called programmers (see chapter 4).[64] This running time might seem especially odd since Plimpton is specifying film versions of plays here, while the length of dramatic plays, which provided the source material for many features, was generally a good deal longer. There are a number of factors that could account for the apparent abridgment in translation. On the one hand, in adapting for film, the absence of spoken dialogue could make individual scenes play faster.[65] On the other hand, commentary in this period repeatedly notes the advantage that film has in showing things merely described in plays, so dramatization in place of dialogue could actually make the adaptation more expansive. There is, however, something of a third hand here: films with very long running times were not uncommon in this period, films that were intended as complete entertainments in themselves. For example, *The Birth of a Nation*, clocking in at about four hours, had opened in New York on March 3, 1915, just a few weeks before the interview with Plimpton. Commentary on the opening of the Strand did note "the unusual length of the picture," but the length of *The Spoilers* was not so unusual for the period as it was unusual in the context of a variety program, and would be unusual for subsequent releases at the Strand.[66]

Slotting a feature into an expected length represents a reversal in performance practice: initially, in small-time vaudeville, the length of the feature helped determine the rest of the program. Thus, in 1914, "Whenever a long picture is booked in a Marcus Loew theatre, one act from the vaudeville bill is left off, so that it actually costs nothing, save the cost of the advertising to show the picture, and this is often a far better drawing card than the act which it replaces."[67] But, eventually, the process was reversed, with the program itself determining the length of the feature. A 1913 edition in *Motion Picture News* proved prescient: "Careful study of the situation persuades us that the unit of the future is likely to be the five-reel picture. The two-hour-and-a-half-entertainment—the two-hour-and-a-half net—is the one that practice has proven out to be the need of the public."[68] A two to two-and-a-half-hour show of live performance, short films, and a 70–90 minute feature became standard practice in the palaces. Two years after the Strand opened, David Horsley, head of a production company recently affiliated with Mutual to produce features, could note, "The tendency of the times seems all toward five-part

features. . . . Of course the one and two reel subjects will always be indis-
pensable as 'fillers' to run with the features."[69] The need for "fillers" was
a perceived need for variety, a rounding out of the program, but the very
presence of fillers placed limitations on the feature. The palace show
became sufficiently standardized that, by the 1920s, theaters would com-
plain if films ran over 90 minutes—and even worse: speeding up the
film during projection or even cutting it was not uncommon in the pal-
aces.[70] The running time of feature films, then, was in part determined
by the need to fit within a larger program that became the key feature of
the movie palaces. This is to say, exhibition explicitly functioned as a
factor in production.

This circumscribing of the feature suggests a tension between exhibi-
tors and producers/distributors that could surface in other ways. Highly
profitable exhibitors had the economic power to rent short films from a
variety of producers/distributors, diminishing the latter's profits. On the
exhibition side, this acted as an added impetus for larger and larger the-
aters, since the larger profit margins granted by size enabled exhibitors
to dictate terms to distributors. Furthermore, while feature film distribu-
tors wanted to have a reliable outlet for their product in order to regular-
ize production, exhibitors wanted to guard against the possibility of
weak features disaffecting their audiences. *Moving Picture World* de-
scribed the problem succinctly in 1914: "Allowing for all the advantages
which a regular program confers on the exhibitor who uses it, it was not
so much the strength of the regular program as the weakness of the aver-
age feature, which must be responsible for the result." That is, a good
program of variety would attract a larger audience than a weak feature
which could offer no other compensation. This article did come up with
the solution that would eventually take place: "none of the successful pro-
ducers of features—I am now speaking of feature specialists—has ever
attempted to supply regular service in addition to the feature. Such a
combination may be in the lap of the future."[71] By the 1920s, the produc-
tion/distribution companies began to gain control over first-run theaters,
and they created a complementary control over the program as well:
feature film producers added short film production to their schedules,
while the surviving companies that had begun with short films and
"complete programs" continued their production alongside features. The
complete program of shorts and features became another way of control-
ling exhibition, ensuring a continuous exhibition outlet for features while

maintaining the apparent need for variety. Significantly, by offering a program to appeal to all tastes, at the least sequentially if not simultaneously, the palace complemented its architecture by democratizing the program.

The emergence of the palace program occurred in a period of competing programming strategies, from the program of short films in the smallest store theaters to the long super-features exhibited without "fillers" in former legitimate theaters. Regularized output, a goal for any production company, would require a standardized distribution system, but that was made difficult by the sheer variety of venues where movies played. The continuing mixed output of various short films and features gave rise to calls for different kinds of theaters as a way of correlating production and exhibition. William N. Selig, who had stated a firm commitment to the short film, nonetheless proposed classifying theaters with diversified programs of short films and those showing features "that will run an hour and a half to even two hours and a half. These will be offered in another class of theatres, and will appeal only to those who have the leisure and inclination to view photo-plays of great length."[72] Programming in this period is a function of architecture, correlating with size: the program of short films was a bid to sustain the store theaters, which could not profitably show features because their greater length would reduce the turnover and number of customers they could entice in the course of a day. As the remarks from the Edison manager should make clear, companies that produced short films could see palace programming as a savior both for their business model as well as for the store theaters that were the primary customers.

After the opening of the Strand, W. Stephen Bush in *Moving Picture World* repeatedly called for making distinctions in kinds of theaters according to programming.[73] In May, he proposed three classes of theaters, with the difference between the first two determined by the kind of feature they showed: "The first-class feature is apt to exceed four reels in length," while the second-class theater will have a shorter feature and mixture of shorts. The third-class theater will be small, that is, the store theater, and as a consequence "owing to a smaller seating capacity, must needs depend chiefly on variety and a short program."[74] By July, he had simplified this to two types of films (single reels and features) and, correspondingly, two types of theaters: "One class of theaters will use mostly single reels, the other will use mostly features. The lines of cleavage are

becoming more distinct every day. One class of theaters will depend for its success mostly on variety while the other class *will run parallel with the legitimate stage*."[75] Both Selig's and Bush's proposals were responses to the different kinds of films being produced and the existing pipelines to distribute and exhibit them. Although these proposals might seem a last-ditch effort to save the store theater as a viable motion picture venue, they actually describe an emerging opposition between the movie/vaudeville palace and the legitimate theater. And this was a difference that related to architecture as well as to programming.

While both were centered in New York City, the legitimate theater, focused on a single dramatic work, utilized what we might call a distribution system that differed from the one used for vaudeville. Because movies were infinitely reproducible, they should have opened up new possibilities for mass distribution and exhibition impossible for live theater. The fact that new possibilities were not sought out indicate how much contemporary practitioners saw movies as a successor to theater, whether vaudeville or legitimate. Throughout the teens, the palace, the successor to vaudeville, and the exclusive feature-length film theater, the successor to the legitimate theater, established themselves as distinct venues in response to the *kinds* of films then being produced. From this distinction emerged a two-tiered system for different kinds of theaters with different kinds of films, in consequence different in architecture as well as in programming, and, importantly, catering to different audiences. This system of differentiation had a continuing impact on movie exhibition and production that lasted into the early 1930s and in somewhat attenuated form through the 1940s, but of sufficient importance that it was addressed in the 1948 Consent Decree that would ultimately sever theater ownership from the production/distribution companies. Finally, this exhibition system had long-term consequences for the ways in which movies were received throughout the classical period. In a range of ways I will detail in the next three chapters, exhibition exerted an inescapable pressure on production.

# 4. ELITE TASTE IN A MASS MEDIUM

There will be very few [live-performance] attractions of the medium class on the road this year. The New York managers are sending out few companies for the coming season and the attractions will be either of the high class or the very cheap sort. . . . One reason why there will not be an opportunity to see so many of these successful plays at popular prices is that the dramatic rights have been obtained by motion-picture producers, and the standard plays produced by all-star casts can be seen on the films for a lower price of admission than the same play could be presented in the theatre with a much cheaper company. There is no room for the No. 2 company when the film offers a better performance at a lower price.

—*Motion Picture News* (1914)[1]

Vast sums of money are being invested daily upon the theory that the silent drama can effectually replace the spoken drama; manufacturers are going to great lengths to secure the original casts of successful plays in order to produce six-reel versions for the screen; new exchanges have been opened expressly to book these lengthy films, and *regular theatrical booking agencies* have opened their doors to these productions.

—*Moving Picture World* (1914)[2]

ALMOST FROM THEIR INCEPTION, LARGE-SCALE FEATURES, THE kind of movies that would subsequently be called "super features" or "specials" or even "super specials," sought an association with live dramatic performances via architecture: they took over legitimate theaters in cities throughout the United States, theaters that would generally revert to live drama after the feature film finished its run. Their status, emphasized by the fact that they continued to operate as legitimate theaters, was intended to reflect a new status for motion pictures. Dubbed the "Father of the Feature," Pliny P. Craft earned that sobriquet in part by importing *Dante's Inferno* from Italy in 1911 and treating it as if it were an important stage production: "He was the first to put a moving picture production into legitimate houses at high prices as a regular road attrac-

tion, using approved theatrical methods."[3] In similar fashion, when George Kleine imported another Italian spectacle film, *Quo Vadis*, in 1913, he drew on the reproducibility of movies in order to present the show in multiple places at once, but in doing so, he nevertheless made it conform to an existing theatrical model: "All the *George Kleine 'Quo Vadis'* companies now established in New York, Chicago, Brooklyn, Philadelphia and Baltimore are doing enormous business, outclassing the receipts of the big dramatic attractions even in season."[4] What were "approved theatrical methods"? Why were there "companies"? Why not simply send prints of the film out to designated theaters?

Seeking to challenge legitimate theater with their spectacular features, both Craft and Kleine logically looked to legitimate theater itself as a model. But "the approved theatrical methods" they employed were a creation of the recent past, a result of what business historian Alfred Bernheim has called an "industrial revolution in theater" that transformed theater as a local institution into a "big business" on a national scale. "During its first one hundred and fifty years," Bernheim describes American theater as dominated by a resident stock system, with "each [theatrical] company entirely independent of every other company. . . . Each company consisted of a group of relatively permanent actors with a repertoire of standard English plays, which later on was gradually augmented by the addition of contemporary successes from abroad."[5] Although self-contained, stock companies could feature performances by a visiting star, "an independent actor who for a limited engagement played with the company in a repertoire of his own selection . . . ," creating a "stock-star system" that, from "1820 to about 1860, . . . was at its height." This system would eventually be replaced in the post–Civil War period by the "traveling combination system" which saw "the organization of the entire company to tour the country, instead of a single star" in a single play complete with the sets and possibly an orchestra to present something close to an original New York production (26–27). "By the nineties," Bernheim notes, "the combination system was firmly in the saddle. It has dominated our legitimate theater ever since" (31). This system gave rise to a business model which needs to be elaborated here because it had a profound effect on the business model of the emerging feature film industry. Bernheim's study, prepared for Actors' Equity and published over a 20-month period in *Equity* (1930–1932), presents an extraordinarily nuanced and detailed economic history of the American stage.

And precisely because it is so thorough, it facilitates tracing out connections to the incipient feature film industry, making evident how much it took from the art form it was seeking to emulate.

As the combination system took over, an organizational problem emerged: "routing some 250 companies over 5,000 theatres in 3,500 cities . . . was a traffic problem of no mean proportion." The solution was twofold and accomplished sequentially. First came forming theaters into a circuit, "a group of theatres so related to each other geographically that they form a logical route for a touring company." The "process of circuit building began energetically with the growth of the combination system" because a circuit offered the advantage of continuous bookings to the combination companies, while it also offered the advantage to theaters of being able to attract first-class combination companies that they might not be able to get individually.[6] The second step came with the booking agencies, which operated as middlemen between the circuits and combination companies, effectively serving to link "a large number of theaters over a wide territory . . . in a sort of amorphous super-circuit, held together not by direct contact between the theatres themselves, but by the centripetal force of booking offices" (Bernheim, 40). As middlemen, booking agencies proved to be the central powerbrokers in the system, with the biggest moving first into theater ownership and then into production (41).

The power of the middlemen was fully realized by the development of the Syndicate in 1896, a trust made up of three entities, "formed with the object of acquiring control of the booking of all first-class theaters in the country." Even before the Syndicate, booking agencies had strengthened their position by moving first toward theater ownership, then toward production. All three members of the Syndicate owned theaters, and all three were regionally distinct, so that together they provided a fairly full coverage of the entire United States. In addition, Klaw and Erlanger, which had established primacy among bookers by demanding exclusivity from its affiliated theaters, operated the booking agency for the Syndicate and continued the policy of exclusivity, which "put the balance of bargaining power into the hands of the booker" (47). Charles Frohman, on the other hand, brought producing prowess as "the foremost producer of the country at the time, certainly from the point of view of quantity" (48). The value of the trust was the reciprocal relationship it granted to theaters and productions: power over one meant power over the other, a lesson not

lost on the emerging feature film companies. It was also a lesson for theater owners not affiliated with the Syndicate.

Bernheim estimates, "At the height of its power, [the Syndicate] surely booked seven hundred theatres—perhaps even more" (52). There had been some attempts to challenge the Syndicate's power, but only one was successful. By 1905, the Shubert organization, which both owned theaters and produced plays, had become enough of a presence in the theater business that "the Syndicate inaugurated a campaign of repression," and a fierce battle ensued as the two syndicates fought each other for supremacy. The battleground was booking, as the Syndicate sought to diminish both aspects of Shubert's business by not sending its own productions to Shubert theaters and not allowing Shubert productions into Syndicate theaters. The emerging film companies, taking their cue from legitimate theaters, had to see that "booking"—"distribution," in terms of the later film industry—was the key to controlling production and exhibition. The Syndicate-Shubert battle had one other important consequence for the emerging feature film industry: shut out of the first-class houses in many key markets, the Shuberts responded by building their own first-class houses to surpass those of the Syndicate, leading to an oversupply of theaters precisely at a time when the theater business was beginning to contract. By 1913, one thousand theaters were affiliated with the Shuberts, providing them with a larger circuit than that controlled by the Syndicate (70).

I have detailed the business model that the legitimate stage had arrived at by the dawn of the feature-length film because I think it is easy to see in it the embryonic form of what would become the motion picture business model. Certainly there is evidence contemporary observers saw the potential value of the legitimate model for the film business. Consider this 1910 comment from a trade journal:

One change is noticeable from a few years ago: The "string" of theaters operated by one company—the so-called syndicate plan—is now quite the vogue. The single theater owner is not so numerous as he was. Under the syndicate plan expenses are reduced, better entertainments can be given and presumably greater profits are made. And so it would seem the syndicate is here to remain. What if the syndicate should start in to manufacture its own films?[7]

With the battle between the Syndicate and the Shuberts, the other syndicate, raging "at its fiercest" around this time, the repeated reference to the "syndicate plan" here has a very particular meaning for a contemporary audience.[8] The ultimate system Hollywood arrived at of studio-owned or affiliated theater circuits to guarantee first-class venues for exhibition coupled with control of production to guarantee a continuous supply for theaters is a procedure that originates in the legitimate theater.

In his study of Famous Players/Paramount as the company that pioneered regularized production and distribution of feature films, Michael Quinn states flatly, "The policies Paramount implemented, policies which would help to give the film industry its modern industrial form, were actually based on methods of the legitimate theater."[9] As examples of Paramount's "indebted[ness] to the standard practices of the stage," Quinn specifically mentions the "run-clearance-zone system," a method of managing competition among theaters, as well as its "percentage-distribution plan," dividing receipts on a percentage basis between distributors and producers rather than paying a flat fee.[10] A trade journal at the time saw giving producers a specific percentage of the profits, as stage productions received a percentage, as an inducement to bring theater producers into the emerging motion picture industry: "The Paramount plan [is] intended primarily to interest producers who have hitherto worked in the so-called 'legitimate' branch of the amusement business."[11] This imitation was conscious and deliberate in the case of Paramount as it sought a slate of feature films that could provide a full season's booking for theaters: "Some time ago it [Paramount] adopted the continuous service system of booking used by Klaw & Erlanger in booking theatrical attractions for many years."[12] This "continuous service system" would eventually evolve into block booking, which would in turn lead to antitrust attacks, quite sensibly since this was, after all, a "system" inherited from a trust.

There were other ways legitimate theater's business practices would lead to antitrust action against the movie studios. The two theatrical syndicates, the Syndicate and the Shuberts, did effectively shut out any other competition by their control of theaters. Producers not aligned with either of them could find themselves completely cut off from the market, a circumstance that directly foreshadows one of the grounds for antitrust action against the film companies a couple of decades later when indepen-

dent production companies faced the difficulty of breaking into the film market. And because the Syndicate "early acquired control over a large proportion of the combination companies" (Bernheim, 52), while the Shuberts were a producing organization as much as they were theater owners, both effectively pioneered a kind of vertical integration, supervising the line from production to booking to theater performance that was echoed in the film industry's integration of production, distribution, and exhibition. But much as these details show correspondences between the two businesses, perhaps the most fundamental resemblance may be found in the way the very structure of Paramount paralleled that of the Syndicate: five regional entities that effectively covered all the theaters in the United States, paralleling the coverage of the three partner firms in the Syndicate, with films provided by multiple producing companies joined to Paramount.

If the emerging film industry looked to the legitimate theater, theater people looked to the film industry to expand their businesses. Quinn notes the large number of theater personnel who became associated with Paramount through the teens: Daniel Frohman as a founding partner of Famous Players, who provided a prestigious Broadway theater to exhibit the firm's first feature; David Belasco; Charles Frohman, one of the Syndicate partners; Oliver Morosco; and Cecil B. DeMille. Looking beyond Paramount, we can see Marcus Loew and William Fox, both theater owners themselves who moved into film production and built important film theater circuits. Conversely, the two theater syndicates looked to become more directly involved in film. The Shuberts entered into an agreement with World Film to have their stage productions filmed.[13] In the following decade Lee Shubert became "a director of Loew's Inc., and a vice-president of the United Artists Theatre Circuit, Inc." (Bernheim, 85). And in the sound era, Shubert would make its circuit available for special-release Hollywood films. Klaw and Erlanger entered into successive relationships with different companies for production and exhibition purposes. First, it formed a relationship with Biograph to produce films. The connection with Klaw and Erlanger had a twofold purpose for Biograph: one, it would grant them access to Klaw and Erlanger plays as a source for quality product; two, it would mean that "the pictures which it is producing will be shown all over the country in theatres which have heretofore been devoted to attractions of the speaking stage."[14] Biograph

never succeeded in transforming itself into a feature film company, and Klaw and Erlanger subsequently moved to forge an alliance with Paramount.

There were good reasons for theater people to take an interest in film as the feature film was coming to dominance (which I will discuss below). First I want to note one last instance of how the "industrial revolution in theater" anticipated the industrial structure of the film industry. Bernheim observes that the combination company removed production from the local theater, taking an organic whole and breaking it up into constituent parts (32). With motion pictures, of course, production always took place away from the theater, so the feature film industry could easily gravitate toward the tripartite organization established by the legitimate theater business: the production–booking agency–theater model would find a precise parallel in the production-distribution-exhibition model of the film industry. Movies might have initially followed legitimate theater by centering production in New York, with the Edison films drawing explicitly on the vaudeville entertainments New York had to offer, as we've seen. But with the advent of the feature film, production began to move West, definitively settling in Los Angeles by the end of the decade. Nevertheless, while production could wander, even with companies that were established late in the decade or in the 1920s, corporate headquarters would stay in New York and remain there for about a half century, leaving top executives a continent away from the people who made their product. In what nowadays can only look like an unnecessary imitation of the legitimate theater, the feature film industry made New York central to the business model.

## THE NEW YORK MODEL

Where New York, due to its wealth, its size, its more immediate contact with the Old World, and its general prestige as the great metropolis of the nation, had already become the principal theatrical city, its influence over the rest of the country in matters theatrical was mainly that of the leader of fashion and taste.
—Alfred L. Bernheim (33)

Where, in the past, new plays might originate anywhere in any state with an active theater community, by the time the feature film was introduced, a New York opening had become critical to the success of a play, for it was a New York opening that would determine productions for the road.

That is, a New York performance was effectively the beginning of a marketing campaign designed to sell a product. Theater historian John Frick has observed, "The theatre, by the beginning of the current [i.e., twentieth] century, had become yet another American industry . . . with its business operations centralized structurally and geographically."[15] The Broadway performance was the necessary precondition for sending out combination companies, but not all companies were created equal: a "No. 1" company might feature some or all the performers of the Broadway production and would play the principle cities; lower-ranked companies—2, 3, and 4—with lesser actors and lower production values might play small cities and towns, with these lesser productions generating complaints.[16]

With this model as a precedent it was easy for those working in drama to see the possibility that one film production could replace all the combination companies. But since a feature film like *Quo Vadis*, say, could play anywhere that had a projector, I want to return to a question I raised at the beginning of this chapter: what does it mean that "'Quo Vadis' companies [were] established" in major cities? These were in effect film combination companies since the film was sent out with the "approved theatrical methods" established by Pliny Craft—that is, the film was combined with all the accoutrements of the New York performance: the musicians, the score, possibly stage performers like dancers and even a special setting.[17] An article from 1927, when the film combination system was still in use, commenting on the long run on *The Big Parade*, specifies what this kind of exhibition involved:

> Eight companies of "The Big Parade" remain on tour playing in leading road-show theaters throughout the country. Each company travels with its own baggage car, and carries a symphony orchestra, and presentation experts, so that the picture is presented exactly as at the Astor Theatre [in New York City].[18]

Even if individual feature films were handled as if they were live performances, no matter how small or remote the city, every film combination company could in effect be even better than the "No. 1" company for live theater; it would in fact be an exact replica of the original New York presentation and advertised as such.

In roadshow performance, theaters at the end of the line got the class 4 touring show with all its shabby trappings, but high-quality feature films

could play smaller theaters at meager admission prices with the same cast and production values as the most lavish first-run theater on Broadway, albeit without the accoutrements that came with roadshow exhibition. Playwright and producer David Belasco, nationally the best-known legitimate producer at the time, saw precisely this advantage when he agreed in 1913 to have his Broadway success with Mary Pickford, *A Good Little Devil*, filmed: "There was only one means whereby the play could be given in more than one city at the same time and with the 'entire production and cast.' This was through the medium of motion pictures. . . . As the result, no city of any size in the country will be deprived next season of this Belasco fairy play."[19] For contemporary observers, feature-length motion pictures challenged the profitability of the road because, even without spoken dialogue, they offered something more.[20]

For the legitimate theater, New York "was the only city where all the plays could be cast and mounted that were needed to supply the theaters throughout the country" (Bernheim, 33), but what granted New York a central role in film exhibition? Given the fact that the infinite reproducibility of movies meant multiple "companies" could play simultaneously, there was no reason why a feature film could not premiere in cities across the country simultaneously, although it would take the motion picture industry roughly *sixty* more years to arrive at this distribution strategy. Why the extreme delay? The likeliest answer is that the existing theatrical business model seemed to dictate that exhibition begin in New York as the original production in legitimate theater began in New York. In similar fashion, Marcus Loew, who owned a chain of small-time vaudeville theaters presenting a mixed program of films and live acts, dealt with the increasing availability of feature films as if each were a vaudeville act meant to travel his circuit rather than something which might play in more than one theater at the same time: "A system for the exploitation of feature motion picture films which is unique because it is the only one of its kind in the country, is used by Marcus Loew. Within the last few months he has instituted the system of booking a big feature and sending it around the circuit of his theatres, principally in New York City, just as a vaudeville act is sent around. . . . As soon as the picture is secured for the Loew houses, Mr. Meinhold [a booking agent] and his assistants prepare to send it around the circuit of theatres, which usually keeps the picture going twelve weeks, playing three days at each house, and, of course, being used only in the Loew houses."[21] As the owner of a

vaudeville circuit, Loew, rather than dealing directly with the film pro-
ducers, followed a vaudeville model by using a booking agent, as if the
feature film were a vaudeville act. Nevertheless, for the *producers* of
feature-length films, legitimate theater provided the model: much as
success in New York determined what combination companies would be
sent on the road in live theater, a New York showing of a feature initially
became a way of promoting its roadshow exhibition in the rest of the
country, and then ultimately any kind of exhibition outside of New York.[22]
For this reason, it soon became commonplace to promote the success of a
New York performance in the trade press, as the copy in a 1914 advertise-
ment for the "Film d'Art Production" of *The 3 Musketeers* demonstrates:
"Broadway's Greatest Pictorial Success entering its third crowded week at
the New York Theatre, the largest play-house devoted exclusively to
screen dramas." The New York premiere would eventually be called "ex-
ploitation exhibition," with exploitation meaning advertising, because
New York exhibition, the model of the legitimate stage, would be used to
sell films in the rest of the country.

Sheer demographics has continued to make New York the dominant
movie market up to today, and in the period when the feature film was
becoming the dominant entertainment in movie theaters, there were no
cities that could begin to approach the market power New York had. In
1926, *Motion Picture News* published a survey of weekly attendance
at theaters in cities over 100,000: New York had weekly attendance
of 4,346,480. The closest runners-up were Chicago at 1,742,259, with
Philadelphia at 1,021,396, and no other city breaking a million.[23] This
means that out of a weekly attendance total of 21,766,366, New York City
alone accounted for roughly 20 percent of moviegoers in key cities. Fur-
ther, include neighboring cities in the New York metropolitan area, and
the number starts to approach a quarter of all ticket purchases.[24] But it
wasn't just population that granted New York a special place virtually
from the beginnings of motion pictures. As the theater center for the
United States, New York would inevitably assume its centrality in film
exhibition as well because the feature film fashioned itself the successor
to legitimate drama.

Strikingly, it was only in the early 1970s that New York began to lose its
special status as new approaches to distribution produced major changes
in exhibition, changes that would eventually break the seemingly existen-
tial tie to live theater. Even though the "road" in legitimate theater always

signified anything outside New York, the roadshow system in theater had sufficient impact as a model for the movies that any kind of reserved-seat, exclusive-run exhibition would continue to be dubbed "roadshow" by the trade press into the early 1970s, even, illogically, performances in New York City itself. The collapse of roadshow exhibition after this period signals the final break between motion pictures and the legitimate stage, a break that would ultimately have consequences for production as well.[25]

Although economic inroads made by movies even before the rise of the feature made them something of an adversary to live theater, the high-class feature film was actually a godsend for legitimate theaters themselves. On the cusp of the feature film, theatrical producer and theater manager Daniel Frohman in a 1910 interview commented on "what has happened in that vast region patronizingly referred to as 'the road.' There it is a lucky manager who is able to get his public to pay the usual price of theater admission." Frohman thought that "the *vaudeville* of the kind supplied with them [motion pictures] *now proves that the pictures in themselves were not sufficient*," but predicted that future mechanical reproductions of Broadway plays "will be very rough on stock companies."[26] Frohman was prescient: over the next four years, the rise of the feature film inversely mirrored the declining numbers of plays sent out on the road: between 1900 and 1909, an average of roughly 300 shows took to the road; between 1909 and 1914 road shows declined from 236 to 124, the decline paralleling the increasing use of feature films as road shows. Then from 1915 to 1920 the number of traveling combination companies declines precipitously, from 97 to 34, creating an almost inverse correlation with the rise of the feature as the dominant motion picture entertainment.[27]

By 1914, when playwright and screenwriter Frank Woods noted "that the big feature craze is drawing a new public to the lure of the moving film—people who have never patronized the shorter pictures to any extent," it had become clear that many people in this new movie audience were abandoning live theater outside of New York City.[28] In a *Motion Picture News* interview, a "theatrical man" predicted only "high-class" or "very cheap" productions on the road: "One reason why there will not be an opportunity to see so many of these successful plays at popular prices is that the dramatic rights have been obtained by motion-picture producers, and the standard plays produced by all-star casts can be seen on the films for a lower price of admission than the same play could be presented in the theatre with a much cheaper company."[29] Theater historian

Jack Poggi surveyed the kinds of plays that could attract audiences in this period, noting they were primarily "musical comedy, spectacle, and the 'literary drama' . . . the only theatrical offerings for which they could not find a satisfactory substitute in motion pictures."[30] By 1916, not only was the decline in the road a fait accompli to contemporary observers, it was greeted as welcome news by a successful New York theatrical producer who had moved into film production: William A. Brady, at the time the head of World Film, stated in an interview, "motion pictures have dealt a severe blow to one phase of the theatrical business, and for that alone we should be duly grateful. I refer to the death of the old Nos. 1, 2, 3, 4 companies that used to flit about the country perpetrating outrages in the name of histrionic art."[31] From the perspective of New York theater, feature-length films essentially eliminated the need for combination companies by offering New York–quality productions throughout the country.

The decline of the road had one other important consequence for movies. I had written above about the Shubert's theater-building program; with the decline of the road, there came an oversupply of theaters, which could be filled by the expanding motion picture audience. Bernheim cites one striking example of the overbuilding: "within five years the number of theatres in Chicago increased from four first-class legitimate houses to more than a dozen" (79). If there were eventually not enough stage productions to fill these theaters, the theaters could turn to motion pictures, but not the kinds of performances that would be staged in the palace; as legitimate theaters, they were simply too small. That is to say, the legitimate venues required very particular kinds of films, films that would seem reasonable substitutes or better for what had been shown there previously and not require the enhancement of vaudeville that Daniel Frohman had thought necessary in 1910 and would in fact continue to be a feature of palace exhibition.[32] The feature film conceived as the successor to the stage play made these legitimate theaters ready-made venues for motion pictures, larger than most nickelodeons, but not of the gargantuan proportions of the emerging palaces. My argument for the importance of these theaters in American film history has less to do with architecture than a previous existing "distribution" system, but architecture is not insignificant.

Although ready-made in terms of the economic situation, these theaters could be architecturally quite varied, depending upon the age of the individual theater. Theaters built in the twentieth century would most

likely have the kind of frontal organization of seating best suited for motion pictures, so these newer theaters would be ready-made in every aspect. On the other hand, although difficult to determine the exact number, most of the older theaters were likely to have a horseshoe-tiered ring design. Nevertheless, two aspects of these theaters would lessen the number of bad seats in comparison to contemporary vaudeville theaters. The much smaller seating capacity with a reduced number of rings meant a lower percentage of seats at extreme angles to the screen. Second, the gallery in these theaters, built back and up because cantilevering was not necessary for the top balcony, had the highest seating capacity of any area above the orchestra. While distance from the stage made these the lowest-priced seats for live theater, their orientation toward the screen made them preferable for a movie theater. Further, the bad acoustics of the gallery noted previously was less of an issue for the "silent drama," as it was frequently called at the time in opposition to the "spoken drama." Whatever the case in the rest of the country, New York's legitimate theaters that eventually became dedicated feature film theaters for the most part had seats arranged frontally to the stage.

Motion pictures in both the legitimate theater and the emerging movie palace attracted new audiences to the movies, although the composition of these audiences was different for each. Jack Poggi posits a change in legitimate theater demographics that is pertinent here: "The galleries [i.e., second balconies], offering cheap unreserved seats, used to draw mostly an audience with low incomes, including many young people and workingmen. The gradual disappearance of galleries—few were included in theaters built after 1920, and the remaining ones were refurbished and called 'second balconies'—indicates, perhaps, the alienation of a considerable part of the audience" (Poggi, 41–42). If the legitimate theater was increasingly limiting its class range, the transformation of legitimate theaters into motion picture theaters for the feature film also transformed the movie audience, moving upwards in class for an audience willing to pay more for presumed quality, although they received quantitatively less than what they would see at the palace. In the variety of its programming as well as the size of its space with its democratizing architecture, the palace conversely embraced a broader class range. Effectively, the opposition in live theater between the legitimate stage and vaudeville was replicated by an opposition between the legitimate theaters used for motion pictures and the palace.

What the feature film in legitimate venues demonstrated was that movies, the theatrical form for the people, could also appeal to elite tastes. While trade journals through the store theater period could clamor for expanding the class makeup of the audience, this movement up in class could also create some anxiety about the motion picture itself, as if movies might lose their base. The hierarchization of the audience, previously the province of live theater, could become a factor in motion picture exhibition as well, albeit in a different way made possible by the infinite reproducibility of movies. With the legitimate theater, hierarchization was expressed spatially via architecture, but with motion pictures the hierarchization was defined both spatially and temporally. Spatially, the initial performance of a certain class of feature film could take place in architecturally distinct and distinctive spaces that would set them apart from most film exhibition sites. As with the legitimate theater, these differences would also be codified by price, but less so *within* the individual theater itself than as a way of defining different kinds of theaters. The legitimate theater for features would command the highest prices, in some cases as high as legitimate theater itself; the next price tier occurred at the palaces, while each subsequent tier would signify its location in the hierarchy with progressively lower prices. What most differentiated movies from live theater is that the films intended for legitimate theaters could also play in the other kinds of theaters and still be the same production. In live theater, lower prices for the venue always meant a lower quality in product as well. With movies, the more expensive theaters could aim for a more luxurious environment and a more elaborate presentation of the film, but the fact that the film itself did not change allowed precisely the same production to appear first in the most expensive theaters and then progressively work its way down to the cheapest.

Film's potential for both spatial and temporal hierarchization laid the foundation for the distribution system of runs, zones, and clearances that lasted in some form pretty much until the age of the multiplex. The runs designate the class of the theater, with first-run generally meaning the movie palaces in urban entertainment districts. Second-run moved further out to surrounding neighborhoods, hence the "nabes," as the trade press called them, and into smaller spaces, although likely well-appointed. Successive runs meant greater geographic distances and shabbier surroundings. As always, New York City was distinctive since the second-run theaters might not be very far from the Broadway palaces and they could

have a comparably palatial size and architecture. Zones reflected a concern that dated back to the store theater period when individual exhibitors would want to contract with an exclusive provider so they would not duplicate a show at a nearby theater. In the subsequent feature-film period, zones related to runs in that they specified a geographic area of similar theaters.[33] Clearances signified the time a film was held from release before it moved to the next stage in the distribution system, an issue that could affect a film economically since, in theory, the larger a "window" between runs, the more an audience anxious to see a particular film might be willing to pay a higher price to do so. Runs represent one aspect of film exhibition that could signal a decline in quality: prints used in first-run would work their way down to subsequent runs with attendant scratches and splices so long as they were deemed projectable. Still, for only ten cents, lower-end audiences would have access to high-class wares, even if slightly tarnished.

In spite of the seemingly protean quality of film that allowed first-class product to appear in low-class venues, there were differences in *kinds* of features that would play in the differentiated theaters in the first stages of exhibition. Committed as he was to the feature film as the successor to the legitimate stage, Adolph Zukor acknowledged this difference, making his own preference clear: "We have now reached a stage where film plays must be treated as other plays and not as merchandise containing so many feet."[34] The great palaces that would be built over the next seventeen or so years would come to be called "presentation houses" since they were defined by a manner of exhibition that did exactly what Zukor said they shouldn't, making each feature fit within a predetermined program of "presentations." Although Paramount features did premiere at the Strand, and Paramount would tout the success of the Strand in its advertising, Zukor's stricture actually points to a tension in the developing models of exhibition: the aims of the legitimate theater and "presentation house" were contradictory to the extent that the former when used for film promoted an individual work while the latter promoted the entire show of which the feature was just one part. In spite of the increasing use of single feature films in legitimate theaters, Samuel Rothapfel, a year after the opening of the Strand, did not see the feature as crucial to exhibition success: "Make your theater the thing, the same as the play in the spoken drama. . . . Good pictures are not necessarily features. This first

run craze is all wrong."[35] Where contemporary observers saw the kinds of film shown in legitimate theater as akin to drama, Rothapfel equates the theater itself to a play. The feature film is *not* the thing.

Why, then, did the feature film become established as the norm in commercial exhibition? Why didn't film exhibition continue to follow the vaudeville pattern? There are two possible ways of thinking about these questions, one economic, the other aesthetic. The overbuilding of legitimate theaters and their consequent use for film exhibition acted as a pressure toward the kind of feature that could compete with legitimate drama literally on its own turf. High-class feature films would enable theaters to capitalize on the growing popularity of movies, while continuing to present the quality performances for which the theaters had been designed. Second, in the emerging movie palaces, the vaudeville model never completely disappeared, as we saw in the previous chapter: there, the feature film was in fact situated within a context that was very different from that of "legitimate" theater, one that made it open to other attractions that figured in the performance. But, and this is an important qualifier, each venue effectively called for a different kind of feature. There was a precedent for the kind of feature that regularly played the palaces: the tabloid, "a condensed play, either dramatic or musical comedy. . . . A tabloid production is usually based on a Broadway success, the original name being retained for its advertising value" (Bernheim, 104). Limited to seventy minutes by Actors' Equity rules, they played in theaters known as "tab show" in a three-a-day format or even on occasion as part of a vaudeville show. As this length is similar to the program films of the period, the tabloid's narrative strategies of condensation and directness might well have operated as a paradigm for the features designed for the presentation house exhibition. In live-performance theater, whether legitimate, vaudeville, or tabloid, the venue itself would generally signify the difference. With film, things were different; while feature films intended for legitimate theaters could eventually play in presentation houses as well, the kinds of feature films intended for presentation houses could not be given roadshow exhibition.

Much as it would find ultimately two contrasting exhibition contexts, the feature developed from two sources, seemingly independently. First was a spontaneous development from the one-reeler, designated a feature at first because of quality, then subsequently by length, expanding reel

by reel. There was some resistance to these early features that surfaced in accusations of padding, with claims that they lacked the compression of the one-reel film. But it is equally likely the resistance stemmed from the awkward manner in which they were inserted into the dominant exhibition format: in the small store-front theaters, where they were initially presented, longer features were frequently shown reel by reel, sequentially over successive days. In small-time vaudeville theaters they could be shown in their entirety by eliminating other elements in the show, but the show itself still exerted a restriction: three reels was generally considered the limit for this format. For this reason, Warner's Features, the first attempt at a movie company by the brothers Warner, was founded in 1913 to provide a "program of three three-part features and three single reels a week, twelve reels in all." They made "features" part of their name, but these were not the kind of features that would play in legitimate theaters. Pat Powers, the head of the new company, noting there are "at least 16,000 moving picture houses in the United States," saw the advantage of their production policy for most of these exhibitors: "They will no longer have to change their pictures every day, as the exclusiveness of our service will enable them to exhibit our films for two days."[36]

For the purveyors of high-class features like the Italian imports or film adaptations of Broadway successes, longer runs generally meant a month or more, but these were bookings intended for legitimate theaters. For Warner's Features, on the other hand, a long run meant two days, and its dedication to the three-reel feature was deemed as "best suited to the needs of the average exhibitor."[37] When Mutual, a successful short film company, sought to transition to feature films, it hedged its bets by combining an output of three five-reel features, dubbed "Mutual Masterpictures, De Luxe Edition," with three three-reel features a week.[38] Length is an issue here because it became associated with quality, as the term "masterpictures" indicates: the very longest films were those that could sustain an entire evening's entertainment on their own, much like a play, and not be as easily relegated to one element of a larger program, even if the most prominent element. The three-reel feature, on the other hand, could fit more comfortably within the program of a presentation house or a smaller theater.

If the three-reel features seemed primarily an expansion of the one-reelers of the past, the "masterpictures" in their very name expressed

an ambition that allied them with features that originated in theatrical performances, like the various versions of Passion Plays that appeared in the late 1890s, or, of more immediate consequence, the European imports, starting with *Dante's Inferno* in 1911, that were much longer and not viable in the small theaters or small-time vaudeville. These features were always exhibited in legitimate theaters at advanced prices and reserved seats and led to domestic product that allied itself with the legitimate theater by adopting recent plays to the screen. By 1914 *Moving Picture World* reported that feature "companies are now enforcing a rule which forbids their pictures being shown in so-called straight 'nickelodeons.'"[39] The feature production companies sought to exert some control over exhibition because their main claim to recognition was the sense of uplift, that they were improving the art form.

For theater practitioners, the movies were, potentially, a new—and some were even willing to claim a better—form of legitimate theater. The special features destined for legitimate theaters helped define film as an emerging art, leading contemporary observers to make great claims for movies as a form derived from the legitimate drama: "Pessimists" no longer "sniff at them [movies] simply because they were an amusement within the reach of the most modest purse," *Motion Picture News* observed in 1913. "It is now pretty definitely determined that the new form of entertainment has a very close relation with the old one, and the former is drawing upon the latter for its sinews of talent in histrionic and producing forces."[40] In 1915, influential editor Martin Quigley stated bluntly, "The motion picture play has hit the spoken drama in many ways. There is no longer the cheap melodrama once so popular in the spoken drama, for better and more convincing melodrama can be seen in the motion pictures. The so-called legitimate stage productions must be unusually meritorious in this day and age, for otherwise the people will seek the motion picture theater as a source of cheaper and better entertainment."[41]

On the heels of the success George Kleine had with Italian imports, helping to fuel the feature craze, it was announced in 1913 that "Mr. Geo. Kleine is building a special theatre on West 42nd street, New York, to show his great productions. . . . The manufacturer [of a feature film] cannot make his money if the exhibitor is not willing to give more life to the film. We cannot blame the manufacturer to open his own theaters, to show that a good film can stand for months on the boards."[42] This report puffs

up Kleine's role since the theater, the Candler, on 42nd Street, was funded by Asa Candler, the cofounder of Coca-Cola, and only rented to Kleine together with theatrical producers George M. Cohan and Sam H. Harris, who had previously booked Kleine's import of *Quo Vadis* into a long run at the prestigious Astor Theatre on Broadway. The Candler opened in 1914 with another of Kleine's Italian imports, *Antony and Cleopatra*, but it was intended as *both* a movie theater *and* a legitimate theater: "the Candler Theatre, the newest playhouse in the Times Square, was thrown open last night. . . . In the fall, under the direction of Cohan & Harris, [it will] become a theatre for the 'legitimate' stage productions, but for the present it will be a picture house."[43] Opening about three weeks after the Strand, it shared a number of features with the other theater, albeit on a much smaller scale, seating only 1,125 people: Thomas Lamb was the architect; the decor was Italian Renaissance; the shape of the auditorium was more square than long; it had a single balcony, rather than the two that were standard in legitimate theaters of the time; the singe balcony was cantilevered and, at 500 seats, approached the capacity of the 625-seat orchestra. The difference in size also meant a difference in approach: like a straight dramatic play, the feature film was the entire show, and this architectural difference became aligned in this period with a specific kind of feature. The theater could define the production: "The more nearly the motion picture theater is made to represent a theater for regular theatrical performance the better the illusion. It is an accepted fact that patrons enjoy moving pictures more when given in regular theaters than in other forms of theaters."[44]

Kleine's Italian imports always played top legitimate theaters in major cities throughout the country. When his import of *Spartacus* opened in Chicago, it was at the city's most lavish theater, the Adler-Sullivan Auditorium, and it was treated exactly like a stage play: "The eight parts are divided into three acts, the first and last comprised of three reels each. Intermissions of 15 minutes each separate the second and third acts. Spirited applause was given at the end of every act."[45] The imported Italian features were crucial to this change in venue: "About a year ago the ball was started rolling with that remarkably fine production, 'Quo Vadis,' a feature in every sense. Then the country went feature crazy. . . . Theatres, previously devoted to the drama, closed their doors to open for feature films."[46] These existing venues were effectively helping to redefine that nature of film: "Motion pictures are fast colonizing Broadway. They are nudg-

ing the legitimate in its own stronghold and are demanding room—and getting it."[47] This was a prescient observation: eventually movies would demonstrate their dominance by taking over most of the theaters with a Broadway or Seventh Avenue frontage, the most visible locations in Times Square, forcing legitimate onto side streets west and east of the Square. The symbolism was not lost on contemporary observers: the movies had conquered New York theater.

Much as these theaters were architecturally different from the palaces that would be built over the next fifteen years or so, they played a crucial role in the development of the feature film because they moved it away from the vaudeville model that the palace embraced. In the Candler advertisement for *Antony and Cleopatra*, the theater foregrounded this difference with a quote from "Professor Branders Matthews of Columbia College": "I think that every student of Shakespere [sic] will find his profit in your production."[48] By effectively giving movies a status they had not previously enjoyed, the professor's quote fit in with a discourse of dignity that had begun to appear with the emergence of the feature film, one that was repeatedly enunciated in the trade press:

> The hour has now arrived when the dignity of the motion picture has risen until it is worthy to stand firmly upon its merits, and to compete on even terms with the best forms of drama. . . . [An] excellent critic on one great New York newspaper some months ago announced in private that he would not review a great film drama because he considered it altogether beneath the dignity of his office as critic. Since that time he has undergone a change of heart and the factor that induced the change was the taking over of the Knickerbocker theater for the exhibition of Triangle plays. (1915)[49]

*Where* the feature films were shown was always more than the convenient taking over of available spaces because the context of existing legitimate theaters affected perception of the film productions, making them equal to "the best forms of drama."[50] Aligning the feature, which required greater investment, with the legitimate theater was crucial for expanding to a higher-class audience able to pay more. In his 1953 memoir, Zukor claimed that prior to the feature most people saw movies "as a thin cut above burlesque and well below cheap vaudeville."[51] With the feature Zukor sought to transform movies by making them "a parallel of

the average stage play" (56). Allying them with a higher class of stage performance would bring in the higher classes.[52]

In the business model the emerging film industry was borrowing from the theater, film did offer one clear advantage. When plays maximized their profits by sending companies on the road, each new company meant additional capital investment. By contrast, the infinite reproducibility of film meant that an initially high investment in production, potentially higher than even the most elaborate first-class Broadway show, could result in lower overall costs when spread over a vast number of theaters. Movies as a consequence allowed for the possibility of a much more varied pricing scheme than in legitimate theater, but spread across a variety of theaters, each operating at a different price point and catering to a different class, ranging from legitimate theaters rented for the occasion down to what *Variety* would come to call "flea pits." Because of the mix of venues, much of the talk of the dignity of the new features also subscribed to a notion of uplift that was inevitably cast in democratic terms: higher-class product brought in the higher classes, but it could also elevate the taste of the lower classes by making available to them that which once only plutocrats could afford.[53] Wherever the film ended up, initial showings in relatively small, exclusive theaters were a crucial part of the releasing strategy that developed in the teens, granting "dignity" a cash value that the film could carry with it into less dignified settings. Initial engagements at legitimate theaters thus enhanced the class status of film, attracted an audience willing to pay more, and garnered higher return on investment, all without compromising the ability to get the dimes and quarters of lower-income audiences at lower-priced theaters along the way. In effect, the performance in a legitimate theater in any city functioned like the New York performance of a play before it went on the road.

Nevertheless, New York remained of vital importance to film exhibition, as evidenced by a theater Vitagraph opened in 1914. Vitagraph was the strongest company to emerge from the short film ranks, the only one to survive into the feature era, and its move into exhibition, although ultimately a failure, presaged an exhibition strategy that the emerging major studios would follow. Vitagraph took over the Criterion Theatre on Broadway, "long one of the leading playhouses in New York and in the very heart of the theatrical district. . . . The plan is to put 'feature films' in the theatre for which prices of admission as high as $1 can be charged and to use the house as a sort of advertising adventure for the films of the produc-

ing company."[54] The Criterion Theatre, descendent of the Lyric Theatre in Hammerstein's Olympia Music Hall complex, had already been thoroughly rebuilt once to replace its horseshoe design with a frontal positioning of the seating in the manner typical of the early-twentieth-century legitimate houses. For this reason, it was easily adapted to moving pictures: "not a seat, with the exception of the upper proscenium boxes, which are seldom used, is cut off from a full view of the screen. . . . A better arrangement of seats could hardly have been obtained had the theater been especially designed for the needs of the picture."[55]

Because of the prominence of Vitagraph, there was speculation at the time that this theater was merely the beginning of a crucial new business strategy, necessary both for sustaining production and the growth of the industry's legitimacy: "It seems a certainty that the success of the Vitagraph Theatre will mean the opening of other theatres along parallel lines by competing firms. This will result in many theatres owned by motion picture firms showing only feature films of the highest quality and competing directly with houses offering speaking attractions."[56] Such rumors alarmed exhibitors with whom it needed good working relationships, so Vitagraph ran an advertisement in *Moving Picture World* a month after opening the theater: "A Message to the Exhibitor WHY DID WE OPEN THE VITAGRAPH THEATRE to demonstrate that Vitagraph features, when presented in the right way, will not only draw crowds, but will bring Higher Class Patronage at Higher Prices? BECAUSE VITAGRAPH films are SO UNIVERSALLY POPULAR and SO SUPERIOR to others than the mere name 'Vitagraph,' is the surest, biggest and strongest box office magnet in the world."[57] Within a decade, all the major producing studios would in fact purchase and even build theaters, in most cases accumulating chains whose numbers dwarfed the Schubert and Klaw and Erlanger chains. But these theaters were mostly in the palace mode, while the Vitagraph Theatre at 800 seats was something very different. Nevertheless, the trade press prediction that other companies would open "theatres along parallel lines" proved accurate. These other theaters, not palaces, proved to be important not just for exhibition, but for production as well since they effectively demanded a product that was not completely identical with the films that premiered at the palaces. For this reason, it is worth considering how the Vitagraph Theatre functioned.

What did Vitagraph mean when it announced it would present features "in the right way"? Other companies had taken over legitimate theaters

on an occasional basis for special features that could warrant ticket prices that competed with live theater. In these cases, they would stage elaborate presentations with full symphony orchestra, chorus, and soloists to accompany the feature, but the feature was always the show, and the live-performance element was always geared toward the feature. On the other hand, although the Criterion had a seating capacity lower than many other legitimate New York theaters, Vitagraph presented an entertainment that at first glance seems closer to the vaudeville-style presentation of the 3,000-seat Strand in its mixture of short films, live performance, and feature film. What might seem one of the odder features of the show, and described as a "distinct novelty in the photoplay entertainment," was "a one-act 'silent drama,' in which the leading stars of the Vitagraph Company will appear,"[58] that is to say, a live version of what might be a Vitagraph one-reeler. And, in fact, later shows did feature stage adaptations of previously successful Vitagraph shorts. At the premiere performance, John Bunny, Vitagraph's most popular performer, appeared in an original pantomime with other well-known Vitagraph performers. Subsequently, other Vitagraph stars would appear in live performance, often on a bill with a feature in which they were appearing.

The peculiarities of the live-performance portions of the entertainment suggest the way in which programming at the Vitagraph departed from the model being established around the same time at the Strand. Unlike the Strand, variety was not the aim of this show; rather, the appearance of Vitagraph stars was a way to enhance and publicize the "Broadway Star Features" the company hoped would become the centerpiece of their production output. The branding of their features as "Broadway" points to the chief publicity value of the theater: whenever a new feature was made available for general release after its New York premiere, it would be advertised in the trade press, much in the manner of a road show in the legitimate theater, as "Fresh from Its Triumph at the Vitagraph Theatre, New York City" or "Direct from Their Record Breaking Runs at the Vitagraph Theatre, New York City" or, simply, "As Presented at the Vitagraph Theatre, New York City." The extent to which the entire show was to function as an advertisement for the Vitagraph studio was evident in a range of self-reflexive strategies in the performance: filmed tours of the Vitagraph studios, live performances that interrupted the film to show the star of the film on the stage, and a Vitagraph film showing an audience at the Vitagraph Theatre watching a Vitagraph film.[59]

All this elaborate entertainment came at a price, especially given the limited income set by the small capacity. But Vitagraph's chief concern in exhibiting was selling its product to other exhibitors, and this warranted making the theater something of a loss leader for the studio. The spur to this was the fact that an expensive three-reel feature, *The Wreck* (1913), did no better than break even: "It was largely the loss we sustained on that picture that determined us to open the theater," J. Stuart Blackton, codirector of Vitagraph, told *Moving Picture World*. The theater consistently lost money, but Blackton explained: "We did not take the theater with any idea of profit in view. It was taken purely as an advertising proposition. . . . Now these big feature films cost us a great deal to make, and for them an exhibitor should, and can, get higher prices of admission, and he can run these features for more than one night."[60] In this regard, Vitagraph's New York theater was following a model established by the legitimate stage: "Though the American theater was highly centralized by 1910, it was still a national theater in the sense that production was intended for distribution throughout the country. Producers expected to make most of their money on the road and were frequently willing to take a loss in New York for the sake of building a long-run reputation that would help them succeed on tour" (Poggi, 28). As on the stage, a successful New York showing at the Vitagraph Theatre would promote theatrical success for individual works throughout the rest of the country.[61]

This use of a Broadway theater for promoting prestigious product did have a lasting impact on exhibition, reinforcing New York as the dominant locus for motion picture exhibition in general, much as it was to the legitimate theater. Although most writing on major studio exhibition strategies in the past has focused on the large movie palaces that were built over the next decade-and-a-half, the feature film had first appeared in the precincts of the much more intimate legitimate theaters, whose content the feature film was effectively displacing. The building of the palaces did not in turn displace those theaters. Rather, a bifurcated system of exhibition emerged: although they were very different, both in terms of size and presentation, the palaces, descendants of the vaudeville theater, and the converted legitimate theaters became the two primary locations for premiering feature films. They would continue to exist as alternative performance spaces into the early 1930s and then in somewhat limited fashion even after that, with the Consent Decrees of the 1940s bringing further restrictions to the system imposed by the government.

This bifurcation in exhibition points to a little-noticed bifurcation in production as well.[62]

## The Legitimate Motion Picture Theater and the Bifurcation of Production

A theater in a central location in a large city and with a certain percentage of transient trade can sometimes run a picture for weeks. . . . Even a poor picture often will hold up for a week or more in a well-established theater of this class. . . . In the smaller cities and neighborhood houses it is of course, impossible to run a picture for more than a few days, and the length of run is governed by the same conditions. (1915)[63]

In 1925, at the height of building all the great palaces, Loew's, the parent company of Metro-Goldwyn-Mayer, opened a new theater on Broadway, the Embassy. The architect for this theater was Thomas Lamb, architect for both the Strand and the Candler. For anyone who has seen other Lamb theaters, the Embassy would look familiar in its Adamesque decorative scheme, and although it lacked a stage, it filled out the front of the auditorium in a familiar tripartite design by use of large murals flanking the screen on left and right, each approximating the size of the screen. Nevertheless, it offered striking departures from Lamb's work that began with his first two theaters with Rothapfel, the Regent and the Strand: as noted, there was no stage; it was all on one floor with a fairly low ceiling, so there was no sweeping balcony; and it held a little fewer than 600 people. Perhaps even more odd, Loew's already controlled two premiere theaters on Broadway with different seating capacities: the Capitol (which had been reduced to 4,620 seats at this point) and the 1,120-seat Astor. In addition, there was the 3,450-seat State, which operated as a "move-over" house—that is, showing movies that had played at the Capitol, often second-run, and occasionally first-run lower-quality fare from other production companies along with vaudeville.

With these resources at hand, why did Loew's need to build the smallest theater on Broadway? A possible answer to this question might be found in King Vidor's autobiography: "One day I had a talk with Irving Thalberg and told him I was weary of making ephemeral films. They came to town, played a week or so, then went their way to comparative obscurity or complete oblivion. I pointed out that only half the American population went to movies and not more than half of these saw any one

film because their runs ended so quickly. If I were to work on something that I felt had a chance at long runs throughout the country or the world, I would put much more effort, and love, into its creation."[64] According to Vidor, this conversation eventually resulted in *The Big Parade* (1925), a film that premiered, after the Embassy was built, at the smallish Astor (1,100 seats), a theater that touted itself as "the key *legitimate* motion picture house of the world" with two showings a day and prices comparable to live theater.[65] The Astor had been a legitimate theater since its opening in 1906, and followed what had become the usual architectural form of the period: frontal seating facing a proscenium stage with two balconies. It had its first film showing with *Quo Vadis* in 1915 and then in the early 1920s increasingly turned to film. The Astor and *The Big Parade* were mutually transformative: *The Big Parade* played there for nearly two years, far exceeding anything that had preceded it, while the Astor emerged from the showing as MGM's primary long-run house into the 1940s.

But why have long runs in a medium-sized theater at all? The palaces usually changed their programs every one to two weeks, and they could accommodate many more people in just one day than the two-a-day Astor could in an entire week. If the weekly change of the palace followed the model of the vaudeville theater, running a feature film in a legitimate theater leased for the purpose effectively meant following the business pattern of that theater. But the long run was not an inherent feature of legitimate theater; when repertory theaters were most common in the nineteenth century, there were some plays that had achieved long runs, like *Uncle Tom's Cabin*, and did so in multiple cities.[66] But as the theater became more like an industry centralized in New York City, the "long run had become its principal goal" (Frick, 198). Vitagraph's notion that it needed a theater on Broadway to showcase its feature films was in fact based on the business practice of the legitimate stage. And success on the stage was generally signaled by the length of the run, which could determine the number of touring companies sent out and the length of the tour. Following this model, the film companies kept tabs on runs not just in terms of weeks and months—at "60 weeks" *The Ten Commandments* "smashed all records"—but the actual number of performances, boasting of them in the advertisements that made clear the feature film was now the equivalent of the stage. As *The Big Parade* headed toward its 90th week, MGM ran the following advertisement (see fig. 4.1):

AMERICAN THEATRE RECORDS
Abie's Irish Rose ...........2156 *times*
Lightnin'........................1291 *times*
The BIG PARADE...........1151 *times*

THE BIG PARADE

A METRO-GOLDWYN-MAYER PRODUCTION
TWICE DAILY  2:30—8:30
SUNDAY MATINEES AT 3

ASTOR | ALL   MATINEES
       | EXCEPT  SAT.  &
       | Holidays 50c to $1
B'WAY at 45th ST.
SUNDAY & HOLIDAY MATS. AT 3

FIGURE 4.1
Nearing its 90th week at one New York theater, *The Big Parade* boasted a record that surpassed most Broadway theater runs.

AMERICAN THEATRE RECORDS
Abie's Irish Rose . . . . . . . . . . 2156 *times*
Lightnin' . . . . . . . . . . . . . . . . .1291 *times*
The BIG PARADE. . . . . . . . 1151 *times*[67]

As it turned out, MGM had need for another theater: at various points in the run of *The Big Parade* it had three other films running at reserved-seat houses, so it always had to rent two. But clearly the Embassy, with its small size and no stage, was intended as something different. This was evident through a series of five teaser ads that ran in the *New York Times* over a six-day period in late August. There are no graphics of any kind, and each ad takes the form of a personal note. The first one begins, "*To My Kind Friends* SINCE the announcement that I have become Managing Directress of the EMBASSY THEATRE many congratulatory notes have

poured in upon me." The writer then tells us a bit about her "enterprise" and lets us know that *she* has "selected Erich von Stroheim's 'The Merry Widow' as our opening attraction," and signs off with "Sincerely, Gloria Gould [seen in a reproduction of her signature] Managing Directress."[68] Who is Gloria Gould and why should we care about what she has to tell us? Well, maybe we don't because she is addressing her "friends," or maybe we'd like to be one of her friends because she is not only the granddaughter of railway magnate Stephen Jay Gould but also an heiress and a socialite who danced at Carnegie Hall at sixteen, married her first husband at seventeen, and then became a theater directress at nineteen.

There was clearly a kind of snob appeal in this campaign. About two weeks after *The Merry Widow* opened, Gloria wrote one more note, but this one was addressed "To Those Returning to Town WHILE you were away a great new institution has appeared on Broadway." Well, if we couldn't get away, we could at least rub shoulders with those who did and with "those who seek the highest achievement in the comfort of quiet beauty."[69] What is striking here is that this is a snob appeal focused on a *movie*, and here the venue was significant. Comment on the theater stressed that it possessed no stage and there would be no live performance preceding the film, with only musical accompaniment featuring the Lehar score from a 15-piece orchestra. These distinctions might seem arcane to us now, but their importance lay in the significance they granted the feature film. Other films that played in legitimate theaters were always pretty much the entire show, with none of the extra features of palace exhibition.[70] But this does not mean there was no live performance: in a practice that dates back to the earliest feature exhibition, the show would usually begin with a live performance thematically connected to the film as a way of introducing the film (see chapter 6). Other than the orchestra, which would invoke the stage *Merry Widow*, there would be no live performance of any kind. In sum, the Embassy was the anti-palace in both its architecture and its presentation methods, creating an exclusive audience for an exclusive art (fig. 4.2). The movie was no longer a feature; rather, it was the whole show.

The Embassy represented an extreme example, which is likely why its success was relatively short-lived, but the insistent use of legitimate theaters for the exhibition of a class of films traded on the symbolic significance of the space. Consider, for example, the following advertisement for Ernst Lubitsch's *The Patriot* (1928), which ran in a trade magazine in

FIGURE 4.2
The Embassy Theatre (1925), New York, an anti-palace dedicated to film art. In the 1960s, the Embassy would in fact become an art theater.

1929 touting Emil Jannings as its star (fig. 4.3). In the context of film advertising of the time, the first striking feature is the seemingly equal importance given to Jannings and Lubitsch. But for me the thing that most stands out is the phrase at the bottom of the ad: "Opening soon on Broadway at $2 admission. Not for sale to motion picture theatres at the present time" (*EH-MPW*, May 5, 1928). If it's showing a movie, why is it not a "motion picture theatre"? Because it has a pedigree that makes it something else. The Broadway theater most likely intended by the ad was the 902-seat Criterion, the theater that served as the Vitagraph Theatre before reverting to straight dramatic plays again. But starting in 1920 with Cecil B. DeMille's *Why Change Your Wife?*, the Criterion became Paramount's primary reserved-seat, twice-daily house and remained such through 1933 when Paramount booked its last reserved-seat film there, *Design for Living*, not coincidentally directed by Lubitsch as well.

The Patriot, as it turned out, did not play the Criterion, likely because of the enormous success of *Wings* (1927), which was in its second year there and would continue until December. While many of Lubitsch's other

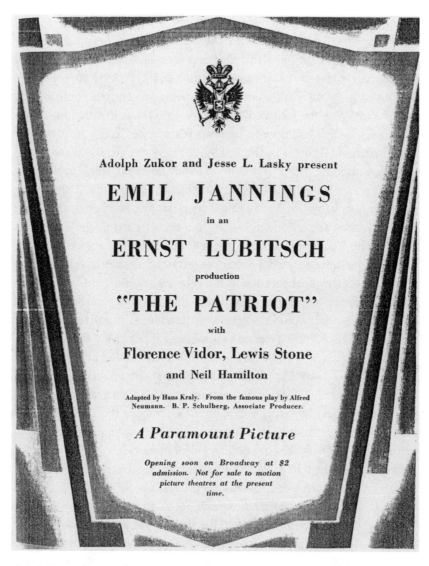

FIGURE 4.3

When does a movie not play in a movie theater? When it seeks to tout its distinction, as *The Patriot* (1928) does in this trade journal advertisement.

Paramount films did get a reserved-seat run at the Criterion, *The Patriot* ended up at the Rialto, a 1,960-seat theater that showed nothing but movies, although it had a ghostly theater past because it was built within the gutted shell of an Oscar Hammerstein theater, the Victoria. Roxy was the first manager of the Rialto, but at this point it was entirely controlled by Paramount. Why the Rialto? Why not the 3,664-seat Paramount, only a block away, which had opened just two years before and was one of the most luxurious theaters in the Publix Theaters circuit, the theater division of Paramount. Both were called "grind" theaters, which meant they ran continuous shows all day. Depending on the booking, the Rialto might or might not charge what were called "popular prices," that is, similar to the Paramount and a good deal less than the $2 cited in the ad for *The Patriot*. The Paramount might have had a similar price scale, but as a "presentation house" provided more entertainment than just the film— as well as, for the most part, a new film every week. But, unlike the Paramount, it was an "extended-run" house, or, in *Variety*'s parlance, simply a "run house," which would always anticipate a longer run than the palace, generally three or four weeks and even longer if box office warranted.

In a report on New York City grosses, *Variety* offered an explanation for the *Patriot*'s booking: "acclaimed by smart mob . . . originally listed for $2 . . . film bunch skeptical of picture outside of big towns because of Jannings, as heavy, winning sympathy; anxiety to get it on program only reason for not giving it twice daily run."[71] Getting it on program means getting it into the system of runs and clearances faster, which could be delayed by months if its acclaim led to success. For this reason, films that played first at a palace were generally "programmers," while *The Patriot* was intended as a "special" and, as such, required some degree of special handling. The Rialto offered that. This system was not exclusive to New York City. So, for example, in a report on theater grosses for Pittsburgh in 1929, *Variety* stated, "Deluge of pictures will send a couple of specials, originally intended for run houses, into one week stands."[72] On the other hand, the system was far more elaborate in New York due to population and the far greater supply of theaters. Because of its twin parentage in legitimate theater and vaudeville, exhibition in this period functioned differently than the textbook runs-zones-clearances system.

About six months before the Paramount Theatre opened in Times Square, intended as its eponymous company's weekly change presentation house for New York, *Variety* announced that Paramount intended to

make the 2,200-seat Rivoli, which it had been using for regular releases, a "run house." It explained that Publix Theaters had recently "converted the Rialto on Broadway into a run house . . . devoted to a policy of runs from six to eight weeks with pictures verging on the special class." Around the time their palace was scheduled to open, Paramount expected the million-dollar *Old Ironsides* to be complete. *Beau Geste* would be playing at the reserved-seat Criterion, and the new Paramount would not do because it would inaugurate "the regular weekly change Publix policy," so Paramount needed "to have a third 'run house'" for *Old Ironsides*. As a picture this spectacular, which would be enhanced by using an oversized screen for a portion of the showing, *Old Ironsides* could benefit from the theater: "At the Rivoli, with a capacity of 2,200, Publix will have the biggest house on Broadway playing to a steady run, and if a picture clicks there . . . a huge gross can roll up."[73]

A film's first showing did not necessarily begin with first run; there was a prior level known as "exploitation exhibition," and this always involved the expectation of a run longer than the common weekly run at the palace. As noted earlier, exploitation meant advertising for movie professionals, and the reason for "run exhibition" preceding first-run was similar to the one offered by Vitagraph when it ran its Broadway theater in 1914: the longer run and especially a long run in New York City effectively primed the film's box office for when it began moving through the system of runs that started with the palace. There were two types of run houses. The Rialto, for example, was an extended-run grind house; these were always smaller than the palaces, although possibly a bit bigger than most legitimate theaters, and a feature film designated a special—or even, as *Variety* had it, "pictures verging on the special class"—was its primary entertainment. The films that played here, drawing in larger audiences because of theater capacity and continuous showings, were generally expected to run six to eight weeks, as *Variety* had noted, and indeed *The Patriot* played for seven weeks at the Rialto. The second category, more exclusive than the grind houses as they featured only specials, was variously known as "extended exploitation run-theaters," or "roadshow theaters," or simply "two-a-day." These were generally much smaller than the grind houses, they charged prices comparable to legitimate theater, offered only two shows a day (three on weekends if film length permitted), and always had reserved seats, which, if box office warranted, could be purchased months in advance.

Films that played at the extended-run theaters, whether grind or two-a-day, were always designated "pre-release" to keep the system of runs and clearances from kicking in. And they had to be kept out of general release—that is, not shown "in motion picture theatres at the present time"—because it was impossible to predict length of run, which could occasionally be much shorter than expected, as we'll see. Further, while these theaters might have an orchestra during the silent period and possibly stage live-action "prologues"—stage shows specifically designed to introduce the films—the films were essentially *the* attraction. Films that played the presentation houses were usually entering first-run general release, beginning the cycle of runs and clearances. Further, they were always shown as one part of a larger program, and if that program featured a name performer, *Variety* would often note that it was the stage show that was the real draw.[74]

I noted the system was more elaborate in New York than anywhere else: in addition to their palaces, MGM, Paramount, and Warners all had multiple run-theaters under their control. Although Fox began as a theater circuit, it was the last major to acquire a palace when it took over ownership of the Roxy shortly after it opened in 1927.[75] Before that, it seemed to be moving away from palace exhibition, earning this headline in *Moving Picture World*: "Fox Abandons Program Pictures; All Specials on 1925–26 Schedule." The article explained: "It has not been hard to prophesy that Fox was about through with program pictures. Increasingly in each successive year for the past five or six years he has made more and more of the larger productions known as special attractions, and less each year of the small pictures cut to the accepted program standard."[76] Fox regularly leased three Broadway theaters for roadshow exhibition, but while the profit potential of specials might have been greater, a slate of nothing but specials limited cash flow, so a year later Fox balanced its run-theaters with a palace.[77] On the other hand, United Artists, which as a distributor for independent producers was more oriented toward specials, announced plans for a new theater chain "to operate twenty pre-release theatres in as many large American cities."[78] Companies that did not own theaters could either lease on a per film basis or enter into an arrangement with a theater manager for extended use. Similarly, outside of New York City, if a city did not have a sufficient number of roadshow theaters at a given time, the producing company could always arrange for bookings with the two legitimate theater circuits. So, for example, Uni-

versal had *All Quiet on the Western Front* booked into Shubert theaters as a pre-release engagement in "key cities" in 1930.[79] In keeping films out of the cycle of runs and clearances, pre-release exhibition had two advantages for the producing studios: exploitation in advance of general release, as noted, but also in the case of reserved-seat showings adding a new price tier. If some people were willing to spend $2 to see a film, then it made sense to attract that audience with an environment that suggested its exclusivity.

## WHAT'S SO SPECIAL?

Differentiation at the level of exhibition suggests a way the industry conceptually differentiated production—other than by genre or A- and B-list production units, the chief differentiations that have been considered by film historians—and it starts with the beginnings of the feature film as a way of meeting contradictory demands for regular output as well as films that could challenge legitimate theater.[80] By the late 1920s, a bifurcation in exhibition systematically reflected a preexisting bifurcation in production. In this period, MGM, for example, would have to decide which films were appropriate for which theaters, what went to the Capitol or the State, what went in for extended runs at the Astor or the Embassy or a leased legitimate theater. That this was a distinction made at the level of production is precisely defined by a 1928 trade journal article:

> Of the 32 pictures being shot here this week four are of the super de luxe class, 20 are of the program class, and the remainder are unclassified product of various kinds. . . . The tendency is to turn out program pictures: and Hollywood is turning most of them out in four weeks—and less time. No studio is taking exception to the rule. . . . [John] Ford's "Hangman's House" is regarded as out of the program class—because of story, budget, director and production values—and came to a close in seven weeks.[81]

How producing studios made these distinctions is evident from this description: items like budget, length of finished film, an epic scope to the narrative, and status of the director were obvious enough elements, easy to determine. But a review of weekly openings in New York from 1920 to 1934 makes clear these were not necessarily the only factors, which likely accounts for the "unclassified product," a kind of yet-to-be-determined

category. So, for example, Lubitsch's *Design for Living*, the last Paramount film to have a reserved-seat run at the Criterion, was only 91 minutes and had an intimate focus on three central characters, although "director and production values" certainly bolstered its status.

Trade advertising makes clear that these decisions generally preceded production: studio ads of a season's production slate would generally highlight "specials" that were intended for pre-release engagement, and it was not at all unusual to single out specific directors as significant. But, as it turns out, even the studios could seek help in trying to determine qualities that constituted a special. In 1926, *Motion Picture News* ran a series of articles by John Grierson, identified solely as a "noted English writer" because this was several years before he became a noted documentary filmmaker. The articles dealt with "picture production problems." One of the most interesting things about the series was that it was not commissioned by *Motion Picture News*; rather, "The articles were written originally for the Famous Players–Lasky Corporation, which gave Mr. Grierson a free hand in developing his criticisms of its own product."[82] The third article in the series is of particular interest here because it is entitled "What Makes a Special?" and his answer strikingly centers on content, which he elucidates by opposing "quality" to "quantity": "though quantity may earn money for a time ("Ben Hur" and "Mare Nostrum" are quantity films) it is quality that finally wins. It is quality that gets under people's skins and makes them remember" (1934). Embracing the democratizing aspect of movies, much as theater architecture itself did, Grierson writes that specials must present "stories of fundamental and (in the high sense) common emotions." To do so, they have to adhere to "Three Essentials": "1. The theme must be simple . . . 2. The theme must be positive rather than negative . . . 3. It must be a significant theme . . . it must smell of ultimate things."

Since trade advertising as well as press releases did identify films intended as specials, we can, of course, also look at the films themselves and most especially the discourse that circulated around these films in advertisements and reviews. As a first example, I want to consider Fox's *Sunrise* (1928) since it perfectly embodies the three "essentials" that Grierson lists. The film's story supports Grierson's claim for a simple, positive, and significant theme, but the discourse around the film suggests more. A couple of things may be noticed in the advertising for the premiere of *Sunrise* in New York in 1927 (fig. 4.4): a simple and abstracting graphic

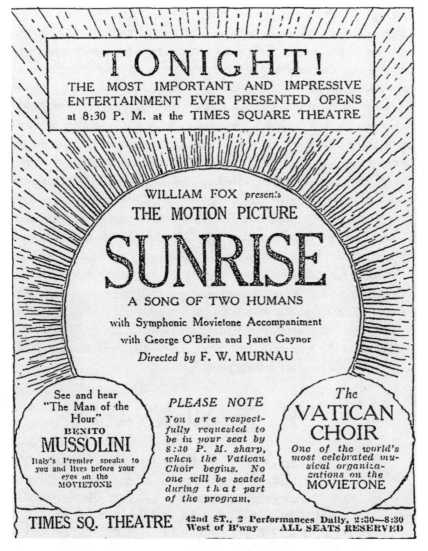

FIGURE 4.4

In this advertisement for the premiere of *Sunrise* in 1927, both graphics and text stress the film's singularity.

rather than drawings or photographs of the leading players, as if the essence of the film could only be caught indirectly; an insistence on singularity and importance; some sense of elevated tone and significance (here achieved partly through supplementary short films, unusual for a two-a-day booking, of the Vatican Choir and "The Man of the Hour," Benito Mussolini); no mention of a stage performance, although a repeated indication of a new technology ("Movietone," Fox's sound system, is mentioned three times); and, finally, an unusual prominence given to the director, who is often not even mentioned in the display ads for the big presentation theaters. In the advertisement for *Sunrise*, F. W. Murnau's name has larger type than the film's two stars, although they were both among Fox's most popular actors. As the film's very long run continued, his name seemed to grow in stature: an advertisement four months into the run put him at the top, gave him even larger type, and billed him as both "Artist and Dramatist!" (see fig. 4.5). Should the director be already widely known to an American audience, his prominence would precede the opening: consider the advertisement that ran the day of the premiere of Lubitsch's *The Student Prince* (1927), the film that finally followed *The Big Parade* at the Astor (fig. 4.6), where Lubtisch's artistic ambition itself is made the primary selling point.

FIGURE 4.5
Attempting to sell *Sunrise* for its artistic achievement, advertising granted director F. W. Murnau more prominence than its two popular stars.

# Lubitsch's Dream

*ERNST LUBITSCH* first attracted world-wide attention with his production "Passion."

He came to this country and in the last few years produced a series of witty photoplays which well deserved eulogy they received.

The great director longed, however, to make a production scaled to the size of his earlier foreign work, but yet possessing the advantages of American methods and cast.

Metro-Goldwyn-Mayer gave him this opportunity. "Old Heidelberg" was selected as a vehicle and Ramon Novarro and Norma Shearer selected as the stars.

Then the rights to "The Student Prince" were purchased, enabling the story to be titled by its well-known American name. Also the musical quality of the accompaniment was assured.

What a delight is in store for you! What a momentous motion picture adventure! How you will thrill when you see

# THE STUDENT
# PRINCE *in Old Heidelberg*

*The Successor to "The Big Parade"*

RAMON NOVARRO
NORMA SHEARER

*Premiere, 8:30*
TONIGHT
*Twice Daily Thereafter*

Gala First Matinee
TOMORROW—2:45

Astor
B'way and 45th St.
BUY NOW!

FIGURE 4.6

Ernst Lubitsch, who had established a reputation for a distinctive style, is made the entire focus of this advertisement for the premiere of *The Student Prince* (1927).

Once the films opened, the ads would be changed to stress the importance of critical reactions. Quotes from critics were rarely used in advertisements for the presentation theaters, but for films that played at extended-run theaters they could seem to be as important as they would later be for the international art cinema of the 1950s. The post-premiere ad for *Sunrise* employed the same graphics as the pre-opening ad, but filled them out—as if the spaces were waiting to be filled in—with rave quotations from six different reviewers (fig. 4.7). One quotation does praise the captivating quality of the story, which would always seem to be the prime aim of classical Hollywood: "one of the sweetest and most deeply poignant stories ever filmed." But most stressed the film's achievement as "cinema art."

This approach could run into problems if there wasn't a good fit between the mode of exhibition and the film itself.[83] Consider Warner Bros.'s attempt to promote another film, *Life Begins* (1932), a film given a two-a-day reserved-seat booking, albeit claiming a top of $1.50 (not common at the palaces) as "popular prices," likely because of a running time (71 minutes) that could make it seem like a programmer. Consequently, the advertisement for the premiere stressed its exclusivity: "This afternoon at the Hollywood Theatre to only critics and writers" (fig. 4.8). The film was so distinctive that the public would have to wait for a separate premiere. The ad for this second premiere remained equally elusive, referring readers to "your favorite critic's comments" for more information (fig. 4.9). This was obviously done with the expectation that the film would receive good notices, and for two likely reasons: it was based on a successful Broadway play, and it dealt with what one critic characterized as "so delicate a theme," life on a maternity ward. The apparent high-mindedness associated with the mode of exhibition allowed for ads that did not in fact say much about the actual content of the movie, invoking by this omission a sense of the forbidden implicit in the title—how does life begin?—and cleverly aligning high-mindedness with sensationalism. Nevertheless, the approach failed when critics declined to fall in line. Referring to your favorite critic could well defer you from attending, and ultimately the advertisement could feature only one critic (fig. 4.10). Within ten days, the theater reduced its prices to 75¢ while keeping the reserved-seat policy and made the sensational aspects overt by advertising a manufactured controversy between two reviews: "The Denver Post challenges the DECENCY of 'Life Begins' . . . but Arthur Brisbane

# "SUNRISE IS MAGNIFICENT"

"Marvelous . . . It stands alone as the film of films . . . It is the best of this year, last year and all the years that have given themselves over to the cinema kind . . . It beats 'Variety,' 'The Last Laugh,' 'Metropolis.'"
—*Daily News*

WILLIAM FOX presents

THE MOTION PICTURE

# SUNRISE

## "A SONG of TWO HUMANS"

With Symphonic Movietone
Accompaniment

*Directed by* F. W. MURNAU

*with* GEORGE O'BRIEN and JANET GAYNOR

"An amazing picture...It is tremendous in its power, so engrossing in its dramatic magnificence, that it stands alone as an example of the art of motion pictures."
—*Evening Journal*

"Between Janet Gaynor and George O'Brien, 'Sunrise' is one of the sweetest and most deeply poignant stories ever filmed."
—*Evening World*

"Murnau is in a class by himself. Whatever praise has been given this German genius has not been enough. A masterpiece up to the last reel."
—*Evening Graphic*

"A remarkable program!"
N. Y. *Times.*

"A masterpiece of cinema art."
—*Evc. Telegram*

*Also, See and Hear on the* MOVIETONE
"THE MAN OF THE HOUR" BENITO MUSSOLINI
and the WORLD FAMOUS
VATICAN CHOIR    GLORIOUS, PERFECTLY TRAINED VOICES

# TIMES SQUARE
THEATRE — 42d St.
WEST OF BROADWAY
Twice Daily, 2:30 — 8:30
Sun. Mat. 3 P. M.

ALL SEATS RESERVED—AND ON SALE IN ADVANCE

FIGURE 4.7
Unlike "programmers," "specials" often relied on critical response to attract audiences.

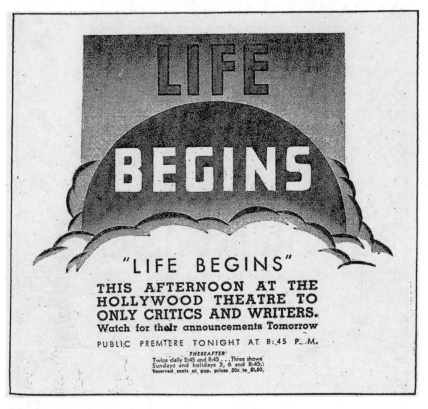

FIGURE 4.8
A teaser campaign designed to give a film that should have been a programmer, *Life Begins* (1932), an aura of exclusivity.

defends it." The *Denver Post*'s review was blunt and headlined "'Life Begins' Film Violates Common Rules of Decency": "its outright frankness in dealing with biological facts best left for the doctor's consulting room is what condemns 'Life Begins!'" Set against this was a King Features syndicated review which recommended that the "picture about life's beginnings *ought to be seen* by husbands that go for a walk when their baby is born, and by those that oppose birth control in all cases."[84] But even challenging potential viewers to see for themselves and decide if the film "is a menace or a masterpiece" wasn't enough: within a couple of weeks, the film was moved over to the Strand, where a stage show could pull in audiences and help sell it in general release.

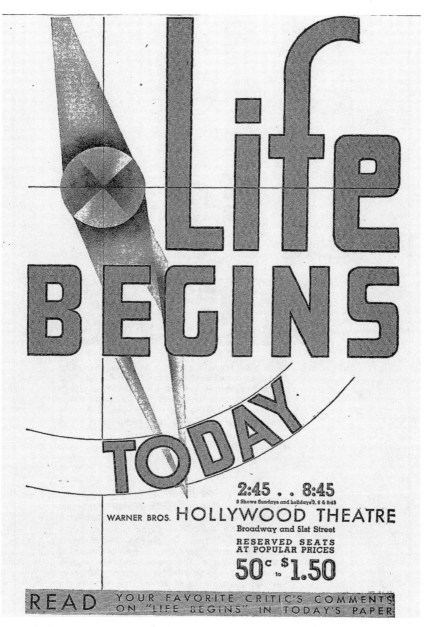

FIGURE 4.9

The deployment of critical response in advance of any actual reviews was a gambit made because of the success of the source material.

**"...IT'S A SIX STAR PICTURE"**

# REGINA CREWE

respected and talented Critic of the
N. Y. American *says*—

# LIFE
# BEGINS

*A First National Picture*

"—is a film for all the women of all the world. And for every man born of woman, too. It's a startling, tensely dramatic subject, treated with exquisite taste and deep understanding. It would wring weeps from a stone god — or a living one. And with its pathos there's rare mingling of comic and tragic masques, as well.

"A story difficult to visualise, one that required courage on the part of the producers, a radical departure from the too oft-beaten trail, 'Life Begins' fulfills every promise, every hope. Seeing is believing. And the world will be convinced.

"Every scene of each individual story is poignant drama that stabs its way to an ever-living memory. So delicate a theme might so easily have been marred. But players and directors alike have maintained the fine balance essential to the success of the production. The picture means that 'Life Begins' for a bigger and better motion picture season. It turns all eyes to the Warner Brothers. This taste of the new product arouses a thirst for more."

**Now Playing HOLLYWOOD THEATRE**

B'way & 51st St. Daily at 2:45 and
8:45. Sundays and holidays 3, 6, 8:45.
Reserved seats at POP. prices
700 seats at 50c . . . 500 seats at 75c . . . 300 seats at $1.00

**50c to $1.50**

FIGURE 4.10

With only one critic effectively cooperating with the advertising campaign, the advanced prices still prominently featured here would be reduced in a week.

A more striking, and perhaps more revealing, failure involved promotion of King Vidor's *The Crowd* (1928). At least from *The Big Parade* on, Vidor proved himself a director whose films ended up in extended-run theaters, a director whose name was always prominently featured in promotion of the films. Yet *The Crowd*, in spite of its very obvious artistic ambition, premiered at the Capitol (fig. 4.11). For a film at a presentation house, the ad gave exceptional prominence to the director, but, still, the name of the theater was in larger type than both his name and the name of the film, and the chief graphic element was a sketch of the bandleader for the stage show. In spite of the small-scale realism for which the film would become known, the chief strategy of the ad was to cast it as an epic by association with Vidor's *Big Parade*, albeit "an Epic of the Great American Middle Class." Still, the theater itself and the entire spectacle of stage plus screen were the draw here, and the expectation was that *The Crowd* would have the standard weekly engagement.

Then something unexpected happened: the film garnered both great reviews and good box office. The failure in this case wasn't in the film, but rather in the choice of theater, so MGM immediately sought to correct this mistake with the "Sensational Announcement!" of "a departure in amusement procedure," namely that *The Crowd* was moving over to the reserved-seat Astor Theatre (fig. 4.12).[85] *Variety* noted, "M-G-M got a lot of Broadway attention with the decision to move 'The Crowd' from the 99¢ Capitol to the Astor for $2.00"[86] The ad makes clear the reason for MGM's "momentous decision"—they had obviously miscalculated on a film they expected to disappear pretty quickly. The teaser ad proclaimed, "This is Motion Picture History," while the ad on opening day reiterated, "There's a News Event that will make Motion Picture History" (fig. 4.13). Since the film "merit[ed] its presentation at the key legitimate motion picture house of the world," the distinction of the theater would lend itself to the film.

So, what makes a special? And what are we to make of MGM's miscalculation with *The Crowd*? What I can take from the ads and from some consideration of the films themselves must be speculative, and I don't to want claim that what I note here is comprehensive, but the following conditions stand out, although they might not all be present or present in equal degree.

• First, the picture is of such quality that it would benefit from being shown exclusively, without the distractions of competing live entertainments.

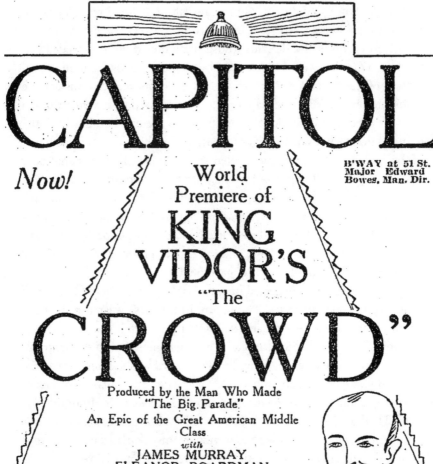

FIGURE 4.11

Turning an artistically distinctive film, *The Crowd*, with a name director into a programmer, for quick play at a palace where small-scale realism became epic.

# SENSATIONAL ANNOUNCEMENT!

*The Metro-Goldwyn-Mayer Company*
*announces that beginning*

## TOMORROW!

KING VIDOR'S AMAZING PRODUCTION

# The CROWD

*will be presented*
*as a reserved seat attraction*
*at the*

# ASTOR THEATRE

*for a limited engagement*
*Today completes its week's run*

*at the*

## CAPITOL THEATRE

## *This is Motion Picture History*

When a film is so great from both a public and a critical viewpoint that it merits such a momentous decision, such a departure in amusement procedure, you surely owe it to yourself to see it.

*First Astor Theatre Performance Tomorrow Matinee at 2:45 p. m.*

Buy Seats Now—Twice Daily 2:45-8:45—All Seats Reserved
Prices: Daily Mats.—Best Seats $1.00. Nights 50c to $2.00

*Last 2 Times Today*

# "THE ENEMY"
# ASTOR

THEATRE     B'way & 45th St.

FIGURE 4.12
Correcting a mistake, MGM makes "motion picture history" not with a motion picture, but by its choice of venue.

*Good Morning!*

# THE CROWD IS NOW AT THE ASTOR THEATRE

*There's a News Event
that will make Motion
Picture History*

Metro-Goldwyn-Mayer is proud that the public and critics have so acclaimed this new King Vidor production as to merit its presentation at the key legitimate motion picture house of the world.

*It has moved in
with a rush*

See it today and you'll see something worth talking about.

Welcome .

# THE CROWD
## to the ASTOR THEATRE

*Limited Engagement*     *All Seats Reserved*
*Twice Daily: 2:45—8:45*     *Daily Mats, Best Seats, $1*

FIGURE 4.13

Because venue could define a film, one as unassuming as *The Crowd* had to prove it warranted entry into "the key legitimate motion picture house of the world."

This is presumably for the benefit of an audience willing to pay $2.00 a seat in New York, or a comparable scale in other cities, but even in the nonreserved-seat, extended-run houses that charged lower prices, there is also an economic benefit since it potentially accumulates more capital than it would through a brief run at a presentation house and could take in more profit because of lower costs in exhibition. Further, the longer runs also potentially increase the take when the film ends up in a presentation house and enters the full general release of runs and clearances. What might now seem one of the strangest aspects of this exhibition method actually makes good economic sense: the end of the engagement at the pre-release house would be followed, usually within a month, by a booking at one of the presentation houses, which was often only a few blocks away from the long-run theater, and usually advertised as "First time at popular prices" (fig. 4.14).

• Second, the film would most likely have a bigger budget than the product that played at weekly change houses, although with its short running time and limited setting, this was certainly not true for *Life Begins*. A film with a larger budget might feature spectacle in its own right, but this was not a necessary condition. The large budget for *Sunrise* went toward its enormous sets, but the film also had a fairly intimate focus, with nothing like the spectacle of battle scenes in *The Big Parade*. The uncertainty of how to handle *The Crowd* likely derives from the combination of its relatively low budget and small scale.

• Third, the film might run longer than average length. Presentation houses preferred films under 80 minutes so that the feature would not interfere with the rest of the program. Longer running times could create problems. For example, Roxy has described a unique four-minute live program he devised to play at his eponymous theater with *The Cockeyed World* (1929), which runs 115 minutes.[87] With much greater lengths, the palace could suspend its stage show as the Capitol did for *Ben-Hur* (1925).

• Fourth, the film could be based on an acclaimed or prize-winning play, which justified a mode of presentation that seemed to echo that of the legitimate theater. This could possibly account for Warner Bros.'s miscalculation with *Life Begins*, but it might also explain why Lubitsch's *Design for Living* was given a twice-daily showing, while *Trouble in Paradise*, Lubitsch's romantic comedy from the previous year and also a special, was given a grind extended-run treatment.

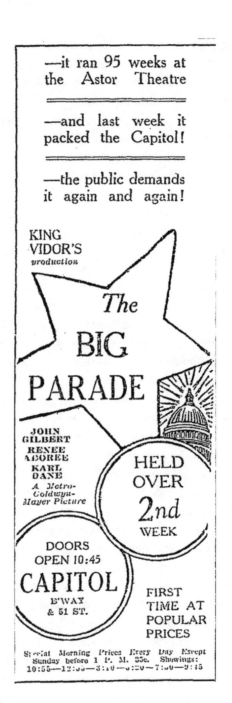

FIGURE 4.14

After nearly two years at an extended-run theater, *The Big Parade* moved five blocks north on Broadway for a palace engagement "at popular prices."

• Fifth, if it did not have origins in an already recognized work, the film could boast artistic ambition in its own right, either through seriousness of theme, the presence of stars who were regarded as particularly accomplished performers, or directors who had a distinctive style. Artistic ambition made critical response important to the success of these films, as we've seen from the heavy use of critical quotes in the advertising.

• Finally, the film might offer striking stylistic or technological innovation, with the two possibly overlapping.

As my last two points should make clear, these were often enough films in which style was supposed to be visible by being sufficiently different from that of films which went straight into conventional release. This mode of exhibition, then, either encouraged or at least allowed for deviances from normative practice. If we can grant that these films could register a visible difference, we have to question where to draw distinctions. "Invisibility" can be a problematic word in describing the classical style, as David Bordwell has noted, but given its frequent use as representing the sine qua non of classical style, I would propose recasting this as an issue of stylistic overtness, a foregrounding of style that does not find intrinsic motivation, versus stylistic covertness. Bordwell himself offers a useful distinction here: "Typically, the opening and closing of the film are the most self-conscious, omniscient, and communicative passages. The credit sequence and the first few shots usually bear traces of an overt narration. Once the action has started, however, the narration becomes more covert, letting the characters and their interaction take over the transmission of information."[88] Bordwell, then, generally accepts the notion of covert narration as central to the classical style, but proposes the possibility of more overt narration so long as it operates within well-regulated conventions.

This seems a reasonable and nuanced refinement of the claim of invisibility. But if it is indeed true, then the following sequence from *Trouble in Paradise* (1932), which opened at the extended-run Rivoli, simply isn't very classical. A simple medium two-shot shows Marianne and Gaston embracing as she is about to go off to a party. Right at the moment they kiss, there is an unmotivated cut to a shot of the couple seen through a mirror above a bed on the other side of the room; as they separate from the kiss, Marianne begins her next line of dialogue: "We have a long time ahead of us, Gaston . . . weeks . . . months . . . years". This shot ends with

"weeks," while "months" and "years" each warrants a separate shot, first of the couple seen in a *different* mirror, then finally as shadows cast upon a bed. When you have three separate shots for just one line of dialogue, only twelve words, and each cut is a hard cut, you cannot help but notice the style. Further, I would claim the cutting is so overt and so peculiar that you inevitably find yourself in a position of consciously trying to interpret style, probably taking the sequence of shots as undercutting Mariette's confidence of a long time together. Keeping all these qualities in mind, it's often easy to predict which films from the classical period ended up in extended-run, pre-release theaters. To take the most obvious example, since its narration strategy was unusually overt, can we be surprised, in spite of its reputation as a commercial flop, that *Citizen Kane* (1941) ran for four months on Broadway in a reserved-seat run at the RKO Palace? And although this was a period in which reserved-seat showings had been cut back from their highpoint in the late 1920s, *Citizen Kane* did receive extended-run, reserved-seat showings at pre-release theaters in other major cities.

If the "specials," then, do on occasion achieve an unregulated overtness in narration, I would locate it chiefly in the work of the camera (as we've just seen with *Trouble in Paradise*), sound recording conventions, and narrative structure itself. If the stylistic departures seemed sufficiently different, they might be treated as technical innovations in the advertising. Consider the ad that ran the day before the premiere of *Strange Interlude* (1932), which contained a host of reasons it should be a special. Based on a Pulitzer Prize–winning play (and so a picture of the famous playwright appears), we learn it is considered Eugene O'Neill's greatest play, and to make sure we recognize the greatness, the year-and-a-half Broadway run is mentioned twice. The play featured a "fascinating method of narration," an innovation that in point of fact revived something fairly old—direct address to the audience—but in a naturalistic context. In the film, it's a development comparable to the most recent technological innovation: "The next step in talking pictures is ready for you! Metro-Goldwyn-Mayer's Startling Innovation" (fig. 4.15). Technology is the come-on, but the real lure here is the appeal of the forbidden: "By means of an entirely new talking picture device you HEAR the secret thoughts of each character in this exciting sex-clouded relationship!" This is simply an early use of voice-over, which would become a convention soon enough. It would get a funny send-up by the end of the year in *Me and My Gal*, a

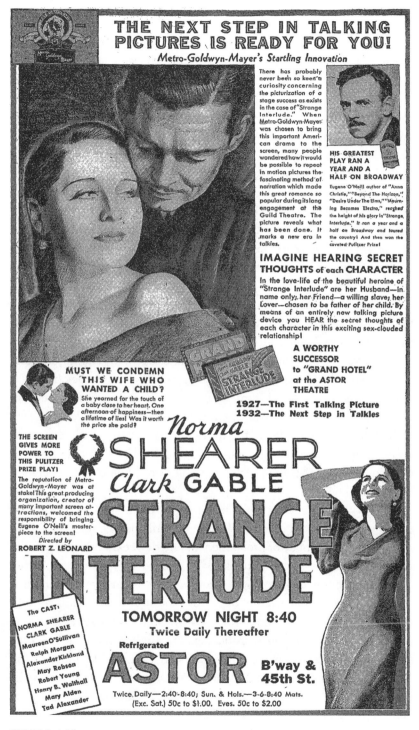

FIGURE 4.15

*Strange Interlude*: touting voice-over as a "next step" innovation that provides access to "secret thoughts."

programmer that played at the Roxy and had Spencer Tracy refer to the earlier movie as "Strange Inner Tube." But at the time it was sufficiently novel to require an introductory title, informing viewers that the characters "will express their thoughts aloud." Further instruction comes from the first character we see, played by Ralph Morgan. After looking around and musing aloud to himself about "this quaint old town," Morgan suddenly focuses on the camera, a disturbed expression on his face, as we hear on the soundtrack: "Queer things, thoughts. Our true selves. Spoken words are just a mask to disguise them." After he looks down, the film resumes a fourth-wall convention, having made clear to us how to understand the seemingly unspoken dialogue.

A year later, *The Power and the Glory* (1932) combined voice-over with a jumbled narrative structure for *its* innovation, "narratage," "the new marvel of talking pictures" (fig. 4.16). The unconventional handling of narrative was matched by a use of voice-over that remained unconventional, a procedure that foregrounds the act of narration itself. This is most obvious in the lip synching of Spencer Tracy and Colleen Moore by a third actor, the narrator Ralph Morgan, once again providing some dialogue in voice-over. Furthermore, he tells us things about the characters that we could not fully get from the images, and he also has us focus on details that are not exactly what the images present. Most striking, in fact, is the heavily *visual* quality of the voice-over narration. We are very much aware of how images may be translated into words, in effect making us conscious of how narration serves to shape perception of both character and event.

I think there is real value in looking at exhibition as a condition of creation in American cinema. We can usefully posit a reciprocal relationship between mode of production and mode of exhibition as a way of allowing for stylistic possibilities that extended the parameters of the classical paradigm, departed from it completely, or even subverted it. Nowadays we have the expectation of departures from mainstream conventions in the films that are produced by the studio's boutique divisions (whether produced in-house or independent acquisitions) or released by small distributors and often exhibited in art theaters like those of the Landmark chain. But there films rarely have a theatrical life beyond their initial art house exhibition. What was different about the bifurcation of both production and exhibition in the pre-television era is that movies made for elite audiences would eventually find themselves in more mass-

# THE RUSH FOR SEATS IS ON!

## Box Office Besieged
## Mail Orders Pour In

Leaders of entertainment world vie with public in clamor to see the new marvel of talking pictures.

●

## TONIGHT ITS PREMIERE
### Tomorrow its praise

FOX FILM presents the first NARRATAGE production . . . a drama so great it required a new method to bring it to the screen!

# THE POWER AND THE GLORY

**SPENCER TRACY** ● **COLLEEN MOORE**

**RALPH MORGAN** ● **HELEN VINSON**

A JESSE L. LASKY PRODUCTION
Directed by William K. Howard    Story by Preston Sturges

●

If you can't obtain seats for the Premiere buy in advance for future performances—all seats reserved—now on sale —mail orders accepted with check or money order attached

TWICE DAILY 2:45 — 8:45
Mats. 55c to $1.10  —  Eves. 55c to $1.65

**NOTE:**
Holders of tickets for tonight's performance are requested to assist the management of the Gaiety Theatre in keeping them out of the hands of speculators.

# GAIETY
### B'WAY AT 46th STREET

FIGURE 4.16
*The Power and the Glory* combined extensive voice-over narration with a jumbled chronology to create the "new marvel" of "narratage."

oriented exhibition venues. Specials could trade on exclusivity as a way of defining their specialness, but exclusivity was temporally limited, and even specials would go slumming.

## SON OF THE VARIETY DEBATE: THE DOUBLE BILL PESTILENCE

There is not much room for argument in discussing the pestilential spread of the double-feature program. . . . Its effect on Hollywood will be to speed up a system that has always suffered from overproduction. It will, if that is possible, corrupt the standards of the film public still further. . . . We can credit the double bill with one healthy result. It has provided a merciful coup de grace to vaudeville, which has been dying with embarrassing reluctance for the last ten years.
—Andre Sennwald (1935)[89]

Hollywood produced 600 pictures last year. . . . Yet there are not brains enough in Hollywood to produce more than 200 good ones. In this lies the real and honest answer to what is wrong with the motion-picture industry.
—Samuel Goldwyn (1940)[90]

The only double feature I've sat through in years is *Gone with the Wind* . . .
—Otis Ferguson (1940)[91]

A May 15, 1929, issue of *Variety* featured the following headline: "13 Films on B'Way at $2—Hurting Legit and Themselves" (9). Although there were four palaces affiliated with major producing companies, nine companies, including the palace-owning studios, were running feature films in the twice-daily theaters.[92] By 1929 the physical plant for premier movie exhibition had pretty much been built, a plant that would last into the early 1970s as a dominant force.[93] Alongside these theaters, the motion picture industry had successfully implemented what the Astor Theatre designated an "amusement procedure," that is, an exhibition method which successfully systematized the diverse venues that led to the ascension of movies as America's dominant form of entertainment: the vaudeville theater, the store theater, and the legitimate stage theater. By weaving together these diverse strands into a coherent whole, motion picture production and exhibition seemed to have reached a kind of equilibrium, one marked by *Variety*'s celebration of "run" exhibition, which seemed to offer the most direct challenge to the legitimate stage. But the equilibrium was about to be shaken by two developments, one internal to the industry, one external.

The year 1926 marked the first successful wide release of a film with a synchronized soundtrack, *Don Juan* with John Barrymore. There was no spoken dialogue; this was essentially a silent film with an accompanying musical score, but a score played by the New York Philharmonic, and even some synchronized sound of clashing swords. Initially it was thought the chief advantage of the soundtrack would be to provide venues in smaller cities and towns with the kind of musical accompaniment heard in big city theaters, although, ironically, as a "Warner Bros. Extended Run Production," the film was initially released on an exclusive basis (fig. 4.17).[94] Still, even at the first showing, *Don Juan* was accompanied by Vitaphone shorts that did have lip synch of people talking and singing (Crafton, 76–81). By 1929, when full-scale production of all-talking films was under way and over 25 percent of the nation's theaters were wired for sound, and a much higher percentage in the major markets, it was clear that the future of movies was with "talkies."

This had an impact on exhibition in a number of ways that was in part accelerated by an external event—the October 29 stock market crash and subsequent depression. Putting on mini-vaudeville stage shows alongside the filmed entertainment added enormously to the weekly payroll of any theater, which meant the simplest way to reduce overhead was by eliminating live performances. Over the next five years or so, as the Great Depression deepened, this is pretty much what happened in all the major markets. (See appendix 1.) As the second largest market, Chicago went from seven stage shows to three by the late 1930s. Most other markets saw the presentation house decline to one theater or even saw presentations eliminated entirely. New York, as always, was distinctive: it alone entered the 1950s with five theaters still featuring stage shows, although the biggest palaces in the outlying boroughs had lost their shows long before. But even of those five, two—the Strand and the Capitol—had both abandoned and then resumed stage shows previously in the 1930s and once in the 1940s. The reason for the ambivalence was straightforward: with the stage shows the expense of running the theater was very high, but without them could the theaters draw enough patronage to sustain such grandiose physical plants? In New York, the potential audience was always enormous, and the right film would get people to these theatrical behemoths. Outside New York, other solutions were sought.

In 1930, Roxy himself, the greatest proponent of vaudeville in the movie theater, predicted the end of the stage show: "I think the day of the

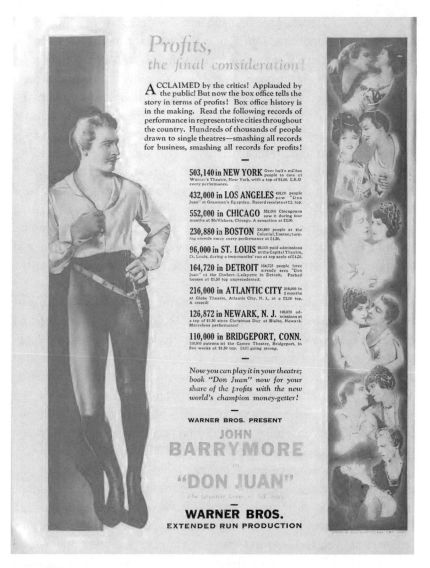

FIGURE 4.17

Although limited in its initial release as an "extended run production," *Don Juan*'s Vitaphone soundtrack provided big city musical performance to smaller venues.

so-called presentation idea with the picture is past, and that the pictures will to be able to stand on their own [sic]."[95] One solution was to expand the short film portion of the program since films could now present the kind of entertainment you would have seen on the stage and even more so to the extent that something like a travelogue could provide vistas not available on the stage. This was helped along by the fact that the late 1920s did see an increase in production in the major studios' shorts units.[96] The other solution proved more controversial: double features, a practice that first began in New England in the 1920s, but only really started to take off in the 1930s.[97] As it evolved, this generally meant pairing the kind of film that would have played as a feature in the palaces with a lower-budget film from the major producers or from independent producers collectively known as "Poverty Row." A number of commentators subsequently compared double bills to vaudeville, and it was common enough that theaters dropping their stage shows would add a second feature to the bill. There had been voices in the past that could attack the live stage shows—notably George Kleine (who had imported the Italian features in the teens), who said that stage shows reduced movies to the status of a chaser.[98] But this was nothing like the reception that greeted double bills: much as they did seem to attract patrons, they also attracted sustained and hostile criticism. As early as 1930, just when double-billing was beginning to expand, *Motion Picture News* could find nothing good about the practice, claiming, in its headline, that it was already "Reaching Alarming Proportions" with the article blaming its increase "due to the lack of good pictures."[99]

What ensued was pretty much a rehearsal of the variety debate of the teens.[100] But the original debate was entirely within the industry itself, and it was pretty much settled by the bifurcation of exhibition. Double bills were something else: although they were primarily a matter of business policy, the discourse around them was very public. Industry spokesmen, newspaper writers, legislators, and government officials all had their say. Polls were taken and polls were published. The earliest one I have come across was conducted by Hal Roach studios "in conjunction with the Hays organization [i.e., the Motion Picture Producers and Distributors of America] and the Women's Better Picture Movement" in 1933. As far as polling goes, this survey provided the high water mark for the anti-"duals" forces: "80 per cent of theatre patrons, film critics and persons in the industry" expressed disapproval. Unspecified was how each group

was weighted, but it's easy to suspect Hal Roach studios, a major supplier of short films like the "Our Gang" comedies and Laurel and Hardy, had a heavy thumb on the scale since "Preference was expressed . . . for a diversified program headed by a feature and supplemented with short subjects." The poll added one new wrinkle to the variety debate: complaints that "the two pictures that are shown do not belong to the same kind of audience" suggested it was possible to have too much variety.[101]

The debate at times took on an almost absurdist dimension since virtually everyone seemed opposed to double bills and blamed everyone else for them: producers blamed exhibitors, exhibitors blamed producers, and both blamed the public who in turn criticized them for providing double bills even as theaters with double bills inevitably did better business.[102] In 1939 the Illinois state legislature passed a bill to cut down on double bills by limiting the total running time of a movie show to 135 minutes, apparently not realizing this would make it impossible to show a fair number of single features with the standard array of short subjects in this time frame.[103] After an uproar, the governor vetoed the bill and then had to have his veto sustained by the state's highest court.[104] The federal government got involved when wartime restrictions on the use of raw film stock were implemented in 1942.[105] A "new 5 per cent cut in raw stock allotments for the current quarter" in 1945 led producer Samuel Goldwyn to proclaim, "then there is no excuse or justification for the continuance of double features."[106]

Beginning with an article he wrote for the *New York Times* in 1936, Goldwyn became the most insistent and vocal opponent of double bills. In this first article, a wide-ranging consideration of the various problems facing movie producers, he dealt briefly with double bills, seeing them primarily as a consequence of overproduction. For this reason, he could conclude optimistically, "I predict that 60 per cent of the double-bill houses will go single-bill within a year."[107] By 1940, when events proved him wrong, he stated simply "Hollywood Is Sick," as the title he used for a *Saturday Evening Post* article declared. There had been a medical complaint about double bills causing eyestrain, but the medical metaphor was common in attacks on it. For Goldwyn, if one theater in a city adopted a double bill policy, soon another would catch the infectious disease and then it would be unstoppable, taking over the entire city. Then he ratchets up his rhetoric: "Double bills are a cancer which will devour the industry."[108] Goldwyn's fear of an unstoppable plague seems borne

out by the numbers: in 1934, *Variety* stated about half of all U.S. theaters were running double bills; in 1940, according to Goldwyn, 60–65 percent of theaters ran double bills; by 1943, "More than three-fourths of the nation's theaters now are dedicated to two-feature shows."[109] Then suddenly, in 1948, as a Motion Picture Association of America survey shows, "Double-features are the established policy of approximately one-fourth of the 18,351 motion picture theaters throughout the country."[110] Wartime restrictions of raw stock possibly had some impact, but that doesn't seem sufficient reason for this reversal.

I would like to consider one other possible explanation because it will return my focus to extended-run theaters. Because he was an independent producer committed to class product, Goldwyn made the kind of film that aimed at extended-run exhibition. The reserved-seat, twice-daily showing never again reached its high water mark of the late 1920s, but it continued into the mid-1930s in New York and in somewhat more reduced form in other major cities. Its steepest decline coincided with the steep increase in double bill exhibition, which is likely why Goldwyn's initial objection tied the double bill to overproduction. By 1940 he had another cause for concern after the experience of his fellow independent producer David O. Selznick with the release of *Gone with the Wind* (1939). In exchange for lending Clark Gable to Selznick, MGM took over distribution and provided financial support as well. Selznick wanted the film shown with reserved seats at the Astor, but while extended-run showings had the capacity to increase ultimate box office take, they interfered with a corporation's cash flow. Because of its investment, MGM wanted to play the film grind at the gigantic Loew's Capitol. The solution was to do both: the film played for six weeks at the Capitol, but reached forty-four weeks at the Astor. *GWTW* did not go into general release until a year later, but in the meantime it benefited from the cash flow of palace exhibition.[111]

There were two lessons to take away from the success of *GWTW*. The first was that audiences were quite happy to watch a very long (3 hrs. 45 min.) movie even in a grind situation. A number of commentators had suggested that one way to counter the double bill pestilence was by making movies so long they would not work on a double bill.[112] Indeed, movies in the early forties kept getting longer, and this then started to prompt complaints about them getting too long, unconsciously echoing complaints about early features versus single-reel films. For example, the film critic for the *New York Times* wrote a magazine article on excessive

length, seeing in it a new medical problem: "Pictures [in 1944] were consistently longer than ever before. Twenty-three of them ran—if that's the word—for more than two hours, and four of them did better than two and a half. The average endurance of the year's 116 first-string features was slightly under 105 minutes and the endurance of the audience baffled the medical profession."[113] The second lesson learned from the *GWTW* release had to do with run-theaters. The studios continued to produce a certain number of films every year that they expected to release in a pre-release method, and these required theaters that could handle the longer runs. One little-known aspect of the Consent Decree of 1941, best remembered for the later decision that would sever theater ownership from the studios, is that the studios were restricted to one film per year for roadshow release.[114]

But the Consent Decree did not affect extended-run grind, and most larger cities had one or two theaters they could use for that purpose. So, in the late 1930s and 1940s, the Rivoli in New York continued to be an important pre-release house for Paramount, United Artists, and 20th Century Fox, mostly for grind but occasionally utilizing reserved-seat bookings, until it became the premiere Todd-AO theater in 1954. In addition to the Strand, Warner Bros. still had a house, the Hollywood, built in 1930 and used for both reserved seats (*Yankee Doodle Dandy*, which ran for five months in 1942) and, more often, extended-run grind (*To Have and Have Not*, which ran for four months in 1944). There was such a large supply of medium-sized theaters in the Times Square area that many of them could be utilized as pre-release grind houses as needed.

But the long run of *GWTW* at the Capitol demonstrated that the palaces could accomplish pre-release runs that would rival or best the extended-run theaters in the 1920s. Even with the decline in roadshow engagements through the late 1930s, pre-release continued to be an important part of Hollywood's distribution strategy, with flagship palaces increasingly serving as pre-release theaters in the 1940s. And so the palaces became more frequently used as pre-release theaters, achieving runs longer than ever before, with ads frequently touting breaking records.[115] But despite the fact that we seem to know so little about it now, "pre-release" was not an obscure industry term: so, for example, the phrase "Special Pre-release Engagement" was featured prominently in New York advertisements for *Annie Get Your Gun* (1950), as if it were something that the average person would understand (fig. 4.18).[116] Yet with changes in

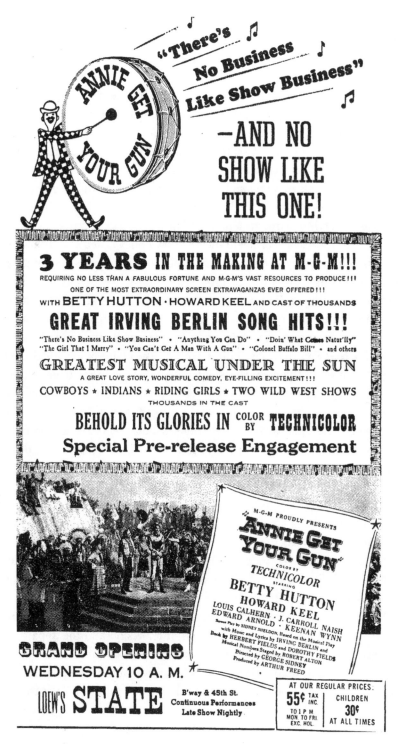

FIGURE 4.18

"Special Pre-Release Engagement" as a come-on for audiences, a term that would still be commonly understood even as television was beginning its ascent.

exhibition practices that begin in the 1960s, we seem to have lost this understanding.

More and more in the postwar period, there seems to have been an attempt to make the palaces function as pre-release theaters had in the past. So, for the premiere engagement of *All About Eve* (1950), the Roxy announced a new policy: "for the first time in history in a theatre with a continuous policy—a program of Scheduled Performances has been devised. . . . Tickets may be purchased in advance. A seat will be assured for all, and no one will be seated after the start of any of the four daily performances."[117] Trying to initiate a new exhibition strategy in spaces designed for other purposes was problematic: the new policy lasted exactly a week, after which the Roxy advertised: "By Popular Demand CONTINUOUS Performances! Come any time! Seating at all times!"[118] Much as there were attempts to collapse distinctions between the various kinds of theaters, the successful long run in New York continued to play an important function in promoting a movie, and most especially the kind of movie, like *All About Eve*, that was selling itself on the claim of artistic distinction. And even in the postwar period with a decline in roadshow exhibition, the length of a New York run, whether pre-release or first-run, continued to seem significant for the rest of the country: "Many first runs . . . are extended in the Broadway showcase houses long past the time they merit merely because the distribs want to pad their ad campaigns and, possibly, the amount of percentage they can ask from exhibs outside the keys, it is held. Fact that a picture has played a certain number of weeks on Broadway, for instance, is always a pertinent point in ad campaigns and in selling the films elsewhere."[119] While exhibition was changing, the New York model held.

But something was lurking that would finally break the model, undermining the bifurcation central to it from the beginning. A 1949 *New York Times* article on the "B" movie, the kind of film that normally appeared in the bottom half of a double bill, suggested one way the double bill could finally disappear: "a combination of television and the apparently increasing selectivity of pictures being evidenced by the public may result not only in the expiration of the 'B' picture but the double feature as well."[120] Whatever need was satisfied in the theater by the "B" picture and double bills could more easily be satisfied by television. The same year, Samuel Goldwyn, belying the belief that Hollywood moguls were terrified by the advent of free TV, wrote a thoughtful piece on how theatrical

film and television programming might coexist in the future. His comment on how television programming might differ from theatrical films is pertinent here: "The knowledge that the spectator will be able to move from one picture to another by the mere turn of the dial is bound to make those who will produce pictures primarily for television concentrate on keeping the audience interested."[121] With one turn of the dial, then, you would be able to go from one picture to another . . . and another . . . and another. Television finally put an end to the variety debate much as its very popular early variety shows put the final nail in the coffin of vaudeville.[122] When it came to variety, vaudeville and shows at the palaces inspired by vaudeville simply could not compete.

# 5. UNCANNY THEATER

## The Twin Inheritances of the Movies

In the fall of 1913 *The Moving Picture News,* a prominent exhibitors trade journal recently purchased by competitor *Exhibitors' Times,* promised among other innovations that it would soon "announce the new name of the merged publications."[1] A couple of weeks later the new name appeared: *The Motion Picture News*! This hardly seems like much of a change now, but the editors clearly regarded it as sufficiently different to help signal the "highest aspiration of The Motion Picture News . . . to represent the art and industry of the motion picture in a dignified, honorable and progressive spirit."[2] How could the change from "moving picture" to "motion picture" possibly seem significant?

Subsequently, *The Motion Picture News* explained the difference by reprinting on its editorial page an article from a Boston magazine entitled "Motion Pictures Versus 'Moving' Pictures":

The error, into which many good people had fallen, of referring to motion pictures as "moving pictures" has led to a number of humorous interpretations of this source of entertainment. Although the masses are not disposed to analyze the origin of any name or designation, there are persons who, realizing that properly projected motion pictures are virtually a quick succession of stereopticon-views, appreciate the correctness of the term "motion pictures."

In a motion-picture house the spectators are concerned only with what is displayed on the screen, and each of the numberless pictures is shown within a limited and stationary space, all of them combining to simulate motion, *but the pictures themselves do not move.* However, as the term "moving pictures" has come to stay, it is applied by discriminating people to inferior houses, whereas the correct and dignified term "motion pictures" refers rather to the respectable and refined character of the display and its environment.[3]

While the dignity of motion pictures, as we saw in the last chapter, could be a function of the performance venue, here *Motion Picture News* makes technology itself key to dignity, "the correct and dignified term 'motion pictures.'" How "motion pictures" advances a "respectable and refined character" more than "moving pictures" is still a matter of exhibition venue since the latter term "is applied by discriminating people to inferior houses." But *Motion Picture News* goes further by effectively conflating class with technological knowledge. We become "discriminating people" by acknowledging our knowledge of how "motion pictures" actually work: in the process we can reject the *spectacles optiques* aspect of films, no longer regarding this as a wonder in itself, as it was in the early vaudeville performances. In centering our concern "only with what is displayed on the screen," we correctly understand motion pictures simply as a *means* to give us access to the best of theater.

Implied in these claims is an opposition between knowledge and enthrallment that suggests a twin inheritance for the cinema and reflects, in turn, the class opposition suggested by the *Motion Picture News*'s reference to "discriminating people." To some degree this twin inheritance also found expression in the opposition between the legitimate theater and the vaudeville theater that I explored in the last chapter. If the twin inheritances of the movies are the legitimate theater and the centuries-old tradition of the magic lantern show along with other *trompe l'oeil* entertainments, then the latter ultimately belonged to the vaudeville theater,

where it could be made *part* of an evening's entertainment, as I discuss in chapter 2 with the Glyptorama, which had preceded the Vitascope at Koster and Bial's Music Hall. In this chapter, I want to explore this twin inheritance as a way of understanding a fascinating exhibition practice that was a standard for film presentation in the teens and twenties, a practice that now must seem very foreign to us.

By defining "properly projected motion pictures" as "a quick succession of stereopticon-views," the *Motion Picture News* article rightly placed movies—yes, I'll opt for the more vulgar and incorrect term—in the context of magic lantern shows of earlier decades. But what would that tradition invoke for a contemporary audience in 1913? In recent decades, there has been valuable writing about the "magic" in magic lantern shows of the late eighteenth and nineteenth centuries, the predilection for phantasmagoria and shock.[4] Placed in this context as a development out of the magic lantern, early cinema may rightly be called, as Tom Gunning has argued, a "cinema of astonishment."[5] Even before the movies, movement as a source of astonishment was a common element in magic lantern shows since they could create a simulation of movement in the image by bodily moving the lantern or manipulating two slides in relation to each other. But the movement presented was of a very limited nature, so that while cinema could seem an extension of the magic lantern show, it also differed in that it apparently—and magically—presented the real thing, an uncanny re-creation of lifelike movement.

But if there was magic in the creation of movement, a seeming sleight-of-hand that fit in with the phantasmagoric tradition of magic lantern shows, it was also magic of a different nature. The magic of the magic lantern shows involved a deliberate manipulation of the environment to fool the senses. For example, total darkness that concealed the exact location of a transparent screen would make it possible for the illusion of specters hovering in an indeterminate space. Change the environment—bring up the house lights a bit—and the illusion vanishes. As a descendent of the magic lantern, movies could also produce such illusions, as was the case in the mid-teens with a cinematic imitation of "Pepper's Ghost," one of the most famous of the nineteenth-century phantasmagoria.[6] Alternatively known as "Kineplastikon" or "Photoplast," this technique, billed as "Pepper's Ghost on the Motion Picture Screen," utilized a partially reflecting sheet of glass to conceal the actual location of the movie screen and give the impression of projected actors moving about the real space of the stage.[7]

F. H. Richardson, the most astute contemporary writer on film technology, observed, "The thing is not, in our opinion, applicable to the motion picture theater. It is *a vaudeville stunt.*"[8] By the time Richardson wrote this, he could assume that most of his readers would agree with him that cinema had cast its artistic lot with the higher form of theater, not with the lower form of stunts, and, significantly, he saw stunts as more appropriate for the vaudeville theater. Since the vaudeville theater was also the model for the movie palace, it is worth noting that similar kinds of stunts have existed throughout the history of movies, of course, most particularly in lower entertainment forms like schlocky movies and the specialized thrill films produced for amusement and theme parks, not the kinds of movies that would aspire to be taken as competing with live drama. On the other hand, it might be possible to claim all movies are stunts since they are based in illusion, but one that does not *require* the sleight-of-hand in presentation of the magic lantern show. Rather, the illusion of movies works differently: *"the pictures themselves do not move,"* as the *Motion Picture News* article noted emphatically, yet so long as the images were projected at the required minimum speed, *nothing* in the circumstances of presentation would allow us to see the still photographs basic to the illusion. The movement, the illusion, took place entirely in the mind of the viewer.

While "persistence of vision" has often been cited, from the beginning of cinema, as the essential explanation for the illusion of movement, it is in fact merely a *precondition* necessitated by the particular mechanical apparatus used to project movies.[9] The stop-and-start mechanism of conventional projectors necessitates a shutter to block light as the film advances from one image to the next so that the screen remains dark for a certain percentage of the time. The persistence of vision only guarantees continuity of image. Even if the illumination were continuous—as it is, for example, with shutterless projectors or flatbed editors—we would still see movement, although there would be no persistence of vision.[10] To this day it is not entirely clear what exactly is responsible for our perception of movement in movies. As a consequence, any possible explanation must seem more mysterious than the more visibly apparent persistence of vision theory.

At least as early as 1912, the year before the *Motion Picture News* articles previously cited, Max Wertheimer in "Experimental Studies on the Seeing of Motion" offered an explanation that broke decisively with the

persistence of vision by identifying the "phi phenomenon."[11] Subsequently, experimental psychologist Hugo Münsterberg explained this phenomenon by summarizing the experimental research of "the last thirty years" in his 1916 *The Photoplay: A Psychological Study*, one of the earliest works of film theory:

> the perception of movement is an independent experience which cannot be reduced to a simple seeing of a series of different positions. A characteristic content of consciousness must be added to such a series of visual impressions. . . . [A]bove all it is clear from such tests that the seeing of the movements is a unique experience which can be entirely independent from the actual seeing of successive positions. . . . The experience of movement is here evidently produced by the spectator's mind and not excited from without.[12]

There is something magical about movement in movies because we cannot fully explain it, but it is a peculiar kind of magic, not at all the result of a sleight-of-hand. Rather, it is magic mysteriously created by and within our minds. It is a kind of *natural* magic.[13]

This mental magic was a central point for Münsterberg's theory since he sought to argue that the uniqueness of film as an art form lay in its ability to imitate the actual processes of the mind. The image was flat, yet perceptual cues in the image prompted the mind to create a sense of depth. The image contained no movement, yet the perceptual cues of rapidly projected still images led the mind to create a sense of movement.

> *Depth and movement alike come to us in the moving picture world, not as hard facts but as a mixture of fact and symbol. They are present and yet they are not there. We invest the impressions with them.* (30, emphasis in the original)

André Bazin might have argued that "Photography affects us like a phenomenon in nature," but it also clearly affects us—and most especially in the movement of movies—as a phenomenon in supernature.[14] There is simply something uncanny in cinema's ability to draw out the magic of our mental apparatus.[15]

Still, my invocation of Bazin at this point and the Bazinian realistic aesthetic suggests another way of looking at the photographic image. I began this chapter by invoking a twin inheritance for cinema. So far I have been concerned with the way in which movies operated as the culminating moment within what Charles Musser has called "a history of screen practice," specifically as the inheritor of a roughly 250-year tradition of magic lantern shows.[16] But as is evident in the preceding chapters, there is another history to which movies belong, and one particularly relevant to a journal like *Motion Picture News* in 1913: the history of the theater. If *Motion Picture News*, like many other contemporary observers, hoped for a change in the dignity of movies by an alliance with the "legitimate" theater, the theater in this period had itself undergone a striking transformation in the previous thirty years or so (as discussed in chapter 1). This was most evident in the stage work of preeminent playwright-director David Belasco:

> The beginnings of Belasco's Broadway career in 1882 marked more than simply a significant personal milestone. Changes were taking place at this time which affected world theatre profoundly; stage naturalism was waging a decisive struggle against the older, established theatrical conventions and practices.[17]

I cannot concern myself here with the programmatic purposes of theatrical naturalism, but "the meticulous attention to material, outward details—in setting, props, lighting, and so on,"[18] the shift away from painted flats to lifelike three-dimensional sets, the new dramatic emphasis granted environment that I noted previously, these innovations are of some consequence to the reception of the feature film. If theater gravitated more and more toward a material realism, then film could seem as much a culminating development in the history of the theater as it was in the history of the magic lantern show.

These twin histories might find a culminating convergence on one object, but they also produce a kind of tension in the object inasmuch as they stake out different aesthetic aims: a kind of supernaturalism set against naturalism, astonishment set against persuasion. This is not to say that audiences weren't astonished by Belasco's meticulous re-creation of Child's Restaurant, complete with the wafting odor of pancakes, on a

theater stage with his production of *The Governor's Lady* in 1912, but this is a different kind of astonishment from that of the movies, based more on our expectations of how elaborate a theatrical set may be. Having the restaurant "exactly reproduced in every detail," as Belasco's prompt book has it, is not really a magical matter any more than naturalistic French director André Antoine's purportedly purchasing "the interior of a student's room in Heidelberg and transfer[ing] it intact to the stage" for a production of *Old Heidelberg* is magical, although certainly astonishing.[19] In some ways, we would be less astonished to have a movie show us the actual Child's Restaurant or the actual student's room *in situ*, and yet the movie is purely illusionistic in a way the theatrical set is not.

A further distinction needs to be made here since the examples I have cited are reconstructions of constructed environments, which means they can, with sufficient time and financial resources, be built on a stage much as the originals were built in reality. But what about natural environments? For *Tiger Rose* (1917), set in the Canadian Northwest, Belasco created a forest onstage as well as an exceptionally realistic rainstorm, while in *The Girl of the Golden West* (1905) he opened the play with a view of Cloudy Mountain in the Sierra Nevadas.[20] For settings like these, various kinds of *trompe l'oeil* effects had to be used, and these did move the sets more into the realm of magical illusionism.[21] For example, the opening of *The Girl of the Golden West* actually created an illusion of movement by means of a vertical rolling panorama that took the audience from mountainside to the town, anticipating, as an observer noted in 1940 "a characteristic 'pan down' of cinema technique."[22] Much as the realism of naturalistic theater seemed to look ahead to film, we still need to make a distinction between realism and reality. Naturalistic theater presented a three-dimensional space sufficiently contrived to invoke an actual setting so that audiences could deem what they saw "realistic." Film, on the other hand, presented a two-dimensional surface on which a preexisting "reality" was reproduced.

In this context, it is understandable that *Motion Picture News* could claim in 1913, "The setting of the photo-play is incomparably more real than anything even a Belasco can give us."[23] As film became more and more a theatrical medium, much contemporary writing on the cinema thought its chief advantage over theater lay in its ability to bring the real world of nature into the artificial precincts of the stage.[24] Tom Gunning has astutely observed, "Restored to its proper historical context, the pro-

jection of the first moving images stands at the climax of a period of intense development of visual entertainments, a tradition in which realism was valued largely for its uncanny effects."[25] Gunning does not include theater in the "visual entertainments" he considers, and it is questionable if European naturalism, in its aim to define the impact of environment on human existence, was consciously searching after uncanny effects. American naturalism and Belasco in particular seem different in this regard since Belasco's realism was often on such a grand scale that it clearly sought to astonish.[26]

Still, if nature in the film image seemed so much more real than any re-creation of the natural environment the stage could offer, the image was also more of an illusion than most *trompe l'oeil* stage techniques since it showed something that, as Münsterberg accurately observed, was not really there.[27] In theater, every object on the stage was present and existed in a space it shared with the audience. In film, the image presented a seeming physical reality contrived from a mere play of light-and-shadow. The paradoxical nature of film in its play of presence and absence prompted a striking response from French drama critic Louis Delluc to his early experience of cinema that is itself playfully paradoxical:

> A chance evening at a cinema on the Boulevards gave me such an extraordinary artistic pleasure that it seemed to have nothing at all to do with art. For a long time, I have realized that the cinema was destined to provide us with impressions of evanescent eternal beauty, since it alone offers us the spectacle of nature, and sometimes even the spectacle of real human activity.[28]

Artistic pleasure from something that isn't art, beauty that is both forever and fleeting—all this suggests the uncanniness of cinema in that it provides an experience that moves us beyond any conventional rational categories that may contain it. But if the cinema has such power to unsettle our confidence in our own perceptual mechanisms, how could it also improve itself by becoming the transparent purveyor of theater?

## CONTAINING THE UNCANNY IMAGE

As the illusions of theater and film are different, a striking difference in the way each exhibited its respective illusions to the audience had become

established by the emergence of the early feature film. That difference and the implications of a distinctive exhibition practice in the teens and twenties will be the concern of the rest of this chapter. Even within the context of fourth-wall staging, which seems to efface its devices and simply present us with a slice-of-life reality, an elaborately decorated gilt proscenium as a frame for the stage setting and actions effectively lays bare the illusion. No matter how elaborate, detailed, and realistic the setting, no matter how naturalistic the performances, they nevertheless exist within the same space as the proscenium, so that the proscenium, framing the otherwise invisible fourth wall, effectively calls on the audience to participate actively in the construction of the illusion. In a sense, the uncanniness of the stage illusion is tamed by the fact that it requires our complicity: we are co-creators of the illusion. In film, on the contrary, the illusion remains disturbingly uncanny because it happens both within us as a consequence of our neurological makeup, yet seemingly independent of us since we cannot deconstruct the illusion.

If the fourth-wall aesthetics of naturalistic theater found a way of marking off the space of the setting from that of the theater, there was less certainty of how the space of the film image, seemingly so different from our space, should set itself off from the rest of the theater. As noted in chapter 1, the earliest showings in vaudeville theaters invoked a kind of magic pictorialism in their presentation with the Vitascope as a successor to the Glyptorama even in its "staging" of the film screen encased within a gilt frame. This practice continued into the nickelodeon era as described in chapter 3 and seems to have been a common exhibition practice until the introduction of the feature film. At the dawn of the feature film, however, another practice was proposed in 1909 that would move film exhibition in a strikingly new direction:

> To our mind, something in the nature of a compromise between the ordinary and a moving picture stage is desirable. Let us imagine the ordinary stage opening. It may be forty or fifty feet across and proportionately deep. But you do not want a picture that size. It seems to us that the best plan in such a case is to set the moving picture screen well back on the stage and to connect the sides of the house by suitably painted cloths or side pieces so that when the house is darkened and the picture is shown the audience have the

impression that they are looking at the enactment of a scene set a little way back on the stage. They look at it, as it were, through an aperture or tunnel, at the side of which there is nothing to distract their attention, but rather something in the nature of a design complementary to the picture which shall concentrate their attention on the latter. . . . The average audience likes illusion, and the greater the illusion, the better it likes it. An ordinary stage play, after all, is only an illusion.[29]

As we saw in the previous chapter, beginning with the earliest feature-length films, movies were being shown more and more frequently in legitimate theaters. But in the architectural space of the legitimate theater, the motion picture image encountered an exhibition problem.[30] While screens at the time ranged from 12 to 20 feet, an "ordinary stage opening" is described here as "forty or fifty feet across." On such a stage, black masking or even a gilded frame situated on a dark stage would only emphasize the smallness of the image and decisively set it apart from the dramatic space of the stage. The solution proposed above of the set surrounding the picture would make the space of the image continuous with that of the stage: there would be a setting across the entire stage as in any live performance, but in effect all the action would take place upstage. In the process, a new illusion could be created that complemented and extended the illusion of realistic stagecraft: where a setting extending to the downstage area could aspire to realistic re-creation, the upstage image could present a photographic copy of the real world. As this writer's praise for illusion suggests, this manner of presentation would effectively ally the magic illusion of the film image with the more concrete illusion of the stage.

Although the "picture set" or "picture setting," as it was subsequently called, would soon become common in first-run theaters, I do not know if the stage setting described in this article is merely a recommendation or the invocation of an actual practice. Nor have I been able to determine precisely when the first picture setting was used. But it is clear that the arrival of the feature-length film, modeled on stage plays, did lead to a manner of presentation that would become standard practice until the introduction of sound: the motion picture screen placed upstage within a theatrical set of some design. As we have seen with the touring companies for George Kleine's imported Italian features, these were like combination

companies in live theater precisely because they were sent around with settings. By 1913, the movie screen encased in a stage set had become enough of a convention that *Motion Picture News* could praise a theater for going a different route: "Instead of having the wings of the stage fitted up with regular scenery, *as is too often the case*, Mr. Lynch draped the whole stage in heavy dark curtains."[31] By 1914 there is evidence of theaters in the Midwest both large and small using picture settings (figs. 5.1 and 5.2).[32]

How commonplace the screen in the stage setting quickly became can best be demonstrated by a more prominent counterexample—the New York showing of D. W. Griffith's *Birth of Nation* in 1915. When *The Birth of a Nation* opened on March 3, 1915, it followed the practice of other big features at the time by renting a theater normally used for live drama, the Liberty Theatre in Times Square. Nevertheless, Griffith wanted to make this showing distinctive, and he did so by using the theater's standing scale of $2.00 top for tickets. Up to this point, legitimate theaters

FIGURE 5.1
The 1914 picture setting for the 2,000-seat New Willis Wood Theater in Kansas City, Missouri, with ferns, flowers, a leafy border, and a running fountain.

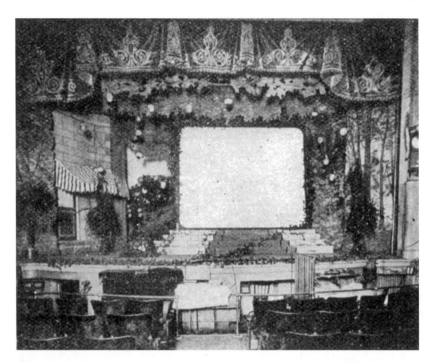

FIGURE 5.2

The Majestic in Cleveland had a picture setting (also 1914) that moved the screen off-center to provide room on its small stage for an orchestra, although it did have an orchestra pit.

used for special-event feature films generally utilized a lower price scale. The obvious ambition expressed by venue and price was very much in keeping with what Griffith claimed in a curtain speech: "he said that his aim was to place pictures on a par with the spoken word as a medium for artistic expression appealing to thinking people."[33] The use of a legitimate theater and its $2.00 top have been noted before, but there was a third unusual aspect to this showing that has gone unremarked, although it is something that actually departed from Griffith's invocation of the "theatrical" as a way to achieve prestige for his film: "In showing the film, the stage at the Liberty Theatre appeared merely as a black background on which the screen was placed. Mr. Griffith, it is said, refused all suggestions for scenic decorations, holding that attention should not be distracted from the picture." This is to say that a manner of presenting the

FIGURE 5.3
The picture setting for *The Clansman* in Los Angeles, February 1915, before the New York premiere in March.

image that would now strike us as conventional was then regarded as a departure from convention. Why?

I can get at the distinction here most clearly by comparing the New York performance to the Los Angeles opening a month earlier at Clune's Auditorium. In New York, the curtain rose on the titles of the film, but at the earlier Los Angeles premiere of *The Clansman* ( D. W. Griffith's first title for *Birth of a Nation*), on February 5, 1915, the curtain rose to a grander spectacle (fig. 5.3):

> In the opening the curtain rises on a Southern home, of two stories, the front adorned with six pillars. The stage of the Auditorium is 100 feet wide and 55 feet deep. The opening is 50 feet. The mansion, which is 68 feet wide or long, if you prefer, sits back 20 feet from the stage opening. As the house appears to view the orchestra softly plays "The Mocking Bird." A woman garbed as Mrs. Cameron

emerges from the front door and sits down to the side. A man dressed as Mr. Cameron comes out, caresses the hand of the woman, and slips into a chair by the entrance. The orchestra shifts to "Suwanee River." The stage lamps are lowered. A light appears in an upper window. The music changes to "Old Kentucky Home." The screen is lowered. The house is in the atmosphere of the story before the title is shown.[34]

This description doesn't specify how the screen was situated once it was "lowered," but Griffith's remarks at the New York premiere as well as my subsequent examples strongly suggest that the screen was made an element of the setting, that in Los Angeles at least "attention [could] be distracted from the picture." Griffith was clearly aware he was doing something radical at the New York showing: in trying to make claims for film art as the equal of stage art, he made the image the stage itself. But the image as stage was hardly the common understanding of the period. As the manager of Clune's Auditorium remarked of the *Clansman* showing, "the proper presentation of a big subject should increase by at least 50 per cent the entertainment quality of the producer's finished work."

Because dominant conventions can be powerful, even Griffith himself had trouble abiding by his notion of the unencumbered image. When he premiered *Broken Blossoms* in New York on May 13, 1919, Griffith did remain true to his ambition to claim the status of legitimate theater for his cinematic work: at a point when he could have used a dedicated film theater because far more had been built and many legitimate theaters had been converted to film theaters, he nevertheless booked the film into the George M. Cohan Theatre and did so as part of his "Repertory Season," thereby enhancing its status as theatrical event. Nevertheless, there were plenty of extra-filmic distractions in the performance: the theater was filled with incense, while colored lights played on the screen throughout the showing to complement the tinting of the image. And the "film," or perhaps more accurately, the evening's entertainment, began in the following manner:

at the rise of the curtain there is a tableau depicting the Chinese priest at prayer over the bier of his loved one, and nearby the Buddha, smiling benignly. This scene is a trifle too long-drawn, and it is a question whether "Broken Blossoms" wouldn't be as effective without it.[35]

As with *The Clansman*, contemporary reports do not say anything more about how the screen was placed on the stage, but practices at the time as well as other performances of *Broken Blossoms* suggest that the screen was situated within the set designed for the prologue. The concern for a special staging of each feature was not limited to reserved-seat theaters in the biggest metropolitan areas. Consider, for example, presentations of *Broken Blossoms* at two smaller city theaters: at the Majestic Theatre in Portland, Oregon, ushers were dressed in Chinese costume to complement a Chinese motif on the stage (fig. 5.4),[36] while the Liberty Theatre in Spokane, Washington, presented "novel stage settings and attractive decorations" (fig. 5.5).[37]

Although I cannot determine a first instance of these picture settings, they do have a clear antecedent in Hale's Tours since the train interior that framed the screen was a constructed world like a stage setting. In chapter 2, I had considered Hale's Tours architecturally, for the way it provided a model for the nickelodeon. But it is also important in anticipating how the film image may be made to relate to its surrounding space. While films were made specifically for Hale's Tours, at the time of its inception there was already a body of films perfectly suited for it, namely the "phantom ride" films popular in England toward the end of the nine-

FIGURE 5.4
For a showing of *Broken Blossoms* in Portland, Oregon, the picture setting had what was considered a Chinese motif complemented by Chinese costumes for the ushers.

FIGURE 5.5
The presentation of *Broken Blossoms* in Spokane surrounded the stage with flowers and featured women in Chinese costume performing in a prologue.

teenth century, "conventionally projected motion pictures of scenic locales which had been photographed from the cowcatcher of a speeding train."[38] Charles Musser quotes a contemporary response to a phantom ride film that is of some significance here:

> The spectator was not an outsider watching from safety the rush of cars. He was a passenger on a phantom train ride that whirled him through space at nearly a mile a minute. There was no smoke, no glimpse of shuddering frame or crushing wheels. There was nothing to indicate motion save the shining vista of tracks that was eaten up irresistibly, rapidly, and the disappearing panorama of banks and fences.
>
> The train was invisible, and yet the landscape swept by remorselessly . . .[39]

As the description makes clear, the name "phantom ride" was appropriate for these films because there was something uncanny about them in

the way they seemed to turn the spectators into phantoms, almost dis-
embodying them. By anchoring the phantom images in its realistically
re-created setting, Hale's Tours in effect kept the phantasmic thrill of the
ride but tamed the uncanny aspects of the medium by making the illusion
extend off the screen into the reconstructed environment of the train car.
The entire train car was not unlike the stage settings described above,
complete with the film image located upstage. As a consequence, the
train car set provided not only a context for the image but also a contain-
ment. If Hale's Tours possibly represents the earliest attempt to encase
the moving image within a theatrical setting, by the 1920s this had
become such a standardized part of film presentation that companies
specializing in picture settings advertised in trade journals, with Novelty
Scenic Studios and Tiffin Scenic Studios the dominant advertisers (figs.
5.6 and 5.7).[40] Also, trade journals would regularly feature examples of
novel picture settings in their pages (figs. 5.8 and 5.9).[41]

Initially, except for extended-run theaters, which would use picture
settings thematically related to the feature film, a distinctive picture set-
ting could serve as a way of branding the theater, as will be evident from

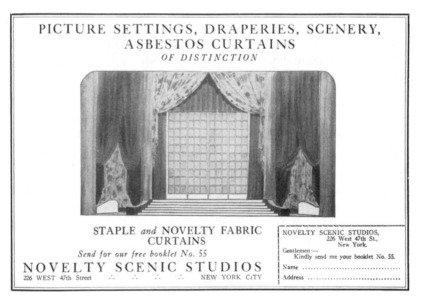

FIGURE 5.6
A trade journal advertisement (1926) for Novelty Scenic Studios with a picture set-
ting that features the recurrent motif of a window that gives way to the screen.

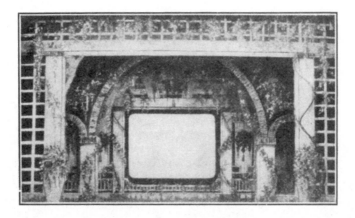

# PICTURE SETTINGS
### *Either Painted or Fabric*

---

# JUNIOR D. K. AUTOMATIC CURTAIN MACHINE
### *Low Price -- Fool-Proof*

---

## TIFFIN SCENIC STUDIOS HARDWOOD NOISELESS CURTAIN TRACKS

---

## COMPLETE LINE OF DRAPERIES FOR YOUR STAGE AND AUDITORIUM

TIFFIN, OHIO

*Send for Catalogue*

FIGURE 5.7

A trade journal advertisement (also 1926) for Tiffin Scenic Studios, with the setting utilizing another recurrent motif, lattice and plants to invoke a garden.

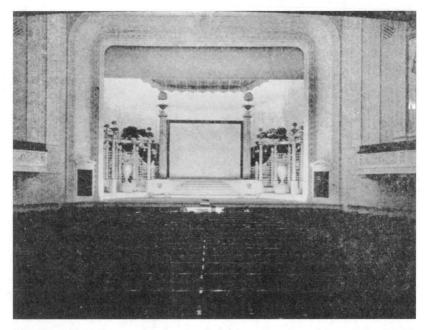

FIGURE 5.8
A fanciful stage treatment in a North Carolina theater (1925), albeit with the familiar garden referents of lattice and plants.

a number of examples below. They became such a common feature of film exhibition in the 1920s that through the late 1920s and even into the early 1930s a section known variously as the "Buyers Index" and the "Equipment Index" in *Exhibitors Herald* and its successor *Motion Picture Herald* had a separate entry for "Picture Sets," listing four suppliers and a recommendation for how the sets could be used in weekly change theaters: "Picture sets in non-presentation houses are usually changed seasonally or prepared for holiday programs and special events. Theaters offering presentation acts make it a point to change weekly the effects surrounding the screen."[42] (For an example of a seasonal setting at the Hippodrome in Buffalo, see figure 5.10.)[43] And the set as a theatrical frame for the movies was not limited to the stage. Photographs of atmospheric theaters, which emerged in the early 1920s, generally just show decorations along the walls or the ceiling, but if you look at them in terms of their stage settings, it seems clear that the theater itself had become an extension of the stage, much as Max Reinhardt around the same time had turned an entire theater into a set of a cathedral for his production of *The*

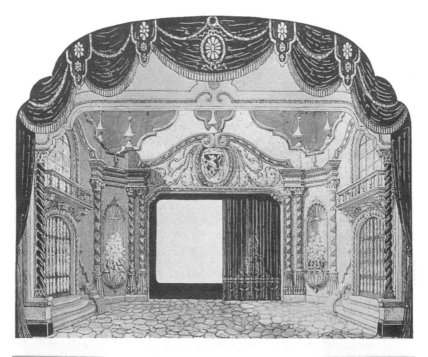
 Atmospheric Setting

FIGURE 5.9
*Motion Picture News*'s suggestion (1927) for a picture setting that might be appropriate for an atmospheric theater.

FIGURE 5.10
A seasonal setting for Christmas at the Hippodrome in Buffalo (1920).

*Miracle.* (For an example of how the stage set connected to the constructed setting of John Eberson's atmospheric Olympia Theatre in Miami, see figure 5.11.)[44]

Before I explore how this taming of the uncanny applied to the picture settings used for film showings in the teens and twenties, I would like to take a brief detour through Sigmund Freud's "The 'Uncanny'" ("Das 'Un-heimliche'") in order to establish more precisely how we might understand the magical effect of the movies as it relates to theatrical form.[45] Freud argues that the uncanny lies in a recurrence either of ways of thinking that have been "surmounted" in a civilization—e.g., animism expelled by the triumph of rationalist thought—or emotions that have been "repressed" in an individual.[46] Terry Castle has given Freud's argument a historical dimension that has some interest for the history of film because it suggests a provocative way of thinking about one of cinema's twin inheritances:

> When did this crucial internalization of rationalist protocols [surmounting earlier forms of thought] take place? At least in the West, Freud hints, not *that* long ago. At numerous points in "The

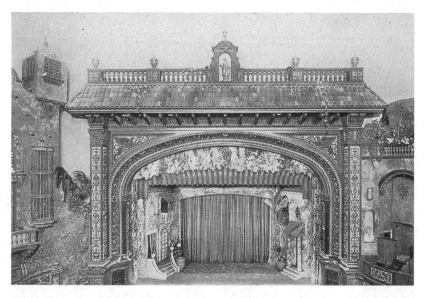

FIGURE 5.11
In this atmospheric theater from Miami (1926), the picture setting connects to the architecture, suggesting that this type of theater might literally be an extension of the picture settings.

'Uncanny'" . . . it is difficult to avoid the conclusion that it was dur-
ing the eighteenth century, with its confident rejection of transcen-
dental explanations, compulsive quest for systematic knowledge, and
self-conscious valorization of "reason" over "superstition," that human
beings first experienced that encompassing sense of strangeness and
unease Freud finds so characteristic of modern life. (Castle, 10)

Enlightenment, then, begot its own forms of darkness and mystification,
something Castle finds most evident in the "ghost-shows of late eighteenth
century and early nineteenth-century Europe—illusionistic exhibitions
and public entertainments in which 'spectres' were produced through
the use of the magic lantern" (141).

Castle notes a striking paradox in the way these magic lantern shows
worked both to demystify and mystify anew, in effect providing a ratio-
nalist explanation in order to create a sense of the uncanny:

The early magic lantern shows developed as mock exercises in scien-
tific demystification complete with preliminary lectures on the fal-
lacy of ghost-belief and the various cheats perpetrated by conjurers
and necromancers over the centuries. But the pretense of pedagogy
quickly gave way when the phantasmagoria itself began, for clever
illusionists were careful never to reveal exactly how their own bizarre,
sometimes frightening apparitions were produced. Everything was
done, quite shamelessly, to intensify the supernatural effect. (143)

Exhibition in a seemingly rationalist context finds a striking parallel in
the earliest film showings, which stressed film as a scientific advance.
Even the early procedure of making the projector part of the spectacle
was to present film as the latest wonder of the scientific age.

Nonetheless, these demonstrations were not purely science; rather,
they became entertainment by a conjunction of wonder and science. The
mechanics of film technology are sufficiently transparent that it is com-
mon knowledge a film strip is made up of still images, as my above citation
from *Motion Picture News* makes clear (*MPN*, Dec. 13, 1913). By contrast, the
technology of a television set is so invisible that it might seem more wonder-
ful than movies in its complexity, and yet it doesn't have the same uncanny
effect because with television we have little sense of stillness magically
transformed into motion.[47] The popularity of persistence of vision as an

explanation for how movies work likely lies in its easily comprehensible science as there seems little mysterious in the ability of intense light to leave a lingering trace on a receptive membrane. It is in fact something we can empirically demonstrate to ourselves. Yet this explanation has also served to *repress* the actual explanation, which does seem more magical since it is a strange phenomenon of the brain. In this way, our supposed scientific knowledge here leaves space for the return of the repressed and with it a sense of the uncanny. As noted in chapter 1, the early Lumière showings would begin by progressively—and magically—transforming a still image into motion.[48] In this way, what begins as science ends as magic, much in the manner of the specter shows described by Terry Castle.

With these speculations on the uncanny aspects of movies in mind, I would like to turn to some of the earliest recorded theatrical exhibitions of film that utilized stage settings. The *Motion Picture News* article that recommended stage settings for the screen suggested a setting that would complement what was shown in the film image. This does seem to be the case with some of the earliest special film features, generally imported, such as *The Last Days of Pompeii* (1913), and this continued to be the case for features that played in extended-run theaters. But in the palaces it was more common throughout the teens to use a standing set that helped give the theater a specific identity. Consider, for example, the attempt to show movies in the vast original Madison Square Garden in 1915 as a way of trying to stabilize its shaky economic situation. The resultant film theater was enormous, approximately 8,000 seats. As a way of filling out the space in front of the audience, the management created a striking arrangement around the screen, intending it to operate as something of a trademark for the theater: "By the liberal use of stage ice and snow, the Fourth Avenue end of the arena has been made to look exceedingly arctic and from the projecting machines at the far end of the room come occasional suggestions of the aurora borealis. All this is to lend color to the slogan 'Meet me at the Iceberg' . . ." The use of the aurora borealis, a kind of natural magic, as a way of enhancing the screen image reflects an the understanding of cinema as a form of magical nature.

Moving the film image into the realm of legitimate theater via the introduction of the feature film seems to have generally demanded a different kind of setting, one that shifted it away from magic and made it more a transparent medium that could mass-produce the theatrical experience previously available only in one theater at one time. In the previous chapter,

I had discussed how the Vitagraph Company took over the "legitimate" Criterion Theatre in 1914 to showcase its move into feature film production. The manner of presentation was crucial to the strategy of the Vitagraph Theater. When the curtain went up on the conventional stage, audiences saw a specially defined set that Vitagraph wanted as part of the theater's identity:

> With the use of the theatre drop-curtain an artistic studio setting, with attractive art objects, draperies, rugs, is revealed. In the center of the studio is a large French window, looking out upon a balustrade.
>
> Through the window is revealed the blue waters of New York Bay, and in the foreground the striking group of skyscrapers that cluster around the Battery.[49]

The view of New York harbor was accomplished through a panoramic painting on a backdrop, and since each show began with the setting of the "sun," lights were strategically cut into the painting to represent stars. In all, this set appears to have been in the tradition of *trompe l'oeil* realism of the stage at this period (fig. 5.12).

FIGURE 5.12
The picture setting for the Vitagraph Theater (1914), New York; after the view out the window presented a simulation of twilight, the window would be replaced by a movie screen.

The set served as a space of live performance that was interspersed with the film showings, but it was most specifically designed to showcase the film image. At the point when the film showing was to start—"dusk"—something magical happened: "The daylight scene faded slowly and lights began to twinkle here and there, all the way out to the lamp upheld in the outstretched hand of the statue Goddess of Liberty. As night fell over the delightful setting, the curtain dropped across the window and rose upon the picture screen hung across the window."[50] The reality of the film image in effect took over from the artifice of reality presented by the painting. In some ways, the painting had an advantage over the film image: it was in color, and it had a palpable physical presence. But it always remained a *representation* of the natural world, rather than the seemingly direct presentation the film image could accomplish.

From the evidence I have been able to gather, I would say that a set as specific as an artist's studio was generally not used in later picture settings. But there is one element here that did have a lasting influence on subsequent settings, what J. Stuart Blackton, the head of Vitagraph, called the "Window on the World."[51] The equation of screen with window seems to bespeak a common understanding of the period. A 1914 *Motion Picture News* article intended to explain the different kinds of screens available to theater owners begins forthrightly: "A projection screen is a window through which the public wants to see as many and as different interesting things as possible."[52] By about 1916 something of a template for permanent picture settings had emerged in deluxe theaters, what I would like to call the "window in the garden" (fig. 5.13). These settings generally present a formal garden, and, since it is a formal garden, elements of older architectural forms; in the middle of this garden, seemingly attached to a structure, is a large window. It is always in this space of the window that the movie image would appear. While the setting has elements of nature, it represents something that is also a construct in the real world, so that it is the kind of thing Belasco might present effectively on the stage without any *trompe l'oeil* effects. And although these settings could often be quite fanciful, there was a Belasco-like concern for physical realism in the use of real foliage and grass, treated to preserve them. And there was often, as in the example presented here, a fountain that could run intermittently (as we saw above) or even throughout the performance.

FIGURE 5.13

The Strand Theatre (1916), Newark, presents a window in the garden, complete with a working fountain.

The stage set used for the opening of the Strand in New York (fig. 5.14) featured another element that was a common motif in the early picture settings that were used in the palaces:

> The setting suggested the interior of a Greek temple, marble-like pillars supported an airy graceful roof, while to the right and to the left, one looked out from the sides of the temple upon hazy landscapes which made one think of woodland and of meadows. The green garlands wound about the top of the pillars, the profusion of flowers in front of the temple, the harmony of the Greek type of architecture suggests even in its ruins—all combined to make a noble and striking habitation for the screen.[53]

Although the structure does not look particularly Greek, the use of a clearly archaic architectural form at the Strand and subsequently other palaces could serve to validate the high-class aspirations of the new medium, the direct competitor to the legitimate theater. On the other hand, the elements of nature invoked the natural world, but in a way that could admit of human intervention, such as the flower arrangements at the Strand or, in other instances, a formal garden. The fountain situated in front of the film image became sufficiently de rigueur that supply

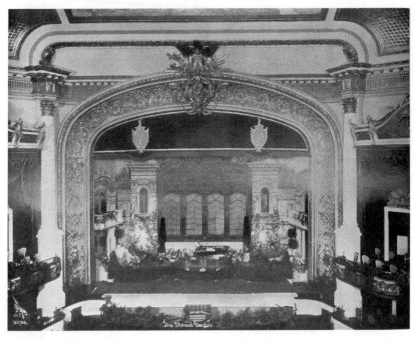

FIGURE 5.14
The Strand (1914), New York, with an elevated style of architecture. Set against enclosed nature of this space is the illusion of a real world in the painted backdrop of "hazy landscapes" at the top left and right of the set.

companies soon began to advertise them in the trade press. But it was a fountain, not a waterfall.[54] In this context of artificially constructed nature, then, the film image could assert its own superiority in its ability to present the real world of nature on the stage of artifice.

Still, if the film image was set apart from the artifice of the setting, the surround for the image was paradoxically a frame that doesn't seem to be a frame.[55] Where the gilded frame of the earliest film showings created a decisive boundary between film image and auditorium space, the picture settings of the teens established a continuity between image and stage set. There was still the frame of the proscenium arch to distinguish the space of the audience from that of the stage, but the proscenium also served to establish picture and picture setting as a kind of organic unity. By contrast, in Hale's Tours the illusionistic space of the flat screen was made continuous with the real three-dimensional space of the train car. In a sense, the entire viewing area in Hale's Tours was a stage set, with

audience members and actors in a drama of tourism. In the conventional proscenium movie theater of the teens, the stage setting and the film image were set off from the audience and connected to each other because they offered differing ways of re-creating the world on stage. The picture setting might have highlighted an opposition between stage and film re-creations of the real world, but it also, contrarily, muted the opposition by making the screen an indivisible element of the set.

## THE THEATRICAL MOVIE SCREEN

At this point I want to return briefly to Freud because the play between opposition and similarity that I have noted in these picture settings parallels an essential point in his essay on the uncanny: a continuity between opposites. Freud begins the essay with an extensive consideration of the meanings of *unheimlich*, how it might be translated into other languages and its various connotations in German. As a preliminary, he notes, "The German word '*unheimlich*' is obviously the opposite of '*heimlich*' ['homely'], '*heimisch*' ['native']—the opposite of what is familiar . . ." (220). But exploration of dictionary meanings leads him to an odd fact: while *heimlich* in its primary meanings is clearly an antonym for *unheimlich*, a secondary meaning of *heimlich*—"Concealed, kept from sight, so that others do not get to know of or about it, withheld from others" (223)—is not. In fact, "among its different shades of meaning the word '*heimlich*' exhibits one which is identical with its opposite, '*unheimlich*'. What is *heimlich* thus comes to be *unheimlich*" (224). The *heimlich* then effectively contains the *unheimlich*, and the uncanny is not so much foreign as something that exists within the known world.

This play of opposites that contains/conceals similarities may be found in the ways the screen was related to its picture setting during the silent period. Nowadays we tend to see the screen image as set off from our space by a sea of black cloth that leaves it spectrally suspended in midair. But in the teens and twenties, at least, much as the film image was usually situated within a stage setting, it was a permeable thing, as if the space of the screen were continuous with the space of the stage, at the same time that it always remained impermeable—the ultimate fourth wall, as I noted in chapter 2. From the mid-teens to at least 1920 there were various attempts to blend stage and screen action, with the film interrupted by a live-action performance on stage that was directly connected to the action of the

film; the stage performance completed, the film then resumed its own course.

The earliest example of this intermingling used with a feature that I've found was the three-hour film version of a well-known novel, *Ramona* (1915), directed by Donald Crisp, better known as an actor, with a separate director indicated for the stage portions.[56] The film was described in advertisements as a "Cinema-Drama," then, a few days after the opening, perhaps to correct the suggestion of simply a drama on film, it was given a more intriguing designation, "A Cinema-Theatric Entertainment."[57] A description that ran before the New York premiere made clear that live-performance sequences would intermingle with film sequences, providing a bridge for separate sections of the narrative: "To heighten the feeling of atmosphere three massive stage settings will be disclosed at intervals during the exhibition. These scenes will be peopled by the characters of the story, but except in the songs they sing there will be no word spoken on the stage. After each setting the theatre will be slowly darkened and then the picture will appear on the screen."[58] Creating atmosphere frequently comes up in commentary as a goal for these stagings, as if live performers are needed to draw us into the remote world of the film. And while the performance was something of an entr'acte for the film, it did not remain completely discrete: "There is the staging, the three great atmosphere-creating sets shown before the prologue and the first and second acts, peopled by types of the period, Indians, musicians, singers. . . . The singing of the sunrise song as *on the screen* we see the members of the Moreno household at their window will linger in memory."[59]

In spite of his earlier attempt with *Birth of a Nation* to make the image the stage, perhaps the most extreme example of intermingling stage and screen came from D. W. Griffith himself. For the New York premiere of *The Fall of Babylon* in 1919, Griffith had the film "exhibited in a setting of singing and dancing numbers that go to make up an elaborate program."[60] An advertisement the day of the premiere made clear the live entertainment was not simply a prologue to the film, a standard practice of the period I will discuss below, but, rather, something that occurred repeatedly throughout the film's showing:

> The production will be preceded by an acted prologue on the speaking stage, and interspersed with ensemble numbers, including Kyra

and a ballet of living dancers—the first entertainment of its kind in America or Europe.[61]

Although *The Fall of Babylon*, originally one section of *Intolerance* (1916), is best remembered for its gargantuan sets and scenes of spectacle, the presentation, repeated in other cities, seemed to acknowledge that film spectacle was not sufficient.[62] In the view of the *New York Times* review, it was in fact the emphasis on spectacle that facilitated the interruptions:

> The dancing and singing numbers interspersed throughout the program enhance the effect of the whole, though their interruptions might impair a more compactly knit story than that of the photo-spectacle whose atmosphere they intensify.

This effectively posits an opposition between spectacle and drama that is crucial for the period and allies the exhibition practice at this performance with a spectacle tradition. A spectacle aesthetic could allow for the possibility of other kinds of spectacle, theatrical as well as filmic. There was nothing inherent in the fiction that created the need for live performers, but the demands of spectacle could.

But why should live performance "enhance the effect of the whole"? The *kind* of spectacle the stage offered as an extension of the screen is key here.

> Actors, dancers and pantomimists in person are also used to augment the performers of the screen. . . . His [Griffith's] effects are obtained by music, stage settings and lighting arrangements which are co-ordinated to the action of the screen.[63]

> They are mainly interludes during the festive scenes on the screen, and the producer adroitly brings the singers and dancers forward in person at appropriate moments.[64]

If the primary appeal of the image is spectacle, as was the case with *The Fall of Babylon*, then the stage, while less convincing as a (re)presentation of reality, nonetheless offers more in terms of visual field because the "stage settings" quite simply expand what we can see. In their breadth, color, play of light in three-dimensional space, and simple physical presence, these

interludes offered more excitement for the eyes. Second, if these "interludes" occur primarily as expansions of "the festive scenes on the screen," the live stage can escalate the sense of festivity by offering song and dance because these are both elements that effectively stop the advance of the narrative and turn the drama into pure spectacle.

In the small number of film exhibitions which cut live performance into the film that I have been able to locate, it is not surprising, given the limitations of the screen at the time, that song and dance are the crucial elements in the interpolated material. Consider the exhibition of this 1920 film at the Los Angeles Theatre as directed by Samuel "Roxy" Rothapfel:

> Twelve minutes after Allan Dwan's magnificent cinema spectacle, "Soldiers of Fortune," is under way, and after we have met his characters in the desert of Arizona and later in the millionaire's ballroom in New York, the picture fades out and the stage is flooded with a glow of amber and gold. *Out of the shadows comes human beings, singing and dancing,* and blending with the flood of color we hear dreamy melodies of South American music.
>
> The illusion lasts a few minutes. The lights are dimmed, melodies join their echoes and then the screen flashes back to us a panorama of a South American city. *One seems to have stepped from the warm presence of real living people* into their own city as the characters of the play again are assembled and we find the locale transferred from gay old New York to the mining camps of the foothills of the Andes.
>
> The cut into the feature is a daring innovation, to say the least, but Mr. Rothapfel has done it successfully. *The continuity of the story has not been interrupted, but rather the action has been accelerated.* Certainly, the South American atmosphere introduced at this time prepares us better than any subtitle for our entrance with the character of the play into that land of jealousies and revolutions.[65]

Of course, this interpolated performance was not just a matter of adding song to the dramatic experience, since songs could be—and were—performed as part of the live musical accompaniment to films at this time. As with *The Fall of Babylon*, there is an implied concern that the live performance might derail the film drama since this description makes the counterclaim of enhancing the narrative and maintaining a continuity

of story and action. Certainly the care that was taken with transitions from screen to stage and back again points to a focusing on continuity. But how the continuity was achieved suggests contemporary understanding of the differences in experience between stage and screen action: having the real people on stage emerge from shadows effectively allies them with the shadow figures on the screen, creating a kind of stage magic that could recall Living Pictures. As with Living Pictures, the presence of real people itself takes on a magical quality. Much as the screen creates a kind of enforced distance from the actors and a resulting coldness, the live performances grant the extra dimension of a "warm presence." The transition back to the film image comes not with people, but with what film can always do better than the stage, "a panorama of a South American city."

This opposition between the shadowy world of motion pictures and the fully embodied world of the stage was made explicit in advertising for an engagement of *In Old Kentucky* at Balaban and Katz's Riviera theater in Chicago in 1920. The film was based on a very popular late-nineteenth-century play best known for its climactic horse race, as shown on the stage with actual horses on a treadmill. In his study of motion pictures as the successor to nineteenth-century theater, Nicholas Vardac claims it is precisely this kind of spectacular scene that movies effectively eliminated from the stage by being able to provide more realistic action and setting.[66] The live performance preceded the famous scene and even brought actual horses onto the stage, but it did not attempt to re-create the race itself, which would seem to support Vardac's claim.

> As those who have seen the picture know the big "punch" of the play is the race which is won by "Queen Bess" and ridden by "Madge" in the absence of the drunken jockey. Interest in the picture at this point is at fever heat, occurring as it does in the fifth reel.
>
> It was at this point the Riviera management brought in their novelty. The film was stopped, the screen raised and disclosed a corner of a typical Kentucky race course. Stable boys are lolling about, darkeys strumming on musical instruments sit beneath the trees while more energetic picaninnies are dancing in the dust. Off in one corner a crap game is in progress. The atmosphere of a hot summer day is conveyed to the spectator by the bright sunlight streaming down.
>
> The time arrives for the jockeys to "weigh-in." "Madge," impersonated by a young lady about the size and build of Anita Stewart

[the star of the film], saddle in hand, dressed in the drunken jockey's riding suit, arrives, accompanied by the Colonel and the caretaker of "Queen Bess." She is spirited to the stable and rides to the judge's stand with the rest of the field. The gong rings. All is activity. The dice and banjos are laid away and the race is on. As the excited crowd leans over the paddock fence cheering the riders on, the screen descends, the orchestra crashes into a lively air and the picture continues with *one of the most realistic and breath taking races ever filmed.*[67]

But if this presentation seems to concede the thrilling realism of the race itself to the film image, why have live performance at all? A clue to contemporary thinking on this issue may be found in observations about stage setting and live performance from two contemporary witnesses. When Samuel Rothapfel—Roxy—opened the Regent in 1913, he devised a stage setting for the screen in a familiar tripartite form, surrounding it with two windows where singers would stand and occasionally perform during the film, as well as an orchestra onstage in front of the screen. An architect who wrote a column for *Motion Picture News* singled this out for praise in striking terms: "Mr. Rothapfel has the right idea, as a picture shown on a plain wall, with practically no frame to it, looks *too cold and mechanical.*"[68] A dozen years later, by which time picture settings and live performance had become standard elements in movie palace entertainment, Eric Clarke, "Managing Director of the Eastman Theatre," a highly regarded presentation house in Rochester, observed, "After an hour and a half of steady concentration on the screen, there is a need for something more—something that will show actual people as a contrast to the shadowy figures that flit across the silver sheet."[69] In the silent era, at least, when the lack of spoken dialogue could make the film image seem all the more a play of light and shadow, more mechanical re-creation than life itself, there was a need to bring real life into play with the simulacrum of life.

As in the other examples of interpolated live performance, not just music but singing figures prominently as a way of moving beyond the cold and mechanical.[70] But with *In Old Kentucky*, this was not intended solely as an interlude that could enhance the atmosphere of the film; rather, there was also some concern with developing the narrative, effectively providing a scene leading up to the race itself that is not present in the film. The expansion of the narrative could possibly increase the sus-

pense of the film by delaying the climactic race, a tactic suggested by the advertising for this performance. But the advertisement (fig. 5.15) also points to a different appeal, one pertinent to my concerns here:

*The Super-Sensation of the Hour The Pulmotor of Riviera Presentation Has Actually Instilled Life Into the Shadows* They Actually Step From the Screen HERE—On the Riviera Stage the Living Characters Enact Their Thrilling Ante-Climax THE STRUM OF THE BANJOS PLANK OUT THEIR ACCOMPANIMENT TO THE DANCING OF STABLE BOYS THE JOCKEYS LED BY MADGE Weigh In at the Paddock to Be Led to the Track on Their Blooded Mounts THE OLD COLONEL STEALS ACROSS THE TRACK TO HIS VANTAGE POINT ON THE FENCE The Tense Moment of Anticipation BECOMES A SEEMING HOUR AND THEN THEY'RE OFF[71]

If we often see the initial appeal of movies as the apparent re-creation of life, this advertisement also makes clear we are always aware it is not actual life. The live performance operates as a "pulmotor," a device to pump oxygen into lungs, because it transforms shadows into actual beings, *grants them a life they do not really have on the screen.* Although the stage setting of a racetrack does not have the reality of the film set at an actual racetrack, it does have the reality of belonging to our world, where live actors can embody "living characters," allied with but different from what we see on the screen. While that sense of presence could play against the excitement of the film's climax by making the filmic action seem all the more remote, the intent seems to be a kind of heightening of our involvement in the action. It does this by making the live performers on the stage surrogates for us as viewers—more prominently, as the advertisement has it, "the old Colonel," who takes his position on the fence to view the race.[72] The "excited crowd lean[ing] over the paddock fence cheering the riders on" authorizes the return to the screen and the climactic race: we can return to the remote world of the film with an increased sense of excitement because we will see what the live performers on the stage, who belong to our world, are reacting to. As the advertisement suggested, live performance may serve to cross that divide, instilling real life into a world of shadows.

In 1921, the Motion Picture Directors Association, a forerunner of the Directors Guild of America, issued a statement to protest current exhibition

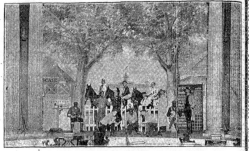

FIGURE 5.15

An advertisement for a 1920 Chicago engagement of *In Old Kentucky*, a late-nineteenth-century melodrama famous for its climactic horse race. This exhibition interpolated a live-action scene just before the horse race.

practices as "a serious menace to any further advances in motion picture production":

> We mean specifically: Atmospheric prologues, vaudeville numbers and expensive orchestras. . . .
>     . . . it is subtly impressing a certain class of our public with the thought that the play is not the thing but that the trimmings are. . . . In the opinion of this association, whose members are dedicating their lives to the betterment of motion pictures, the over-elaborate prologue is a useless adjunct to the feature picture, often destroying dramatic effect and turning the climax to anti-climax . . .[73]

I have found no further examples of interpolated scenes after 1921, but this statement does mention another practice, the use of prologues, that did in fact continue throughout the silent period. The prologue had originally begun with the feature films shown in exclusive theaters, much like the staged introduction to the 1915 Los Angeles premiere of *The Clansman* described above. The Embassy Theatre in New York City, discussed in the previous chapter as an unusual extended-run theater, was distinguished by its lack of a stage. What this meant for contemporary audiences was a feature theater without any live performance other than the orchestral accompaniment, a theater in which the film play really was the only thing, which the Motion Picture Directors Association had argued for. Whether or not the absence of the prologue led to the theater's failure, this was the only feature-dedicated theater of the period to my knowledge that did attempt to do away with live performance outside of the score. Live performance, either prologues or vaudeville acts, would continue in first-run theaters throughout the silent period, with some presentation theaters replacing their vaudeville with the prologues typical of the pre-release theaters, the Motion Picture Directors Association's protest notwithstanding. And the prologue in particular was a practice that the releasing companies promoted as well because of the belief it attracted audiences to the feature.

Although the interpolated scene in the Riviera presentation of *In Old Kentucky* did seem to acknowledge the superiority of film in the spectacle of the horse race, the staged horse race nevertheless figured in other exhibitions of *In Old Kentucky*, but usually as a prologue. In fact, First National, the releasing company of *In Old Kentucky*, not only encouraged

theaters to stage a horse race, but even provided assistance to help them do so:

> In the early history of "In Old Kentucky" the treadmill with the genuine horse race as the culmination of a prologue figured prominently. Certain branch offices of First National Exhibitors' Circuit, Inc. made arrangements to supply treadmill and supplementary apparatus with the production.[74]

This is precisely the kind of scene that Vardac claimed film eliminated from the stage. But why then was this considered so successful, so much so that it would be imitated in other prologues? There is in fact some evidence of a genre emerging as it earned the sobriquet "the treadmill prologue," as this comment on the exhibition of a Maurice Tourneur film, *The County Fair* (1920), demonstrates:

> The treadmill prologue has been repeatedly demonstrated effective. Despite the cost involved in its use it has invariably exercised such stimulating influence upon ticket sales that it has taken its place in the list of practical presentation properties.[75]

One reason for the continuing value of these staged races is suggested by a comment on the photograph of such a race, which was "snapped while the horses were galloping at such a pace that their legs and feet didn't register." Compared to filmic illusion, a staged horse race is lacking as reality because we must be complicit in the illusion: as the treadmill keeps the running horses in the same place, we effectively have to imagine forward movement. But the very physical presence of the actual horses, our ability to see the speed of their hoofs and feel their strenuous effort, makes the race exciting in a different way. The film might be more realistic in showing movement through an actual space, but it also lacks the physical immediacy of live performance. There were reasons, then, for limiting this scene to the prologue where it could not be directly compared to the film.[76]

Why did the interpolated scenes fall by the wayside, while live prologues became standard practice until the introduction of sound? As we've seen from various examples of live theater–film performance, direct

comparison was not entirely to the advantage of film as a representation of reality because film's reality was always that of a shadow world, a magical reality. This sense of continuity between screen and stage setting in these early experiments could actually heighten the uncanny quality of the screen by setting the otherworldly, disembodied film actors against actors who were palpably present on the stage. Keeping this quality in mind, we might say that one possible function for the proscenium—and this was very much the case with Richard Wagner—was to create a sense of distance. By its nature, film was inherently remote, its world definitively cut off from ours as the world of the stage can never be. Yet much as the *heimlich* contains and perhaps represses the *unheimlich*, the stage setting sought to transform the image from the eerily strange to the eerily familiar. The early prescription in *Moving Picture World* for framing the screen to create the illusion of film actors performing in the real upstage space of the set, well before this became common exhibition practice, was intended to enhance the status of film. But as often happens in a movement from low to high, the attempt to move film into the higher precincts of the legitimate theater carried with it a certain repression. The stage settings so common in this period effectively served not as a frame, but rather as a container for the film image.

If the free play between film image and stage performance that happened in the interpolated live scenes effectively increased the uncanny quality of the image, the prologues often seemed to embrace an opposite function. The interpolations, perhaps inadvertently, destroyed the diegetic world of the film, while the prologues were intended to provide an entry into it.[77] Prologues usually took an element or a scene from the film and dramatized it before the film as a stage performance. On occasion, the entire plot of the film might even be synoptically presented as a pantomime. Generally, some kind of vocal performance was included in the prologues, with either dialogue or songs to contrast with the eerily mute film actors, who could move their lips without issuing any sounds. Since the prologue dealt with the same narrative material as the film, it implied a contrast in forms of expression. Yet one of the most frequent explanations for the prologues in contemporary commentary was to get the audience in the right mood for the feature film, which is why they were often called "atmospheric." If so, why couldn't the film itself get the audience in the mood?[78]

## Curtaining the Spectral Image

The prologue served as a bridge from the physical world we shared with the space of the stage to the incorporeal reality of the film, as if something were needed to ease the transition from the familiar to the strange.[79] Correspondingly, handling the transition from stage action to the onset of film image loomed as one of the strongest concerns in trade press discussion of prologues. Over and over again, praise would be offered for a novel way of effecting the transition. The ambition was always to make this as seamless as possible. Consider, for example, the first film of prehistoric monsters running wild in an island paradise, *The Lost World* (1925). This adaptation of "Sir Arthur Conan Doyle's Stupendous Story of Adventure and Romance," as the main title puts it, exudes an uncanny aura in two ways. It is an almost textbook example of the Freudian uncanny in that it brings back the lost past of the prehistoric world and inserts it, contrary to all rational expectation, into a contemporary reality. But it also highlights the cinematic uncanny in a very particular manner: Willis O'Brien's first work in a feature film with stop-action clay models doesn't simply reproduce actual movement with still images; it creates movement that was never there to begin with, movement that only begins when our brains process the film image.

*The Lost World* is, of course, unimaginable on the stage, and yet, true to contemporary exhibition practice, the prologue tried to place it in a stage context. For the Boston showing of the film, a prologue was devised that *Motion Picture News* especially commended to other exhibitors. It made striking use of magical *trompe l'oeil* effects unique to the stage:

> the presentation was effected by a series of painted scrims—three in number—and an intriguing use of lights. . . . The scrims are hung in rotation and depict various phases of "The Lost World" story. When lighted from the front, they appear to be opaque and bring the color out vividly. . . . With a soft orchestral accompaniment, lights were slowly brought up on dimmers, disclosing a jungle scene. As the tempo of the music increased, the first borders were dimmed down while the electrician came up on the second border, thereby erasing the first jungle scene and slowly taking the audience deeper into the jungle vastness. A similar operation with the second and third borders disclosed the plateau in the distance, the

musicians building the attendant suspense with their weird and mysterious music. Slowly the first and second scrims are taken away and the lights dimmed down on the third scrim and the opening scenes of the picture projected as the third scrim is hauled up into the flies, disclosing the screen.[80]

Since the movie screen was always placed upstage in theaters of this period, the movement from stage action to film image generally involved a kind of moving in, as if the audience were being invited to move from a world it recognizes to an unfamiliar, uncanny world. The final image on the third scrim, "the plateau in the distance," effects a seamless transition to the first filmic image, the main title over a drawing of the jungle setting with a plateau in the distance (figs. 5.16 and 5.17). The deliberate use of stage magic in the *Lost World* prologue in effect renders the film image an extension of the stage effects, at once familiar and strange.[81]

FIGURE 5.16

The stage set designed for a 1925 Boston engagement of *The Lost World*, with a landscape on a painted backdrop that anticipated a landscape in the film's titles.

FIGURE 5.17
The opening title of *The Lost World*, with a background painting that seems to follow from the stage set in the Boston performance.

For a variety of technical reasons that I will deal with in the next chapter, picture settings disappeared with the introduction of the talking film. As if to compensate, the transition from stage to screen was forged with the elaborate curtain arrangements which would last, with somewhat less elaboration, for the next forty years or so. Consider, for example, this description of the Egyptian, an atmospheric theater which opened in Boston in 1929:

There are five curtains, each seeming to increase in magnificence. The first, or asbestos curtain, depicts an old temple in Egypt, with a view of the Nile and the pyramids. The second curtain bears a likeness of the mouth of a temple, and some ruins of ancient buildings are in the background. On the third curtain, the scene is partly of the desert and of the Nile, and on the river is a sailing vessel. The fourth curtain is of Egyptian lace. The fifth and final curtain is of bright gold satin in folds.[82]

Although an atmospheric theater, the stage lacks the set design that would have made it continuous with the auditorium. Instead, the curtains have taken over the function of the picture setting, but in a way that marks a progression from concrete representations of Egypt, a kind of travelogue, to the abstraction of the final curtains. As such, they also seem to be taking over some of the function of the live stage presentations, albeit defining the general mood of the theater itself rather than the particularities of the feature film.[83] It is likely that not every curtain would be used as a direct lead-in to the feature, but the description makes clear that all the curtains were intended as part of the entire show, with the progression finally yielding to the last curtain and the screen itself. Even if the curtains managed to ease the transition to the screen as a kind abstraction of the prologue, there is nevertheless something peculiar about their use with films, something I can get at by contrasting this with their use on the stage.

Why have a proscenium arch and curtains at all? Their function in the theater, as we've seen, created a new relationship between audience and performer/performance, with the curtains functioning as an extension of the proscenium, keeping remote and perhaps magical what a nonproscenium theater would simply make available.[84] In the illusionistic theater, the curtain is necessary to maintain the illusion, to create the sense of a world that is clearly distinct from ours and seemingly sufficient unto itself. It does not allow us to see how that world is created, but rather presents it to us as fully formed. This is to say that all construction takes place *behind* the curtain; the curtain keeps alive a sense of magic in its production of effects by keeping us distant from the moment of production. It is for this reason that a curtain rising on a second or third act spectacle set will inevitably produce applause. But the curtain is necessary solely because the space of the stage is continuous with our space. Like the proscenium itself, the curtain creates a barrier that can make the space of the stage seem special.

Yet the curtain is a strange phenomenon as it stands in relation to the screen: not only is no barrier needed to distinguish the space of the screen from that of the auditorium, but also the curtain serves little practical function in the movie theater. It might offer some protection to the screen, a function that has been claimed for it in the past, but the fact that curtains are no longer used points to how little necessity there is for protection. The strangeness of curtains in movie theaters lies in the fact

that the production of the image has its origins *on the other side* of the curtain, beginning in the space that we inhabit. The movie image does not come into existence solely as it strikes the screen, but, rather, it comes into existence when it strikes any object that might come between it and the screen. That is to say, an image can, and generally did, in past exhibition practices, appear on the curtain itself.

In order to make sense of the image on the curtain, it is worth keeping in mind a point made earlier: through the teens the most common word for what we now call screen was in fact "curtain." In the store theater period, when there was no actual curtain, calling the screen a curtain was to acknowledge that there was no playing area behind the stage, that everything took place in full view, seemingly in front of the curtain of a conventional theater, with nothing concealed. The movement of the film image onto a proscenium stage with the advent of the feature film changed the way in which the "curtain" was conceived; it could become a "screen" that itself was subject to curtaining.[85] The placement of the screen *within* the proscenium was in part also a matter of necessity since theaters continued to use the stage as a performance space alongside the screen presentation. But placing the screen behind the curtain also signaled a different way of experiencing the film image, since it now began in an almost disembodied state located more in our space, before it settled into its rightful space on the screen.

Presenting the film image on the curtain at the beginning and end of the show was a way of temporarily granting the image its uncanny due: from the strange spectral image that billowed with the folds of the opening curtain we could move further in, much as in the *Lost World* prologue, to a space where the image asserted, by contrast, a seemingly concrete reality. This sense of movement into and away from the film that first acknowledges, then contains, the uncanny aspects of the image might also make sense of a common practice for theaters in this period: curtains would close after the series of short subjects that always made up the program, only to reopen with the feature film. This could be done without a pause in the film, with direct change-over from one projector to the other. As a result, the image would play continuously on the closing and opening curtains, as if to suspend the world of the short subject and prepare us to enter the world of the feature, briefly making the image spectral before it returned to a seemingly more solid situation on the screen.

"Motion pictures" might be the correct term, as *Motion Picture News* insisted, and "moving pictures" a heresy; the images are still, and still they move. The stage illusion of the treadmill race is almost exactly the opposite: the horses move and yet they remain in place. This is an illusion we can easily deconstruct as we watch it. By contrast, with motion pictures, we know what we see cannot be real, and yet we accept it as a reality and end up calling it "movies." Later writers would disparage the early feature film as "canned theater," yet this was not right.[86] Exhibition practices suggest that audiences have never viewed film as a transparent recording medium. From their beginnings, the movies have been uncanny theater.

The picture settings prevalent in film exhibition throughout the silent period could anchor the spectral image in the reality of live theater. Like canned food, the term "canned theater" suggests something like the original, but also deficient. The repeated calls for the human voice to mitigate the mechanical quality of the film image suggest that the addition of the soundtrack in the late 1920s could help anchor movies in our reality, while never completely eliminating the uncanny quality of the film image.[87] It is likely for this reason that sound at a minimum did away with the play between live performance and film that was typical of silent film exhibition: while vaudeville-style performances continued in a limited number of big city theaters until the 1950s, the prologues were abandoned. But if sound brought the film image closer to a self-sustained theatricality, it created other problems by forcing a change in the way the image was situated in architectural space, a shift that eventually changed the status of the screen itself, transforming it from a theatrical to an architectural object.

# 6. THE ARCHITECTURAL SCREEN

## SOUND, SPACE, AND THE WANDERING SCREEN

The screen, for reasons hard to explain, is the part of their theatre's equipment which the exhibitors neglect most . . . when it comes to the screen anything seems to be good enough.
                    —M. H. Schoenbaum (1914)[1]

In locating the motion picture within a tradition of magic lantern exhibition, I had invoked Charles Musser's call to see "cinema within a larger context of what we shall call the history of *screen practice*" (*Emergence*, 15). Musser's argument has had a powerful impact on how we look at early cinema, but he himself says little about the actual screens, either in their two-and-a-half century history that precedes the motion picture or the motion picture screen itself. He is not alone. Oddly, this most visible piece of filmic illusion is the one thing both film history and theory have

most overlooked. Most writing on film's "technological apparatus" has focused entirely on image creation (the camera, lenses, lighting, film stocks, etc.) and, to a lesser extent, image production (the projector).[2] As a reflecting surface the screen apparently limits itself to giving back unchanged the images presented to it. It is for this reason the screen has found its place in film studies primarily as metaphor, its very passivity facilitating its transformation into other things.[3] In this regard, film scholars seem to be following in the footsteps of exhibitors for whom the creation of the image was often a secondary concern. And theater owners who sought to maximize their audiences were content to have seating arrangement dictate dimensions and placement of screen, rather than the other way around. By implication, the screen is eternally the same, a simple place that merely receives the production of an elaborate mechanical apparatus located elsewhere. All you have to do is find a blank wall somewhere, and the cinematic apparatus will take care of the rest.

But the screen doesn't merely receive an image; more accurately, it acts upon the image, determining how we will see it. For practitioners, most of the early concerns about the screen had to do with how well it reflected light, especially in the illuminated theaters of the store period. But also early on, as we've seen, there was some concern with possibly constructing a screen that could mitigate distortion from side seats, a concern that would be forgotten until the early sound film. Early sound is precisely the period I want to consider here because it forced practitioners to think anew about the screen as technology. As a way of getting beyond the notion of the screen as passive, I would first like to look at an exceptionally active screen, one whose activity was anchored to the architectural space it inhabited. In March, 1928, MGM premiered a special, *The Trail of '98*, a tale of the Alaska gold rush from thirty years before, with hopes that it would equal the success of *The Big Parade* in its combination of spectacle and intimate drama. Generally favorable reviews did not find the drama as compelling, but were almost uniformly overwhelmed by the spectacle. In its presentation, MGM certainly sought to overwhelm by means of an exhibition innovation, the "Fantom Screen." Advertising for the New York premiere was relatively discreet, with no mention before the opening and afterward, merely indicating this was "The Picture on the 'Fantom' Screen."[4] Critical reception was sufficiently enthusiastic that more was claimed for the Los Angeles premiere at Grauman's Chinese

Theatre, "Introducing—the famous FANTOM SCREEN that will revolution-
ize cinema presentation."[5]

As it turned out, the Fantom Screen was not so much an innovation as
the refinement of another innovation utilized two years earlier with an-
other spectacle film, *Old Ironsides*, which introduced audiences to the Mag-
nascope, although there was no indication of the device ahead of time in
either advertising or publicity releases.[6] The *New York Times* reviewer
was appropriately astonished: "as an additional feature of the entertain-
ment, the scene that ended the first half of the picture was a startling
surprise, for the standard screen disappeared and the whole stage, from
the proscenium arch to the boards, was filled with a moving picture of a
replica of Old Ironsides. This brought every man and woman in the audi-
ence to their feet. . . . Some conception of the magnificent effect of this
enlarged screen can be gained from its dimensions, which are 30 by 40 feet
[that is, height by width], whereas the usual screen in the Rivoli is about
12 by 18."[7] That last figure is itself important because it reminds us how
very small the screens were at this time, even as the space around them
had grown to enormous dimensions. The relationship of image to the
oversized proscenia of the palaces became an increasing concern of the
late twenties for a number of reasons I have to explore in this chapter.

The Fantom Screen sought an even more dynamic means of chang-
ing the relationship between image and theatrical space. A *Variety* re-
view provided the most precise description: "Fantom Screen, a device on
rollers, is an improvement upon Paramount's Magnascope because the
picture can double its size in moving down front and then reduce to normal
as it retreats up stage. All at will. Working in conjunction with a special
projector holding a wide angle lens, this illusion's main achievement lies
in the reduction following the enlargement, no matter if the public will
only remember the big flash. Shrinking to normal size is done to take up
the story and keep the characters from appearing out of proportion."[8] Ma-
gnascope would continue to be used occasionally for spectacle scenes up
through the early fifties, with the last instance the "aquaballet" in *Million
Dollar Mermaid* (1952) at Radio City Music Hall. The reason it was always
limited to isolated scenes was not solely to prevent giant-sized perform-
ers as the *Variety* review suggests; rather, there was an awareness of the
degradation of the image because of a pronounced graininess that oc-
curred when the image went much above twenty-four feet or so.[9]

For all the elaborateness of the presentation, which had a screen on rollers and a stage crew to move it sixteen feet forward to the curtain line, the use of the Fantom Screen in *The Trail of '98* was appropriately brief: "Despite 'Trail's' running time of two hours, the effect is used but twice for a total flash of less than a full minute, being employed to emphasize two spectacular scenes."[10] This sudden transformation in the image-space relationship seems to have had the power of returning the spectator to the earliest cinema, and most especially Biograph's "Empire State Express," as evidenced by a report in the *Los Angeles Times*: "In reproducing the horrifying snowslide in Chilkoot Pass on May 2, 1898, in which ninety-three persons lost their lives, the crushing tons of snow appear to be on the point of actually falling into the audience, such is the realistic effect created by the employment of the invention at the Chinese."[11] No doubt, both the suddenness of the transformation as well as its brevity, helping to conceal the flaws of the image, produced a cinematic coup de theatre. By this I intend not the conventional meaning of a sudden turn of events, but rather a sudden change in how we perceive events: "The effect is, of course, electrifying and carries a big punch."[12] Given the impact, it's not surprising industry observers would anticipate further application. J. J. McCarthy, who helped pioneer the road show, "said that the use of a similar device in connection with 'Intolerance' would have given that picture a two-year run on Broadway,"[13] while the *Variety* review posited; "other companies will undoubtedly use it, if they can, and after the directors glimpse the possibilities they'll 'shoot' their big stuff with Fantom Screen in mind" (Sid., Mar. 28, 1928). But this was a moment supremely *of* the theater, a moment defined by the context of a specific theatrical space. It would never be imitated, however, because, within a year, the screen began its own migration down toward the curtain, permanently taking up a new residence.

It would be tempting to say the reason for the change was the sound film. In one aspect alone the problem inhered within sound technology itself. Initially, there were two competing systems, one that synchronized film with a large wax disc and one that carried a soundtrack on the film. The disc system, marketed by Warner Bros. as Vitaphone, was first out of the gate with *Don Juan*. There were two competing sound-on-film systems, Fox's Movietone and RCA's Photophone, but they were compatible featuring soundtracks that could be played on the same projector.

While there were some claims that the discs had better sound, the sound-on-film systems eventually became the standard for the simple reason that the sound was good enough, but, more importantly, it could never go out of sync. Nevertheless, sound-on-film had one real drawback. In silent film, the image extended from sprocket hole to sprocket hole, leaving no place to put the soundtrack but in the image area, turning the four by three frame into something closer to a square. Dissatisfaction with this new aspect ratio eventually led to reducing the height of the frame to return to roughly a four by three image. This double reduction meant that the aperture for sound-on-film was smaller than the disc system, which consequently had a brighter image. Debating the relative merits of the disc and sound-on-film systems, a "veteran publicist and trade paper editor" in 1929 noted, "It is sound quality, in the final analysis, which is going to determine the 'talker's' future entertainment value, and as yet, sound-on-film is certainly not superior to sound-on-disc in tone quality, while in photographic values it is, on average, much inferior."[14] It is perhaps an indication of attitudes of the period that this contemporary observer makes the quality of the sound more important than image quality because ultimately sound *did* compromise the quality of the image, a compromise that the industry needlessly accepted as necessity.

These were problems that could find solutions in technological fixes like improvements in illumination and finer grain film stocks. Nevertheless, *how* sound technology was deployed within theatrical space became a major source of problems, and these could not be so easily solved. That effectively implementing sound technology was a central concern in this period is evident from the countless articles on acoustics that appeared in the trade press as well as the journal put out by the Society of Motion Picture Engineers (SMPE), the group that worked to establish technical standards in both production and exhibition.[15] Although there were acoustical engineers at the time, how acoustics worked in the voluminous spaces of movie palaces was a sufficiently novel problem as to give rise to contradictory notions: so, the claim that the human voice was the same regardless of whether it came from an actual person or a mechanical reproduction was set against the notion that amplified sound worked differently; or the belief that the best space for good acoustics was a rectangular space·was set against claims that the best space was square or even that shape didn't matter.[16] Virtually all of these articles dealt with how sound was dispersed within the auditorium, and eventu-

ally a consensus was reached, with a recognition that spaces which had been built for live performance would require a kind of deadening via absorbent materials to make amplified speech intelligible. On the other hand, there seems to have been a consensus from the start on where the sound should originate as it began its journey out into the auditorium, and in this case the consensus was based on a terrible mistake.

The placement of speakers appears not to have been debated.[17] It is not until 1931 that I have found any comment on this in industry discourse, and then it is presented as if it were self-evident: "In order to give *a perfect illusion of the source of the sound*, the horns should usually be placed directly behind the screen, which, in turn is perforated over the entire surface to allow the sound to penetrate."[18] While articles on the acoustics of the auditorium were grounded in scientific discourse, often presenting complex equations, the decision to put speakers behind the screen was not undertaken for any scientific reason. In fact, any scientifically reasoned understanding would have argued against the placement behind the screen because hearing is not as spatially sensitive as vision. The simplest evidence for this is experiential: any sudden loud noise will immediately cause us to scan our visual field to determine a precise origin of the sound. Further, the rapid postwar growth of the drive-in as a place to see a movie demonstrates that audiences had no trouble accepting the radical displacement of the soundtrack into their cars while they watched an image on a distant screen.[19] Because there was a widespread belief that the addition of spoken dialogue as well as singing would bring movies closer to the stage play, I suspect the behind-the-screen speakers was a misguided imitation of live performance, an attempt to ally sound spatially with the performers.[20] Whatever the reasons, American exhibition conformed to American production practice in seeking an absolute unity between image and sound, even if that unity were illusory. And it did so to the detriment of the image.

This is to say, unity came at a high price: in order to allow the speakers behind the screen to function, the screen was shot full of tiny holes to allow for sound transmission, generally "42 perforations per square inch, each perforation being 0.005 in. in diameter."[21] In an April 1930 column, F. H. Richardson, who had written a standard projection manual, noted that the image for the sound film "did not seem quite as snappy as it once was."[22] But it was not until 1932 that he located the problem in the perforated screen and undertook a one-man crusade against it in the pages of

*Motion Picture Herald.* From September 1932 through June 1933, Rich-
ardson wrote six articles on perforated screens, with the final article a re-
print of an address he gave in May at a joint meeting of the New York branch
of the SMPE and the Projection Practice Committee, a committee he was
instrumental in forming.[23] Over roughly a similar period, Richardson
wrote multiple articles on screen illumination, a related concern, among
other things publishing statistics from his theater surveys that showed
the illumination in actual theaters to be wanting.[24] Light had been a cen-
tral concern in Richardson's writings, from his earliest columns when he
insisted that a well-illuminated small screen made more detail available
to the viewer than a poorly lit large screen even in large auditoriums. But as
influential as he was, Richardson was never able to have the industry accept
the solid screen as a standard: indeed, to this day, perforated screens with
speakers located behind them continues to be the dominant practice in
commercial motion picture theaters.[25]

Film histories dealing with the impact of sound on the image has gener-
ally focused on issues of production and sound technology itself. But sound
practice in the theater had an impact on how the image was perceived
within architectural space, and that shift in turn had an impact on produc-
tion. The objections that Richardson raised are relevant to understanding
that impact. Richardson's first objection echoed other complaints about the
sound screen, with earlier commentary claiming generally "a perceptible
loss of light" or more specifically a "25% reduction."[26] In a 1929 paper pre-
sented to SMPE, the head of Raven Screen Corporation found more than
lowered illumination a problem: "The lack of clearness, depth and detail
and the presence of blurs and smudge . . . are due to the pores or perfora-
tions in the screen." But changing the angle of the perforations, a "method
of screen construction . . . now being perfected," would improve both sound
transmission and reflectivity.[27] Changing the perforations possibly repre-
sented an improvement since, by 1932, Richardson estimated a light reduc-
tion of 10 percent, but that was a guess based on how much area the perfora-
tions occupied rather than direct measurement of light on the screen. By
contrast, a more scientific survey by the SMPE in 1947 estimated that the
average screen reflects back only 70 percent of the light projected onto it.[28]

Richardson identified two other problems that followed from the per-
forated screen. The first led to a further reduction of reflectance: because
"air circulates through perforations to some extent . . . we shall presently

find the hole to be surrounded by a ring of discoloration." The result was that "the reflection power will fall off very much more rapidly." All screens will progressively lose reflectance with time, but the solid screen used for silent film could be cleaned and/or recoated to extend its life. The perforations of the sound screen not only sped up the decreasing reflectance, but made cleaning difficult and recoating impossible. And if it weren't bad enough that it affected illumination, the perforated screen was actually not so great for sound, creating what Richardson referred to as a "baffling effect." Because longer sound waves, transmitting lower registers, bend more easily than short waves, transmitting high registers, the longer waves had an easier time getting through the tiny perforations. For this reason, sound tended to be bassy, requiring that amplification boost treble ranges to compensate.[29]

As it turned out, the speakers behind the screen, the source of all these problems, had a kind of cascading effect. Next to go was the upstage position of the screen, and most especially its location in a picture setting. There were two problems here. The location of the screen placed the speakers fairly closer to the back stage wall, making reverberation a problem; trying to limit the direction of the sound waves was one solution, but moving the screen downstage would also help.[30] Second, the upstage position impacted on the audibility of the sound as it left the screen. Hard surfaces that might have figured in picture settings would act as sounding boards, misdirecting the sound. And the tall fly houses of most of these theaters could operate as a kind of sound trap, lessening what sound reached the auditorium. Photos of screens in the early sound period show them still located in picture settings, so it likely took experience to evince these problems: by 1930 the screen has generally moved to just behind the curtain, initially often framed by other curtains.[31] This is where it would stay until new theater architecture in the 1960s definitively eliminated stage, proscenium, and curtain, leaving nothing but the screen itself at the front of the auditorium.

With the screen at or near the curtain line, an evolving practice would become convention: first the theater's curtain was used to demarcate the space of the screen on the stage; eventually the stage curtains would open fully on a sea of jet-black cloth in the middle of which was the smallish motion picture screen.[32] Solving the sound problem by bringing the speakers to the edge of the auditorium, this new arrangement created

three new problems in turn, all related to vision. Removed from its "shadow box" at the back of the stage, the screen at the curtain line would no longer face a spillover of light from the orchestra pit since there was no longer an orchestra, but ambient light in the auditorium, necessary to allow movement during continuous showings or reading programs, could affect screen brilliance, muddying the contrast of the film image.[33] And although screens did grow larger in this period, perhaps in response to their new surroundings, their neutral or black surround emphasized their smallness in relation to proscenia generally ranging between 50 and 100 feet. The aborted move toward wide-gauge filmmaking in the late 1920s suggests an awareness on the production side of the problems created by this new configuration of architectural space. By 1928 the trade press was already running stories about a possible shift to wide-gauge filmmaking from 35mm. Theaters being built in this period generally had wider proscenia in anticipation of this change, which actually exacerbated the problem of 35mm exhibition by making the screen effectively smaller in relation to the stage opening. And although the attempt at wide film ultimately failed, it, together with the limited success of Magnascope, possibly had an impact on standard 35mm projection: "Larger screens are generally being installed for standard projection, the size used in the larger houses on the [West] Coast being 18 feet by 24 feet."[34]

Finally, although the downstage position of the screen began as an attempt to improve the sound in the large auditoria of the movie palace, the changed relationship between the screen and architectural space effectively gave new life to an old problem. We saw in previous chapters that early architectural writing showed an awareness of the distortion created by viewing angles in wide theaters, yet the palaces embraced exceptional width as a way of reaching their enormous capacities. It is worth keeping in mind, then, that feature film exhibition had made the upstage position of the screen a convention by the time the palaces were being built, which suggests the architects designing these palaces might have done so with the expectation that films would be shown in this manner. Conversely, the wide auditoria might have prompted exhibitors to see a necessity for picture settings. Whatever the reasons, placing the screen about twenty feet or so upstage in wide auditoria offered two advantages: it ensured that even the front row of seats could be placed close to the stage and still be at a comfortable viewing distance from the image, while it simultaneously reduced the angle at which the screen was viewed from

seats at the far left and right of the auditorium.[35] Given the extreme widths of some theaters, there was likely some distortion from side seats in the palaces in any case, but it became more pronounced and affected more seats after sound was introduced. Commensurately, the early sound period saw an increasing preoccupation with distance from the screen and the angle on which it was viewed, with a concern about distortion from side seats returning to trade journal discourse.

Much of my discussion here has been about the screen as a technological object, the final piece of an apparatus engineered to display a motion picture. But the last few issues I've brought up all derive from a transformed relationship between image and architectural space. Delivering the screen from its location in a theatrical set dramatically changed the way people viewed the image, effectively altering the status of the screen. The earliest ways of thinking about the screen architecturally focused on how it could be fit into existing structures, from the vaudeville house, where it could both fit in a gilt frame in the manner of Living Pictures and be made to operate at the same time like a drop curtain, to the legitimate theater, where it could be made a part of conventional set designs. In these instances, the screen was effectively passive, never determining the space it inhabited. The new context of an indeterminate dark space had two consequences in the way the screen appeared. Most immediately, it began to seem inadequate in ways that it never had before, both in terms of its size and its relationship to architectural space. Second, the screen now had the potential to be seen not just as part of the cinematic apparatus, but as an architectural object itself, both defined by *and* defining the space it inhabited.

## BEN SCHLANGER, ARCHITECT OF THE IMAGE

Many of the older theaters were constructed during the days of vaudeville and stage presentations. The picture was of secondary importance . . .
—Herbert A. Starke (1943)[36]

Whereas the traditional theatre had been designed around the stage and live performances, the new movie theatre was planned around the projection booth.
—Maggie Valentine (1994)[37]

The screen is the motion picture stage. It is the nucleus of the whole theater design, the point around which the whole theater should be built.
—Ben Schlanger (1932)[38]

Because of the large capital investment in the exhibition infrastructure, established ways of distribution, and record attendance figures coming out of World War II, the sites for first-run exhibition were pretty much the same in the early 1950s as they were in the late 1920s. Furthermore, conventional views of their achievement could linger well past that, informed by a nostalgia both for the architectural exuberance and the mass communal ritual these buildings evoked. Writing in 1994, architectural historian Maggie Valentine makes a claim that theater practitioners of the late teens and twenties would have readily agreed with:

> Measurements that govern seating arrangements are less crucial [in movie theaters than in live-performance theaters], because there are no "bad" seats, given the size and angle of the screen. Sight lines are inherently better, acoustics clearer, and there is no stage lighting to interfere with either. Seats are not only better but cheaper. (4)

Valentine's final point on price makes evident she is echoing the earlier claims of the democratic promise of the movie palace, the notion that the movie screen presented the same view to all regardless of where you sat in the auditorium, regardless of what you could afford to pay. As we saw in earlier chapters, the fact that the movie camera presents us with an image that is always from the same perspective was the foundation for the myth of equal-opportunity viewership.[39]

But the fixed perspective of the film image was also the foundation for an early objection to dominant movie theater form published in an architecture journal in 1932:

> The spectator's position for viewing the screen performance is not an arbitrary one, as it may be in the legitimate theater. He must be seated within a confined area suitable for viewing the two-dimensional screen surface. The view obtained by each spectator of the screen is a similar one, for the perspective effects that would be seen from different vantage points in real life or on the legitimate stage have already been achieved by the moving eye of the camera. This means that the spectator's view of the screen images already thrown into perspective must not be additionally foreshortened or converged. A distorted view of the two-dimensional picture surface

with images and background already thrown into perspective is very disturbing to ocular and physical comfort.[40]

This contrarian voice belonged to a young architect, Ben Schlanger, who had the temerity to present a paper at a meeting of the Society of Motion Picture Engineers proposing a new theater design that rejected all the conventional thinking about movie theater architecture, noting as he did so, "Ten years ago the presence of a theater architect at a meeting of motion picture engineers would have been unlikely."[41] Unlikely as it was, Schlanger felt architects and engineers had to join together to make movie theater architecture modern, to have form truly follow function. In a discussion after the paper, one of his interlocutors fully understood this: "I have expressed myself often to the effect that in the past the theater has been built and the optics of the motion picture put into it. This [Schlanger's proposal] is a serious attempt to build a theater around the optics of the motion picture" (Schlanger, ibid., 170).

If Schlanger was a singular voice at the time, eventually he would achieve "international recognition as one of the most important contemporary influences on the development of cinema and theater architecture."[42] He did this through his own architectural designs, his work with an engineer to develop a new kind of movie screen, and a large body of writing in a number of architecture journals, the *Journal of the Society for Motion Picture [and Television] Engineers*, and a regular monthly column in *Motion Picture Herald* over a thirty-year period. Schlanger's earliest writing appeared within a changed context: sound had become an essential part of motion pictures, live performance had been eliminated in most presentation houses, and the Depression had begun to affect exhibition sufficiently that the palaces were forced to lower prices. With most theaters reduced to the single purpose of showing movies, Schlanger's articles became the strongest and ultimately most influential voice for a modernist aesthetic in theater design:

With all other fields of architecture moving forward, the motion picture theater, weirdly reacting to its mechanicalism, has somehow taken on surroundings savoring of oriental voluptuousness. . . . It is necessary to get behind the turrets, classic columns, and archways to see what really exists. These architectural features have always

so bedecked the theater as to obscure that which was functional and expressive of its purpose. Of all the fields of architectural endeavor, what branch could so well express itself as the motion picture theater—an architecture inspired by a mechanism which so delicately transmits various degrees of light and sound? Why not an architecture for the theater interior that would be limited to the treatment of the intensity, placement, and projection of light in its various moods?[43]

In this changed context, Schlanger's call for an architecture that made the screen "the nucleus of the whole theater design" began to dominate. He spearheaded a different way of thinking about theater architecture, one that was likely influenced by the aborted move to widescreen exhibition in 1930. Commensurately, his voice would become increasingly important in anticipating the widescreen revolution of the 1950s. By the end of the century, the basic architectural form Schlanger had arrived at in the fifties in his own architectural projects would become a template for most new movie theater-building, a form so pervasive that its subsequent use was likely not conscious imitation.

But Schlanger is also of interest precisely because he saw a correlation between architecture and film style. Perhaps because he was an amateur photographer himself, he was able to articulate a theoretical understanding of film that could find echoes in the writings of such different theorists as André Bazin, Siegfried Kracauer, and Stanley Cavell. For him, architectural space could not only affect how we perceived movies, it could be one factor shaping how movies were made. He explicitly stated this connection in a 1933 article which specified what he considered unfortunate limitations of American film style:

The motion picture screen is being ineffectively used. . . . The reason for this is two-fold and traceable to both the production and re-production phases of the art. Firstly, an appreciable area of the screen is being ineffectively used and even wasted by present practices of placing the main focal action or interest only within a limited portion of the screen. Secondly, theatre auditoriums are unsuitably built to accommodate proper vision of a more advantageously used screen. . . . The screen is the combined problem of production and exhibition phases of the motion picture.[44]

Anticipating the statistical analysis of film images that could be found in academic film studies about a half century later, Schlanger undertook an analysis of "the chief action or chief point of interest of some 120 scenes. These scenes were picked at random from about 20 current films, an average of 6 scenes per film, representing in all six of the major American producing companies." What Schlanger found was "the present predominant use of a very limited area of the entire screen for depicting action" (9). Why viewing conditions necessitated this style was an issue frequently addressed in his articles.

In movie theater architecture itself as well as in the early writing in trade journals, the screen simply took the place of the stage, however inadequately. Schlanger, on the other hand, saw a fundamental difference in the kind of viewing necessitated by stage and screen: "the sightlines to a stage (a horizontal plane necessarily fixed in position) presented an entirely different problem from one of devising sightlines for a motion picture screen (a *vertical* plane, the elevation of which is not necessarily fixed in position)."[45] If we look at the screen as an architectural element, as Schlanger did, we can say that it possesses both constant and variable dimensions. Architecturally, the one constant is a seemingly simple one: except for oddball instances like the Fantom Screen, the screen in a theater always occupies a fixed point in space. In this regard, the screen does place definite constraints on theater architecture. To take the most obvious example, in spite of the Lumiére brothers' early experiment with a two-sided screen, as a flat surface a conventional film screen will not allow for a theater-in-the-round.[46] There may be specialized screens that are most likely to show up at fairgrounds or theme parks, like a screen, in the manner of nineteenth-century panoramas, that completely encircles its viewers. But for the most part and in most conventional uses, the screen dictated an audience placed in front of it, and it limited the spaces that audience may inhabit.

From this simple condition of fixity, the screen established the possibility for fairly radical departures from traditional stage theater design. The screen itself might reflect a good deal of movement, but because spectators are looking at a flat picture whose perspective has been determined by the position of the camera, the audience's attention is effectively always fixed on one object, the screen itself. With the stage theater, on the other hand, the audience sees characters and setting as it would in real life, from a variety of perspectives, so attention may be selectively directed by

movement along the whole width of the proscenium. For this reason, as Schlanger saw it, stage and screen theaters create a different spatial relationship between spectators and spectacle, a relationship that had to be articulated by the architecture. For example, Schlanger proposed among other things a startling reworking of floor slopes to emphasize the vertical axis.

The earliest writing I have found that defines the proper relationship between movie theater space and the screen is a 1932 article in the *Journal of the Society of Motion Picture Engineers*:

> The proper size [of the screen] should be chosen:
> (A) Minimum desirable width is one-sixth the distance of the screen from the farthest seats.
> (B) Maximum desirable width is eight-tenths the distance of the screen from the front seats.
> (C) Intensity of lamps is an important factor limiting the size.[47]

To some degree, this formulation still treats the screen almost as an afterthought, since theatrical space here determines size. That is to say, the thinking still very much reflects earlier approaches in asking, how do we make movies fit into this space? By 1937, Ben Schlanger kept part of this formula (the most distanced seats), but reversed it to let the screen itself dictate theatrical space: the first row of seats should be set at a distance equal to 0.87 times the width of the screen (closer than the above formula); the last row should be no further than six times the width of the screen; and, recognizing side-angle distortion as a problem, he expanded the formula to a concern with width, recommending that the rows of seats should fall within a 60-degree angle originating at the screen.[48] This formulation was subsequently repeated by others with some frequency in the pages of *Motion Picture Herald*, the most important trade journal for movie exhibitors.[49] The point of both these sets of rules was to live up to the democratic promise of the movie theater, to make every seat a good seat indeed, and to allow the camera eye alone to serve as the viewer's eye.

The recommendations came fairly late in the development of the nation's theatrical plant, they didn't have the force of law, and, finally, they even represented something of a compromise since "studies of viewing conditions have indicated a factor of $3.5W$ [i.e., a maximum distance of $3.5$ times the width of the screen] as a reasonable one for such visual limits as 'long

shots' generally."[50] And in any case, evidence had begun to emerge that audiences were not taken in by the democratic myth, that they in fact full well knew some seats were better than others. From early on Schlanger had called for SMPE to survey audience seat preferences; in 1941, the *New York Times* reported on such a survey, and the full results were printed in *JSMPE* in January 1942.[51] The survey deliberately sought out real-life conditions, covering the two-and-a-quarter hours of an evening show at a small (570-seat) theater in New York City. Checkers were scattered throughout the theater, taking note of when people entered (it was a continuous show) and where they sat, with later arrivals obviously more restricted in their choices, so particular attention was paid to the preferences of early arrivals. The distance from screen to back wall was equally divided into six sections. Of the 453 people who did come, only one sat in the first section, the area closest to the screen. If other seats were available, the side sections with the greatest distortion were about as popular as the front section, although the fact that one side section did allow smoking affected the distribution. By far, the greatest number of people sat in the third and fourth sections. This was only the first of a number of surveys because the SMPTE Theater Design subcommittee wanted to account for different auditorium sizes and shapes, different screen sizes and illumination, and any other factors that might affect decisions on where to sit. A 1950 article in *Motion Picture Herald* referenced "extensive surveys" SMPTE was conducting and reported a clear preference in one for the middle third of the auditorium, front to back, and an avoidance of seats outside of a 60-degree angle.[52]

Regardless of audience preferences, other considerations could end up dictating architectural design. The dual function of the movie palaces, the attempt to combine a live stage theater with a movie theater, obviously ruled out even the ambition of building a theater around the screen. And the desire to make every seat a usable seat had economic motivation, of course. Seats could be placed both closer and further away than these rules dictated so long as patrons were willing, if not entirely happy, to sit in them. Until the 1950s, surveys by the Society of Motion Picture and Television Engineers found an average distance for theaters of 5.2 times the width of the screen.[53] Since this was an average that included a balance between large and small houses, the distances in the first-run movie palaces would have far exceeded the six-times-width recommendation.[54] Finally, the great width of the palaces also dictated that many seats were

placed on angles outside the 60-degree arc, especially after the screen moved down to the curtain line.

For theater chains, and most especially the parent film companies that owned the theater chains, size was a virtue in itself, enabling them to turn their minority percentage of the nation's theaters into the majority percentage of box office receipts. But size also meant a large number of seats that either stood at a great distance to the screen or an extreme angle. In fact, George Schutz, the editor of the "Better Theatres" section of *Motion Picture Herald*, estimated in 1948 that one-third of the audience in the large first-run theaters saw a distorted picture.[55] Consider, too, the relationship of screen size to the depth of the auditorium. First of all, the screens are doubly framed, a smallish rectangle of light set in black masking that is then framed by a fairly large proscenium. As Ben Schlanger noted in 1951, "Black masking and a dark auditorium were necessary parts of picture exhibition when screen illumination was feeble and when there was a lack of picture steadiness."[56] Over the years, various reasons were offered for the masking. Schlanger himself instanced the need to make the image appear brighter and to conceal the vibration of projection equipment.[57] In addition, the palaces had created a new need: because of the large size of the auditoria which placed the projection booth at the back of the balcony, black masking squared off the image, making less apparent the keystoning caused by sharp projection angles. That is to say, the image was actually trapezoidal, but was made to appear square, a neat piece of trickery played on the audience: if you saw a squaring off of the image, you didn't notice the distortion. That practitioners knew keystone distortion was a problem is evident in one architectural feature of the New York Roxy "out of the ordinary in the average motion picture theatre": the projectors were "set an angle of less than ten degrees, therefore practically eliminating distortion from the source. In order to obtain this position, it was necessary for the booth to be located in the center of the mezzanine balcony. This was accomplished at a sacrifice of two hundred seats."[58] This proved not to be a model for other theaters, however, because reducing capacity was rarely seen as a positive and architecturally it was easier to place the booth at the top of the balcony and use black masking to downplay distortion.

As early as 1908, F. H. Richardson had recommended a small black border in order to give the image a clearly defined frame: "If, however,

your curtain is larger than your picture, it will be found to add greatly to the effect if the surplus is blocked off in dead black (not a shiny black, but a dead one)."[59] The next year, his recommendation focused on illumination, assuming, as other commentators at the time did, that the black border would make the image seem brighter. Nevertheless, even as the black surround was becoming dominant there was already awareness of its deficiencies, especially after the introduction of the sound film. First of all, as noted above, whatever the justifications, masking had the odd effect of making a small image seem even smaller and, by virtue of the double framing, at a fairly great remove from the audience. Second, these very small screens in very large halls necessarily made it difficult to see details in any shot further back than medium distance. And black masking actually exacerbated the situation: a two-year study by the Illuminating Engineering Society of Great Britain reported in 1939 that a dark border around a light picture perversely had the effect of reducing visual acuity, making it more difficult for the eye to resolve detail.[60] Richardson's early recommendations for black masking were strictly as a border; that is, he expected a black surround three to four inches wide, and that became common practice even with a picture setting, so that the immediate area around the screen had a band of black to delineate the film image. But sound changed the practice, extending the black surround up to the full width of the proscenium. Figures 6.1 and 6.2 show two films from the classical period with scenes in theaters that will give some sense of what the small image on the large stage in a black void looked like. *Footlight Parade* (1933) is in an unspecified theater (likely a stage set), but a presentation house so it provides a good sense of the difference between the screen and stage entertainments. *Saboteur* (1942) is specifically set in Radio City Music Hall (albeit accurately re-created in the studio), so the image appears even smaller.

Since the screen surrounded by black masking (albeit minimized by the greater size of the screens) has become a convention we are still utilizing, it is important to recognize dissatisfaction with the practice even as it was becoming convention. The most sustained and serious attempts to eliminate masking took place in the post–World War II period, led chiefly by Schlanger; but much earlier, in the period following the introduction of the sound film, a variety of alternatives were proposed. The search for alternatives was likely a response to the elimination of the picture setting,

FIGURE 6.1A

James Cagney in *Footlight Parade* comes to see a "talkie," a "B" western with John Wayne, identified in the movie as *Slaves of the Desert*, but actually *The Telegraph Tale* (1933). The black masking fills more of the proscenium than the film image.

FIGURE 6.1B

A "flesh show" following the talkie fills the proscenium, but Cagney, realizing live performances in movie theaters are doomed, says "Breadline, I hear you calling me."

FIGURE 6.2

*Saboteur*'s accurately rendered studio re-creation of Radio City Music Hall, which at the time had one of the largest movie screens in the United States. Curtains are not fully opened, but would be for stage shows, which filled the proscenium and could even extend beyond on wall ramps that rose from the stage toward the back of the auditorium.

which suddenly created a vacuum on stages with overlarge proscenia. At the 1927 opening of the Roxy, for example, a novel screen surround set within a proscenium 70 feet wide was described in a souvenir program: "a delicate gauze [surrounding the screen] behind which there is a cyclorama of silver cloth with various colored lamps playing on it gives a soft, diffused light to the picture."[61] Ben Schlanger subsequently observed, "In the Roxy Theater you had a fixed intensity illuminated border for several months. I tried an illuminated border for a year in a theater up on Broadway and 95th Street [the Thalia Theater, 1931]. They were all unsuccessful, because any illumination around the picture which is not synchronous with the particular intensity or hue of color of the frame of the picture being shown is as disturbing as a black border."[62] Within a couple of months the Roxy went back to the conventional black masking, but work on eliminating black masking continued. Richardson himself recommended a

different color beyond the black border to provide the benefits of the border (particularly visible movement of the image), but allowing it to blend into the surrounding environment.[63] Others suggested an illuminated surround of different colors and no black border, a projected surround with decorative elements that effectively recalled the picture settings or no border at all: "A new method of hanging the screen eliminates the necessity for the usual black border, thus reducing the contrast between bright picture and the background, improving viewing conditions."[64]

Given the size of the image, the double framing of black masking and proscenium, and problems in visual acuity, coupled with an understanding that these all represented deficiencies in exhibition, I want to suggest that the decoupage of the standard Hollywood film, with its emphasis on telling close-ups to direct audience attention, might in part be a function of the conditions of reception. Ben Schlanger saw precisely this connection:

> Cinematographic technique depends to a great extent on the ratio between picture size and viewing distance. If we said, for example, that a picture had to be viewed from a distance equal to ten times the width of the image, we would know that the story would have to be dramatized pretty much by the close-up method. The scenic material, which is certainly important to an illusion of reality, would be without detail to many members of the audience.[65]

Schlanger is exaggerating the width-distance ratio here for the point of argument, although some of the largest theaters like the Roxy or Radio City Music Hall did in fact have something like this configuration. Even in theaters that didn't reach this extreme, however, the small screen in the large space was at a minimum conducive to a style that relied on medium to close shots to make narrative points, an approach generally associated with the Hollywood classical style.

Although subsequent writing on classical style has looked at its evolution in terms of production, Schlanger was not alone in seeing a connection between style and exhibition, suggesting his was a more common perception from the period in which the "classical" films were being made. Two projection experts from the Eastman Theatre in Rochester, in a paper before the annual SMPE convention in 1928, also made a direct connection between the space of the theater and the distance of the camera:

The theatres [in the teens and twenties] were made much larger. Light sources were then inadequate. Projection optical equipment was inadequate. The film itself showed graininess, if enlarged too much, also, the general quality suffered considerably. By reason of all this the theatres were compelled in many cases to limit the size of their projected picture. . . . The necessity of keeping the size of the projected picture within small limits was partially overcome by the use of close-ups, and semi-close-ups. In some cases features have been made in which there were more close-ups than long shots.[66]

And if a film happened to be made that did not seem aware of the architectural limitations of exhibition, they said their practice was to correct what they saw as a problem of production: of *The Black Pirate* (1926), they write, "This picture was singularly lacking in the usual profusion of close-ups. Scene after scene consisted of medium or fairly long shots. Because of this it was decided that it would get over better if projected slightly larger than our standard screen." Instead of their usual 21 by 17 foot screen, they opted for 28 by 21, which, they report, "worked out very satisfactorily" (346).

To what extent may there be a correlation between film style and architectural space? Barry Salt's statistical analysis of Hollywood films of the twenties does demonstrate a generally closer position for the camera in this decade than in the teens, and the camera seems to get progressively closer as the decade wears on.[67] Since this shift in style follows upon the explosion of movie palace construction for prime first-run theaters throughout the United States in the teens and twenties, it seems likely that the places of exhibition had some impact on the product that was exhibited. Conversely, when Salt's figures on European films point to much greater camera distances, I'm not inclined to regard this as purely a cultural preference for distance. A survey of international theaters published in *Exhibitors Herald-World* in 1929 suggests that one possible reason for this difference lay in the differences in exhibition:

With approximately 27,000 theatres in Europe seating 12,000,000 people, only 19 have a seating capacity of over 3,000; 23 seat from 2,500 to 3,000; only 84 have from 2,000 to 2,500 seats; 267 have a seating capacity from 1,500 to 2,000 and 1,250 from 1,000 to 1,500

seats each. There are more than 18,000 theatres (*a good proportion of which barely qualify as motion picture theatres*) with less than 500 seats each. The average cinema capacity in Europe is less than 480.[68]

As my added emphasis indicates, this writer clearly thought there was something very wrong with the small size of these theaters; some of them might not even be theaters! While Europe at this time had more theaters than the United States, the writer's attitude might make sense if you consider that the New York metropolitan region alone likely exceeded all of Europe in the number of theaters with over two thousand seats.[69] These marked differences in theater architecture between the United States and Europe might well explain another odd fact that Salt's analysis of camera distances reveals: the American films of Alfred Hitchcock and Fritz Lang generally have a much higher number of close shots than the films they made in England and Germany respectively.[70]

If the screen as the key element in a theater's architecture placed constraints on film style, the technological screen exerted a similar pressure. As part of the cinematic apparatus, the screen had one technological constant—sufficient illumination, a central concern of *JSMPE* articles throughout the classical period. Insufficient reflectance, which surveys revealed to be a common problem in many theaters, was as conducive to a close-up style with shallow focus as the problems created by architectural space. Objects seen close-up in an insufficiently illuminated image are simply more intelligible than those seen at a distance since visual acuity increases with screen brightness.[71] As a consequence, insufficient illumination operates as a kind of parallel to the problems created by great distances: it leads to a preference for close-up in order to show detail, since detail would not stand out sharply on its own given the illumination problems in a majority of theaters. Furthermore, at low illumination levels, shallow focus helps an object stand out against background more forcefully than it would in a deep-focus style.

There is some evidence that the production side of the industry was aware of screen illumination problems in exhibition and might have sought adjustments that would deal with these problems. In a 1930 address to the Society of Motion Picture Engineers, Irving Thalberg reported on the formation of a "Producers-Technicians Committee" by the Academy of Motion Picture Arts and Sciences in 1929. Of the six areas the committee was to investigate, five had to do with production and film pro-

cessing, but the sixth was "screen illumination." Noting that "the problem of the quality of the projected picture seems to center on brightness contrast," Thalberg promised: "Minimum standards will be formulated for illumination attainable by the majority of theaters. Because of economic considerations, de luxe houses will exceed these and very small houses will not be able to reach them, but they will be practicable for the great majority of houses. The density of release prints can then be related to this standard."[72] In 1931, F. H. Richardson wrote a column calling film density "A Real Projection Problem," and quotes a Wisconsin small-town exhibitor who was using carbon arcs, but still had problems with some films: "'Dracula' has some scenes in the early part which, so far as the amount of light available to the small town theatre projectionist was concerned, could have been replaced with black leader with almost as good results, and that is no exaggeration, either."[73] The low contrast and generally flat lighting styles that are typical of 1930s Hollywood films are likely in part a consequence of screen illumination. In similar fashion, improvement in carbon arc technology in the late 1930s made possible the more complex lighting styles of 1940s films.

A long-standing problem of illumination across the surface of the screen possibly impacted on film practice in one other aspect. Illumination of the screen is both a matter of light source—i.e., the projecting apparatus—and the actual composition of the screen material. The choice of screen material, however, was in part a function of space the screen inhabited, which is to say space determined the type of screen used. Essentially two types of screen were available for theater use until the 1950s: the "specular" screen, which reflected light back in the same direction it was sent and thus retained more of the illumination directed at it, and the "diffusive" screen, which dispersed the light over a larger angle. Until the fifties, the specular screen was considered most appropriate for narrow theaters where patrons could be assured of remaining within a narrow angle of vision. The dispersal screen was necessary for larger houses, which meant virtually all first-run theaters, but this accentuated a problem in illumination, namely that the sides of the screen reflected only 64.5 percent of the visible light at the center.[74] The centering of the image (which has been made both a hallmark of the Hollywood cinema and interpreted in ideological terms) could in fact be a consequence of the sharp drop-off of light toward the edges of the image.[75] As we will see, the move to wide-gauge filmmaking in 1930 demonstrates that even

Classical Hollywood could abandon centering as a stylistic imperative. But in standard 35mm exhibition, the small screen and the vast theatrical space coupled with the problem in even illumination likely contributed to making the center of the image dominant.[76]

If the deep distance of architectural space and problems of illumination had an impact on the distance of the camera, let me speculate further by considering the width of the auditorium. I can evoke the problem most clearly if I use Radio City Music Hall, the last of the great picture palaces and one of the largest. Until the widescreen revolution of the early fifties, the Music Hall utilized a screen approximately 33 feet wide, one of the biggest in the country, set in a proscenium 100 feet wide, set in an auditorium approximately 200 feet wide.[77] This means that a fair block of seats at the Music Hall lay outside the 60-degree arc of the screen with a resultant distortion of the image and often extreme distortion at the ends of the rows.[78] This has one direct consequence for the kinds of image projected on the screen, as noted by Schlanger in 1932: "Distorted views of form and background on the screen are accented most when the forms and background appear in sharp perspective." In noting this, Schlanger is actually objecting to dominant cinematographic practice of the time, for he adds: "A view taken in sharp perspective in motion picture work is one of the most forceful and effective instruments of the motion picture art. Thus, *it is necessary that the means of exhibiting must be allied with the production of the motion picture as well.*"[79]

By pointing to problems of distortion and stating his own preference for sharply defined images, Schlanger effectively offers one explanation for why deep focus, a common feature of cinematography up through the teens, was not a good cinematographic style for large movie theaters since it would accentuate distortion.[80] And, importantly, he insists, as he repeatedly does throughout his writing, on a connection between production and exhibition. André Bazin assumed that shallow focus resulted from cutting procedures geared toward focusing audience attention: "Soft focus only appeared with montage. It was not only a technical must consequent upon the use of images in juxtaposition, it was a logical consequence of montage, its plastic equivalent."[81] Bazin posits a very specific causality here, with cutting procedures determining cinematographic practices. But it is just as likely that both cutting and shallow-focus style are in part determined by another, external constraint, that of theatrical space.

## Architectural Space and Classical Style

These are frankly speculative observations, and perhaps never fully susceptible to proof or disproof. But in claiming that an exploration of film theater architecture points to ways of rethinking important aspects in the history of film style, I have taken my lead from Ben Schlanger, fully aware that Schlanger was not a filmmaker, so that his writing, however suggestive, always operates at a remove from actual production circumstances. There is nonetheless one concrete piece of evidence that might limn the extent to which filmmakers were thinking about the screen in relation to architecture as a stylistic constraint: the early attempts at wide-gauge filming in 1930–1931, most especially Fox's 70mm "Grandeur" system since it.was the only one that led to four feature films released in wide gauge, with an additional two features from MGM and one released by United Artists.[82] It might seem odd that the studios would expect exhibitors, early in the Depression, to foot the bill for new wide-gauge projectors so soon after they all had to invest in sound equipment, a requirement that did drive low-performing theaters out of business in the previous year or so. Still, the timing is not coincidental: wide-gauge filmmaking offered solutions to problems introduced by sound film, problems related both to the image, its situation in architectural space and its illumination, and to sound itself since the wider soundtrack made possible with wider film produced a greater frequency range and better dynamics.[83]

Because there was no way of reducing the wide-gauge image onto conventional 35mm film as would become possible in the 1950s, filmmakers had to shoot two different versions, one in wide gauge and one in 35mm.[84] The wide-gauge versions, intended for exhibition on screens at least double the size of the screens in even the largest deluxe theaters, made possible something that had never existed before: an image that came close to filling the spacious prosceniums, an enlarged image more commensurate with the enlarged dimensions of the movie palace itself.[85] As such, wide-gauge film powerfully changed the existing relationship between image and theatrical space in a manner that had consequences for conventional stylistic practices. I propose that differences between 35mm and wide-gauge versions offer a likely test case for determining how the period understood the relationship between the screen and its architectural space.

Consider Raoul Walsh's *The Big Trail* (1930), filmed in the Fox Grandeur process.[86] The film has also long existed in a standard 35mm print.

Walsh was the director for both versions, although each utilized a different cinematographer. At first glance the Grandeur print seems a radically different film since its shooting style departs from other films of the period, with images much denser and the camera much less directional, often to the point that you occasionally have to search through the image in a given scene in order to find the speaker.[87] Still, direct comparison of the two versions reveals there is less cutting in the 70mm version, but in general the cutting patterns are fairly similar to the 35mm. The key differences actually come in areas I've been suggesting up to this point: the limitations imposed by sound film on exhibition, camera distance, and depth-of-field. I want to look at how these differences play out in three specific moments from the film.

I. Indian scout Breck Coleman (John Wayne) visits family friend "Mother" Riggs (Marcia Harris). In the Grandeur version, the scene begins with an extraordinary shot of six women by a fence in the front yard washing and combing their hair (fig. 6.3). The women are arranged in the image so that five form a diagonal line to the right of the image where Coleman will enter through an opening in the fence. A woman sitting on the far right balances the image, but there is no clear centering of focus since lines converge toward the opening in the fence. As Coleman starts to walk out of the image, there is a cut to a three-quarter shot of "Mother" Riggs at a pump feeding dogs. Coleman walks up to her in the center of the image and greets her (fig. 6.5). A fence on the left and a cabin on the right frame the image, but the background remains clearly defined and full of action: a wagon drives by as well as a number of horseback riders. In the 35mm version (fig. 6.4), one woman is eliminated from the first shot, while the remaining five form more of a circular grouping with a center point near the center of the image. After Coleman walks in on the far right, there is a cut to a long shot of "Mother" Riggs in the center of the image feeding her dogs, with the pump to the left of her. Here the shot is actually much longer than in Grandeur, but the background is closed off by the cabin on the right and a tree and a fence on the left. Furthermore, as soon as Coleman says hello, there is a cut to a loose medium shot and a shift in angle so that the two are standing against the indistinct background of the house (figs. 6.6a and 6.6b), which effectively acts like a shallow focus shot since no distinct lines are visible and all attention is allowed to concentrate on the centered foreground activity. As they walk

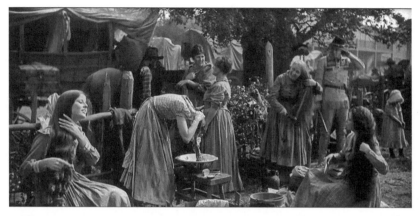

FIGURE 6.3
Coleman (John Wayne) comes to visit Mother Riggs in this complex widescreen composition that moves the eye across the width of the image.

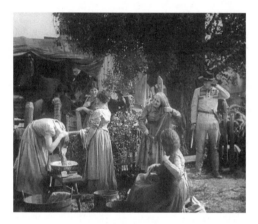

FIGURE 6.4
The parallel shot in the 35mm version has a tighter composition dominated by the roughly circular arrangement of the smaller group of women.

towards the house at the end of the sequence, there is a pan to the doorway, as if to suggest the limitations of what the camera can see. Although the doorway is not visible in 70mm, there is no camera movement in that version.

II. This sequence introduces the heroine, Ruth Cameron (Marguerite Churchill), an impoverished Southern woman who is moving West with her brother Dave and much younger sister, "Honeychild." It also

FIGURE 6.5
Mother Riggs shows Coleman how much her twin daughters have grown as both stand before a very busy background.

introduces the first of two villains, Mr. Thorpe (Ian Keith), an equally impoverished Southern gentleman who has become a river gambler. Again, the 35mm has the need for one additional shot, but the general purpose of the cutting in both versions is similar. In 70mm, it is as follows:

1. A long shot of the upper deck of a boat looking out toward the river; the boat and the people on it fill the left and bottom of the image (fig. 6.7). Miss Cameron stands in the center of the image, while her sister sits to the right on a railing which her brother, further right, leans against. The captain of the boat enters from the left and walks up to Miss Cameron. He speaks: "Well, Miss Cameron, we be . . . "

2. Approximately a three-quarter shot with the four characters spread out across the image and no real center to the shot (fig. 6.9). The captain and Miss Cameron face each other, occupying the left half of the image. The captain completes his sentence: ". . . landing in a few minutes." The captain tries to talk Miss Cameron out of her plans to go West, but she objects. Miss Cameron: "Why there's no place to turn back to." captain: "Why . . . "

3 (#1). The captain finishes: ". . . there isn't a home in all the South that wouldn't welcome the daughter of Colonel Cameron." Mr. Thorpe appears from the crowd to the left of the captain, walks forward to the right and leans against the railing, obscuring our view of Honeychild

FIGURE 6.6A
In 35mm, as Coleman greets Mother Riggs (feeding the dogs), a quieter background
has some activity barely visible behind the fence on the left.

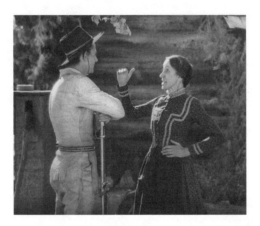

FIGURE 6.6B
The one additional shot in 35mm is used to bring the viewer closer to characters as
they talk, letting them dominate the image as background becomes indistinct.

and Dave as Miss Cameron tells the captain, "We must keep the family
together." As she turns around to her sister, Mr. Thorpe walks to the left
and out of the image. On his leaving, Miss Cameron says, "And our
brother Dave is almost a man grown."

4 (#2). Dave: "Ruth is right, Captain. The Cameron tribe must stick
together."

FIGURE 6.7
On the riverboat, another complex composition of two converging diagonal lines that move the eye to the scenic background.

FIGURE 6.8
The parallel shot in the 35mm version: the family grouping, now more centered, has clearly become the primary focus of the shot.

In the 35mm version the camera is more emphatic, both through cutting and mise-en-scène.

1. A long shot of the upper deck of a boat looking out toward the river, but the shot has been moved closer in than in 70mm, reducing our view of the river and trees to a fringe at the top of the image (fig. 6.8). Here the railing is moved into the center, so that the family grouping of Miss Cameron, sister, and brother is now more centered

FIGURE 6.9
In 70mm, there is a cut to a closer setup for the dialogue, but there is no clear center to the image: the two speakers are on the left, the Cameron brother and sister on the right.

FIGURE 6.10
The cut to the closer setup in 35mm removes the brother and sister from the image to keep the focus squarely on the two speakers.

and symmetrical. The captain enters from the left and moves behind Miss Cameron, beginning to speak, "Well, Miss . . ."

2. A close medium two-shot symmetrically balanced of the captain and Miss Cameron (fig. 6.10) as the captain finishes his sentence: ". . . Cameron, we be landing in a few minutes." There are people behind them looking out at the river and land, but what we can see of river and trees is distinctly out of focus. The cut on dialogue is slightly

different here, taking place when Miss Cameron says, "Why, there's no place to turn back . . ."

3. Full shot, with the railing now to the right of center as in #1 of the 70mm version (fig. 6.11). While there are four characters spread across the image as in #2 of the 70mm version, here Miss Cameron is definitely in the center as she finishes, ". . . to." Mr. Thorpe enters and moves forward to the center, partially blocking our view of the captain and Miss Cameron as the captain tries to talk Miss Cameron out of her plans: "It's a tough proposi– . . ."

4 (#2). The cut back to the previous shot, eliminating Thorpe from the image, allows us to see the two speakers unimpeded. Captain: ". . . –tion, girl, this pioneer life in the savage wilderness." . . . Miss Cameron: "We must keep the family togeth–"

5 (#3). Mr. Thorpe is now leaning on the railing (fig. 6.12), fully blocking our view of Miss Cameron as she finishes her sentence: "–er." Mister Thorpe starts to walk off as Miss Cameron turns to her sister and he walks out of the image as Miss Cameron says, "And our brother Dave is almost a man grown."

III. Coleman has his first exchange with the second and more treacherous of the two villains, Red Flack (Tyrone Power [Sr.]), inside a trading post. The key difference here is substituting crosscut singles for a two-shot, but there is a significant difference in cinematography as well. In Grandeur, the confrontation takes place as follows:

1. Long shot of the interior of a trading post with the large and bright entryway in the background to the right of center (fig. 6.13). In the foreground the bottom image is framed on either side by Indians counting furs. Other people and objects are visible in the image. As Coleman (*left of center*) tells the trading post owner (*right of center*) he'll scout for the wagon train, and the owner tells him Red Flack is the wagon boss, Flack himself enters from behind the boss to the left and walks to the center. Boss: "Likely you two've met be . . ."

2. Medium two-shot of Coleman (*left*) and Flack (*right*) (fig. 6.15). Although focus on the background is somewhat soft, setting, furs, other objects, and two men who enter a door and walk to the right are all legible. The boss (*offscreen*) finishes: ". . . fore." Flack (*looking Coleman up and down*): "Nah . . ." Coleman (*with a steady gaze*): "I reckon not." Boss (offscreen): "Coleman's gonna scout for the train. And he understands, Flack, that he's to have final say in all matters dealing with the

FIGURE 6.11
In 70mm, Mr. Thorpe stands between sister and brother, visually breaking up the family as the dialogue speaks to the need of keeping the family together.

FIGURE 6.12
In the 35mm version, Mr. Thorpe blocks our view of Miss Cameron as he takes over the center of the image.

Indians." Flack: "Yeah, well, who's got the final say about bossing the bull– . . . "

3 (#1). Flack: " . . . –train?" As Flack says this, the Indian on the right moves forward toward the center to place a fur on a pile.

The 35mm again requires one more shot:

1. A three-quarter shot of the interior of the trading post, with Coleman on the left and the boss on the right, part of the doorway visible to

FIGURE 6.13
Another very busy image in 70mm, but again with two diagonal lines converging on a figure in the background.

FIGURE 6.14
Although the same busy setting, the much closer 35mm camera and the placement of the characters, pulling Flack into the empty center, makes the characters dominant.

the right behind him (fig. 6.14). The top of an Indian's head may be seen in the foreground right of center; his activity is not clear. The boss starts to move back further to the right at the sound of offscreen steps; Flack enters and moves into the center. Boss: "Likely you two've met be– . . ."

2. Close medium shot of Flack (fig. 6.16a). Boss (o.s.): ". . . –fore." The doorway light is behind Flack and a passing shape seems to be a

FIGURE 6.15
The confrontational dialogue is played out in a medium shot in 70mm without cutting. Note the rifle barrel to the left of Coleman and the knife handle on his right.

person, but otherwise the background focus is soft to the point of abstraction. Flack (*looking Coleman up and down*): "Nah . . ."

3. Close medium shot of Coleman (fig. 6.16b). As in #2, the background focus is soft to the point of abstraction. Coleman (*with a steady gaze*): "I reckon not." Boss (offscreen): "Coleman's gonna scout . . ."

4 (#1). Boss: ". . . for the train." The scene continues as above.

Although the patterns and purposes of the cutting is the same in both versions, in all three sequences, the 35mm camera is clearly more emphatic in directing viewer attention. This is precisely the reason for the one additional shot in each sequence in 35mm. Even on the rare occasion when the 35mm version uses a longer camera distance, as it does briefly in the first example, the mise-en-scène moves the viewer's eyes to the foreground center by blocking off the background activity. This scene also presents the most overt attempt at directing attention in that the ensuing conversation plays against the nondescript background of the cabin, while the Grandeur version loads the background with competing activity. This neutralizing background cannot simply be a function of the lesser width, but, rather, a consequence of the overall smallness of the image in relation to the vastness of the auditorium space. On the postage stamp screen of conventional 1.33:1 installations, the competing activities of Grandeur would have to register more as distraction than enhancement.

FIGURE 6.16A
In a closer medium shot than the 70mm camera setup, Flack firmly denies ever having met Coleman.

FIGURE 6.16B
A comparably closer medium shot of Coleman, who reciprocally denies knowledge of Flack. Note we can no longer see the rifle barrel or the knife handle.

In trying to understand the different stylistic choices here, we have to keep in mind that original expectations for the Grandeur screen looked to a greater height as well as width. This is precisely a point made by the Eastman Theatre's projection specialists about a film the theater showed on an enlarged screen similar to Magnascope: "When the opportunity came to show a picture of really big dimensions it was quite natural that it should make a great impression. It was like being let out of doors after

a long sickness. The audience could see the character as large as in the ordinary close-up, with plenty of background also." This was a response to specific sequences from a feature film enlarged for dramatic effect; when they considered the possibility of an entire movie on a Magnascope-style screen, the close-up becomes unnecessary: "It would be interesting to see a feature, with all scenes taken at long enough range so the entire picture could be run on a large screen" (Townsend and Hennessy, 353). Another contemporary observed changes in shot scale that will be introduced by wide film would effectively alter what we think is a long shot or a close-up: "The ordinary screen figure in a long shot is probably two or three feet tall. In a medium shot or close-up, it reaches six or ten feet. In a wide film, the figure may reach a height of 18 feet. You can *see* that!"[88] What is particularly striking about both quotes is that shot scale is not measured in distance from the camera so much as in figure size. This suggests that the intimacy we ordinarily think was the primary purpose of the close-up in classical style was not a function of distance, but, rather, of size. That is to say, on a very big screen even a medium shot can give you a "big head," which casts this early term for close-up in a different light.

All this makes evident that even in longer shots characters might occupy approximately the same space on the screen they would have had on smaller screens, or possibly appear even larger. This would explain why, throughout *The Big Trail*, the camera is simply further back in the 70mm version. If the 35mm cuts to a tight medium shot, the 70mm is likely to cut to a loose medium or a three-quarter shot, and occasionally it won't cut at all. Because the relative size of the character was likely similar in the two versions *as projected*, cutting patterns remain similar between the two versions: the cutting always brings a movement in, even if the 70mm is rarely as close and never as isolating on detail. Further, lines of dialogue are generally overlapped across the cut, but the 70mm seems more likely to let them play in long shot because it is easier to pick up detail on the big screen. Arthur Edeson, the cinematographer on the 70mm version of *The Big Trail*, was specific about this difference when he wrote, "Grandeur reduces the number of close-ups considerably, as the figures are so much larger that semi-close-ups are usually all that is needed."[89] The close-up has become such an *essential* part of Hollywood storytelling, it's hard to imagine a time when film practitioners might have welcomed the ability to do without it, but this is precisely what you can read in an *American Cinematographer* article on the production of *Happy Days* (1930),

the second feature made in Grandeur: "Viewed from a practical view-point, the *Grandeur* proportions offer many advantages to all concerned. The director can film his spectacular scenes and stage dancing numbers to their best advantage, with fewer cuts—and no need of close-ups."[90] In the 1950s, when screens were much larger and the protocols of the classical style had become ingrained, there was concern with how the close-up would work on the ultra-wide CinemaScope screens, as if the close-up were a necessary part of film style. But at a time when the procedures we now ascribe to the Classical Hollywood cinema were still relatively fresh, the key issue for *Happy Days* and *The Big Trail* was not the use of close-ups on a wide screen but making the image large enough to obviate the need for close-ups.

Compositional strategies in the two versions of *The Big Trail* are frequently as different as camera distances, often seeking to establish different playing areas in 70mm, while a definite focal point appears in 35mm. Where the brushing and shampooing women in the first example form a tightly encircled grouping with a center point near the center of the image in 35mm, the comparable shot in 70mm creates a center point of two intersecting diagonals toward the right of the image. Similarly, in the second example, shot #2 in 70mm has four people effectively set in two different spaces, with most of our attention focused on the left where the two speakers stand. The comparable shot in 35mm (#3) also has four characters, but now Miss Cameron, the central speaker, is made central in the image as well. While both versions dramatically contrive to have Mr. Thorpe block our view of a family member just at the moment Miss Cameron asserts the family must stay together, in the 35mm he does so from the center of the image so that he blocks our view of Miss Cameron herself. In 70mm, he appears further to the right, blocking our view of the sister and brother, and eliminating the need for a cut-in to Miss Cameron as she starts to deliver this line, which is what happens in the 35mm version in order to keep both Miss Cameron and Mr. Thorpe a strong presence in their respective images. As a consequence, the 70mm version in effect creates two competing focal points.

Finally, there is the matter of cinematography. Compositional matters aside, the general look of the film is fairly similar in both versions except when the camera moves into medium and closer distances. Then, one of two things happens. Either the mise-en-scène in the 35mm version is set up so that background detail is eliminated, as in the first two examples,

or the depth-of-field is rendered shallower. In general, while backgrounds in the 70mm might be somewhat soft in closer shots, they never approach the extraordinary shallow depth-of-field of closer shots in the 35mm. This is established most forcefully in the final example. The scene might seem a prescient example of later theorizing over widescreen aesthetics that preferred two-shots to cutting, but I find the handling of background here even more striking.[91] In 70mm, the background might be soft, but clearly defined, and, as always, very active. The cutting to singles in 35mm, on the other hand, makes the actors' bodies truly imposing in their detachment from the background. It also ensures (importantly for the period, I think) the absence of lines of perspective that could foreground distortion. At an early demonstration of Grandeur in 1929, F. H. Richardson especially highlighted "No Distortion Anywhere": "I sat in a box which was one flight up, way over to the right side and down front. I of course expected a heavy side angle distortion, but could see none at all. Don't ask me why. I don't know. It just was so far as I could detect, not there."[92] It is very unusual for this writer not to venture some explanation for such a technical effect. And given the extreme viewing position he is assuming, it is likely there was still some distortion in the image Richardson saw, and it was simply enthusiasm for the radical improvement offered by the image that swept him away: 70mm solved the problem of sound film.

At a minimum, I hope it is evident from the 70mm version of *The Big Trail* as well as contemporary commentary that conditions of projection in American theaters affected procedures of production in Hollywood film. Procedures, established for reasons subsequently forgotten, may nevertheless take on a life of their own and remain an atavistic standard as if they were addressing some essential need, most clearly manifested in the changing attitudes toward the close-up. Throughout motion picture history, attempts were frequently made to change the relationship between the space of the screen and the space of the theater. Most often, these attempts explicitly acknowledged they were confronting problems for motion picture presentation that were inherited from conventional theater architecture. And with the resultant changes in screen presentation came at least the possibility for changes in film style. So, for example, while the move to deep-focus cinematography and the more complex lighting styles of the 1940s has been seen as conditioned by faster camera lenses, the improvements in carbon arc technology as well as faster projection lenses were a precondition for projecting these films adequately.[93]

## New Screens in Old Spaces

In discussing screen technology I have had to set the fifties as something of a boundary because the advent of widescreen technology changed not just the way people thought about screens, but also about the spaces they inhabited, ultimately making Schlanger's principles a paradigm for theater design. But this change was more gradual than suggested by the enthusiastic reception of Cinerama in 1952 and CinemaScope in 1953 as radical innovations, both rating front-page stories in the *New York Times*.[94] Changes implemented in the decade before wide screen generally aimed at dealing with the problems of the physical plant inherited from the theater-building of the teens and twenties. To solve the problems, the changes concentrated on three areas: the screen as a flat surface, the actual material that made up the screen, and the way the screen related to architectural space. Most of innovative work in these areas had begun earlier, but it was the postwar period, likely spurred on by dwindling audiences and the promised rise of television, that saw the greatest application of these changes. In general, the changes sought to reorient the spectator to the image on the screen. The chief changes were in the shape, material, and size of the screen as well as a more concerted effort to do away with black masking, led by Ben Schlanger.

Distortion in the great palaces remained a real concern in the classical period, and consequently work on changing the flat surface of the screen began anew in the mid-1940s. The "Cycloramic" screen revived the curved screens first attempted in the teens. The "Retiscope Concave Screen," named after the retina since "the shape of the screen corresponds to that of the eye," boasted a screen with curves along both horizontal *and* vertical planes to claim "the elimination, or at least substantial reduction, of distortion of the motion picture image from seats at the extreme sides of the screen end of the auditorium."[95] The Retiscope inventor followed up with a "concave-convex" screen, which was not in fact convex; rather, it became flat at the center, but appeared convex because of its concave frame and might well have been the same screen with a new marketing campaign. The marketing worked to get a notice in *Newsweek*:

Ever since the movie industry surmounted its two major technical problems—sound in 1927 and color in 1929—it has cavalierly ignored

the nuisance of the distortion that results from looking at a flat screen from an angle. Now, twenty years after sound, relief in the form of a new-type curved screen is within reach of unfortunate moviegoers relegated to far-side seats for whom Betty Hutton's face will no longer take on proportions of the late Edna Mae Oliver's.[96]

The matter-of-fact tone in a mass-market magazine possibly indicates the extent to which people regarded screen distortion as an unfortunate part of the moviegoing experience. The "concave-convex" description might have given the Retiscope inventor new ideas because he was back in 1950 with the "Trans-Color Convex Screen System," which once again claimed a "Distortion-Free Picture," but this time on a screen that curved *outwards* along horizontal as well as vertical planes.[97]

Changes made on the surface of the screen and its material attempted to deal with brightness and light distribution, itself possibly improved by the curvature.[98] A fiberglass screen, patented in 1944 and installed in Loew's theaters and other chains in the late forties, claimed in its patent application, "the glass cloth screen passes to the entire audience a more adequate amount of diffused reflected light and without 'screen glare.' "[99] Further, loose weaving of the fiberglass allowed a continuous surface without perforations, which further boosted illumination levels and led to enlarged screens.[100] If the curved screens anticipated widescreen technology, the greater reflectance likely led to claims that anticipated another technology of the fifties: the Retiscope screen claimed, "Gives illusion of depth to the picture," while the Cycloramic went with the less modest "Amazing new depth—third dimension effect!"[101] All of these changes would ultimately be superseded by developments that were a necessary precondition for the introduction of wide screen.

The most influential development in the "maskless" screen came from theater architects Ben Schlanger and Jacob Gilsten, who held a public demonstration in October 1937 of a device designated in its 1938 patent as a "Screen and Synchronized Light Field."[102] The *New York Times* noted the device, given the more compact moniker "screen synchrofield" for the demonstration, sought "to eliminate the 'artificial limitation' of the present screen upon the spectator's field of vision." The screen was in effect surrounded by a second screen that angled out from the flat surface into the auditorium, picking up and diffusing light from the main screen.

The intent was to create a gradual merging between screen and auditorium that broke down the marked sense of separation effected by black masking:

> "The side walls of the motion-picture theatre auditorium can now be made to blend into the 'Screen Synchrofield' surfaces, thereby making it further possible to project the spectator into the scene of the action," the inventors explained. "For successful results, these walls must be designed to reject, or receive light reflections from the screen to a proper degree."[103]

In effecting a merger of screen and auditorium, the "screen synchrofield" was both more particular and less distracting than the color harmonies of the Roxy because it made the light surround entirely dependent on the motion picture image itself. In doing this, it effectively anticipated true wide screen and actually had a direct impact on theater design in the 1950s.

Up until that time, installation was pretty much limited to theaters designed by Schlanger himself. But in 1952, RCA, one of the largest movie theatrical supply companies, took over the distribution of the device as the "RCA Synchro-Screen," calling it the "first major improvement in 25 years in the pictorial presentation of motion pictures."[104] The "Synchro-Screen" had an impact on screen installations far beyond any of the earlier experiments in part because it came in a period of increasing screen size, which was often linked as a response to the rise of television. As an RCA advertisement emphasized, the "Synchro-Screen has effect of extending picture beyond limits of flat screen and out onto broad wings . . . makes picture seem larger, less confined."[105] Further, the ad touted the screen as "The Perfect Stage Setting for Motion Pictures," a phrase that was subsequently used in a *JSMPTE* article Schlanger cowrote: "The Synchro-screen as a Stage Setting for Motion Picture Presentation." Whether or not this was intentional, this does seem to invoke the picture settings of the twenties, as if the new screen offered a solution to the problem created by the loss of the picture settings, but a solution entirely determined by the film image itself.

Writing in 1951, Schlanger noted, "There has been a tendency in actual screen installations towards a somewhat larger picture in recent months," and there had indeed been repeated calls for larger screens in

the recent past. Schlanger saw this in part influenced by a technological development that had been receiving demonstrations for industry personnel since 1949: "The 'Cinerama' screen process . . . has forcibly displayed to many persons who have seen it, the tremendous importance of the really enlarged picture." For Schlanger, the Synchro-Screen created what he called "Full Vision Movies."[106] Based on the demonstration showings of the new process, a *Motion Picture Herald* article directly compared Schlanger's screen to Cinerama, for its " 'panoramic' effect" because it could make even the image on conventionally sized screens appear to be larger than it actually was, as the RCA ad claimed. Acknowledging the "word *panoramic* more nearly describes the method known as Cinerama," the article nonetheless highlighted an observation from Schlanger that seems to stress a similarity: "The total luminous area fills more than three times the field of vision of the patron, compared with the present size and type of picture."[107] The Cinerama screen would often obscure or eliminate existing proscenia when it was installed, requiring structural changes to move the screen into the space of the auditorium, but the Synchro-Screen had the advantage of seeming to move the image past the proscenium while allowing the architecture to stand. The fact that it could fit within existing architecture makes clear that the Synchro-Screen represented a solution to the problems of the palace: not only did it make the visual field of the screen seem larger, it pushed the screen further back behind the proscenium arch, restoring the earlier relationship between screen and auditorium for which the palaces were designed and which the picture setting required. The top flange could also help with the acoustical problem that came with that position, while the distance from the proscenium would reduce the distortion in the side seats.

The Synchro-Screen did in fact directly anticipate the screen of the future in one specific way. At the beginning of December 1952, about two months after the New York premiere of *This Is Cinerama*, the RKO 58th Street theater in New York installed an enlarged Synchro-Screen "nearly three times the size of the average, old style screens."[108] Even a screen this size (30 ft., 7 in. wide) could not fill the proscenium of the 2,500-seat neighborhood theater, but the light-reflecting wings from the screen did, facilitating an illusion that the image seemed to dominate the front of the auditorium with a continuous visual field filling out the space of the proscenium as specially designed picture sets once did. The most striking thing about this particular installation in terms of future

development lay in an alteration of the film image's aspect ratio: the theater "increased the width without increasing the picture height" by cropping out 7½ percent of the height.[109] The lateral extension of the image led "RKO people [to] jokingly call their 58th Street theatre presentation 'the poor man's Cinerama.'"[110] Furthermore, the claim pronounced at the first public demonstration of the "screen synchrofield" in 1937 that the new screen made it "possible to project the spectator into the scene of the action" directly anticipated Cinerama's advertising claim that "it puts you in the picture" by fifteen years.

From its first well-publicized installations early in the 1950s, Schlanger's maskless screen successfully bred imitations, ranging from homemade devices to competing light surround systems, usually with the claim that it made the image appear wider.[111] Producing studios clearly saw the connection between the light surround and the wide expansion of the image. When Paramount, the first company to crop an image for added width, introduced its widescreen system in mid-1953, it was on a Synchro-Screen with a curvature added to it.[112] Since the Synchro-Screen could provide a sense of moving beyond the proscenium, it continued to be installed in new theaters at the least into the 1970s.[113] But the chief change it introduced, the ambition to create "full-vision" motion picture presentation, was dramatically realized by Cinerama, which directly led to a permanent change of the motion picture screen, one that would not just fill, but in some cases extend beyond the proscenia of the palaces and lead to changes in new theater design.

# CONCLUSION

## Ontological Fade-Out

### ART CINEMAS, CINEMA ART

As I conclude this narrative, I arrive at a period when the motion picture image in its most common use is beginning to move outside of the architectural spaces that had contained it for most of its history. This happened in two ways, the first moving the image into the great outdoors, the second into domestic space. In both cases, the image continued to be contextualized by a setting, but the setting was now radically removed from anything that suggested conventional theater. With that break, I would suggest, the status of the image itself began to transform. If the major transformation took place outside of theatrical space, within the space of the theater a different transformation took place as well.

While changes in screen design inevitably led to changes in architecture, there was one major development on the architecture front in the

period leading up to the wide screen that had a powerful effect on screen technology and the status of the screen itself: the postwar period saw a boom in drive-in theater-building, previously a form of exhibition that had been primarily regional. In 1948, a survey by the Motion Picture Association of America revealed there were 743 drive-ins across the nation, of which 137 were "year-round operations." Of these, the "majority . . . stick to a single-feature policy."[1] By 1950, the number had jumped to 1,980 and reached 4,700 by the end of the decade.[2] The drive-in created conditions of exhibition unlike anything that had been seen in in-door theaters. For example, a car "even in the second ramp of a large theater [would be] at a point 173 feet from the screen . . . ," a distance much further than anything in the biggest palaces.[3] And that was only from the second "row": one Chicago drive-in in 1950 had a throw-distance from projector to screen of 475 feet.[4] Because of the distances created by an audience of automobiles, drive-ins of necessity featured much larger screens than those in conventional theaters, even before the introduction of widescreen technologies (1952–1955). While Radio City Music Hall's standard screen in the early fifties was exceptionally large at 33 feet, a 1949 article reported the "drive-in picture is seldom smaller than 40 feet wide."[5] In 1951, another Chicago drive-in reported a screen 70 feet wide, which happened to be the same size as the screen at Radio City Music Hall *after* the introduction of CinemaScope two years later.[6] Many drive-ins did not convert to widescreen right away because in effect it meant replacing their largest building, but when they did, the Scope screens often far exceeded the widest in indoor theaters. The very size of these screens created problems of illumination never dealt with before, not least because outdoor conditions, even in rural areas, could often not depend upon the level of darkness possible in indoor theaters. Improvements in carbon arc technology, needed for drive-ins in the late forties, made possible the widescreen illumination in the fifties.[7]

Even more critical for my concerns here, the drive-in redefined how the screen related to architectural space by virtue of the fact that the screen itself was one of the very few architectural elements left from the conventional theater. There was a kind of architecture here to the extent that orderly spaces had to be laid out to mark where each car should park, with each space clearly designated by a pole for the portable speaker to be latched to the car window, but the architecture was more like a blueprint— an outline of forms on a flat surface—than an actual building, or, perhaps,

a kind of invisible building. By its gargantuan size, the screen was the most visible element, but the extraordinary distance from viewers reached proportions far in excess of SMPTE's recommendations. Still, because the screen provided the most prominent of the drive-in's four architectural elements, alongside the combined projection booth–refreshment center, the ticket booth, and the marquee, it could achieve a dominance of its space unlike anything in indoor theaters before wide screen. In the drive-in, the screen was no longer an object defined by architectural space; rather, the screen had become the theater itself.

The drive-in screen possibly revived something of the uncanny aspect of the movie image by making it a spectral reality suspended in a night sky. On the other hand, the other postwar phenomenon to detach the screen from its theatrical context did place the film image in a specific architectural space. The spread of broadcast television was initially limited by the Federal Communications Commission (FCC) in the postwar period, but then escalated throughout the 1950s, until it reached most Americans. In theory, the television image, potentially showing much the same things shown in movie theaters, could be shown anywhere. But early on, in spite of the movie industry's attempts to link it to the theater through "theater television," showing live events like boxing, television did become identified with a type of architectural space—the home. From a survey of home magazines of the early fifties, Lynn Spigel has shown how the television set was made a domestic object: "As the magazines continue to depict the set in the center of family activity, television seemed to become a natural part of domestic space. . . . Photographs, particularly in advertisements, graphically depicted the idea of the family circle with television viewers grouped around the television set in semicircle patterns."[8]

The space around the image was now more individualized, and how people positioned themselves in relation to the image was now more a matter of choice. Movies had been literally domesticated in the home, but the drive-in was also marketed as a family experience: admission at many drive-ins was by car, not individual viewer, or else children were admitted free, with the expectation that both policies would encourage family attendance; the space of the car was a personal family space transported to the moving image; and the drive-ins offered activities for the entire family, ranging from laundromats to playgrounds with concession stands that could be used for dinner.[9] That is, the drive-in also served to individualize

space by offering a variety of options for each individual, only one of which actually involved watching a movie. Ultimately, in both the case of the drive-in and the home, the image had lost the aura granted it by the theatrical space. Now it was simply one element within a space for a variety of activities.

It would take another forty years or so for the cinematic image to be fully divorced from specific architectural spaces, finally achieving the ubiquity that was always inherent in the medium. Consequently, we live in a world that surrounds us with moving images, in every conceivable kind of architectural space as well as outdoors: they have become an inescapable part of our lives. As potential contexts for the texts were becoming increasingly varied, cinema's seeming existential bond to theater, purportedly proven anew by the arrival of *This Is Cinerama*, was fading. As my journey through the varying configurations between image and architecture that took place in the space of the theater over a 60-plus-year period has returned me to my point of departure, I would like to echo a comment frequently heard in continuous-performance movie theaters: "This is where I came in." But in sketching out more of the context for the claim that film was and is an art of the theater, I find this affirmation more complicated than might appear at first glance.

Most saliently, there is a double irony in *Motion Picture Herald*'s use of Cinerama as a demonstration of film's theatrical essence. First off, installing Cinerama required a radical reorientation of architectural space within the theater: the projection booth at the rear of the balcony became a useless relic of the past; in its place three separate projection booths had to be built at the back of the orchestra; seating capacity had to be reduced so that all viewers would be within an angle to receive the impact of the Cinerama effect; a seeming warehouse full of drapery covered over the once-lauded architectural detail of the auditorium, both to let the screen dominate the space, but also to improve the acoustics for a seven-channel sound track, with sound originating in the auditorium itself as well as behind the screen; and, most importantly for my concerns, the apparent elimination of the most visible signifier of live theater, the curtained proscenium arch—in the first New York installation the oversized deeply curved screen, 51 feet wide by 26 feet high, had to be placed *in front* of the proscenium. Second, the five Cinerama features exhibited from 1952 to 1962 were in many ways closer to the kinds of film that predated the rise of the feature film, which early on positioned itself as the direct

competitor to the legitimate theater: *This Is Cinerama* is basically a two-hour travelogue, which pretty much describes the next four Cinerama releases, with occasional gestures made toward narratives, but always narratives of tourism. As John Belton has noted, "The Cinerama medium is ideally suited to the 'nature' documentary and the sightseeing excursion."[10] The cost of installing Cinerama was sufficiently prohibitive that the initial showing of *This Is Cinerama* was limited to only seven theaters. In spite of this and the generally limited box office appeal of feature-length travelogues, within fifteen months the film was expected to gross $6.5 million.[11]

Cinerama managed to turn a profit over a ten-year period with travelogues and a limited number of theaters–$82 million in only twenty-two theaters—but "each successive Cinerama picture earned less than the one before."[12] It was clear that continued growth and profitability would require both a move to narrative films and a substantial increase in the number of theaters equipped to show Cinerama. The two went together: *The Wonderful World of the Brothers Grimm* (1962), the first of a series of features MGM committed to make in Cinerama, turned Loew's flagship Capitol in New York City into the Loew's Cinerama, a couple of blocks north of the Strand, which had become the Warner Cinerama ten years earlier.[13] In contrast to the legitimate theater where it premiered, the spatial dimensions of the great palaces were more suited to Cinerama: the screen at the Capitol, heralded in the advertisements as "Super Cinerama," at 90 feet wide by 33 feet high, approached doubling the size of the original Cinerama screen.[14] At the same time, sightline requirements of Cinerama dictated a drastically reduced seating capacity, cutting the Capitol's 5,300 seats down to 1,525.[15] With commitments from MGM and United Artists to make narrative features in the process as well as a move away from the three-projector technology to a single 70mm projector, Cinerama announced a theater-building plan with a design based on Buckminster Fuller's geodesic dome, hoping to build 300 theaters in the United States and another 300 theaters abroad, what I would like to call theaters of the future because this was a design based in technology, a form appropriate for an art based in technology.[16] While a limited number of new theaters were built, in the United States only the Los Angeles Cinerama theater utilized the dome design. Repurposed movie palaces remained the primary venue for the process, and it did initially help them survive the precipitous box office declines of the sixties. The Capitol/Loew's Cinerama,

for example, remained a successful exhibitor of Cinerama films through *2001: A Space Odyssey* in 1968.

Making a commitment in the early 1960s to build 300 new theaters might seem foolish in the face of competition from television, but this was actually part of a trend, heralded by a *New York Times* headline in 1962, "Movie Theaters at Building Peak," with 183 new indoor theaters (as opposed to drive-ins, which accounted for another 95) beginning construction in the previous two years. Many of these were in response to the postwar growth of the suburbs, as the *Times* noted: "Long Island claims the largest concentration of new theaters within a single area, with 29, most of these in the suburbs near Manhattan." New York City itself saw five new theaters open in the same period. But these theaters were moving in a very different direction from the Cinerama theaters: "The local pattern [in New York], which is indicative of the national trend, has been toward the development of small 'art houses,' with many of the large old 'movie palaces' converted to reserved-seat operations for long runs of the spectacle type of films."[17] Emblematic of this shift, a new theater opened on New York's East Side about six weeks before the transformed Capitol debuted as a Cinerama theater. Dubbed "Rugoff's Unique Cinema I–Cinema II," these duplex theaters pointed to a different direction for theatrical exhibition in the age of television, a direction that would effectively set the pattern for future theaters.[18] Cinemas I and II would become a landmark in what *Variety* called the "New B'way," heralding a shift away from Broadway as the primary site for extended-run films: "If the building trend continues along Third Ave., industryites envision the street as the new home of important first-run pictures, including hardticket entries."[19] Most of these new theaters were art houses, and there were enough of them to lead the *New York Times* to run a map showing their locations.[20] The reasons for the shift had to do with the growing importance of international art cinema to American exhibition.

In an article on plans for the two auditoria that made up Cinemas I and II, *Variety* specified that the "larger theater will play both Hollywood product, including hardticket entries [i.e., a reserved-seat, two-a-day run], or foreign product that has a larger appeal," while the small theater would be for "specialized art films" ("Rugoff–Becker's 2-Level Theatre"). The possibility of reserved-seat bookings might seem odd for an art house, but what was intended here was not the kind of big-budget movies getting roadshow treatment on Broadway at the time. The context for this state-

ment was the postwar revival of reserve-seat extended-run cinema, which began not with Hollywood spectacles of the 1950s, as often assumed, but, rather with the British invasion in the postwar period, kicking off with Laurence Olivier's *Henry V* (1946). British films in particular achieved runs far in excess of anything achieved by a Hollywood film since *Gone with the Wind*: a bit over a year for *Henry V*, fifteen months for *Hamlet* (1948), and over two years for *The Red Shoes* (1948). As in the 1920s, when Hollywood sought to present itself as the successor to the legitimate theater, the length of the run became part of the movie's exploitation. For *Hamlet*, Universal-International gave out a press release boasting that fifty-eight weeks (and still showing) "establishes the run of the film as the fourth longest 'of any motion picture in New York history.' "[21] And about two months before *The Red Shoes* finally closed, an advertisement exclaimed, "**100th Week!** In The All-Time History of Broadway . . . There Has Never Been A Run Like . . . There Has Never Been A Hit Like . . . There Has Never Been A Motion Picture Like . . ."[22]

The old pattern of booking films into legitimate theaters in or near the Times Square theater district was used for *Henry V* and *The Red Shoes*. But *Hamlet* was treated differently, opening in a 475-seat theater on the East Side on a street lined with the city's most exclusive apartment houses in a space that had previously housed an art gallery—a theater so exclusive that it began its first year with a yearly subscription fee. As the Park Avenue–art gallery ambience of this theater suggests, the extended-run engagements, whether two-a-day or grind, that would become common in East Side theaters were different from the roadshow engagements that took over the demotic palaces on Broadway in the 1950s. The implication was always that these were films aimed at a discriminating audience, much like the one Gloria Gould was wooing for the Embassy in 1925. Commensurately, the theaters didn't sell popcorn, but many did feature espresso in their lobbies and sometimes even artwork for sale on their walls, the products serving to define the patrons, either in actuality or aspirationally.[23] Because of the common language, however foreign the accent, British films such as *Great Expectations* (1946), which opened at Radio City Music Hall, could play in more conventional movie theaters.[24] But as the East Side exhibition circuit grew larger, more British films, especially those that seemed more culturally specific, sought long exploitation runs in these small-scale theaters and for reasons similar to the long runs in the 1920s: to help sell the films outside of New York.[25]

If British films had occasional success in the American market in the past, one of the most striking features of the postwar period was the increasing movement of foreign-language films outside of the niche they had previously occupied. To do this, a successful New York run was essential. So, for example, a film like *Diabolique* (1955) could end up playing in neighborhood theaters outside of New York in French and with subtitles. In 1961, *La dolce vita* became one of highest-grossing foreign films in the domestic U.S. market. The rising popularity and new commercial potential of the international art cinema gave a renewed impetus to the bifurcated releasing system: by the late sixties, Hollywood would open small-scale but artistically ambitious films in the growing number of East Side art theaters in New York with the expectation of runs that would go on for several months, exploitation for the mass release that would follow. A Broadway opening, on the other hand, was for movies with more mass-market appeal, with the biggest-budgeted ones receiving the roadshow treatment.[26]

The rise of the art film suggests that *Variety* was wrong to call the East Side theaters a "New B'way." If anything, it was more like Off-Broadway, which began to become an important force in New York theater after the war. But ultimately the move to the East Side might best be seen as a move away from theater altogether. Within this new emerging movie district, Cinemas I–II sought distinction, and most of all did so through architecture. In the first announcement of plans for the new theater, about sixteen months before the theater opened, Ben Schlanger, who had done a number of other theaters for Rugoff, was listed as the sole architect: "In preliminary drawings by Ben Schlanger, designer of the Murray Hill Theatre and one of the architects for Lincoln Center, a 750-seat theatre will occupy the main floor, with a 250-seat auditorium on a lower level."[27] Somewhere in the process of developing this building, the name of Andrew Geller was added. At the time, Geller, described in an obituary simply as "Modernist Architect," was best known for his domestic and commercial architecture; as far as I can determine, the Cinemas I and II was his first and only theater building.[28] The architects of the great palaces from the teens and twenties built reputations on the basis of their theater buildings, but their specialization has likely kept them out of most histories of twentieth-century architecture.[29] Like them, Schlanger, although as much the modernist architect as Geller, did not have a reputation outside of theater architecture circles. Engaging Geller ensured that the

building itself would receive notice, which it did—two articles in architecture journals as well as a feature article in the *New York Times* with a large reproduction of the "Architect's sketch" to show how the design of the theater worked.[30] The theater's distinction was also acknowledged by the Municipal Art Society of New York, which awarded Geller and Schlanger a Certificate of Merit "for the design of two motion picture theatres, Cinema I and Cinema II, which bring the qualities of elegance and reserve to a field in which they most usually are absent," as well as two other awards for architecture.[31]

The class connotations in "elegance" and "reserve" that lift these theaters outside the commercial vulgarity of past theater-building point to another referent embodied in the architecture. The *Architectural Forum* article singles out one aspect of the façade worth considering here: "The first theater building with an open façade in New York City, Cinema I has a second-floor lobby which is an inviting showcase for passers-by" (121). This was a marked difference from past theaters, where light was effectively kept out: a theater that was part of an office building would have conventional windows in its façade, but this great expanse of glass across the width of the building was unusual (fig. C.1). There was, nonetheless, a model for this design: Lincoln Center for the Performing Arts. To keep an architectural harmony, the three central buildings—the Metropolitan Opera House, flanked on either side by the New York State Theater and Philharmonic Hall—all had an arcaded façade, like Cinemas I–II, and second-floor lobbies visible through glass along with the chandeliers and artworks inside (fig. C.2).[32] Like Cinemas I–II, which partitioned the massive window with marble-sheathed pilasters, the glass façades of the three Lincoln Center theaters were partitioned by white columns of varying designs. There was a fourth building, one for drama, but it was much smaller, and tucked away behind Philharmonic Hall; although it used a glass façade facing into a ground-floor lobby, the overall design was different from the three central buildings. While the Lincoln Center model is evident in its design, Cinemas I–II audaciously opened three months ahead of the first Lincoln Center building, Philharmonic Hall. (Figure C.3 foregrounds the key elements of the design via abstraction in an advertisement announcing the opening of the theaters.)

How, then, could Lincoln Center serve as a model? Architectural drawings of the three buildings had already appeared.[33] More important,

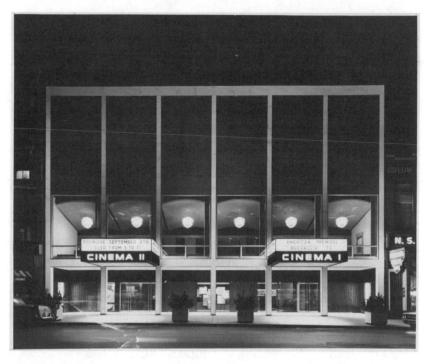

FIGURE C.1

The Cinemas I–II (1962), the "first theater building with an open façade in New York City." It also featured a second-floor lobby visible from the street, a beacon of interior light at night, and marble-sheathed pilasters evenly spaced across the façade.

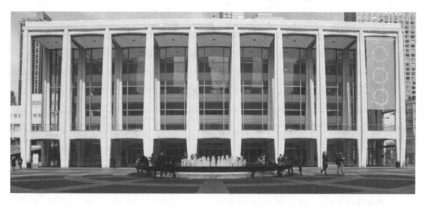

FIGURE C.2

Philharmonic Hall (1962) at Lincoln Center, with the Center's unifying design motif of glass façades divided by marble columns and second-floor lobbies visible from the plaza.

**CINEMA II**       **CINEMA I**

The first *truly new* theatres in thirty years—designed and erected from the ground up for the showing of motion pictures.

Cinema I and Cinema II are two theatres housed in one structure at Sixtieth Street and Third Avenue. Each theatre is

complete unto itself, with its own marquee, entrance, lobby, lounges, and auditorium. Though designed with a flowing

abundance of space, the theatres achieved a unique intimacy. The auditorium, as perfect as sight and sound engineering

can make them, set new standards of comfort. Feature times will be staggered, providing a continuous choice of convenient

show times. Gracing the spacious lounges is the permanent art collection, a group of specially commissioned sculpture

and paintings, as well as a gallery exhibition which will display the works of contemporary artists on a revolving

basis. Coffee will be served in the lounges. Yes, tomorrow two new theatres will enchant and delight all New York.

FIGURE C.3

This advertisement ran in a number of publications in advance of the opening, the abstraction of the theaters stressing the design connection to Lincoln Center.

Ben Schlanger was one of the architects involved in Lincoln Center, as the first announcement in the *Times* noted, back when Schlanger was the only architect listed for Cinemas I-II and had already provided "preliminary drawings."[34] It would take Lincoln Center three decades to add its own film theater; in the meantime, Cinemas I–II could become the premier space for film as one of the arts, not film as an analog to theater. And the Rugoff chain clearly wanted the resemblance to be noticed: an undated press release from the time stated explicitly, "Cinema I–Cinema II are planned as the core of an International Film Center on the East Side, which will act as a crosstown complement to Lincoln Center."[35] Further, most Rugoff press releases highlighted Schlanger's connection to Lincoln Center. The point was to recognize film as its own art form, not a derivative of the stage, something that warranted its own structure, much as each of the arts at Lincoln Center had its own building. A full-page ad that ran the day before the opening pressed this claim: "The first *truly new* theaters in thirty years—designed and erected from the ground up for the showing of motion pictures."[36] The claim that the theaters were innovative because they were designed solely for movies echoes claims made for the 1929 Film Guild Cinema, the "first 100% cinema," as described in this volume's introduction; but even that theater with its elaborate camera-like iris around the screen and plan for projected images all over the auditorium seemed to embrace the extravagance that was typical of the period. By contrast the auditoria of Cinemas I–II were almost nondescript.

It is not possible to prove that Schlanger provided the Lincoln Center connection, or who in fact should receive credit for which aspects of the building. Schlanger did write to Geller a number of times pointing out they had agreed they should always be listed equally as architects.[37] It is evident the auditoria were entirely Schlanger's work, both from echoes of Schlanger's other theaters as well as the advertisement, which seems to tout an architect who embraced engineering "as perfect as sight and sound engineering can make them." The larger auditorium in particular seems a reworking of a design he had provided the Rugoff chain with the Murray Hill Theatre three years before, but both Cinemas I–II auditoria had features typical of Schlanger, from the Synchro-Screens to the seating arrangements (in the larger theater, a modified stadium arrangement and continental seating to eliminate aisles) to the neutral wall treatments (fig. C.4).[38] As significant as these elements were, equally significant was what the theaters lacked: no stage, no proscenium and, most importantly,

FIGURE C.4
Schlanger's neutralizing auditorium in gun-metal gray. Here Schlanger could fully integrate the Synchro-Screen into the architectural space by making the side flanges continuous with the walls, the top flange with the ceiling.

no curtain.[39] This has since become a convention of movie theater architecture, but at the time curtains were the last vestige of conventional theaters still being included in other new theaters. Pulling back the curtain, so to speak, was Schlanger's way of realizing an ambition from his earliest architectural designs, the culmination of film asserting its own artistic identity.

Much as using the screen to define architectural space looked ahead to future movie theater architecture, the form of the dual theater design, which garnered the most comment at the time, looked ahead in terms of function to the mulitplex. The theater was seen as innovative, although it was hardly the first duplex. Like the Duplex Theater of Detroit described in the introduction, the design was a response to developments in production, but very different circumstances led to a different design and a different set of goals. The theaters were not twins; rather, they were piggybacked with very different seating capacities (fig. C.5).[40]

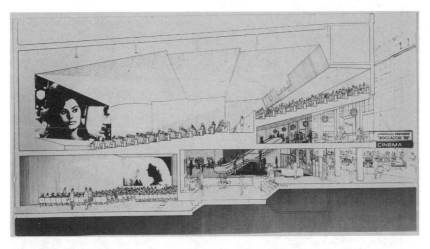

FIGURE C.5
An architectural design that created different spaces for different kinds of films,
with the smaller auditorium preferred for more specialized, less commercial films.

A *Variety* article explained the function: "Policy is a flexible one. Both
theatres might play the same picture at different curtain times. . . . Could
be, too, that the 300-seater will run an import while the 700-seater plays
a non-art entry, or the 300-seater will take a picture from the 700-seater
on a moveover run."[41] More important for the future direction of exhibi-
tion was the combination of certain kinds of Hollywood films, foreign
films with broader appeal, and films aimed at a narrower audience. The
combined theaters meant that the commercial success of the larger audi-
torium could help sustain the limited cash flow of an extended run in the
smaller auditorium, essentially setting up the pattern that would be uti-
lized by the later multiplex. Given the way the theater had positioned itself
as the most distinguished setting for the art of film, it quickly became
the most sought-after booking for Hollywood's artistically ambitious
films such as *Mean Streets* (1973) and *Days of Heaven* (1978), with the
theater granted an exclusivity that had once been reserved for pre-release
theaters in the classical period. And it maintained its artistic aura by alter-
nating Hollywood art with foreign films with popular appeal and big inter-
national stars such as *Boccaccio '70* (1963), its opening film, and *Tom Jones*
(1963), as well as smaller-scale imports such as *Il Posto* (1963).

Rather than say that cinema in this period discovered its true voca-
tion, as Siegfried Kracauer wanted it to when he complained about Berlin's

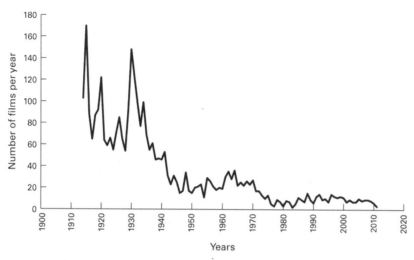

FIGURE C.6
Feature films based on theatrical sources, 1914–2011

presentation houses, I would prefer to posit that the prestige of Cinemas I–II and the consequent shift away from Broadway to the East Side signaled how much cinema began to loosen its tie to theater.[42] The best evidence for this is the move away from theater itself as a source for movies. In its earliest decades, drama was one of the primary sources for feature films (and continued to be with occasional ups and downs). But from the 1970s on, adaptations of stage plays decline rapidly, as the chart in figure C.6 demonstrates. (For a more precise breakdown, see appendix 2.) At a certain point, Hollywood became more likely to look to old television shows and comic books as prime source material for mass market movies rather than to the theater. And with the rise of the international art cinema and eventually a native American art cinema, serious movies no longer defined their seriousness by claims of being the successor to theater, but rather asserting their status as an entirely separate art form.

## CURTAINS FOR CINERAMA

If Schlanger's Synchro-Screen ("the poor man's Cinerama") could, like Cinerama, seem a way of redeeming the giant space of a palace, in the context of a smaller theater it functioned differently: here it was not the poor man's anything, but rather the theater's defining architectural

element, refusing to be concealed by a curtain, in its own way effectively announcing the independence of film art. On the other hand, the curtain was a key part of Cinerama's exhibition protocol, as exemplified by this ad copy for *Search for Paradise* (1957), the fourth Cinerama travelogue, which emphasizes: "When the theatre lights dim and the curtains open . . . and open . . . and open—you are plunged into the entertainment experience of your lifetime."[43] *This Is Cinerama*, the first film, began with a conventional 1.33 black-and-white introduction, narrated by noted journalist and radio commentator Lowell Thomas, and projected at a size that would have been used for ordinary movies. The Cinerama curtain was located very close to and directly in front of the screen, following a track of the screen's curvature. An audience seeing Cinerama for the first time could assume much of the curtain was decorative, and, indeed, for the Thomas prologue, the curtain opened only as wide as the initial small-screen image. Concluding his twelve-minute introduction, which had provided a brief history of art (from cave painting to the Renaissance in forty seconds), then moved on to the various technological innovations to make images move and then speak, Thomas finally intoned in his well-known stentorian voice, "Ladies and Gentleman, *this* is Cinerama!" At which point the full Cinerama image, all three panels, flooded the screen (although the image was a bit obscured since it was in a dark enclosed space at the beginning of the roller coaster ride at Rockaways' Playland. The contents of the image seem timed to the movement of the curtain since it took forty seconds for the roller coaster to reach the top of the first incline and the first truly panoramic view, the curtain signaling the drama of our realization that we are looking at an image much bigger than just three times the size of the conventional image, an image both taller as well as much wider.[44] From this peak, as the car began its precipitous descent, screaming was heard throughout the theater. The screams didn't emerge from anyone visible in the image, but the audience could hear them all around the auditorium thanks to seven-track stereophonic sound. And the audience could well understand why the screamers seemed to be in their midst since the image, playing on the viewer's peripheral vision, effectively created a very powerful sense of vertiginous movement. As John Belton notes, there were reports of brisk Dramamine sales at nearby drugstores during the intermission. This was the "Cinerama effect," and every Cinerama film thereafter featured its own "roller coaster" moment, even the narrative films that began to be made in 1962.[45]

The fact that the narrative films also embraced the roller coaster effect does suggest something different about the Cinerama features that is worth exploring. It is not at all unusual in the history of American film for films featuring a new technology to find ways of exploiting that technology, foregrounding it more than later films would. But by the time Cinerama turned to narrative, the technology was ten years old, and yet it still needed its roller coaster moment. Since the travelogues literally traveled, it was easy enough to provide a sequence of dizzyingly rapid movement, with images shot from airplanes especially favored. But how to motivate such a sequence in a narrative film? How, for example, could a western, *How the West Was Won* (1962), the second Cinerama narrative feature, end with a series of breathtaking and, yes, vertiginous aerial shots? Only by moving outside its narrative confines to provide a tour of the contemporary American West, presumably the fruits of what had been won within the narrative. That American filmmakers understood Cinerama as creating a very different experience of space is perhaps evident from the fact that Warner Bros. announced in 1956 that it was considering Cinerama for a film version of *The Miracle*, the Max Reinhardt play that in the 1920s turned an entire theater into a cathedral, altering the way an audience experienced a stage setting. But the roller coaster effect was something different, a thrill experience that really existed apart from the narrative, like the ending of *How the West Was Won*.

Ordinarily, Hollywood filmmakers would try to locate motivation in the narrative and seek appropriate stylistic devices to present such events, but here the technology itself motivated the moment. This signifies an important difference that was understood by a review of *The Wonderful World of the Brothers Grimm* (1962), the first narrative film in the process: "Although the performers, from stars to bit players, are uniformly ingratiating—and properly nasty as occasion requires—if there is a star that shines beyond compare in this two hour and 15 minutes show (plus intermission) it is SPECIAL EFFECTS."[46] There was always a demand for the Cinerama sights to be so impressive that we could overlook the flaw of the very visible lines that demarcated the three images. But the particular nature of this spectacle was its sense of presence, the way in which the film image seemed to overwhelm the reality of the theatrical space we inhabited. This was the value of travelogues for Cinerama, the ability of the process to give us the illusion that the image of real places merged with the auditorium, even extending into the seating area. In effectively making us

tourists, Cinerama obliterated the fourth-wall aesthetic that regarded the proscenium as a picture frame, an understanding shared by late-nineteenth-century theater practitioners and early dramatic filmmakers. And it was precisely that possibility for merger that led Schlanger to object in 1935 to the very name "motion picture" in terms that seem to anticipate Cinerama: "The viewer of the motion picture should not be looking at a picture or through a picture frame; rather, he would like to feel as though he existed at and when the action is supposed to be taking place, even though the 'subject' may be past history." From early on, a guiding principle of Schlanger's theater design was that the ideal film image should have no defined shape: "the particular beauty or form and proportion of its shape are of no importance. As contrary as it may seem, it is the apparently 'shapeless shape' that is most adaptable for the motion picture— a shape that would make the viewer the least conscious of a limited boundary."[47] The slow opening of the curtain that always began a Cinerama movie rendered the screen a shapeless shape, seemingly boundless as it extended to our peripheral vision. For a travelogue, the curtain might have seemed a vestige of theatricality, but it was essential to Cinerama performances because the curtain served to make the reality of the image itself *dramatic*.[48] The move into fiction filmmaking after a decade of travelogues should have located the drama back in the action, but technology effectively foregrounded the drama of the image and made the reality of the fictional world magical.

Making special effects the star, and doing it so forcefully that it warrants all caps, represents a transformative moment, one that looks ahead to the cinema of the future, a future that begins to be realized with the last Cinerama feature to play at the reconfigured Loew's Capitol, Stanley Kubrick's *2001: A Space Odyssey* (1968). Although the film was still drawing crowds, it lasted in its premiere house only five and a half months because the Capitol was scheduled for demolition to make way for an office building and a new legitimate theater.[49] *2001* moved two blocks south to continue its reserved-seat run at New York's other Cinerama theater, proving to be one of the more popular of the 1960s big-budget roadshow releases.[50] Yet much as the film looks ahead to the future literally in its plot and figuratively in its style, it would be impossible to conceive of this film being produced were it not for the commercial success of the art cinema in the period leading up to it. Starting with the main title, an alignment of planets is a key visual motif in this film, appropriately since

the film itself now seems something that could happen only by an alignment of the stars, creating just the right circumstances for such an oddball success. It is an art movie or, more precisely, an art movie as the period understood it, which means slow-moving, underplayed, and, by the end at least, obscure in its meaning. Furthermore, there are long periods without dialogue: we are twenty-two minutes into the film before we hear anyone speak, while the entire final section ("Jupiter and Beyond the Infinite," all twenty-three and a half minutes of it) has only one character and no spoken language.[51] Finally, the only actor who might qualify as a star, Keir Dullea, does not appear until about fifty-five minutes into the film. Possessing qualities that would certainly alienate a twenty-first-century audience seeking spectacle, it is also the most expensive art movie ever made, which means it is not an art movie for Cinema I, where Kubrick's next film would premiere, but rather a movie made for a grand space like the palatial Loew's Capitol.[52]

Early film theory often focused on defining the essence of cinema, certain that whatever it might be, it was not theater. On the other hand, American practitioners in the early days of the narrative feature film were convinced that's exactly what they were doing and doing so within spaces that came out of live theater. Ultimately, there is no essence of cinema or, rather, the essence is malleable, our perception of the text constantly changing as contexts change, as I hope this study has shown. *Motion Picture Herald* on Cinerama as an art of the theater notwithstanding, *2001* seems to me a film poised between the cinema of the past and the cinema of the future, a film unlike anything that came before it, and yet still at times drawing on past conventions for its effectiveness. Much as it repeatedly underplays its drama, the film's middle section (titled "Jupiter Mission—18 Months Later") is at sixty-two and a half minutes its longest, straddling the intermission, and is also the section with the most conventional markers of a dramatic work. This section has the most extended dialogue sequences, and—with one important exception—the dialogue mostly takes place between humans who speak in robotic monotones and an ingratiating computer who likes to talk about his feelings. Despite this contrast, we gradually perceive an increasing distrust of the computer, especially by Dave (Keir Dullea), that contributes to a growing and quietly dramatic sense of menace throughout this section. This menace is fully realized in the chilling twenty-minute suspense sequence that begins the second half of the film, a sequence in which HAL

systematically kills Frank (Gary Lockwood), the only other character we have gotten to know; removes the life support from the three hibernating astronauts also on this mission; and then tries to kill Dave, which leads to Dave's eventual destruction of HAL.

In this middle section especially, it seems clear that Kubrick was utilizing the unusual size and shape of the Cinerama screen.[53] The section begins with the first instance of the roller coaster effect as Frank runs inside a giant wheel that makes up the living and working areas of the spacecraft, a high-angle camera looking down on him and tracking forward as he runs, our peripheral vision viscerally affected by the various objects alongside the floor he runs on.[54] However, at the beginning of this sequence, Kubrick's first shot of the interior (perhaps to suggest how the space relates to the exterior of the craft seen in the previous shot) has the floor as a vertical on the left side of the image, so that Frank appears to us horizontally, seemingly suspended in space, which he literally is. The effect is to make apparent in the next shot something that perhaps was always inherent in the roller coaster effect, namely that much as it seems to present a continuous space, it is also profoundly disorienting. The two shots that follow from it create a further dizzying effect: a low reverse-angle shot of Frank tracking backwards that makes the floor look like a ceiling, a disturbance underscored by our ability to make out objects along the floor/ceiling that look like sarcophagi with little glass windows through which we can see faces; then another high-angle shot following Frank, but this time much closer in and oriented in such a way that makes it look as if he is about to fall on the floor he is running along. From this point on, the style of the film changes from its first two sections—the camera, even when still, repeatedly assuming positions that, aided by a complex set design, puts objects and characters or the two characters to each other at odd, precipitous angles. Emphasizing the disorientation are the many point-of-view shots for HAL, the panopticon who sees and hears everything on the ship, while there are no point-of-view shots for the human characters. Even as the drama seems to be taking a turn toward the conventional, the images themselves are at their most unconventional, but here serving the dramatic purpose of making the environment itself a source of unsettling disturbance. That is, up until . . .

That one important moment. In its initial showings, 2001 featured possibly the most powerful coup de theatre I've ever experienced in a movie house, an experience I've never forgotten and so directly con-

nected to a specific theatrical space that no contemporary exhibition of this film can re-create it outside the small number of Cinerama theaters left in the world. I had previously written about the mysterious movement of the Fantom Screen as a coup de theatre, but one that was created entirely by its unexpected manner of exhibition. *2001* is different to the extent that this moment, as with most plays, is immanent in the text, but made fully theatrical since the film was effectively integrated into a kind of performance in its initial showings.

In the lead-up to this coup, Dave and Frank have individually become concerned that something is not quite right with HAL, and they need a place to talk outside his purview. They choose an enclosed private pod used to travel around the ship, under the pretense that there is something wrong with its communication system. Making sure that HAL cannot hear them, they begin to discuss their suspicions. Meanwhile, there are two things to note about how this scene functions in the film. First, this is actually the only conversation that Dave and Frank have together, although they've been in the film for about half an hour by this point. Second, as if to reflect this fact, the shooting style becomes more "normal," no longer resorting to the odd angles used previously. In fact, the image achieves a real stability that is almost comforting in its context, as the world seems to have become more settled and secure: it is now completely symmetrical, with the backs of their two chairs occupying the left and right of the image, with Dave on the left and Frank on the right, facing each other with similar profiles, while between them, in the middle of the screen, there is an oval window through which we can see a computer terminal. Here, however, an asymmetry created by two elements introduces a new sense of disquiet: HAL's red eye on the terminal just to the right of center and behind it a spacesuit and helmet displayed as if it were a person, the conflation of inanimate and animate echoing the computer's seemingly human personality (fig. C.7).

Before I describe the rest of the scene, however, I need to note that in nineteenth-century theater—and even later—the curtain could be an important part of the coup de theatre, a very rapid drop of the curtain following the unexpected turn of events, leaving the audience astonished about what they have just seen and very uncertain about how things will proceed. We've already seen that the curtain was important to early Cinerama presentations, but advertising descriptions of the curtain opening effectively conveys an essential part of the presentation: because the curtain

FIGURE C.7

*2001: A Space Odyssey*—A highly symmetrical environment expresses the characters' sense of security while the asymmetry in the oval window suggests otherwise.

was on a deeply curved track almost flush against the screen, it always moved very slowly. The opening of *2001* seems to acknowledge this because the unusually stylized MGM logo is positioned very narrowly within the dead center of the image, which is where the initial titles remain. It is over a minute into the film that the main title, *2001: A Space Odyssey*, appears across the width of the screen.

Now back to Frank and Dave in the pod: troubled over HAL's increasingly strange behavior, they discuss what to do next. When they conclude they might have to disconnect HAL, there is a closer shot through the window of the computer terminal, seeming to reflect where Frank and Dave are looking, as they discuss how to manage the task. Cut back to the two-shot of Frank and Dave, and right around this point in the scene, the curtains began to close . . . and close . . . and close. As the curtains effectively create a drama that was not quite in the text, we wonder why, why are they closing before we have any sense of where the narrative is going? The last audible dialogue we hear from Dave will lead to a visual revelation: noting that no computer of this sort has even been disconnected before, Dave turns his head toward the terminal and makes HAL fully human as he worries, "Well, I'm not so sure what he'd think about it." At this point, there is a cut, as if in response to Dave's statement, to an extreme close-up of HAL's red eye. With the curtains now more than half closed, a reverse-angle shot suddenly shows HAL's point-of-view—with

Dave now on the left and Frank on the right—and an iris shot of Frank's lips as he speaks.[55] The camera is about to move, and that movement could conceivably have been expressed by moving the iris, but the movement stays within the iris so that the image appears in the one part of the screen the curtains have not yet reached. The camera pans to the left, watching Dave's lips move in close-up, then to the right and back to Frank's lips, then once more to Dave. At the moment we realize that HAL is lip-reading, the curtains have completely closed, through which we can read: INTERMISSION.

It is precisely the antidramatic strategy of much of Kubrick's narrative that makes the theatrical gesture of the curtain's closing so intensely dramatic. This was indeed a moment that truly belonged to the theater. Other movies after this have had effective moments that could rank as a real coup de theatre—could anything be more startling than the chest-busting scene in *Alien* (1979), for example? But I cannot think of a film since then whose effectiveness was so tied to the space in which it was exhibited. Ben Schlanger's movie theater interiors—with their anticipation of stadium seating, the neutral walls and their uncurtained screens—might have looked ahead to theaters of the future, while Cinerama tried to make sense of theaters of the past. But with this one startling moment of an interaction between curtain and screen, Cinerama, looking back to the nineteenth-century panorama, and *2001*, looking ahead to the late-twentieth-century's effects-driven movies, heralded a final transformation: in a single coup, living pictures, life-size pictures, moving pictures, motion pictures, movies, photoplays, talkies, cinema—all became a lost art of the theater.

# APPENDIX 1

## Stage Shows and Double Features in Select Markets

## Outside New York City

This data is based on newspaper advertising in respective markets.

### Atlanta

The double feature does not arrive widely in Atlanta until 1940. Stage shows are prominent at the Loew's Grand, Howard, and Capitol throughout 1928, but shows tend to persist only at one venue at a time throughout the 1930s (the Loew's Capitol is the outlet with shows from 1929–1930 and from 1934–1938, while the Fox has stage shows from 1930 to 1932). The Capitol continues as the only outlet in town with stage shows through 1944; by the following year it has taken up the double feature.

## Boston

In 1928–1929 there are stage shows regularly running at Keith's, Metropolitan, Scollay Square, Loew's State, and the Orpheum. By 1933, Scollay Square has started showing double features. The other theaters continue with stage shows, including RKO-Boston as well, until 1934. RKO-Boston begins showing double features in August 1934, and by December of the following year the State, Keith's, and the Orpheum have joined them. By 1938, stage shows have halted at the Orpheum, State, Metropolitan, and Keith's. RKO-Boston continues with stage shows until 1952, though frequently coupled with double features. Stage shows appear to stop entirely by 1953.

## Chicago

In the late 1920s, multiple palaces featured stage shows (the Oriental, Chicago, Tivoli, Uptown, Marbro, Granada, Paradise, Avalon, etc.). After the coming of sound, this pool constricted slightly. Stage shows continued regularly at the Chicago, Oriental, Uptown, State-Lake, Palace, and Stratford until 1935. Double features began to be regularly advertised in late 1936/early 1937 at neighborhood theaters. By the late 1930s, only the Chicago, Oriental, and Palace were still consistently featuring stage shows, with the Chicago and Oriental continuing to feature stage programs until 1954–1955.

## Hartford

In the late 1920s the Allyn and Fox-Poli consistently featured stage shows. Double features are already in progress at the Majestic, Lowe's, and Colonial by 1929–1930. The stage show at Fox-Poli disappears in 1933, replaced with double features. The Allyn resurfaces with stage shows briefly, but then moves to double features. By the mid-1930s, the Palace is the only outlet featuring stage shows, with all other first-run theaters showing double features. By 1937, the Palace has also joined their ranks.

## Milwaukee

In 1928, the Wisconsin, Palace Orpheum, Riverside, and Strand all regularly featured stage shows. By the end of 1929, the Palace Orpheum and the Strand discontinued stage shows. The Wisconsin and Riverside continue with stage shows until the mid-1930s, occasionally joined by the Warner and Alhambra. By the end of 1935, the Wisconsin has also discontinued stage shows (in addition to the Warner and

Alhambra). While the double feature began to appear at neighborhood theaters in late 1934, it didn't appear at the palaces until 1935–1936. The Riverside continued as the only venue for stage shows into the 1940s, while virtually all other theaters had taken up double bills. By 1945, the Riverside had also discontinued its show in favor of double features.

## PITTSBURGH

In 1928, the Harris, Penn, Davis, Enright, Sheridan Square, and Stanley all regularly feature stage shows. By the end of 1929, only the Stanley, Penn, Enright, and Harris were still consistently featuring shows. By the end of 1931, the first double feature arrives, at the Harris, and the stage show begins its decline. By mid-1935, the Penn has discontinued its stage show, while the Stanley remains the only outlet in the city with a stage show over the period from 1935–1940. The Stanley finally discarded its stage show in 1945, though it does not take up the double feature.

## WASHINGTON

In early 1928, the Loew's Palace, Fox, and Earle all feature stage shows. By the end of the year, the Earle has dropped out of the picture, only to resurface in late 1930. The three palaces continue with stage shows, but by the end of 1932 the Loew's Palace has dropped out of the picture. Stage shows persist at the Fox and Earle until 1936. The Loew's Capitol and Earle continue with stage shows until the 1940s. Double features finally replace the stage show at Earle in 1946.

# APPENDIX 2

## Feature Films Based on Theatrical Sources, 1914–2011

Numbers have been derived from the *American Film Institute Catalog*, using the key words "based on the play," "based on the musical," "based on the operetta," "suggested by the play," "based on the unproduced play," "based on the unpublished play," and "based on the one-act play." Not surprisingly, the highest totals coincide with the rise of the feature film (1914–1920) and the introduction of sound (1929–1932). Plays continued to be a significant source for films into the 1960s, with a marked decline beginning in the 1970s.

| | | | |
|---|---|---|---|
| 1914 | 103 | 1918 | 87 |
| 1915 | 170 | 1919 | 92 |
| 1916 | 88 | 1920 | 122 |
| 1917 | 65 | 1921 | 64 |

| | | | |
|---|---|---|---|
| 1922 | 59 | 1962 | 35 |
| 1923 | 66 | 1963 | 28 |
| 1924 | 55 | 1964 | 36 |
| 1925 | 71 | 1965 | 22 |
| 1926 | 85 | 1966 | 25 |
| 1927 | 65 | 1967 | 22 |
| 1928 | 54 | 1968 | 26 |
| 1929 | 92 | 1969 | 23 |
| 1930 | 148 | 1970 | 27 |
| 1931 | 123 | 1971 | 17 |
| 1932 | 99 | 1972 | 17 |
| 1933 | 77 | 1973 | 13 |
| 1934 | 99 | 1974 | 10 |
| 1935 | 69 | 1975 | 13 |
| 1936 | 55 | 1976 | 5 |
| 1937 | 61 | 1977 | 3 |
| 1938 | 46 | 1978 | 9 |
| 1939 | 47 | 1979 | 7 |
| 1940 | 46 | 1980 | 3 |
| 1941 | 53 | 1981 | 8 |
| 1942 | 31 | 1982 | 7 |
| 1943 | 23 | 1983 | 2 |
| 1944 | 31 | 1984 | 5 |
| 1945 | 25 | 1985 | 11 |
| 1946 | 15 | 1986 | 9 |
| 1947 | 17 | 1987 | 7 |
| 1948 | 34 | 1988 | 15 |
| 1949 | 17 | 1989 | 9 |
| 1950 | 15 | 1990 | 6 |
| 1951 | 20 | 1991 | 12 |
| 1952 | 21 | 1992 | 14 |
| 1953 | 23 | 1993 | 9 |
| 1954 | 11 | 1994 | 10 |
| 1955 | 29 | 1995 | 7 |
| 1956 | 26 | 1996 | 14 |
| 1957 | 21 | 1997 | 12 |
| 1958 | 18 | 1998 | 11 |
| 1959 | 20 | 1999 | 12 |
| 1960 | 19 | 2000 | 11 |
| 1961 | 30 | 2001 | 7 |

| | | | |
|---|---|---|---|
| 2002 | 9 | 2007 | 9 |
| 2003 | 7 | 2008 | 9 |
| 2004 | 7 | 2009 | 8 |
| 2005 | 10 | 2010 | 6 |
| 2006 | 8 | 2011 | 3 |

## BEST PLAYS OF THE YEAR ANTHOLOGY—ADAPTATIONS

The *Best Plays Theatre Yearbook* has been published every year since 1920, generally featuring a selection of ten plays (occasionally more, occasionally less, depending on perceived quality) that had played in New York that year. Since these plays represented the most critically acclaimed works of the year, and often enough among the most commercial, they were also often attractive to film producers in Hollywood's Classical period as is evidenced by the numbers that were adapted to film in the list below. The drop in works adapted from this series parallels the general drop observable in the American Film Institute's data. Perhaps even more striking are the percentage of plays in each volume that were adapted, with the period from 1920–1949 distinguished by roughly two-thirds of all published "best" plays made into movies.

| Year | Number | Year | Number |
|------|--------|------|--------|
| 1920 | 5 | 1946 | 5 |
| 1921 | 7 | 1947 | 8 |
| 1922 | 10 | 1948 | 5 |
| 1923 | 6 | 1949 | 6 |
| 1924 | 8 | 1950 | 5 |
| 1925 | 8 | 1951 | 5 |
| 1926 | 4 | 1952 | 5 |
| 1927 | 5 | 1953 | 5 |
| 1928 | 9 | 1954 | 2 |
| 1929 | 6 | 1955 | 7 |
| 1930 | 9 | 1956 | 5 |
| 1931 | 7 | 1957 | 4 |
| 1932 | 7 | 1958 | 4 |
| 1933 | 5 | 1959 | 4 |
| 1934 | 8 | 1960 | 3 |
| 1935 | 5 | 1961 | 6 |
| 1936 | 7 | 1962 | 4 |
| 1937 | 5 | 1963 | 3 |
| 1938 | 6 | 1964 | 3 |
| 1939 | 5 | 1965 | 4 |
| 1940 | 7 | 1966 | 4 |
| 1941 | 8 | 1967 | 4 |
| 1942 | 3 | 1968 | 6 |
| 1943 | 5 | 1969 | 4 |
| 1944 | 5 | 1970 | 5 |
| 1945 | 8 | 1971 | 3 |

| | | | |
|---|---|---|---|
| 1972 | 2 | 1992 | 2 |
| 1973 | 3 | 1993 | 2 |
| 1974 | 2 | 1994 | 3 |
| 1975 | 4 | 1995 | 1 |
| 1976 | 3 | 1996 | 1 |
| 1977 | 3 | 1997 | 0 |
| 1978 | 5 | 1998 | 0 |
| 1979 | 4 | 1999 | 1 |
| 1980 | 3 | 2000 | 0 |
| 1981 | 2 | 2001 | 2 |
| 1982 | 5 | 2002 | 0 |
| 1983 | 5 | 2003 | 0 |
| 1984 | 5 | 2004 | 0 |
| 1985 | 1 | 2005 | 1 |
| 1986 | 0 | 2006 | 2 |
| 1987 | 2 | 2007 | 2 |
| 1988 | 3 | 2008 | 0 |
| 1989 | 2 | 2009 | 0 |
| 1990 | 2 | 2010 | 0 |
| 1991 | 3 | | |

## Percentages of plays adapted

| | | | |
|---|---|---|---|
| 1920–1929 | 69.4 | 1970–1979 | 34 |
| 1930–1939 | 64.6 | 1980–1989 | 27.5 |
| 1940–1949 | 60 | 1990–1999 | 15.6 |
| 1950–1959 | 46 | 2000–2010 | 7.2 |
| 1960–1969 | 41 | | |

# APPENDIX 3

## Filmography

*Alien* (1979)

*All About Eve* (1950)

"Annabella Serpentine Dance" (1895)

*Annie Get Your Gun* (1950)

*Antony and Cleopatra* (1913)

"Arrival of a Train at La Ciotat" (1895)

*Beau Geste* (1926)

*Ben-Hur* (1925)

*Big Parade, The* (1925)

*Big Trail, The* (1930)

*Billy the Kid* (1930)

*Birth of a Nation, The* (1915)

*Black Pirate, The* (1926)

*Bocaccio 70* (1962)

*Broken Blossoms* (1919)

*Citizen Kane* (1941)

*Clansman, The* (1915)

*Cockeyed World, The* (1929)

*Crowd, The* (1928)

*Dante's Inferno* (1911)

*Days of Heaven* (1978)

*Design for Living* (1933)

*Diabolique* (1955)

*Don Juan* (1926)

*Dracula* (1931)

"Drunkard's Reformation, The" (1909)

"Empire State Express" (1896)

*Fall of Babylon, The* (1919)

*Footlight Parade* (1933)

*Gone with the Wind* (1939)

*Good Little Devil, A* (1914)

*Grand Hotel* (1932)

*Great Dictator, The* (1940)

*Great Expectations* (1946)

*Hamlet* (1948)

*Happy Days* (1930)

*Heart of a Child, The* (1920)

*Henry V* (1946)

*Il Posto* (1963)

*In Old Kentucky* (1920)

*Intolerance* (1916)

*It's a Wonderful Life* (1946)

*La dolce vita* (1961)

*Last Days of Pompeii, The* (1913)

*Life Begins* (1932)

*Lost World, The* (1924)

*Mare Nostrum* (1926)

"McKinley" (1896)

*Me and My Gal* (1931)

*Mean Streets* (1973)

*Merry Widow, The* (1925)

*Million Dollar Mermaid* (1952)

"Monroe Doctrine, The" (1896)

*Old Ironsides* (1926)

*Patriot, The* (1928)

*Power and the Glory, The* (1932)

*Quo Vadis* (1913)

*Ramona* (1915)

*Red Shoes, The* (1948)

"Rough Sea at Dover" (1896)

*Saboteur* (1942)

*Search for Paradise* (1957)

*Soldier of Fortune* (1920)

*Spartacus* (1913)

*Spoilers, The* (1914)

*Strange Interlude* (1931)

*Student Prince, The* (1927)

*Sunrise* (1928)

*Ten Commandments, The* (1923)

*This Is Cinerama* (1952)

*To Have and Have Not* (1944)

*Tom Jones* (1963)

*Trail of '98* (1928)

*Trouble in Paradise* (1932)

*2001: A Space Odyssey* (1968)

"Umbrella Dance" (1895)

*Why Change Your Wife?* (1920)

*Wings* (1927)

*Wonderful World of the Brothers Grimm, The* (1962)

*Wreck, The* (1913)

*Yankee Doodle Dandy* (1942)

# APPENDIX 4

## List of Theaters

Academy of Music (New York)
American Theatre (Salt Lake City)
Astor Theatre (New York)
Auditorium Theatre (Chicago)
Bayreuth Festspielhaus (Bayreuth, Germany)
Butterfly Theater (Milwaukee)
Candler Theatre (New York)
Capitol Theatre/Loew's Capitol/Loew's Cinerama (New York)
Cinema I-Cinema II (New York)
Cinerama Dome (Los Angeles)
Clune's Auditorium (Los Angeles)
Coliseum Theater (Seattle)

Criterion Theatre (New York)
D'Oyly Carte English Opera House (London)
Duplex Theater (Detroit)
Eastman Theatre (Rochester)
Egyptian (Boston)
Embassy Theatre (New York)
Film Guild Cinema (New York)
George M. Cohan Theatre (New York)
Grand Opera House (Pueblo, Colorado)
Grauman's Chinese Theatre (Los Angeles)
Haymarket Theatre (London)
Hippodrome (Buffalo)
Hippodrome (New York)
Hollywood Theatre (New York)
Koster and Bial's Music Hall (New York)
Liberty Theatre (New York)
Loew's State (New York)
Los Angeles Theatre (Los Angeles)
Lyric Theatre (New York)
Majestic Theater (Cleveland)
Majestic Theatre (Detroit)
Metropolitan Opera House (New York)
Metropolitan Opera House (Philadelphia)
Murray Hill Theatre (New York)
New Amsterdam (New York)
New Willis Wood Theatre (Kansas City)
Olympia Music Hall (New York)
Olympia Theatre (Miami)
Orpheum Theater (Chicago)
Orpheum Theater (St. Joseph)
Palace of Delight (Philadelphia)
Paramount Theatre (Times Square Paramount) (New York)
Radio City Music Hall (New York)
Regent Theatre (New York)
Rialto Theatre (New York)
Riviera (Chicago)
Rivoli Theatre (New York)
RKO 58th Street (New York)
Roxy Theatre (New York)
Schiller Theater (Chicago)

Strand Theatre (New Jersey)
Strand Theatre/Warner Cinerama (New York)
Victoria Theatre (New York)
Vitagraph Theatre (New York)

# ABBREVIATIONS USED FOR CITATIONS IN NOTES

| | |
|---|---|
| *EH* | *Exhibitors Herald* |
| *EHW* | *Exhibitors Herald-World* |
| *FD* | *Film Daily* |
| *JSMP[T]E* | *Journal of the Society of Motion Picture [and Television] Engineers* |
| *MPH* | *Motion Picture Herald* |
| *MPN* | *Motion Picture News* |
| *MPW* | *Moving Picture World* |
| *NYT* | *New York Times* |
| *Var.* | *Variety* |

NOTES

INTRODUCTION

1. George Schultz, editor, "Cinerama and the Future," *MPH*, "Better Theatres" sec., Oct. 10, 1952, 19 (emphasis added).

2. John Anderson, "Bite-Size Indies in Competition on Your Couch," *NYT*, Nov. 14, 2010, AR14.

3. There are many books that do this, most notably Ben M. Hall, *The Best Remaining Seats: The Golden Age of the Movie Palace* (1988), and Ross Melnick and Andreas Fuchs, *Cinema Treasures: A New Look at Classic Movie Theatres* (2004). A more academic study, although equally nostalgic in its view of the age of the movie palace, may be found in Douglas Gomery, *Shared Pleasures: A History of Movie Presentation in the Unites States* (1992).

4. This is not to say that unconventional framings might be used to deliberately alter the way we look at a familiar object, a process Erving Goffman refers to as "keying" in a study that explores how framing experience affects

our understanding. Goffman, *Frame Analysis: An Essay on the Organization of Experience* (1974), 40 ff.

5. I intentionally write "spaces" here because I do not want to claim a simple linear development. Broadly construed, theatrical space at the beginning of motion picture exhibition could suggest a variety of architectural configurations, including, as Charlotte Herzog has demonstrated, the circus and fairs. In making this connection, Herzog acknowledges she is "focusing on the exterior of the building," which makes her concerns different from mine. But the interior space of the circus can be related to the horseshoe design I will be discussing later in chapter 1. Herzog, "The Archaeology of Cinema Architecture: The Origins of the Movie Theater," *Quarterly Review of Film Studies* 9.1 (Winter 1984): 13.

6. I use the qualified "pretty much" here because there are instances in the history of exhibition in which the object could be overtly transformed by the theater in various ways: the use of hand-cranked projectors in the silent period, allowing theaters to speed up running times should large crowds lead to an attempt to fit in an extra performance; the lower quality of image illumination not uncommon in second-run theaters of the 1930s; architectural limitations causing reduction in the width of widescreen movies from the 1950s on; from the 1950s through the 1980s, the use of multiple-track stereophonic sound only in big-city first-run theaters; and so on.

7. This derives from an earlier practice in theaters that had tiered rings; while most of the rings above the first floor were fairly shallow, the last ring would generally culminate in a deep and steeply raked seating area. The increasing use of cantilevers in balconies through the late nineteenth century made feasible the deep and capacious balconies that would become a distinctive feature of the movie palace, something I will discuss in more detail in chapter 3.

8. An "Architect's sketch" of the resultant three theaters may be seen in *Boxoffice*, Aug. 19, 1968, a24.

9. "Detroit to Have Duplex Theater," *MPW*, Sept. 12, 1914, 1525.

10. An article that ran about a month after the theater opened in January 1916 began with the assertion, "The popularity of Detroit's Duplex theater is said to be exceeding every anticipation." "Among the Picture Theaters," *MPW*, Feb. 12, 1916, 965. By July, it had apparently achieved renown: "Detroit, Michigan, the Home of the Famous 'Duplex,'" *MPW*, July 15, 1916, 397.

11. This description appeared in the first announcement of the theater, roughly fifteen months before its opening. The sketch in figure I.2 accompanied the article, "Detroit to Have Duplex Theater," *MPW*, Sept. 12, 1914, 1525. In an article written two months before this announcement, Lee Dougherty, a "stage director" for Biograph, provided a succinct statement of the "problem" with the feature film: "with the varied program of single and split reels, occasion-

ally boosted by a two or three-reel production, one is always sure of being entertained, no matter what time he enters the theater." Lee E. Dougherty, "Conditions and Features," *MPW*, July 11, 1914, 226.

12. This resistance was part of what Michael Quinn has cited as competing definitions of cinema that emerged in the 1910s, with the emphasis on short films an example of "the 'variety model' of cinema": "a certain kind of cinema which could be called 'going to the movies,' where an audience member would simply stop by the theater and spend one or two free hours watching films." As will become clear in subsequent chapters, these differing models of programming would also become an issue of architecture that continued into the sound period. Michael Joseph Quinn, "Early Feature Distribution and the Development of the Motion Picture Industry: Famous Players and Paramount, 1912–1921" (PhD diss., University of Wisconsin–Madison, 1998), 47.

13. "Features and Time Schedules," *EH*, Jan. 8, 1916, 22.

14. It was, in fact, the commitment of some manufacturers to the smaller theaters that convinced them the short film would always have a future. See, for example, William N. Selig, "Present Day Trend in Film Lengths," *MPW*, July 11, 1914, 180; Carl Laemmle, "Doom of the Long Feature Predicted," *MPW*, July 11, 1914, 185; "Warner's Features, Inc.," *MPW*, July 18, 1914, 262; John J. Coleman, "The Ultimate Triumph of the Single-Reel Production," *MPW*, Oct. 17, 1914, 325; "Kessel Replies to Brady Article," *MPN*, Mar. 20, 1915, 58.

15. Postlewait, "The Hieroglyphic Stage: American Theatre and Society, Post–Civil War to 1945," in Don B. Wilmeth and Christopher Bigsby, eds., *The Cambridge History of American Theatre* (1999), 2:162. Postlewait's notion of reciprocal influences circulating between live theater and motion pictures can, I believe, be profitably expanded to the very sites of performance. In citing Postlewait here, I want to take the opportunity to note an odd imbalance between theater historians and film scholars. Where theater historians are likely to include film in their purview, film scholars are less likely to make theater a part of the cultural context in which films appeared. The most important exception to this is Ben Brewster and Lea Jacobs, *Theatre to Cinema: Stage Pictorialism and the Early Feature Film* (1997). This impressively researched book presents a compelling argument that demonstrates the impact of nineteenth-century staging practices on early American film style, an argument that has been an important influence on my thinking about the impact of live-performance theaters on motion picture theaters as well as the impact of architectural space on the development of American film.

16. Douglas Fox, "The Film Guild Cinema: An Experiment in Theatre Design," *EHW*, "Better Theatres" sec., Mar. 16, 1929, 15.

17. The poster appears in a photograph of Kiesler in the exhibition catalogue: Lisa Philips, *Frederick Kiesler* (1989), 162.

18. Complementing the view of film as a serious art form that became increasingly common through the 1960s, the Anthology Film Archives in New York claimed precisely this distinction with a seating design that isolated audience members from one another to allow a more perfect communion with the screen image: "The patron sinks back, sealed off in the equivalent of a box-like, high-winged chair, lined with black, fireproof velvet. Neighbors are visible only lap-high, through arm-rest cutouts." Howard Thompson, "Silence Says a Lot for Film Archives," *NYT*, Dec. 4, 1970, 55. Advertising for this theater echoed the way the Film Guild Cinema promoted itself: "The first film museum in the world devoted entirely to film as an art, Anthology Film Archives will open to the public the invisible cinema, a radically new construction for film presentation" (*NYT*, Nov. 29, 1970, 32).

19. S. B., "The Theater," *Wall Street Journal*, Feb. 9, 1929, 4.

20. Walter Rendell Storey, "Picture Theatres Made to Fit Our Day," *NYT*, June 9, 1929, SM8.

21. Fox, "The Film Guild Cinema" (emphasis added).

22. Four months after the Film Guild Cinema's opening, Storey noted, "The additional machines required for these effects have not yet been installed, so that at present only somber walls look down on the audience" (Storey, "Picture Theaters Made to Fit"). Further, on the basis of a 1977 interview with Lillian Kiesler, Kiesler's second wife, R. L. Held writes, "Kiesler's plans were never fully realized. A shortage of funds prevented the fabrication of the special projectors for the ceilings and the walls." Held, *Endless Innovation: Frederick Kiesler's Theory and Scenic Design* (1982), 51.

23. Donald C. Mullin, *The Development of the Playhouse: A Survey of Theatre Architecture from the Renaissance to the Present* (1970), 152–53. This production of *The Miracle* was clearly an important point of reference in 1920s American theater. Peter Bauland cites critic Burns Mantle describing the impact of the production: ". . . 'for some weeks thereafter there was not much else talked about in theatre circles.'" Further, Bauland notes, "Articles about *The Miracle* appeared in almost every major magazine throughout the United States for the remainder of the season. Even *Scientific American* and *Architectural Record*, in their April, 1924 issues had extensive pictures, diagrams, and discussion of the complicated technical aspects of the production." Bauland, *The Hooded Eagle: Modern German Drama on the New York Stage* (1968), 59–60.

24. In general, there seems to have been a strong association of the "art film" with German cinema in this period, beginning with *The Cabinet of Dr. Caligari* (1920), which John Larkin Jr., writing in *Theatre Magazine* in 1926, described in the following manner: "One might well call him [i.e., *Caligari*] the father of our few art movies and *Broken Blossoms* the mother." Larkin, "The Guild Movie Is Here," *Theatre Magazine* (May 1926): 62. The German connection

was even stronger with the Shadowbox, "the first full time art theatre in the United States" (1925), which "was programmed by the Screen Guild, an organization formed by Joseph Fliesler, a former film critic now working for Ufa-USA, the American sales agent for the German production company, Ufa." Tony Guzman, "The Little Theater Movement: The Institutionalization of the European Art Film in America," *Film History* 17.2/3 (2005): 266.

25. The Theatre Guild's relationship to O'Neil suggests another connection to Kiesler because Kiesler had designed the setting for a 1923 production of *The Emperor Jones* in Berlin. R. L. Held describes this production in *Endless Innovation*, 19–20.

26. For contemporary appraisals of this movement, see Kenneth Macgowan, *Footlights Across America, Towards a National Theater* (1929), and Sheldon Cheney, *The Theatre: Three Thousand Years of Drama, Acting and Stagecraft* (1929), 499 ff.

27. Kiesler, "Building a Cinema Theatre," in Siegfried Gohr and Gunda Luyken, eds., *Frederick J. Kiesler, Selected Writings* (1996), 17.

28. See, for example, Sheldon Cheney, *The Art Theatre* (rev. ed., 1925), and Kenneth Macgowan, *The Theatre of Tomorrow* (1921).

29. Richard Southern notes that the word "proscenium" can mean very different things at different times in theater history, noting, for example, that it simply refers to the performing area in the "open stage" theaters of Shakespeare's time. For this reason, Southern prefers the more precise term "picture-frame stage" to designate the kind of framing I am referring to here. I have used the word *proscenium* in this instance, however, because it was generally the term used by those attacking conventional picture-frame staging in the teens and twenties and then again, with renewed force, in the post–World War II period. Southern, *The Open Stage* (1953).

30. Fox, "The Film Guild Cinema," 70; quotation cited from a review of the opening performance by William Bolitho in the *New York World*. Here, Bolitho is describing the kind of "audience participation" that would become an increasing concern of avant-garde theater practice.

31. "Film Arts Guild Opens New Theatre," *NYT*, Feb. 2, 1928, 20.

## 1. MAKING MOVIES FIT

1. Mary C. Henderson, *Theater in America: 200 Years of Plays, Players, and Productions* (1986), 236, 246.

2. Charles Marowitz, "Introduction," in Martin Bloom, *Accommodating the Lively Arts: An Architect's View* (1997), ix.

3. Bloom, ibid., xiii.

4. Macgowan, *The Theatre of Tomorrow*, 187.

5. Perhaps not coincidentally, the Auditorium Theatre was used as a movie theater as early as 1914. George C. Izenour, *Theater Design* (2d ed., 1996), 82. Izenour's lucid exploration of sight lines and acoustics covering more than 2,000 years of theater-building in the West strongly influenced my thinking about the changing ways the cinema image has worked within architectural space.

6. Henderson, *Theater in America*, 254.

7. Sullivan, quoted in John Szarkowski, *The Idea of Louis Sullivan* (2000), 36.

8. Felicia Hardison Londré and Daniel J. Watermeier, *The History of North American Theater: The United States, Canada, and Mexico: From Pre-Columbian Times to the Present* (2000), 173–74.

9. Mullin, *The Development of the Playhouse*, 114.

10. Margarete Bieber, *The History of the Greek and Roman Theater* (1961), 59.

11. Simon Tidworth, for example, sees a stylization in language (as well as costume and movement) as a consequence of the theater structures. Tidworth, *Theatres: An Architectural and Cultural History* (1973), 9.

12. Richard Leacroft, *The Development of the English Playhouse* (1973), 29. Tidworth sees the Elizabethan theater derived from early performances staged in "the yard of an inn," although he does acknowledge, "An alternative theory is that they copied bear-baiting arenas. Probably both came into play" (Tidworth, ibid., 60). Whether inn yard or bear-baiting pit, the important point here is that they were multipurpose spaces, much as early motion picture theaters were.

13. In a much acclaimed 1970 production of *A Midsummer Night's Dream*, a play that could give rise to very elaborate scenography as a response to its densely imagistic language, Peter Brook deliberately countered this tradition with a striking bare white stage to restore the primacy of the language. An article responding to the 1971 New York performance of this production noted: "Brook knows that . . . the only way to prick into life its [the play's] pulsating germ plasm is through the only thing about it that can be real for us—its language. The white set . . . is Brook's way of making a *tabula rasa* out of our cluttered, encumbered imaginations, but it is also a giant sounding board for Shakespeare's multi-leveled language." Jack Kroll, "Placing the Living Shakespeare Before Us," *NYT*, Feb. 7, 1971, D1.

14. Jonathan Crary in *Techniques of the Observer: On Vision and Modernity in the Nineteenth Century* has an extended discussion of these visual novelties (1990:104 ff). Since these devices are often related to an interest in the reproduction of reality and I will have occasion to write about the reality effect of motion pictures, I want to note that Crary offers an important countercurrent in the simultaneous movement toward an exploration of the limits of human vision, the result of scientific research: "our physiological apparatus is again

and again shown to be defective, inconsistent, prey to illusion, and, in a crucial manner, susceptible to external procedures of manipulation and stimulation that have the essential capacity *to produce experience for the subject*" (92, emphasis in original). In particular, Crary notes it was from the mid-1880s on that the study of the phenomenon of the after-image, the continuing presence of an image on the retina, led to the invention of optical devices for entertainment.

15. Although film scholar Allison Griffiths has written about panorama paintings as an important precursor of mid-twentieth-century widescreen and large-screen film exhibition, my interest in them is somewhat different because the manner of exhibiting panorama paintings did have an impact on film exhibition during the silent era, which I will discuss in chapter 5. Griffiths, *Shivers Down Your Spine: Cinema, Museums, and the Immersive View* (2008), 37–79.

16. T. Allston Brown, *A History of the New York Stage: From the First Performance in 1732 to 1901*, vol. 3 (1903), 371.

17. Ralph Hyde, *Panoramania! The Art and Entertainment of the "All-Embracing" View* (1988), 84. In a historical survey of New York theaters, Ruth Crosby Dimmick lists the "Colisuem [*sic*]" simply as a theater. Dimmick, *Our Theatres To-day and Yesterday* (1913), 51.

18. See Brown, *A History of the New York Stage*, 547. See also George C. D. Odell, *Annals of the New York Stage*, vol. 15 (1949), 197–99.

19. In tracing the impact of painting on theatrical methods, I am following a model established by George Kernodle in an important study of the impact of painting on stage and set design in Renaissance theater, *From Art to Theatre: Form and Convention in the Renaissance* (1944).

20. Hyde, *Panoramania!*, 131.

21. Stephan Oettermann, *The Panorama: History of a Mass Medium* (1970), 66. The moving panorama also effectively anticipated motion pictures with a picture that was literally moving within a delimited frame in order to create the illusion of movement within a stationary space.

22. Although Crary does not write about this, how the panorama painting was staged does effectively reflect the contrary trends that Crary sees in nineteenth-century visual arts. While three-dimensional objects were used to enhance the realism of the painting's flat surface, the enforced distance of the painting itself reflected an understanding of the limitations of binocular vision in perceiving depth since distance diminishes the importance of binocular vision, giving priority to other depth cues like object-scale.

23. Percy Fitzgerald, *The World Behind the Scenes* (London: Chatto and Windus, 1881), 79, quoted in Martin Meisel, *Realizations: Narrative, Pictorial, and Theatrical Arts in Nineteenth-Century England* (1983), 44.

24. Hyde notes, "For a while it seemed that photography might come to the aid of the ailing show-panorama industry. Charles A. Close in 1893 suggested that cycloramic paintings be given a coat of white paint and photographic images projected upon them. He himself devised a way of doing this, exhibiting at the Chicago World's Fair in 1893 an Electric Cyclorama. The apparatus he used for projecting his 360° images consisted of a battery of projectors, kinetoscopes, and kinemotographs, accommodated (with their operator) in a giant lantern hung from the ceiling like a vast chandelier. . . . In 1901 the Lumière brothers, August and Louis, established at 18 rue de Clichy their Photorama, at which photographs of French scenery were projected onto a 360° screen." Hyde, *Panoramania!*, 181.

25. Charles Musser, *Before the Nickelodeon: Edwin S. Porter and the Edison Manufacturing Company* (1991).

26. For details on this showing and how it carefully promoted the Lumière apparatus, see Alan Williams, "The Lumière Organization and 'Documentary Realism,'" in John Fell, ed., *Film Before Griffith* (1983) 157 ff.

27. In smaller cities and towns, "opera house" was something of a generic term for theater and could in fact designate auditoria no bigger than those commonly used for straight plays in larger cities and possibly smaller.

28. See Robert Allen on the modular form of vaudeville and its receptivity to early motion pictures, which could not sustain an entire evening's entertainment. Allen, *Vaudeville and Film, 1895–1915: A Study in Media Interaction* (1980), 46 ff.

29. Musser notes that three performers who were appearing at Koster and Bial's were among the earliest Kinetoscope subjects, "the first of many variety and vaudeville performers to visit the Black Maria over the ensuing year [1894]," and he describes Edison as "an aficionado of variety entertainment" (Musser, *Nickelodeon*, 39 ff.). This being the case, it is perhaps not surprising that "the principal components of the Edison repertoire from 1894 on were condensations of vaudeville turns, circus acts, and minute excerpts from popular plays." Allen, *Vaudeville and Film*, 101–2.

30. Jack W. McCullough, "Edward Kilanyi and American Tableaux Vivants," *Theatre Survey* 16 (1975): 25, 27.

31. Although each living picture could suggest a painting or a statue, not all were drawn from specific artworks. An announcement of Oscar Hammerstein's Living Pictures at Koster and Bial's stated, "They will include groups of statuary, patriotic scenes, and reproductions of some of the works of great artists." "Theatrical Gossip," *NYT*, May 3, 1894, 8.

32. "Notes on the Stage," *NYT*, May 20, 1894, 12; "Theatrical Gossip," *NYT*, June 27, 1894, 8; "Theatrical Gossip," *NYT*, June 1, 1894, 8; "Notes of the Stage," *NYT*, May 27, 1894, 12.

33. Lee E. Dougherty, "Conditions and Features," *MPW*, July 11, 1914, 224.

34. Some of this paradox is captured in a term used to describe Kilanyi's living pictures in 1894: "animate art." "Theatrical Gossip," *NYT*, May 30, 1894, 8.

35. "Kilanyi's Glyptorama," *New York Dramatic Mirror*, Dec. 7, 1895, 19 (emphasis added).

36. As Tom Gunning has argued, illusion is as central as realism to the way motion pictures were perceived. Gunning places particular importance on the manner in which the first Lumière films were shown: "the films were initially presented as frozen unmoving images, projections of still photographs. Then, flaunting a mastery of visual showmanship, the projector began cranking and the image moved. . . . As in the magic theatre the apparent realism of the image makes it a successful illusion, but one understood as an illusion nonetheless." Gunning, "An Aesthetic of Astonishment: Early Film and the (In) Credulous Spectator," *Art and Text* 34 (Spring 1989): 34–35.

37. In similar fashion, panorama entertainments, another form that sought to create a perfect illusion of reality by combining a painted background with three-dimensional objects in the foreground, found itself eclipsed by movies. Hyde notes, "In the opening years of the twentieth century the effect of the cinema on the panorama was even more calamitous than the effect in the 1960s of television on the cinema. In the face of cinema competition virtually every rotunda in the world shut up shop." Hyde, *Panoramania!*, 199.

38. "Immensity in Living Pictures," *NYT*, Nov. 25, 1895, 9.

39. "Kilanyi's New Living Pictures," *NYT*, Dec. 3, 1895, 6.

40. "Edison's Vitascope Cheered," *NYT*, Apr. 24, 1896, 5.

41. The description of the Vitascope program is taken from "Edison's Vitascope Cheered," ibid., and Charles Musser, *The Emergence of the Cinema: The American Screen to 1907* (1990), 116. The specific quotations are from the *Times* article. Musser identifies the films that were shown: "Six films were shown, but only five by the Edison Company. The first to be projected was a tinted print of *Umbrella Dance*, with the Leigh sisters. Subsequent views included Walton and Slavin (a burlesque boxing bout from 1492), *Finale of 1st Act of Hoyt's 'Milk White Flag'* (not listed on the programme), and *The Monroe Doctrine* . . . a comic allegory that was overtly political. . . . The final film was of a skirt or serpentine dance. . . . Opening night critics were most impressed by the second film shown, *Rough Sea at Dover*," an "actuality" made by Edison's "English competitor Robert Paul." Musser, *Nickelodeon*, 62–63.

42. "Kilanyi's Glyptorama," *New York Dramatic Mirror*, Dec. 7, 1895, 19.

43. "Edison's Vitascope Cheered," *NYT*, Apr. 24, 1896, 5.

44. "Edison's Latest Invention," *NYT*, Apr. 26, 1896, 10. There is some reason to question the accuracy of the measurements since the resulting aspect ratio would be far different from the 1.33:1 of the Vitascope image. If the 20-foot width is accurate, the resulting image would actually be closer to the

Glyptorama frame (20 x 15 vs. 20 x 14). There was another interesting discrepancy that turned up in the two *Times* articles on the premiere: the first ("Edison's Vitascope Cheered") specified, "The moving figures are about half life size," while the second ("Edison's Latest Invention") noted, "Figures appear a trifle over life-size on the screen."

45.   Julius Cahn, ed., *Julius Cahn's Official Theatrical Guide* (1896), 67.

46.   "Queen Isabella's Art Gallery," *NYT*, Mar. 22, 1894, 5; quoted in McCullough, *Theatre Survey* 16:31.

47.   I have not come across any writing in this period that dictates placement of the screen, as would become common later. But contemporary illustrations always show the screen right at the proscenium, as contemporary description also points to that placement. The fact that the image is also often shown as much larger than what was actually projected could perhaps make these illustrations open to question, but calling the screen a "curtain," for reasons noted in the text, makes the downstage position seem most likely.

48.   The following indicates common practice in vaudeville theaters in 1910: "It [the screen] is often found taking the place of a drop curtain where vaudeville is shown, and rolled up and down at least twice at every performance." "A Picture Lover," "Chicago Notes: Helpful Hints to Exhibitors," *MPW*, Apr. 2, 1910, 501.

49.   Charles A. Whittemore, "The Motion Picture Theater: IV. Heating and Ventilating and Type of Plan," *Architectural Forum* 27.1 (September 1917): 72.

50.   Sachs, *Modern Opera Houses and Theatres*, vol. 1 (1896, reissued 1968), 3.

51.   Mullin, *Development*, 146.

52.   A photograph of the Schermerhon Symphony Center, home to the Nashville Symphony, may be seen in Allan Kozinn, "Foreclosure Is New Blow to Nashville Symphony," *NYT*, June 8, 2013, C1, C4.

53.   "The first half of the seventeenth century saw the formation of all the essential features of what one calls the modern theatre (though the term is now out of date)—the picture-frame stage and its horseshoe-shaped auditorium with tiers of galleries or boxes." Tidworth, *Theatres*, 65.

54.   Brooks McNamara, "The Scenography of Popular Entertainment," *The Drama Review: TDR* 18.1 (Mar. 1974): 21.

55.   Leacroft, *Development of the English Playhouse*, 150; Arthur S. Meloy, Architect, *Theatres and Motion Picture Houses: A Practical Treatise on the Proper Planning and Construction of Such Buildings and Containing Useful Suggestions, Rules and Data for the Benefit of Architects, Prospective Owners, Etc.* (1916), 3. A more modern understanding of acoustics makes the issue more complicated than mere distance: Vern Knudsen demonstrates under certain conditions the human voice may be clearly heard up to 102 feet away. See Knudsen, "Acoustical Deign of Multiple-Use Auditoria," in Izenour, *Theater Design*, 460–78.

56. How important this was to contemporary viewers may be seen by the comment in a *Chicago Tribune* article about the Dankmar Adler Central Music Hall (1880) whose main balcony was "like the shape of a horseshoe, and extending it back over the lobby or foyer, the entire dress circle is exposed. . . . This will enable the entire audience to see itself." Cited in Joseph M. Siry, *The Chicago Auditorium Building: Adler and Sullivan's Architecture and the City* (2002), 54. Nevertheless, within nine years, Adler working with Louis Sullivan would radically reorient the seating plan, drawing on the Bayreuth Festspielhaus. But old forms die hard: Siry notes that, according to Frank Lloyd Wright, "the wealthy of Chicago wanted a 'golden horseshoe' of boxes like that found in the Metropolitan Opera House" (394). In *Theater Design*, Izenour provides a longitudinal perspective of the new design (227) and notes the compromise form "resulted in virtually the prototype of that which was to occur 80 years later in the design of the new Metropolitan," which also sought to combine a modern theater with tiered rings (281).

57. "Edison Vitascope Cheered," *NYT*, Apr. 24, 1896, 5.

58. George Blaisdell, "Nicholas Power Urges Standardization," *MPW*, July 11, 1914, 223.

59. But staging could not correct everything. When the late-eighteenth-century Drury Lane Theatre made one of the side boxes by the proscenium the royal box, the Duke of York reportedly exclaimed, "the worst box in the theatre for seeing a play!" even though much of the action likely took place on the forestage. Leacroft, *Development of the English Playhouse*, 162.

60. The advent of perspectival scenery in the late sixteenth and early seventeenth centuries effectively limited the playing area of the stage: "One unavoidable difficulty about this otherwise convenient economy was that the entrance of any actors near the back of the stage was to be avoided, since they would be out of proportion with the vanishing lines of the architecture of the scene at that point." Richard Southern, *The Seven Ages of Theatre* (1961), 225.

61. "Music Hall Notes," *NYT*, Oct. 20, 1896, 5.

62. A brief item on the premiere of the cinématographe noted, "The moving pictures it shows are unusually clear and free from vibration." "Notes of the Summer Shows," *NYT*, June 30, 1896, 4.

63. "The Summer Shows," *NYT*, July 5, 1896, 10.

64. "Vitascope to Cast Figures on Canvas at Koster & Bial's," *NYT*, Apr. 14, 1896, 5.

65. The *Times* article claimed that Frohman's remarks "put into the mind of Mr. Edison another possibility," and then detailed Edison's plan to film two train engines crashing into each other as well as plans to film Pope Leo XIII in Rome, two things that could not be seen otherwise on the vaudeville stage, unlike the other films at the premiere program.

66. See Nicholas Van Hoogstraten, *Lost Broadway Theatres* (rev. ed., 1997), and William Morrison, *Broadway Theatres: History and Architecture* (1999).

67. Mary Henderson alludes to this in passing: "At the beginning of the era [1870], the deep stage, proscenium boxes, and horseshoe auditorium prevailed, but by 1900 they were supplanted by the shallow picture-frame stage and the smaller fan-shaped auditorium with boxes on the side walls above the orchestra." Mary C. Henderson, "Scenography, Stagecraft, and Architecture," in Wilmeth and Bigsby, eds., 2:489. I have found no commentary that directly relates staging practices to architectural innovation.

68. Hiram Kelly Moderwell, *The Theatre of To-day* (rev. ed., 1928), 31.

69. While praising the D'Oyly Carte Opera House in London, he notes, "if there be anything to complain of, it is that the uppermost tier has been continued so as to form a deep 'well' or chute which, to my mind, is a disgrace to a modern theatre that claims to provide for the comfort of the audience" (Sachs, *Modern Opera Houses* 1:36). He offers a similar complaint about another London theater (1:38) as well as the Paris Opera House (Sachs, 2:7).

70. "It was the first theater in the United States in which the fan-shaped, curvilinear auditorium departed completely from the traditional prevailing horseshoe shaped designs and in which most of the seats on several levels faced the stage." Londré and Watermeier, *The History of North American Theater*, 173.

71. Reprint of article from *The Builder* (London) in *American Architect* 106.2017 (Aug. 19, 1914): 107.

72. Mullin notes an increase in capacity at the end of the eighteenth century with the added tiers effectively forcing a closeness because of sound and sight problems: "The increase in capacity compelled the actors to play down center in order to be heard . . . [while] those at the ends of the horseshoe had difficulty in seeing more than the front of the stage" (*Development*, 138).

73. Wagner was not the actual architect of the Festspielhaus, but the double proscenium and the frontal seating were ideas that originated with him. See Juliet Koss, *Modernism After Wagner* (2009), 25–66.

74. Mullin claims the Festspielhaus "changed the course of the playhouse in a single stroke. . . . [Its] advantages . . . for producing and viewing realistic drama were so obvious that they could not but sweep the field" (ibid., 144). I think he is right to connect design to issues of staging, although all of his examples are drawn from the twentieth century. Siry, on the other hand, does trace the way the Festspielhaus influenced the Auditorium (*Chicago Auditorium*, 106–7).

75. In a recent book, my colleague Pannill Camp argues that the ideological underpinnings of such changes were forged in the 1770s in France, challenging the settled narratives that locate the roots of stage realism in the nineteenth century. Camp, *The First Frame* (2014).

76. Richard and Helen Leacroft, *Theatre and Playhouse* (1984), 120. Since it was a convention of theaters in this period to use a raked stage floor to enhance the perspectival illusion of the scenery, the Leacrofts note that box sets were installed with some difficulty; the first flat stage in England they cite is from 1897. The raked stage plus the difficulty of changing scenes possibly impaired large-scale adoption in Europe. There is some evidence the situation was different in the United States. (See note 78.)

77. A leaflet for the theater cited in Richard Southern, "The Picture-Frame Proscenium of 1880," *Theatre Notebook* 5.3 (Apr.–June 1951): 60. Southern does provide a critical contemporary view worth noting here: the writer posits the gilded frame "seems to reduce what is going on upon the stage to a mere picture overpowered by a heavy and elaborate setting" (61). The writer clearly sees this as a negative, but he does effectively grant setting a kind of expressiveness it did not have previously, a point I will develop below.

78. Contra Bergman and other theater historians, Brewster and Jacobs claim "a whole series of pressures tended to drive the action to the front of the stage, and helped to retain small forestages through most of our period" (*Theatre to Cinema*, 151). They are equally skeptical about the use of the box set. But there is much evidence to the contrary. For example, "The German theatre man Edw. Devrient, who visited Paris in 1839 and eagerly studied the new *mise-en-scène*, in one of his letters raised the question how the box set was illuminated. . . . Devrient confirms . . . that he had been able to study the mimics of the actors even in the background of the room furthest from the footlights." Gösta M. Bergman, *Lighting in the Theatre* (1977), 262.

In the United States in 1868, "Edwin Booth completed his Booth's Theatre. . . . Several new features were included by Booth that others rushed to imitate. For the first time the stage was no longer raked, but flat. All vestiges of the apron stage were banished. . . . For the first time, also, the stage was not rigged with grooves which required flats to be mounted in a regular pattern; instead the wings were held in position by braces pegged to the floor, and thus could be placed at any convenient angle. . . . The American playhouse had found its pattern." A "contemporary magazine illustration" of the theater shows a set with side walls extending the depth of the stage and a woman standing midstage with a man kneeling before her (Mullin, *Development*, 130–31). Finally, in 1879, with the Madison Square Theater Steele MacKaye sought "to create an architecturally ideal theater": to do so, he used two box sets mounted on an elevator, facilitating a rapid scene change and "replaced the conventional horseshoe shaped balcony . . . with a deeply sloped central balcony that gave almost all patrons a frontal view of the stage." Such is the conservative nature of theater architecture that drawings of the interior do in fact show a U-shaped balcony that still has seats facing into the body of the

auditorium, albeit with more rows in the center. Siry, *Chicago Auditorium*, 70–71.

79. Bergman does note that Wagner later claimed this was due to a mistake and in later performances "a faint light filtered down from sources near the ceiling" (300).

80. This is from Percy Fitzgerald in the book *Lamb's Dramatic Essays with a commentary by Percy Fitzgerald* (cited in Bergman, *Lighting*, 294). This is the same Percy Fitzgerald who compared new staging practices to panoramas, noted earlier in this chapter.

81. On an Edison compilation DVD set, Charles Musser notes that there were many films of "serpentine dances." If there were any others from 1895, it might well have been a different film. But based on observation of extant films, it is very likely all of the films were staged in similar fashion. *Edison: The Invention of the Movies* (DVD set, New York: Kino Video–MoMA, 2005).

82. Musser notes of these early films, "The dark background also placed its subjects in bold relief in a manner that recalls Edweard Muybridge's serial views" (*Emergence*, 78).

83. Here is the description of the film from a contemporary review: "When the hall was darkened last night . . . an unusually bright light fell upon the screen. Then came into view two precious blonde young persons of the variety stage, in pink and blue dresses, doing the umbrella dance with commendable celerity. Their motions were all clearly defined. When they vanished, a view of an angry surf breaking on a sandy beach near a stone pier amazed the spectators" ("Edison's Vitascope Cheered"). The only visual specification here is color, which suggests hand-tinting. But Charles Musser has written there are two striking continuities in the early Edison films: "the black backgrounds and the frontal organization of the mise-en-scène" (*Nickelodeon*, 34). Since there are many extant Edison films of women dancing which have this arrangement, it is likely that "Umbrella Dance" was similar.

84. Musser writes that it was common practice to show a film a half dozen times. Further, because Koster and Bial's used two projectors, it is likely the repetitions were timed to the preparation of the other projector: "while one film was being shown on one machine, the subject on the other could be taken off and replaced by a new one (a process that took approximately two minutes)" (*Emergence*, 117).

85. *N.Y. Mail and Express*, Apr. 24, 1896, 12, cited in Musser, *Emergence*, 116.

86. Brooks McNamara, "Scene Design and the Early Film," from Jay Leyda and Charles Musser, curators, *Before Hollywood: Turn-of-the-Century Film from American Archives* (1986). McNamara does see an explicit connection between set design and lighting that is worth keeping in mind because clearly the move to electric light did not happen overnight: "typically three-dimensional detail was merely painted on a drop or flat and did not bear very close inspection.

The best of such scenery, however, was certainly effective on the rather dimly lit stages still found in many theaters" (53). Implementation was likely delayed in smaller cities and towns because electric lighting was more expensive than gaslight (Bergman, *Lighting*, 287). Although McNamara thinks shooting on real locations had some impact on set design in early narrative film, he still sees live performance theater as a key influence: "The film industry's move toward the creation of detailed realistic interiors was not simply an attempt to bring them into line with the real exteriors that were being used. Another obvious influence was the popular realism of Broadway producer-director David Belasco and his imitators in the theater" (56).

87. In a collection of Biograph *Bulletins* that reprints many newspaper responses to the earliest showings of the Biograph in a variety of cities, there is frequent comparisons to the Vitascope and claims for the superiority of the Biograph, but never once is a large-size image mentioned. A few articles state the image is the size of the theater curtain, but then often use the familiar phrase, "life-size." The only specific mention of screen size is 40 square feet, which is not credible because it would be much too small. Kemp Niver, *American Biograph Bulletins* (1971), 9–33.

88. *N.Y. Mail and Express*, Oct. 17, 1896; reproduced in ibid., 14.

89. "The Biograph at Olympia," *NYT*, Oct. 13, 1896, 5.

90. The *Times* article on the premiere lists the other titles: "Niagara Falls," "A Stable on Fire," "Joseph Jefferson in the Drinking Scene of 'Rip Van Winkle,'" "Trilby and Little Billie," and "The Washing of a Pickaninny by His Mother." As with the Vitagraph show, this program draws on actual stage performances, but it also has more of a balance between them and events in the real world staged for the camera. "Niagara Falls," which was singled out for praise in the article, seems intended as a parallel to "Rough Sea at Dover" ("The Biograph at Olympia").

91. A third report citing the terror of the train went further in audience reaction, but was also spatially ambiguous:

At first you seem to be looking straight away down a railroad track. Suddenly the Empire State Express looms in sight 'way off in the distance and comes steaming toward you—right dead at you full speed.

It makes even an unimaginative person kind of shiver and wish he could get off to one side, but women—it scares them to death.

Two ladies who were in a box last night screamed and fainted. (*N.Y. Telegram*, Oct. 15, 1896, cited in Niver, *Bulletins*, 14)

Since all the rings of the Olympia Music Hall were made up of boxes, these two women (a different couple?) could have faced the screen at a more

propitious angle, while the writer seems to include the entire audience in the path of the train. This, along with the fact that no one else noticed women actually fainting, might be enough to doubt the description, but here's another reason. This report seems to echo an article written in advance of the premiere, suggesting the terrified reaction was something Biograph was hoping for: "the Empire State Express running at full speed, full actual size, and with such realistic effect, seems to be coming straight out to crush its way through the spectators" (N.Y. Mail and Express, Oct. 17, 1896, cited in Niver, ibid., 12). In this description as well, the writer expects all members of the audience, regardless of where they are in relation to the screen, will feel the effect of the advancing train equally. In contrast, another contemporary observer in a different city simply saw a train moving across the screen right to left, thrilling but not dangerous: "a fast New York Central train, tearing down a half mile of track till it rushes across a stage like a palpitating monster, as big as reality" (Cincinnati Enquirer, Nov. 2, 1896, in Niver, ibid., 15).

But here's one last reason to doubt all these reports: almost all of reports from other cities of terrified reactions are *reactions of women*, or, as the writer above notes, men may kind of shiver, but women are scared to death. A large group of children, on the other hand, were apparently a good deal more fearless than the fainting women, as a report from Kansas City demonstrated: upon seeing the Empire State Express as it "roared across the stage," "The children were up in their seats and 2,160 little voices united in a shout that stopped people in the street. From that moment the children simply acted with the performers and cackled" (Niver, ibid., 20).

92. A *Scientific American* cover story on the Biograph has a series of sketches showing different aspects of the new invention, one of a performance in a theater. This is often taken as representing the premiere performance, but the interior is very clearly not the Olympia Music Hall. In any case, the screen is located at the curtain line, where the image fills the entire proscenium. This seems unlikely for reasons I state in note 87, and it was fairly common to exaggerate the size of the screen in these drawings, perhaps to reflect the impression of a dynamic film image. *Scientific American*, Apr. 17, 1897.

93. Brewster and Jacobs minimize the effect of distortion from side seats: "Although film viewers in extreme positions see a distorted picture in which figures are laterally or vertically compressed, those figures have the same relationship to one another for the whole audience, however small their angular separation might have been for the camera" (*Theatre to Cinema*, 171). However, as subsequent chapters will show, audiences were disturbed by the distortion in the side sections of the movie palaces and even in the side seats closer to the screen in small store theaters, neither of which offered viewing angles as extreme as those in a horseshoe theater. As someone who saw *North*

*by Northwest* (1959) in its premiere showing at a very crowded Radio City Music Hall, and forced to sit in the furthest side section on the left in the front third of the auditorium, I can testify that the distortion was a constant disturbance and subsequent theatrical viewings of this film were very different. And even from this vantage point, the distortion would have been less than what someone seated in the front box of the Olympia would have seen.

94. Bottomore, "The Panicking Audience? Early Cinema and the 'Train Effect,'" *Historical Journal of Film, Radio and Television* 19.2 (1999): 189.

95. *N.Y. Mail and Express*, Oct. 12, 1896, reprinted in Niver, *Bulletins*, 12.

96. *Julius Cahn's Official Theatrical Guide*, 61.

97. Brewster and Jacobs have an excellent discussion comparing handling of depth onstage and in a movie, graphically demonstrating how the film image creates an extreme change in size as it denotes distance (*Theater to Cinema*, 170–71).

98. As part of the promotion for Richard Schickel's series, *The Men Who Made the Movies* (1973), I had the good fortune of having lunch with Raoul Walsh, who had begun his filmmaking career in 1916. Over the hour-and-a-half conversation about his films, he repeatedly used the phrase "big head," never "close-up."

99. A contemporary theater guide cites the capacity of the Olympia Music Hall as 3,815 seats: 509 seats were in the orchestra while 500 were in the gallery, the only two locations along with a limited number of boxes that had a more or less frontal view of the stage. This should give some indication of how many viewers actually had a bad view of the screen. *Julius Cahn's Official Theatrical Guide of 1896*, 69.

100. The *New York Times* article on the Vitascope premiere noted a difference: "In only two of the pictures shown Thursday night were the colors brought out" ("Edison's Latest Invention"). The only example I've come across of a contemporary viewer questioning the realism of a black-and-white image is from a Maxim Gorky essay quoted by Tom Gunning: "For Gorky, the cinématographe presents a world whose vividness and vitality have been drained away: '. . . before you a life is surging, a life deprived of words and shorn of the living spectrum of colours—the grey, the soundless, the bleak and dismal life.'" Gunning, "Astonishment," 34.

101. These are issues dealt with extensively by Rudolf Arnheim in *Film as Art* (1957) precisely to claim that film is *not* a transparent re-creation of reality.

102. *N.Y. Mail and Express*, Oct. 13, 1896, 5; cited in Musser, *Emergence*, 152.

103. "Edison's Latest Triumph," *NYT*, Apr. 14, 1896, 5.

104. As an example, a 1907 article uses "canvas" to indicate "flat" in the theatrical sense of painted scenery: "In the moving picture factory . . . scene painters are constantly at work making new canvasses for the picture dramas." "How the Cinematographer Works," *MPW*, July 13, 1907, 299.

105. "The Modern Moving Picture Theatre—Ch. V, Showing the Picture," *MPW*, Oct. 16, 1909, 520.

106. Macgowan, *The Theatre of Tomorrow*, 178–79.

107. Brewster and Jacobs see the cutting strategies that begin to be deployed in the period of this film as a response to the limitations imposed on the pictorial style by the relatively small width of the film image compared to the stage (*Theatre to Cinema*, 189 ff.).

108. While the reverse-angle cutting creates a spatial reality not possible on the realistic stage, Tom Gunning, in a fine analysis of this sequence, suggests character psychology as the key motivation for the cutting: "the psychological development of a character, primarily conveyed by editing, forms the basis of a film. . . . By intercutting the play and Johnson's reaction, Griffith allows the film to take place—so to speak—in the character's mind." Gunning, *D.W. Griffith and the Origins of American Narrative Film* (1991), 169.

109. In writing this I am not claiming motion pictures as the inevitable outcome of nineteenth-century theater as A. Nicholas Vardac does in *Stage to Screen: Theatrical Method from Garrick to Griffith* (1949). Rather, I aim to use theater history as a way of positing the horizon of expectation through which contemporaries experienced the first film showings.

## 2. STORE THEATERS

1. S. S. Hutchinson, "Kinematography in the United States," *MPW*, July 11, 1914, 175–76.

2. Eileen Bowser has cautioned, "It would be impossible to count accurately the number of nickelodeons existing at any one time. They were constantly going out of business and springing up anew. Most of the available figures do not distinguish true nickel showplaces from every other place where motion pictures were exhibited." Bowser, *The Transformation of Cinema, 1907–1915* (1990), 4.

3. Robert Grau, "Vaudeville in Moving Picture Theatres," *MPW*, May 7, 1910, 726.

4. "A Newly Invented Cinematograph Screen That Does Not Need Darkness," *EH*, May 6, 1916, 26.

5. *MPW*, July 11, 1914, 175–76.

6. Q. David Bowers and Kathryn Fuller-Seeley, *One Thousand Nights at the Movies: An Illustrated History of Motion Pictures* (2013), 74.

7. Ross Melnick has an extensive description of Rothapfel's work at his first theater in his biography, *American Showman: Samuel "Roxy" Rothapfel and the Birth of the Entertainment Industry, 1908–1915* (2012), 39–55.

8. "Exhibiting as a Fine Art," *MPW*, Feb. 12, 1910, 202.

9. S. L. Rothapfel, "Observations by Wide-Awake Exhibitors—Management," *MPW*, Mar. 12, 1910, 373.

10. Rothapfel, "Management of the Theater (con't.)," *MPW*, Apr. 9, 1910, 548 (emphasis added).

11. H. F. Hoffman, "Picking a Show," *MPW*, May 7, 1910, 726–27.

12. See Melnick, *American Showman*, 351–69.

13. *MPW*, July 11, 1914, 176.

14. A brief article in *MPW* charted the change in production from November 1906 to March 1907: in November, 10,000 feet of "new film subjects" were "placed upon the American market"; in March, the number jumped to 28,000. The following observation specifically relates this increase to the demands of store theaters: "Two Nickelodeons located in one block, changing reels three times weekly, each using new subjects only, were forced to show the same pictures more than half the time in November, 1906, while in March there was no need of duplicating at any time." "For the Nickelodeon," *MPW*, May 4, 1907.

15. Allen, *Vaudeville and Film*, 212–13.

16. Gunning, *D.W. Griffith and the Origins of American Narrative Film.*

17. Preceding the rise in narrative film production Allen cites, Charles Musser notes that dramatic films had rentals in higher proportion than their percentage of production: "A statistical analysis of Edison production records for 1904–1905 shows that staged or acted films sold approximately three and a half times as well as actualities, a ratio that remained constant for the following two years of this survey and was probably typical of the wider industry" (*Emergence*, 375). This suggests the possibility that the nickelodeon was a response to the popularity of the narrative film and then in turn helped to promote that popularity. See also Musser, "Moving Towards Fictional Narratives: Story Films Become the Dominant Product, 1903–1904," in Lee Grieveson and Peter Krämer, eds., *The Silent Film Reader* (2004), 87–102. In *The Red Rooster Scare*, Richard Abel argues that the French firm Pathé, which had "shifted into a factory system of production," fueled the nickelodeon boom because it was able "by 1905–1906 to produce and deliver a variety of films of high quality, en masse and on a regular, relatively predictable basis" (1999), 29–36.

18. "Photoplay New Literature," *Exhibitors Film Exchange*, Sept. 4, 1915, 19.

19. Rollin Summers, "The Moving Picture Drama and the Acted Drama. Some Points of Comparison as to Technique," *MPW*, Sept. 19, 1908, 211 (emphasis added).

20. Quoted without citation in Bowers and Fuller-Seeley, *One Thousand Nights*, 54 (emphasis added).

21. Rick Altman has argued against the status of the store theaters as the first dedicated motion picture theaters: "A more satisfactory approach to the nickelodeon phenomenon would recognize the fundamentally multimedia nature of the storefront theater program. While a few nickel theaters concentrated

exclusively on film, by far the majority of nickelodeons combined film with illustrated songs or vaudeville" (Altman, *Silent Film Sound* [2004], 182). One problem with this claim is that Altman, like many other historians of early cinema, makes no distinction between the terms used for these theaters. Countering this is the very theater that Altman uses to make a claim for "by far the majority of nickelodeons," Keith's Nickel Theatre in Providence. While it had become, as its name indicates, a nickel theater featuring mostly movies, it did not occupy a store lot, but was rather a freestanding theater which had previously functioned as a playhouse hosting traveling stock companies and eventually a Keith vaudeville house (185–90). As a vaudeville house, it had some claim to fame: "It is said that it was at this house that the 'continuous performance' had its origin" (*Providence Magazine* 18 [Oct. 1916]: 653). Because of an oversupply of theaters, many poor-performing theaters like this one were being turned over to movies alongside the burgeoning growth of the store theater. In fact, a contemporary source reports of the Nickel, "This was *the first real theater* used for five-cent shows in this country" (M. B. Leavitt, *Fifty Years in Theatrical Management* [New York: Broadway Publishing, 1912], 171; emphasis added). Altman is correct that song slides were often used between films, albeit in limited fashion: the presence of one or two illustrated songs does not seem to me sufficient reason to claim the store theater was anything other than a movie theater. If we were to eliminate all theaters making use of some kind of live musical performance as part of the movie show, then we would have to conclude there were no movie theaters in the entire silent period.

22. "Report of Jury Award," *The Brickbuilder* 23.2, "The Moving Picture Theatre Special Number" Supplement (Feb. 1914): 6.

23. "The Brickbuilder Annual Architectural Terra Cotta Competition," *The Brickbuilder* 22.11 (Nov. 1913): xxxviii.

24. In his *Motion Picture Work* (1915; rpt., 1970), David Hulfish has a section on the requirements for starting a theater. For him a motion picture specifically means "A Store-Front City Theater Building," which he illustrates with a rectangular plan that would fit within a roughly 25 by 50 foot lot. For him, theaters "having a 50-foot front and seating five hundred or more people" would be "vaudeville theaters rather than simple picture houses" (176–88).

25. "The New Era in Film Construction," *MPN*, Nov. 11, 1914, 72.

26. "The Moving Picture Theatre," *Architect's and Builder's Magazine* 42.8 (1910–1911): 319–22. By contrast, Jean-Jacques Meusy has noted, in France "there were no architects specializing in the construction of cinemas before the First World War." Consequently, although France appears to have built grander dedicated movie theaters earlier than the United States, "exhibition companies constructed their halls in the image of the theaters." Meusy, "Palaces and Holes

in the Wall: Conditions of Exhibition in Paris on the Eve of World War I," *The Velvet Light Trap* 37 (Spring 1996): 89.

27. *MPW*, Oct. 16, 1915, 417.

28. *MPW*, Apr. 23, 1910, 635.

29. *MPN*, Nov. 1, 1913, 36.

30. In spite of this early specialization *as a business practice*, general histories of architecture rarely have any information on theater architecture beyond ancient Greek theaters. Movie theaters are mentioned almost never, with Radio City Music Hall the singular exception because of its art deco features.

31. "A New Department," *MPN*, Apr. 11, 1914, 17.

32. *EH*, May 6, 1916, 23.

33. The earliest article I have found in either a trade journal or an architecture journal about movie theater architecture focuses entirely on the exterior: "Architecture for Nickelodeons," *MPW*, Feb. 1, 1908, 75. More recently, we have a book whose title makes the focus clear: Maggie Valentine, *The Show Starts on the Sidewalk: An Architectural History of the Movie Theatre, Starring S. Charles Lee* (1994). Finally, the sixty-six photos of store theaters and nickelodeons that appear in Bowers and Fuller-Seeley are all of exteriors (*One Thousand Nights*, 59–90).

34. Charlotte Herzog, "The Archaeology of Cinema Architecture: The Origins of the Movie Theater," *Quarterly Review of Film Studies* 9.1 (Winter 1984): 13.

35. Marvin Carlson, *Places of Performance* (1989), 118.

36. Of the twelve theaters that line 42nd Street from Seventh to Eighth Avenues, seven had narrow fronts with passageways leading to auditoria on 41st and 43rd Street. See the map of theaters in Van Hoogstraten, *Lost Broadway Theatres*, 2–3.

37. Photographs of exteriors in Herzog as well as in Q. David Bowers, *Nickelodeon Theatres and Their Music* (1986), generally follow this pattern, occasionally inverting it to place the most eye-catching element on top (Bowers, 30). Herzog traces these façades to the circus tent shows, and the presence of the box office as part of the façade does seem to show the circus influence (Herzog, 20). Otherwise, it seems to me the more immediate influence of live theater is equally credible and perhaps more pertinent.

38. F. H. Richardson, "Plain Talk to Theatre Managers and Operators—Ch. XXV, Decoration—Facades," *MPW*, Nov. 20, 1909, 713.

39. William M. Hamilton, "Has the Motion Picture Business Come to Stay?" *MPW*, May 9, 1908, 412.

40. "W. C. DeMille Talks on the Drama," *MPW*, Oct. 9, 1915, 258. DeMille does seem to be deliberately echoing voices for an advanced theater that had already begun to be heard, most especially in reaction against the performance practices of David Belasco.

41. John M. Bradlet, "Motion Picture Theatre Construction Department," *MPN*, Nov. 1, 1913, 36, 38.

42. "Illumination in the Modern Theatre," *MPN*, Aug. 15, 1914, 42.

43. Edward Bernard Kinsila, "Modern Theater Construction," *MPW*, Oct. 16, 1915, 417 (emphasis added).

44. A 1916 article by W. T. Braun, "the foremost architect of motion picture theaters," specifies "50 feet wide 100 feet deep . . . is about the average city lot," a number identical to the lot size proposed for the *Brickbuilder* contest. A subsequent article on a suburban theater suggests a similar lot size: "50 feet frontage by 125 feet in depth." The relative consistency of lot size at this point suggests two things: the earliest store theaters occupied half a lot, while the subsequent movie palaces may have had to find ways of fitting within an increasingly crowded urban landscape, but they did not conform to conventional lot sizes. W. T. Braun, Architect, "Theater Planning and Building," *EH*, May 6, 1916, 24, and Braun, Architect, "Theater Planning and Building: The Suburban Theater," *EH*, May 20, 1916, 25.

45. Writing in 1916, when "very few of the remodeled store buildings still house moving picture exhibitions," W. T. Braun noted that alleyways on either side were required by law in most localities. W. T. Braun, Architect, "Theater Planning and Building," *EH*, May 6, 1916, 23. Nevertheless, for newly built theaters within both urban and suburban blocks, Braun still proposes a long and narrow theater.

46. The number of exits would depend upon the theater's capacity. If only one exit was needed, which is the case in figure 2.2, symmetry could be maintained with an alcove to the other side of the screen, here used as the space for a piano.

47. F. H. Richardson, "Projection Department," *MPW*, June 27, 1914, 1826.

48. John M. Bradlet, "The Construction and Conduct of the Theater," *MPW*, Apr. 23, 1910, 635.

49. "Colonial Theater, Wichita, Kan," *MPW*, Feb. 24, 1912, 677.

50. John M. Bradlet, "On the Road," *MPN*, Oct. 25, 1913, 31.

51. Grau, "Vaudeville in Moving Picture Theatres," *MPW*, May 7, 1910, 726.

52. C. Y., "The Lighting of Theaters," *MPW*, May 7, 1910, 743.

53. "Screens and What to Know About Them," *MPN*, Aug. 15, 1914, 33.

54. *MPW*, Jan. 6, 1911, 76.

55. *MPW*, Mar. 16, 1912, 987. Was there any evidence of the effectiveness of the curved screen outside of the advertisements? The only seeming independent observation comes from a 1912 article that does a comparison with a flat screen with less compelling results: when viewing the image from the extreme side angle of box seats, the writer notes, "it cannot be said that all distortion disappeared, but the foreshortening did not seem too obvious." On the other hand, the article appeared in a journal with a good deal of advertising

for this very screen. H. F. H., "The Perfection Concave Screen," *MPW*, Mar. 23, 1912, 1057.

56. "Conversation Heard in the Office of a Dealer in Motion Picture Machines," *MPW*, May 4, 1907, 138.

57. See Bowser, *Transformation*, 94–95, and Brewster and Jacobs, *Theatre to Cinema* (165–70).

58. "Too Near the Camera," *MPW*, Mar. 25, 1911, 633. I have found one early—and unusual—dissenting voice: "The moving picture may present figures greater than life size without loss of illusion . . ." Summers, "The Moving Picture Drama and the Acted Drama," *MPW*, Sept. 19, 1908, 211.

59. "Editorial—The Factor of Uniformity," *MPW*, July 24, 1909, 115.

60. J. M. B., "The Size of the Picture," *MPW*, Mar. 11, 1911, 527.

61. The excessively long theater in New Haven mentioned above did have a comparably larger screen, specifically 19 feet. Richardson, "Projection Department," *MPW*, June 27, 1914, 1826.

62. F. H. Richardson, *Motion Picture Handbook: A Guide for Managers and Operators of Motion Picture Theatres* (1910; 2d ed., 1912), and Richardson, *Bluebook of Projection* (6th ed., 1937).

63. F. H. Richardson, "Plain Talk to Theatre Managers and Operators—Ch. XIX, The Curtain," *MPW*, Oct. 2, 1909, 444.

64. F. H. Richardson, "Trouble Department," *MPW*, Nov. 5, 1910, 1050.

65. Is the long and narrow theater a distinctively American form? This is a question well worth asking if it does have an impact on American film production. Unfortunately, it is hard to determine from sources I have been able to locate, but there is some evidence that things were different in Europe. A 1910 article on a new "de luxe" London theater that seats 450–500 specifies dimensions of 40 feet wide by 68 feet long. "The screen is 14 by 12 feet, and is set in a beautifully finished proscenium." An American theater at this time would likely have used length rather than width to achieve this capacity. "A London Moving Picture House De Luxe," *MPW*, Feb. 26, 1910, 293.

66. "W. C. DeMille Talks on the Drama," *MPW*, Oct. 9, 1915, 258.

67. Charles A. Whittemore, "The Moving Picture Theatre," *The Brickbuilder* 23.2, "The Moving Picture Theatre Special Number" Supplement (Feb. 1914): 41.

68. John M. Bradlet, "Construction Decorations," *MPW*, Jan. 21, 1911, 134.

69. "Seating and Interior Decoration—Seating a Theatre," *MPN*, Aug. 15, 1914, 31.

70. Thomas Bedding, "The Eternal Feminine and Her Hat," *MPW*, Apr. 9, 1910, 546.

71. Bowers, *Nickelodeon Theaters*, 97, 34. Eileen Bowser quotes a 1909 *Moving Picture World* article stating, "All theaters should have a sloped floor. The day of the flat floor is past." Bowser does question this, but provides no counter-evidence: "That might be, but more theaters still had flat floors than sloped ones" (Bowser, *Transformation*, 126).

72. "The Princess of Milwaukee," *MPW*, Oct. 22, 1910, 938; "New Empire, Detroit, Mich.," *MPW*, Dec. 5, 1914, 1369.

73. See Ben Singer, "Manhattan Nickelodeons: New Data on Audiences and Exhibitors," *Cinema Journal* 34.3 (Spring 1995): 5–35, and the series of replies that followed in its wake: two replies in the Spring 1996 issue together with a response from Singer and then another two articles in Summer 1997 with another reply by Singer.

74. W. Stephen Bush, "The Triumph of the Gallery," *MPW*, Dec. 13, 1913, 1256. Musser notes a similar hostility in the U.S. (*Emergence*, 432).

75. Frohman, "The Moving Picture and Its Place in American Drama," *The Brickbuilder* 23.2, "The Moving Picture Theatre Special Number" Supplement (Feb. 1914): 4.

76. H. L. Nella, "Technical Talks," *EH*, June 17, 1916, 23.

77. "A London Moving Picture House De Luxe," 293. For the dimensions and seating capacity of this theater, see note 72.

78. "Amongst the 'Gods,'" *MPW*, Jan. 29, 1910, 118. Throughout this period, *Moving Picture World* repeatedly lobbied for higher prices as a way of raising the class status of motion pictures. For this reason, the editorial goes on to note, ruefully, "Here in New York City the exigencies of the building laws forbid the erection of a proper moving picture palace with seats ranging in costs, let us say, from a dollar down. Were those laws abrogated, no doubt some capitalist would come forward and give New York what it does not at present possess, and that is a proper moving picture palace." When that palace did in fact arrive, with the opening of the Strand, differential pricing was not crucial to its success.

79. "The Modern Moving Picture Theatre—Ch. IV, Handling the Visitor," *MPW*, Oct. 9, 1909, 482.

80. Untitled, *MPW*, Apr. 13, 1907, 88 (emphasis added).

81. "The Comet and the Solar Screen," *MPW*, Sept. 10, 1910, 572. Smell was also connected to light in this East Side tenement theater; this sentence immediately follows the description of the perfuming usher: "Most noticeable was the amount of diffused light throughout the auditorium."

82. John M. Bradlet, "The Construction and Conduct of the Theater. II.—Flooring," *MPW*, Apr. 30, 1910, 679.

83. W. Stephen Bush, "The Coming Ten and Twenty Cent Moving Picture Theater," *MPW*, Aug. 29, 1908, 152 (emphasis added).

84. Henry C. Montague, "Necessary Precautions in the Interior Construction of Moving Picture Theaters," *MPW*, Mar. 21, 1908, 228.

85. "Caput Augmenti," *MPW*, Aug. 21, 1909, 247.

86. Will Hemsteger, "Explaining the Picture" (letter), *MPW*, Aug. 13, 1910, 359.

87. "Coliseum Theater, Seattle, Wash.," *MPW*, July 15, 1911, 26.

88. "Saxe's Orpheum Theatre," *MPW*, Feb. 24, 1912, 675.

89. Fred Mariott, "An English View of the American Moving Picture," *MPW*, July 24, 1909, 116.

90. For this reason, a European theater that wasn't dark could be treated as news of progress by American journals, as this report on a new theater in Berlin demonstrates: "The new theatre contains one featured which is an absolute novelty in German motion picture houses, namely, that it does not require to be darkened while the films are being shown." Untitled, *MPN*, Jan. 4, 1913, 7.

91. "America First in Picture Theatres," *MPN*, Mar. 21, 1914, 25.

92. On the other hand, the late-nineteenth-century darkening of the auditorium discussed in the last chapter could initially be associated with danger in the European theaters as well. Iain Mackintosh has noted: "The gradual darkening of the auditorium at the beginning of Queen Victoria's reign convinced the righteous churchgoer once again that the 'pit' of the theater was well named. . . . Darken the auditorium and . . . scouts from the neighboring brothels might overstep the limits of decency. A semi-darkened auditorium was therefore a dangerous place." Mackintosh, *Architecture, Actor and Audience*, 37.

93. "Keith and Proctor and the Picture. Valuable Appreciation and Progress," *MPW*, Jan. 14, 1911, 70.

94. "Vitagraph Picture Theater," *MPW*, Feb. 14, 1914, 786.

95. "Chicago Notes: Helpful Hints to Exhibitors. By a Picture Lover," *MPW*, Apr. 2, 1910, 507.

96. John M. Bradlet, "Construction Decorations," *MPW*, Jan. 28, 1911, 184.

97. F. H. Richardson, "Projection Department"—"Lighted Auditoriums," *MPW*, Jan. 27, 1912, 259 (emphasis added).

98. C.Y., "The Lighting of Theaters," 741.

99. F. H. Richardson, "Trouble Department," *MPW*, Oct. 29, 1910, 989.

100. Theater historian John Gassner writes, "illusion can be created for the works of nineteenth-century realists and their twentieth-century successors only when the acting area is treated as both geographically and psychologically distinct from the area occupied by the audience." Gassner, *Directions in Modern Theatre and Drama* (1965), 55. One might reasonably object that film by its nature does not need to make such a distinction, in which case the architectural solutions that sought to set the screen in a different space from that of the auditorium are similar to the injunction not to look at the camera.

101. F. H. Richardson, "Plain Talk to Theatre Managers and Operators—Ch. XIX, The Curtain," *MPW*, Oct. 2, 1909, 444.

102. George B. Rockwell, "Framing the Screen," *MPW*, Sept. 23, 1911, 874. In the same column, Rockwell pointed to another value for black masking at the time: "Many exhibitors make the mistake of putting a frame around the screen and then go hunting for a lens to fill the space left, with the result that as [sic] it is practically impossible to procure a lens that will fit the curtain exactly to the

edges. The picture will be either too small or will overlap the frame and if the frame is gilded as it is in most cases, the dancing shadows prove very distracting to the eye of the audience and in no way help to produce good results."

103. Charles E. Schneider, "The So Called Daylight Screens," *MPW*, Apr. 15, 1911, 824.

104. "A Screen Suggestion," *MPW*, Apr. 8, 1911, 754.

105. F. H. Richardson, "Trouble Department," *MPW*, Nov. 12, 1910, 1109. Richardson also notes, "In Australia they are projection moving pictures 35 feet wide," a much greater size than almost all U.S. theaters.

106. "A Plate Glass 'Curtain,'" *MPW*, July 31, 1909, 166.

107. Advertisement for "Silverine Curtain Coating," *MPW*, July 31, 1909, 166.

108. Montague, "Necessary Precautions in the Interior Construction of Moving Picture Theaters," *MPW*, Mar. 21, 1908, 228.

109. "A Newly Invented Cinematograph Screen That Does Not Need Darkness," 26. An article in *The Brickbuilder* detailing the specific architectural requirements for the film theater explains one reason for this law that speaks to concerns about the dangers of motion pictures: "at stated intervals the lights shall be turned on to relieve the strain on the eyes." Whittemore, "The Moving Picture Theatre," *The Brickbuilder* 23.2 (Feb. 1914): 42.

110. A 1908 article suggests placing the screen at the front of the theater and the projection booth at the rear for greater safety, and even claims that "many of the new places being opened are so arranged." However, I have not come across any other description of theaters from this period that were in fact so designed. "A Hint to Builders," *MPW*, Mar. 28, 1908, 256.

111. In fact, one kind of theater that emerged in the late 1920s regularly used projectors behind the screen, but it disappeared from the urban landscape as a consequence of television: the newsreel theater, which, not unlike a latter-day store theater, showed a mix of short films, cartoons, and newsreels, usually running about an hour. Space in this instance seemed the primary concern since a system of mirrors facilitated projection in a small space behind the screen, while the lack of a booth in the auditorium allowed for higher seating capacity.

112. See, for example, "Old Albany Theatre Closes" *MPN*, Aug. 8, 1914, 22.

113. "A New Department," *MPN*, Apr. 11, 1914, 17.

114. "America's Biggest Picture Theatre," *MPN*, Mar. 14, 1914, 19.

115. Ibid. Additional information of the size and shape of the theater has been taken from "American Theater, Salt Lake City, Utah," *MPW*, July 10, 1915, 275.

116. I should caution I am not claiming one-to-one causation here. Constance Darcy Mackay, for example, in what is I believe the first study of the Little Theater movement traces it "back to 1887 when the first small experimental theatre was established in Paris by André Antoine." Mackay, *The Little Theatre in the United States* (1917), 2. There are certainly many factors that play into

the Little Theater movement. I simply want to claim the store theater as one of those factors.

117. Dorothy Chansky, *Composing Ourselves: The Little Theatre Movement and the American Audience* (2004), 4.

118. Wilinsky, *Sure Seaters: The Emergence of Art House Cinema* (2001), 52.

## 3. Palatial Architecture, Democratized Audience

1.  Stephen Orgel, *The Illusion of Power: Political Theater in the English Renaissance* (1975), 2.

2.  I have previously referenced Robert C. Allen, on movies and vaudeville, and Charlotte Herzog on circus and traveling shows. See also Charles Musser, with Carol Nelson, *High-Class Motion Pictures: Lyman H. Howe and the Forgotten Era of Traveling Exhibition, 1880–1920* (1991).

3.  "Longest Projection in the World," *MPW*, June 27, 1914, 1816.

4.  Allen, *Vaudeville and Film*, 325. Similarly, Charlotte Herzog's statement that "the vaudeville theater made a significant contribution to the architectural style of the nickelodeon" (22) would not apply to the store theater, but tautologically to the vaudeville-theater-turned-nickelodeon (Herzog, "The Archaeology of Cinema Architecture," 11–32).

5.  Allen, "Motion Picture Exhibition in Manhattan, 1906–1912: Beyond the Nickelodeon," *Cinema Journal* 18.2 (Spring 1979): 10.

6.  Since, as has often been noted, the term "feature," as it emerged from the store theater period, often signified quality rather than length, I have opted here to use the term "feature-length." Because a vaudeville-style program would effectively limit the length of each "act" for the sake of overall variety, the programming strategies of small-time vaudeville would hardly encourage feature-length production. I address this issue more fully later in this chapter in the section, "The Vaudeville Legacy and the Variety Debate."

7.  In tracing his straight line from small-time vaudeville to the movie palace, Allen briefly mentions the legitimate theater as a site for feature exhibition, but overlooks the systematic role these theaters played in the development of the feature-length film.

8.  Allen, *Vaudeville and Film*, 231–32.

9.  Irvin R. Glazer, *Philadelphia Theaters: A Pictorial Architectural History* (1994), 5.

10. Irvin R. Glazer, *Philadelphia Theaters, A–Z: A Comprehensive Record of 813 Theatres Constructed Since 1724* (1986), 183.

11. Allowing 3 feet for each row, a standard figure in this period, would result in a depth of 141 feet, with the likelihood of some standing room space behind the last row adding to the depth.

12. Oddly, while the biggest opera houses had distances of a bit over 100 feet, the second longest was not a tiered horseshoe theater at all, and in fact had its seating all on one level: Warner's Bayreuth Festspielhaus at 108 feet, 3 inches. The only greater distance was the People's Theatre at Worms, which Edwin O. Sachs writes was directly influenced by Bayreuth, but "only to a limited degree," using something of a modified horseshoe. Sachs, *Modern Opera Houses and Theatres*, 1:29–32.

13. Nathan Myers, "Architecture and Construction," *MPN*, Apr. 18, 1914, 27.

14. "Million-Dollar Theatre Opens," *MPN*, Apr. 18, 1914, 23. I list the capacity as approximate because there were somewhat different claims in contemporary reports, ranging from over 3,000 up to 3,500. A 1913 floor plan by Thomas Lamb lists the capacity as 2,979, but I could not determine if this represented what was on the final blueprint. Another floor plan from the early 1920s shows the addition of seats to the back of the orchestra, which possibly accounts for the higher capacity in later theater directories, such as those published by the Film Daily Year Book. These floor plans are held in the Thomas W. Lamb architectural records, Dept. of Drawings and Archives, Avery Architectural and Fine Arts Library, Columbia University.

15. Measurements here are approximate because they are based on architectural plans published in *American Architect* that do not indicate specific distances. Because the external dimensions of 155 feet by 277 feet were published (the remaining space taken up with stores and offices), it is possible to establish a scale for other spaces in the building. The orchestra was 112 feet wide for only about two-thirds of its depth since the seating area narrowed as it approached the stage. "The Strand," *American Architect* 106.2022 (Sept. 23, 1914): pl. 2. I also need to qualify the claim of a square since the space of the orchestra and the space of the balcony differed in that the balcony was built up and over a lobby area behind the orchestra. So, while the auditorium appeared square from the orchestra, the balcony pushed back a bit toward a rectangle.

16. Kinsila, "Modern Theater Construction," *MPW*, Nov. 20, 1915, 1485, and *MPW*, Dec. 25, 1915, 2348.

17. Kinsila, "Modern Theater Construction," *MPW*, Mar. 4, 1916, 1459.

18. I. T. Frary, "The Allen Theatre," *The Architectural Record* 50.5 (Nov. 1921): 359.

19. Ibid.

20. W. Stephen Bush, "Opening of the Strand," *MPW*, Apr. 18, 1914, 371.

21. With the move to frontal seating in the twentieth century, side boxes were conceived as a way of echoing the horseshoe design without having a horseshoe.

22. W. Stephen Bush, "Opening of the Strand," *MPW*, Apr. 25, 1914, 502.

23. Siry, *The Chicago Auditorium Building*, 22–24.

24. Ibid., 5. This was not a completely disinterested ambition: "Peck also envisioned access to cultural privilege as a politically effective counterweight to labor agitation and violence" (121).

25. And this rejection had more than an aesthetic purpose: "above all, the Auditorium was to be the prime symbol of Chicago's aspirations to a regionally distinctive cultural life that professed a socially inclusive, democratic character. This ideological aim compelled Adler and Sullivan to rethink conventions of nineteenth-century European and American opera houses and to create a room that was a critique of this type" (Siry, *Chicago Auditorium*, 197).

26. *The Builder*, May 23, 1865, as quoted in Mackintosh, *Architect, Actor and Audience*, 43.

27. W. Sidney Wagner, "The Stillman Theatre, Cleaveland, Ohio," *The Architectural Record* 43.4 (Apr. 1918): 307, 310.

28. Henderson, "Scenography, Stagecraft, and Architecture," 2:493.

29. The total capacity comes from a contemporary theater directory. It does not offer a breakdown by section, but a photograph allows an estimate of balcony capacity. Gus Hill, ed., *Gus Hill's National Theater Directory*, (1914), 614.

30. J. A. A., "Regent Theatre, New York City," *MPW*, Dec. 20, 1913, 1402. The Regent did not attract much attention until Samuel Rothapfel took over management in November, and subsequent commentary for the most part focused on Rothapfel's programming practices rather than the theater's architecture.

31. Seating capacities are taken from *Gus Hill's National Theatrical Directory* (1914–15).

32. Consider, for example, this description of a theater in Rochester that sounds like a smaller version of the Strand, complete with its democratizing of the distinct spaces of the theater: "The balcony is built on the new method of cantilevering that has of late years come into vogue and which makes possible the construction of a modern theatre without the use of constructive columns on the first floor; instead of the usual high ceiling on the first floor the space between the first floor and balcony has been devoted to a spacious mezzanine with larger openings from same to first floor, which give a view of the audience from the mezzanine." "Sacrificing Seating Capacity for Ideal Projection," *MPN*, Jan. 9, 1915, 98.

33. Thomas W. Lamb architectural records, Columbia University.

34. Gregory Waller discusses this practice and how it was used in limited fashion in film theaters in the small southern city of Lexington, Kentucky, as well as theaters specifically designated for a black audience. Waller, *Main Street Amusements* (1995), 161–79. The city was small enough that the problem of palace architecture with its large open balconies apparently did not arise. In *Shared Pleasures*, Douglas Gomery also mentions a separate entrance to a

blacks-only balcony in the South, a practice carried over from live theater, as well as blacks-only theaters, but does not indicate how palaces handled segregation (155–70). Matthew Bernstein, who has studied exhibition in Atlanta, however, has told me in conversation that the palaces there did have a separate entrance to an area of the balcony that was partially walled off from the rest, overtly hierarchizing the democratic space.

35.  "Million Dollar Theatre Opens," *MPN*, Apr. 18, 1914, 23.

36.  For example, a contemporary article in *American Architect*, noted, "This is a feature often prominent in Continental theatres, but rarely introduced into the plan of theatres in this country, as it absorbs large spaces that are usually demanded for seating." The Strand did, of course, have high seating capacity, but this was accomplished by the unusual depth and raking of its balcony, which then freed up space for the rotunda. By being tied directly to the balcony and serving as a transitional space from the orchestra, it departed from European opera houses. J. Victor Wilson, "Strand Theatre, New York," *American Architect* 106.2022 (Sept. 23, 1914): 184.

37.  Cornelius Ward Rapp and George Leslie Rapp were the architects for Chicago-based Balaban & Katz theaters, which were eventually acquired by Paramount.

38.  Charles A. Whittemore, "The Motion Picture Theater I. Comparison of Two Types of Plan," *Architectural Forum* 26.6 (June 1917): 174.

39.  Bush, "Opening of the Strand," *MPW*, Apr. 25, 1914, 502.

40.  Since Siry sees this as a prime impulse behind the building of the Auditorium Theatre, he provides an extensive history of class relations and particularly the importance of theater in nineteenth-century Chicago.

41.  "Crowds Flock to Strand Opening," *MPN*, Apr. 25, 1914, 18.

42.  W. Stephen Bush, "The Quest of Quality," *MPW*, Oct. 17, 1914, 308. This article is a prescient insight into inevitable conflicts between exhibitors, who depend on the regular attendance of their patrons, and the studios, which depend on regular output of product. Since *Moving Picture World* was a trade journal for exhibitors, it is hardly surprising that Bush would like to see the power residing in the hands of the exhibitor, who should have the freedom to choose product on the "open market" as a way of ensuring quality rather than having to take a "feature service," a forerunner of what would eventually be called "block booking."

43.  Bush, "Opening of the Strand," *MPW*, Apr. 25, 1914, 502.

44.  "Crowds Flock to Strand Opening," *MPN*, Apr. 25, 1914, 18.

45.  W. Stephen Bush, "A National Moving Picture Theater," *MPW*, Aug. 8, 1914, 809.

46.  Kinsila, "Modern Theater Construction," *MPW*, Oct. 16, 1915, 417.

47.  Quoted in Kathryn H. Fuller, *At the Picture Show: Small-Town Audiences and the Creation of Movie Fan Culture* (1996). Fuller provides a useful discussion of the importance of the Strand and other urban palaces to small-town exhi-

bition. Fuller mistakenly identifies Paramount as part-owner of the Strand; the fact that Paramount did not own it but nonetheless featured it in advertising points to its importance for national exhibition.

48. "The Moving Picture Theatre," *Architecture and Building* 43.8 (May 1911): 319.

49. George K. Spoor, "Value of Short Length Subject—The Feature: Its Use and Abuse," *EH*, July 15, 1916, 47.

50. "Achievements of 'Nineteen-Eleven,'" *MPW*, Jan. 13, 1912, 106.

51. Alfred H. Saunders, "A Forecast," *Moving Picture News*, Jan. 4, 1913, 6. This article appeared about ten months before the journal changed its name to *Motion Picture News* (see chapter 6).

52. "Facts and Comment," *MPW*, Dec. 25, 1915, 2329.

53. Michael Quinn "Distribution, the Transient Audience, and the Transition to the Feature Film," *Cinema Journal* 40.2 (Winter 2001): 40.

54. Indeed, at least four different distributors provided films for the opening of the Strand, something that would be very unlikely only a decade later.

55. The *New York Times* quotation is from April 12, 1914. The others are from *MPW*, April 25, 1914. Because the official program for the opening did not list all the entertainments, the description of the program is a composite, drawn from coverage in the *Times* and the trade press. The only thing missing from this list that would become standard in later palace programs up through the 1950s is the short animated film, but even this early Rothapfel was taking note of animation's possibilities, noting the "comic cartoon, which has lately come into vogue, is another gain for variety on the program." "The Art of Exhibition," 324.

56. "The Art of Exhibition," 324 (emphasis added). In the course of the interview, Rothapfel does note, "I realize, though, that the film of greater length, or if you will, the feature, has come to stay, but I think it will be materially shortened in the future." Rothapfel's programming strategy was a key factor in determining the length of the feature.

57. According to an article on the opening, the Strand was "originally intended to be a home for big musical productions at popular prices." "New Strand Opens; Biggest of Movies," *NYT*, Apr. 12, 1914, sec. 3, 15.

58. William N. Selig, "Present Day Trend in Film Lengths," *MPW*, July 11, 1914, 181.

59. Carl Laemmle, "Doom of Long Features Predicted," *MPW*, July 11, 1914, 185.

60. Spoor, "Value of Short Length Subject," *EH*, July 15, 1916, 47.

61. W. Stephen Bush, "Is the 'Nickel Show' on the Wane?" *MPW*, Feb. 28, 1914, 1065. Rick Altman has proposed seeing Hollywood genres as inherently mixed forms. Might we consider the variety aesthetic as one reason for this? Altman, *Film/Genre* (1999).

62. "Weak Spots in a Strong Business—VII," *MPN*, Mar. 20, 1915, 33.

63. "San Francisco Greets Two Eastern Showmen Heartily," *MPW*, Jan. 4, 1919, 48.

64. "Weak Spots in a Strong Business—VII," 33. It is worth noting that Plimpton's comments begin with a strong defense of the short film not just as an element in palace programming, but also for the "smaller exhibitor," who would show nothing but short films, an exhibitor who would in fact no longer exist by the end of the decade. My calculation, following F. H. Richardson, is based on a running time of 18 minutes for each reel: "Twenty-five minutes is the extreme limit of time for 1,000 feet of film. Fifteen to twenty minutes is ordinary time for most subjects, and only once in a great while will you get a thousand foot film that may be run in less than fifteen minutes—none more than one minute less. Ordinary time for ordinary reels of film is about eighteen minutes." Richardson, "Plain Talk to Theatre Managers and Operators— Ch. XV, Speed," *MPW*, Aug. 21, 1909, 249.

65. In the article Plimpton specifically dismisses the absence of dialogue as a reason for shorter running times. Seemingly, for him, the causation is external, the need to allow time for other elements in the program.

66. "Crowds Flock to Strand Opening," *MPN*, Apr. 25, 1914, 18.

67. "Booming the Feature Film," *MPN*, Jan. 17, 1914, 32.

68. "Is the Short Length Film Doomed?" *MPN*, Oct. 25, 1913, 14.

69. "Public Wants Larger Films, Says David Horsley," *EH*, Jan 15, 1916, 28.

70. Richard Koszarski describes both practices in *An Evening's Entertainment: The Age of the Silent Feature Picture, 1921–1928* (1990), 53–59.

71. W. Stephen Bush, "The Regular Program," *MPW*, Sept. 5, 1914, 1345.

72. Selig, "Present Day Trend in Film Lengths," *MPW*, July 11, 1914, 180.

73. One of the earliest calls for different kinds of theaters, a 1910 article in *The Nickelodeon*, still assumes a variety format of short films interspersed with musical entertainment. It is only the quality of the films that calls for the different architectural spaces. (H. I. Dillenback, "Looking Into the Future," *The Nickelodeon*, Mar. 15, 1910, 143–44.) By 1914, calls for theater classification became more common in the trade press for a simple reason: the emergence of the feature-length film provided a rationale rooted entirely in an emerging difference in production.

74. W. Stephen Bush, "Gradations in Service," *MPW*, May 2, 1914, 645.

75. W. Stephen Bush, "The Single Reel—II," *MPW*, July 4, 1914, 36 (emphasis added). It seems likely that Bush's change of opinion derived from a simple fact: "We cannot close our eyes to the fact that theaters with small capacity using mostly single reels are going out of business all around us."

## 4. Elite Taste in a Mass Medium

1. "Film Drama Supreme in New Orleans," *MPN*, Aug. 8, 1914, 14.

2. John J. Coleman, "The Ultimate Triumph of the Single Reel Production," *MPW*, Oct. 17, 1914, 325 (emphasis added). Coleman, a writer and director of

single-reel films, offered this observation with some misgiving, as he did not think the move to features was an entirely good thing.

3. Hugh Hoffman, "The Father of the Feature," *MPW*, July 11, 1914, 272.

4. "George Kleine's Production 'Quo Vadis,'" *MPN*, June 7, 1913, 13 (emphasis added).

5. Bernheim, *The Business of the Theatre: An Economic History of the American Theatre, 1750–1932* (1964), 10; first published in *Equity* (July 1930–Feb. 1932).

6. Ibid., 35–37. Twice at this point in his discussion Bernheim compares theater circuits to chain stores. Writing for an audience that has witnessed the explosive growth of the chain store over the previous decade, Bernheim clearly intends this as no more than a suggestive analogy, for in each instance he goes on to specify how theater circuits were not like chain stores.

Not so film historian Douglas Gomery, who applies the analogy to movie theaters and treats it as explanatory argument. Based on Gomery's discussion, the claim that movie theater circuits utilized chain store strategies has become a sufficiently common assumption in film studies such that a detailed refutation is required here. First of all, Gomery's primary source, *The Visible Hand* by Alfred D. Chandler, Jr. (1977), establishes a model that is somewhat different from what Gomery presents. For Chandler, whose discussion appears in a chapter on "Mass Distribution," chain store organization is centered on how to distribute a variety of products across a variety of outlets within a given region. This in itself should suggest why the analogy doesn't work: most obviously, chain stores sold products manufactured by other companies even when they might use their own label, while owners of both legitimate theater circuits and big movie theater circuits also functioned as producers. Second, Gomery is quite willing to adjust historical facts to fit his argument. In an earlier article ("The Movies Become Big Business: Publix Theatres and the Chain Store Strategy," *Cinema Journal* 18.2 [Spring 1979]: 26–40), Gomery writes, accurately, "During the 1920s chain stores became a significant force in the U.S. economy," providing details of chain store growth in that decade (26). In *Shared Pleasures*, he repeats the bulk of this article, but adds a discussion of two theater circuits from over a decade earlier, which problematizes the causal claim he seeks. His solution is to adjust the time frame: "In the latter part of the nineteenth century and during the first two decades of the twentieth century the United States economy was altered by the innovations of national wholesaling and chain store retailing" (*Shared Pleasures*, 35). Finally, Gomery's argument often doesn't make sense in its own terms. Consider the following example of "scientific management": "as A&P grew to become the dominant grocery chain, it could seek and secure discounts from its suppliers, be they farmers or mass producers of household items. A&P would buy in bulk at lower-than-normal unit prices. . . . Movie chains would do the same by booking theaters with the same films" (ibid., 35–36). The analogy

between buying in bulk and booking theaters is at best forced, at worst absurd.

Perhaps a contemporary observer from the period of chain store growth can supply the best response; a 1928 *Motion Picture News* editorial specifically rejected this analogy: "Chain stores have proven very successful but are utterly unlike chain theatres. They deal in an inanimate product which is sold almost entirely on the basis of bargaining. You don't sell bargains in picture theatres, but you do sell service to the public" (William A. Johnson, "Editorial," *MPN*, June 16, 1928, 2010). Ultimately, I think the strongest refutation of the chain store analogy is, following Occam's razor, the simplest: since film practitioners saw themselves as the successor to legitimate theater, why should they look elsewhere for a model? They had one at hand, and they made use of it.

7.  "Little Items Gathered in the East," *The Nickelodeon*, Apr. 1, 1910, 172. Richard Abel cites part of this quote as evidence of the chain store influence, in spite of the insistent use of the word "syndicate" here. Abel, *Americanizing the Movies and "Movie-Mad" Audiences, 1910–1914* (2006), 282.

8.  "From the spring of 1909, for about three or four years, the wars between the Shuberts and the Syndicate was at its fiercest" (Bernheim, *Business*, 70).

9.  Quinn, "Early Feature Film Distribution," 141.

10. Richard Abel claims a run-clearance-zone "system innovated by General Film" in the nickelodeon period, but if Quinn is correct, it might be more accurate to say that both this and Paramount's practice had their roots in legitimate theater. See Abel *Americanizing*, 47–48.

11. "Paramount Pictures Corporation," *MPW*, July 11, 1914, 264. Tellingly, this economic motivation was cast as a quality issue, as W. W. Hodkinson, president of Paramount, noted: "Under our system of handling features of merit the producer will, to a very large extent, participate in the actual profits of his productions. These profits will be in proportion to his quality. Can you imagine a greater incentive to a capable and ambitious producer? You see it is in the very nature of our plan to force quality."

12. "Paramount in Combine with Klaw & Erlanger," *Exhibitors Film Exchange*, Nov. 6, 1915, 3.

13. "Shuberts and World Film in Big Deal," *MPW*, June 20, 1914, 1700.

14. "Vitagraph Leases Broadway Theatre," *MPN*, Nov. 15, 1913, 17. This did not mean only Klaw and Erlanger, since it was announced early on that Marcus Loew would subscribe to service from a combine of Biograph and Klaw and Erlanger ("Biograph Company and Klaw & Erlanger to Combine and Form the Protective Film Company," *Moving Picture News*, June 21, 1913). But the connection with a major legitimate theater chain could help open doors to other venues. Loew, however, would mean small-time vaudeville, which suggests that Biograph did not conceive of the feature film in the same terms as Para-

mount, and this perhaps finally doomed Biograph's efforts to enter into feature production.

15. Frick, "A Changing Theatre: New York and Beyond," in Wilmeth and Bigsby 2:198.

16. In a discussion of the decline of the road in the teens, theater historian Jack Poggi notes: "the critics (notably Walter Prichard Eaton) blamed the producers for lowering standards and exploiting the public by misleading advertising. In one New England town, Eaton wrote, a musical comedy advertised as a 'second company' arrived with six musicians, shabby scenery, poor actors, and worse singers." Jack Poggi, *Theater in America: The Impact of Economic Forces, 1870–1967* (1968), 33–34.

17. The need to send out a set for a performance taking place on film might seem the oddest feature of these companies. This is an issue I will look at more fully in the next chapter.

18. "'Big Parade' Breaks Long Run Record," *MPN*, Jan. 28, 1927, 293.

19. "Belasco and the Famous Players," *MPN*, May 10, 1913, 141. An article on the formation of Paramount Pictures the following year showed the advantage of movies by contrasting two imaginary announcements: "ANY LEGITIMATE THEATER Broadway, New York City Any Date First Performance 'HIS MASTERPIECE' by David Belasco All-star cast.——ANY PICTURE THEATER New York or Elsewhere (Same date as above) First Presentation 'HIS MASTERPIECE' by David Belasco Original Cast and Production." "Paramount Pictures Corporation," *MPW*, July 11, 1914, 264.

20. See Poggi, *Theater in America*, 28–45.

21. "Booming the Feature Film," *MPN*, Jan. 17, 1914, 32.

22. *MPW*, Mar. 21, 1914, 1602. Eventually a Los Angeles showing would achieve an importance second only to New York because of the national attention that a Hollywood premiere could garnish. Still, advertising in the trade press was always more likely to refer to a Broadway run of a film rather than Los Angeles.

23. *MPN* published subsequent surveys of smaller cities and towns, but this first one in many ways was most significant because it would include all first-run theaters, which generated the most income for the producing companies. J. S. Dickerson, "21,766,366 Weekly Attendance in Key Cities," *MPN*, Nov. 6, 1926, 1751. The date is also worth noting because both the Times Square Paramount and the Roxy opened after this survey was taken. That is to say, there was a great deal of very large palace-building that followed the survey, which suggests that weekly attendance figures by the end of the decade could well have gone a good deal higher.

24. Although he does not seem aware of the marked difference in the size of the New York City audience, Robert Sklar argues that performance at the weekly-change movie palaces affiliated with the major studios by the 1930s was crucial

for a film's exploitation in the rest of the country. In a case study of the Strand, Warner Bros.'s Broadway palace, in the mid-1930s, he cites a key reason: "the Strand's weekly grosses seem to predict, in a strikingly stable way, final domestic rental income" (201). Sklar's focus is chiefly on palace showings, which leads him to minimize the continuing importance at the time of long-run exhibition, which I discuss below. Sklar, "Hub of the System: New York's Strand Theater and the Paramount Case," *Film History* 6.2 (Summer 1994): 197–205.

25. For a brief overview on how the shift away from the tiered exhibition system related to changes in production, see William Paul, "The K-Mart Audience at the Mall Movies," *Film History* 6.4 (Winter 1994): 487–501.

26. "Future of Moving Pictures," *MPW*, June 18, 1910, 1044 (emphasis added). The article is listed as "By Daniel Frohman, in the New York 'Sun,'" but it is not actually authored by him; rather, it contains extensive quotations from an interview. Not everyone agreed with Frohman at this point. A 1911 *Moving Picture World* article, written as "The Italian films are just beginning to arrive in this country, and they are creating a furore [*sic*]," claimed that the great increase in the number of movie theaters had not "reduce[d] the patronage extended to the higher priced stage offerings." "The Ever Potent Moving Picture," *MPW*, Sept. 2, 1911, 612.

27. Bernheim provides a chart with the number of road shows on tour for the first week in April and the first week in December; the numbers presented here are his averages for April and December (75). I should note that Bernheim does *not* grant motion pictures the primary role in the decline. In a very nuanced history, he outlines a number of internal reasons for the decline, reasons that should not be ignored. But Bernheim does tend to treat movies monolithically, overlooking the great changes in film exhibition taking place in this period. I suspect the two stages of decline reflect those changes. The first stage coincides not just with roadshow exhibition of big features, but also with Robert Allen's timeline for the ascent of small-time vaudeville as a key venue for film exhibition, an exhibition strategy that did convert many existing theaters into movie theaters. (See Allen, *Vaudeville*, 230 ff.) And, of course, the second, more dramatic fall coincides with the rise of the feature film not just in roadshow exhibition, but also in the palaces that begin being built around the same time.

Perhaps the most dramatic evidence for the impact of the feature film on legitimate theater can be found by setting Bernheim's chart against charts documenting the increase in feature film production through the teens provided by Ben Singer in "Feature Films, Variety Programs and the Crisis of the Small Exhibitor," in Charlie Keil and Shelley Stamp, eds., *American Cinema's Transitional Era: Audiences, Institutions, Practices* (2004), 79–83. The year 1920 represents the lowest point in this period for legitimate theater, perhaps a con-

sequence of the new excitement the feature film is generating. After that, the number of touring shows throughout the 1920s hovers around the seventies.

28. Frank E. Woods, "What Are We Coming To?" *MPW*, July 18, 1914, 442.

29. Quoted in "Film Drama Supreme in New Orleans," *MPN*, Aug. 8, 1914.

30. Poggi, *Theater in America*, 35.

31. "William A. Brady on 'Films and the Stage,'" *EH*, Jan. 8, 1916, 16.

32. This is not to say that all of these theaters were used solely for feature films. It was not unusual for some to adopt a small-time vaudeville program or a program of short films. But venues that wanted to present themselves as first-class were more likely to gravitate toward the feature film.

33. The kind of theater determining a zone more than geography led to a striking oddity when most of the live-performance theaters that lined 42nd Street between Seventh and Eighth Avenues were converted to movies houses. Construed as a separate zone, these theaters showed movies in second-run that had recently played around the corner at nearby palaces. Given the extended-run strategy described below, it became possible for a movie to go from a pre-release booking to a palace showing and then into a neighborhood theater without ever leaving Times Square.

34. "New Blood in New Programs," *MPW*, June 6, 1914, 1394.

35. Rothapfel, quoted in James S. McQuade, "The Rothapfel-Mutual Tour Banquet," *MPW*, Nov. 27, 1915, 1645.

36. "P. A. Powers to Provide Exclusive Films," *MPN*, Aug. 9, 1913, 15.

37. "Warner's Features, Inc.," *MPW*, July 11, 1914, 262.

38. "This significant development gives the Mutual a total of six multiple reel feature releases a week—the greatest feature output of any releasing organization in the world today." "Mutual Bids for Dominant Place in Film World," *EH*, Dec. 18, 1915, 3.

39. W. Stephen Bush, "Stop the Vandals," *MPW*, Nov. 28, 1914, 1210. Since "nickelodeon" did not signify size, capacity should not be seen as a factor in this rule.

40. "Picture Theatres and Others," *MPN*, Dec. 20, 1913, 18.

41. Quigley, "Made-in-America Films," *Exhibitors Film Exchange*, Oct. 23, 1915, 10.

42. "Manufacturers as Exhibitors," *Moving Picture News*, Sept. 27, 1913, 30.

43. "The Candler Opens with a Fine Film," *NYT*, May 8, 1914, 13.

44. Edward Bernard Kinsila, "Modern Theater Construction," *MPW*, Oct. 16, 1915, 417.

45. "'Spartacus' at the Auditorium," *MPW*, May 23, 1914, 1121.

46. Horace G. Plimpton, "The Development of the Motion Picture," *MPW*, July 11, 1914, 197.

47. "Picturizing Broadway," *MPN*, Jan. 2, 1914, 18.

48. Advertisement in *NYT*, May 14, 1914, 20.

49. "Motion Picture Criticism," *EH*, Nov. 13, 1915, 10 (emphasis added).

50. Here are a couple of other examples connecting dignity to the feature film. The president of the William L. Sherry Film Company noted "the big features have done more to increase the high-class patronage of the motion picture theatre than any other single agency. A conservative estimate would credit them with a fifty per cent increase as to quantity and a far greater average with reference to dignity of the industry." (William L. Sherry, "Do Features Pay?," *MPN*, Mar. 21, 1914, 19. Sherry is billed as a "state-rights feature buyer.")

    Adolph Zukor, the founder of Famous Players, the first company devoted exclusively to feature film production, stressed "the necessity and advisability of connecting with one of the foremost legitimate producers [i.e., Daniel Frohman]." Zukor claimed his Famous Players strategy of high-class features had the "primary power to elevate the motion picture to a dignity and distinction hitherto unhoped for and a stage equal to *the better element* of the legitimate drama"("Adolph Zukor, the Benefactor of Posterity!" *Moving Picture News*, Jan. 25, 1913, 14–15; emphasis added). In all these cases, "dignity" is specifically connected to legitimate theater/drama, a connection which made the venue itself of greatest importance.

51. Adolph Zukor, with Dale Kramer, *The Public Is Never Wrong* (1953), 11.

52. The connection between the feature and the upper classes was repeatedly stressed in the trade press. In a 1914 interview, feature producer Jesse L. Lasky stated, "Features, to my mind, proffer a concrete, lasting future in that, within their short year of existence, they have accomplished what the 'one-real' [sic] subjects failed to attain in fifteen years, viz., to interest the classes" (Jesse L. Lasky, "Accomplishments of the Feature," *MPW*, July 11, 1914, 214). A *Motion Picture News* editorial the same year claimed that features appealed to the "well-to-do classes" ("Keep the Feature Above Reproach!" *MPN*, Mar. 21, 1914, 34).

53. As noted in my discussion of the investor's desires for the Chicago Auditorium Theatre, the ambition for uplift was not unknown in the late-nineteenth-century theaters. But theater could never afford to charge so little for its product as motion picture producers could in the late stages of a film's run.

54. "Film Company Gets Criterion Theatre," *NYT*, Nov. 3, 1913, 9. Vitagraph apparently was forthright in its purpose for the theater, since almost precisely the same language appears in a trade press report which noted that Vitagraph intended "to use the house as a sort of an advertising venture for the films of the producing company." For a contemporary audience, the article suggested the prestige of the venue by noting the timing of the premiere: the Vitagraph would follow the run of David Belasco's latest play. "Vitagraph Leases Broadway Theatre," *MPN*, Nov. 15, 1913, 17.

55. "Vitagraph Picture Theater," *MPW*, Feb. 14, 1914, 786.

56. Wm. A. Johnston, "A New Departure," *MPN*, Feb. 21, 1914, 13.

57. Advertisement in *MPW*, Mar. 7, 1914, 1281.

58. "Vitagraph Picture Theater," *MPW*, Feb. 14, 1914, 787.

59. "Vitagraph Theater Changes Bill," *MPW*, Aug. 22, 1914, 1085. This was, of course, not unlike the short at the opening of the Strand that showed the Strand itself. The key difference here was that the Strand's short promoted the individual theater, while the self-reflexive gestures in the Vitagraph show were to promote the studio and, most importantly, its feature film output.

60. George Blaisdell, "Vitagraph Company Not Exhibiting," *MPW*, Apr. 11, 1914, 192. One of the most insistent statements throughout this article is that Vitagraph does not intend to compete with other exhibitors, that the theater is there to help exhibitors. The theater could operate for Vitagraph like the legitimate theater in one other way: how the film worked in its New York showing could lead to editing, additional scenes being shot, or changed intertitles before the film was put into general release. In fact, *The Wreck* was re-released in 1919 with additional footage shot to bring it up to the then standard five-reel length and presumably make good on its initial financial failure. *The American Film Institute Catalog of Motion Pictures Produced in the United States: Feature Films, 1911–1920*, vol. F1 (1988), 1072.

61. Vitagraph was actually behind the curve in not realizing the potential for expansion this theater offered: "This theatre may prove the entering wedge in realizing that long-cherished dream of many motion-picture producers and theatrical firms—the alliance of a picture company and a chain of theatres." Wm. A. Johnston, "A New Departure," *MPN*, Feb. 21, 1914, 13. This would, of course, become the primary means by which the largest production companies established their dominance in the 1920s.

62. The only other discussion I have found of this bifurcation is in Sheldon Hall and Steve Neale, *Epics, Spectacles, and Blockbusters: A Hollywood History* (2010), 41–61, but the presentation is fairly garbled because they are unaware of the connection between the combination system and roadshow exhibition, they ignore different levels in A-list production, and they do not distinguish between extended-run/reserved-seat and extended-run/grind or pre-release films and programmers. Particularly off-base is the claim that "in the 1920s . . . the major companies began to provide premiere runs at higher prices on Broadway for nearly all their feature productions" (44). This essentially collapses the differentiation in features that was central to studio production policies, most importantly the opposition between specials and programmers. Finally, the claim of a "standardization of exhibition" (96) ignores the continuing use of pre-release exhibition into the 1950s.

63. "Discussion of 'Longer Runs,'" *EH*, Nov. 20, 1915, 19.

64. Vidor, *King Vidor: A Tree Is a Tree* (1953), 111.

65. *NYT* ad for *The Crowd*, Feb. 25, 1928, 11.

66. John Frick reports on a production of *Uncle Tom's Cabin* playing 100 performances in Troy, New York, in 1852. The production then moved to New York City and played 300 consecutive performances from 1853 to 1854. Frick, "A Changing Theatre," 199–200.

67. *NYT*, advertisement for *The Big Parade*, May 29, 1927, sec. 7, 3.

68. *NYT*, Aug. 19, 1925, 14. Even in the unlikely event that Gould had personally selected the film, she did not exactly have a free hand. As a Loew's house, the Embassy limited its fare to MGM films, and, inevitably, some of the studio's biggest-budgeted films of the year. As a way of bolstering the exclusivity of the films, the theater was never billed as Loew's; rather in its initial showings, advertisements listed it as Gloria Gould's Embassy Theatre. Even a *New York Times* article on the opening of the theater made no mention of Loew's. "Embassy Theatre to Open," *NYT*, Aug. 23, 1925, sec. 7, 3.

69. *NYT*, Sept. 8, 1925, 28.

70. A 1926 *Film Daily* article on "road shows" states the following: "It concentrates entirely on the production being shown without interpolation of news reels, comedy, educational, prologue or variety act." *FD*, Aug. 1, 1926, 4.

71. *Var.*, Aug. 22, 1928, 10.

72. *Var.*, Nov. 27, 1929, 8.

73. "Paramount's 3d Run House," *Var.*, June 23, 1926, 8. See chapter 6 for a discussion of the screen at the Rivoli.

74. As a way of presenting a more nuanced view of the transition to the feature film, Ben Brewster proposes that "short film cinema and feature cinema in the early 1910s were essentially parallel institutions." But the development of the extended-run theater suggests another way of looking at this: while there was a period of overlap, the presentation house was an evolution out of the nickelodeon, also with its roots in vaudeville, while the extended-run theater, with its roots in the legitimate theater, was the parallel institution to both nickelodeon and palace. Brewster, "Periodization of Early Cinema," in Keil and Stamp, 74.

75. "Roxy Theatre Added to Fox Chain," *MPN*, Apr. 8, 1927, 1254.

76. *MPW*, Apr. 4, 1925, 442.

77. In addition to these alignments, New York offered so many theaters that it was always possible to lease one for a specific film. So, for example, during the almost two-year run of *The Big Parade*, the two reserved-seat theaters MGM regularly used were not sufficient, and so it had to lease legitimate theaters, having as many as four road shows running simultaneously in this period.

78. "Schenck Organizes Film Theatre Chain," *NYT*, May 24, 1926, 24. Joseph Schenck, chairman of United Artists' board, made a precise distinction: "This does not mean in any sense of the term that we are building first run houses. The term 'pre-release' simply means that instead of hiring a legitimate theater . . . we shall first show the films simultaneously in the theaters of the new circuit. In a word, establishment of pre-release motion picture theaters means substitution of our own theaters for special legitimate houses." "United Artists Enters Exhibition; 20 Key City Pre-Release Houses," *FD*, May 24, 1926. It should be noted that Schenck specifically opposes pre-release theaters to "first run houses." The new chain would soon lead to U.A. taking over half ownership with Paramount of the New York Rivoli, which, as discussed earlier in the text, Paramount had made an extended-run theater in 1926, the same year Schenck proposed the pre-release circuit.

79. " 'U' Road Shows 'All Quiet' in Shubert Houses," *MPN*, May 24, 1930, 81. Reserved-seat engagements of this film were already under way in New York, Los Angeles, San Francisco, Detroit, and Baltimore, all big enough cities for Universal to have been able to make arrangements on its own. But box office warranted expanding the reserved-seat range, and for that it needed legitimate theaters. This article specifies that the film will have a $2 top at all houses.

80. After its first two feature films, when Famous Players needed to regularize output in order to be assured of access to appropriate theaters, "To produce sufficient films, Famous Players developed a new production strategy known as the 'Thirty Famous Features a Year' program and divided its productions into A, B, and C classes; with the original goal of producing theatrical adaptations [applying] only to films in the A class. . . . Famous Players' new program set in motion the firms' transition to what *Motion Picture World* called 'regular features.' No longer was each Famous Players film an adaptation of a major play with a major stage star, making it a special event. The company also produced a number of films with limited budgets, lesser known stars, and original scenarios, all in less time." Notably, "theatrical adaptations" signified the highest level of production, that is, the kinds of films that would play in legitimate theaters, not the vaudeville-style palaces. Quinn, "Distribution," 50.

81. "Schedules Tend to 'Programs': PFL Shooting Seven; M-G-M Six," *EHW*, Mar. 17, 1928, 27.

82. *MPN*, Nov. 20, 1926, 1933.

83. It might be possible to claim this for *Sunrise* as well since Donald Crafton has detailed how the long run in New York was actually manufactured by Fox and not warranted by actual attendance. Crafton, *The Talkies: American Cinema's Transition to Sound, 1926–1931* (1997), 425–528. The *Life Begins* example suggests there might be another way of looking at this, namely, that *Sunrise* did in fact live up to what the advertising promised, as the critics' response indicated.

This alone might have been reason to manufacture the run, even at a loss to the studio, since there could be a payoff down the road, as Crafton seems to acknowledge with a successful run in its subsequent Los Angeles engagement. But by 1928, this was already an established practice in motion picture exhibition, as I had pointed out in my discussion of the Vitagraph Theatre, and one that explicitly followed the practice from the legitimate theater: be willing to take a loss on the New York engagement in order to increase profits in subsequent exhibition.

84. *Life Begins* advertisement, *NYT*, Sept. 6, 1932, 15.

85. *NYT*, Feb. 24, 1928, 14.

86. "Roxy Did $29,463 on Holiday," *Var.*, Feb. 29, 1928, 7.

87. "When we go all through running 'The Cockeyed World' and using a very short magazine [i.e., newsreel] we found we had four minutes left for entertainment. We had to use a big symphony orchestra, a line group, and principals in four minutes. We got away with it." "Stage Shows in Picture Theatres Out, Says Roxy," *MPN*, July 12, 1930, 51.

88. David Bordwell, *Narration in the Fiction Film* (1985), 160. See also Bordwell, "The Classical Hollywood Style," in Bordwell, Janet Staiger, and Kristin Thompson, *The Classical Hollywood Cinema: Film Style and Mode of Production to 1960* (1985), 25 ff.

89. Sennwald, "Two for the Price of One," *NYT*, Sept. 15, 1935, sec. 9, 3.

90. "Producer Says Crisis Faces Film Industry," *NYT*, May 8, 1940, 29.

91. Ferguson, "Weep No More, My Ladies." The article on double features and block booking originally ran in *The New Republic* (June 3, 1940); reprinted in Ferguson, *The Film Criticism of Otis Ferguson*, ed. and with a Preface by Robert Wilson (1971), 298.

92. Of the palace-owning companies with road shows in smaller theaters, MGM had three (not an unusual situation for MGM in this period), Warner Bros. had two, Fox had one, and Paramount had one. In addition, Paramount had two films at extended-run grind theaters. Of the remaining roadshow bookings, United Artists had two, while Universal, First National, Pathé, and Sono-Art each had one. "13 Films on B'Way at $2."

93. This is not to say there was no more building in this period, most significantly in 1932, with Radio City Music Hall and its sister theater, the RKO Roxy, which might be fairly described as the last two palaces. Subsequent theater-building in the 1930s and 1940s tended to be smaller neighborhood theaters or, especially after the war, small theaters for art films.

94. Warner Bros. did run a four-page advertisement in *Film Daily* with the headline "Profits, the Final Consideration!" and then listed the attendance figures for nine cities with extended-run presentations, the larger cities with a $2 top,

the smaller cities at $1.50. It is not surprising that both New York (listed first) and Chicago (slightly higher) had over a half million customers. But there were also 110,000 patrons listed for Bridgeport, Connecticut, a city with a population of 146,716 in 1930 (www.ct.gov/ecd/cwp/view.asp?a=1106&q=250674), with the advertisement boasting more patrons to come: "Still going strong." *FD*, Feb. 27, 1927, 6. There is some uncertainty about whether the film was run road show or grind; Crafton claims grind (*The Talkies*, 82), but the prices listed in this advertisement suggest road show.

95. "Stage Shows in Picture Theatres Out, Says Roxy," *MPN*, July 12, 1930, 51.
96. "Expansion of Short Subjects Indicates a Limitless Field," *FD*, May 30, 1926, 4–5.
97. Susan Ohmer provides a well-researched overview of the growth of the double bill, the debates around the practice, and the polling on it in. Ohmer, *George Gallup in Hollywood* (2006), 91–119.
98. "'Presentation' Making Films Chasers for Vaudeville," *MPN*, Dec. 2, 1927, 1697.
99. "Double-Featuring Reaching Alarming Proportions and Crowding Out Shorts," *MPN*, Nov. 15, 1930, 35.
100. In a 1943 article, Frank S. Nugent directly connected the double bill to vaudeville: "Historically movies killed vaudeville; and vaudeville, from its death bed, put the curse of double features on the nation." Nugent, "Double, Double, Toil and Trouble," *NYT Magazine*, Jan. 17, 1943, 11. Furthermore, in her study of double feature exhibition in the 1940s, Janet Staiger establishes that variety was the primary attraction not just for patrons, but also for exhibitors: "the double-billing policies and frequent program changes in most subsequent run-theaters offered variety of a different sort—variety in terms of the sheer volume of films being booked in the local theater and the different types of films included in the programs." Staiger, "Duals, B's, and the Industry Discourse About Its Audience," in Thomas Schatz, ed., *Boom and Bust: The American Cinema in the 1940s* (1997), 76. Since neighborhood theaters generally changed their bills twice weekly, double bills would yield a crop of over 200 films per year for these theaters.
101. "Double Features," *NYT*, Apr. 16, 1933, sec. 9, 3.
102. Thomas Brady, "Hollywood Has 'Double' Trouble," *NYT*, July 7, 1940, sec. 9, 3.
103. "Battle Proposed Anti-Dual Bill Limiting Ill. Shows to 135 Mins.," *Var.*, July 12, 1939, 6.
104. Doris Lockerman, "Double Feature Ban Called Both Fine and Ruinous," *Chicago Daily Tribune*, July 2, 1939, 5; "Horner Vetoes Measure to Bar Double Movies," *Chicago Daily Tribune*, July 28, 1939, 7; "Horner Veto of Anti-Dual Bill Measure Is Upheld," *Boxoffice*, Dec. 23, 1939, 14.
105. Harold Heffernan, "Double Feature Programs Will Come to an End on First of December," *Atlanta Constitution*, Oct. 8, 1942, 18.

106. Goldwyn, quoted in A. H. Weiler, "By Way of Report," *NYT*, Feb. 11, 1945, sec. 2, 3.

107. Goldwyn, "What's the Matter with Movies?" *NYT Magazine*, Nov. 29, 1936, 7–8.

108. Goldwyn, "Hollywood Is Sick," *Saturday Evening Post*, July 13, 1940, 18–19, 44.

109. "50% of U.S. Now Dualing," *Var.*, Feb. 27, 1934; "Hollywood Is Sick," 18; Frank S. Nugent, "Double, Double, Toil and Trouble," *NYT Magazine*, Jan. 17, 1943, 11.

110. "Double-Bills Lead Here," *NYT*, June 21, 1948, 17. The article also revealed that "theatres in the New York film exchange area lead in the double-feature field, with 76.6 per cent of the houses presenting twin bills regularly." In making sense of this figure, it is worth keeping in mind that neighborhood theaters in New York greatly outnumbered first-run theaters because of the city's population, and also these theaters were often the size of palaces in most other cities, so they were more dependent on attracting capacity crowds.

111. Susan Ohmer has an excellent history of the release of *GWTW* based on archival materials. But she has one assertion worth questioning: "MGM withdrew *Gone with the Wind* from theaters in July 1940 with the intention of re-releasing it again in January 1941" (*Gallop*, 181). Factually this is not accurate since *GWTW* continued its reserved-seat engagement at the Astor into the fall, when it was finally replaced by Charles Chaplin's *The Great Dictator* in early October 1940. More pertinent to my concerns is the fact that none of the sources Ohmer draws on describe the 1941 performances of *GWTW* as a re-release because it was all part of the orchestrated initial release of the film. I mention this not to be captious, but rather to suggest how little we know of releasing strategies in this period. For example, in an article on the January 1941 engagements of *GWTW*, which Ohmer calls a "re-release" and *Film Daily* terms a "general release," it is explicitly contrasted to the road show, according to an MGM executive: "We plan to get behind the *general release* of 'Gone with the Wind' with advertising and publicity campaigns just as we would any other big picture coming out of roadshow engagements. It's still brand new to the great mass of theatergoers and it will be exploited and handled accordingly." Quoted in "May Eliminate Profit Guarantees on GWTW," *FD*, Oct. 17, 1940, 3 (emphasis added).

112. Bosley Crowther, for example, suggested that "there is always the possibility that the producer, by making long pictures, is intentionally striking a blow at double features" (Crowther, "Length Vs. Strength," *NYT*, July 14, 1940, sec. 9, 3). Furthermore, a 1944 article specified longer running times as Hollywood's deliberate strategy "for ridding the screen of double features" (Fred Stanley, "The Hollywood Slant," *NYT*, Aug. 6, 1944, sec. 2, 1). Nevertheless, as features did get longer in the 1940s, wily distributors could get around this seeming impediment by doing a reissue of two older movies and cutting both to fit in a three-hour time slot. Decades ago, I rented a 35mm print of *It's a Wonderful Life* (1946) for a class and, having assumed it was a theatrical print, was surprised to discover it missing about twenty minutes. There was noth-

ing artful about the cuts: whole sequences missing, with the deletions made obvious by abrupt termination of soundtrack music.

113. Nugent, "How Long Should a Movie Be?," *NYT Magazine*, Feb. 18, 1945, 10. As a way of driving home his point that the new lengths were unwarranted, Nugent contrasted running times of fairly routine movies from the previous year and found them close to running times from large-scale spectacle films of the 1920s.

114. Throughout the 1940s, only seventeen films opened in New York in reserved-seat engagements. Strikingly, British imports accounted for 30 percent of the reserved-seat films and more than half in the postwar period. (For the importance of British films in the postwar years, see the Conclusion.)

115. A 1949 article took note of this: ". . . during the war years when pictures enjoyed exceptionally long runs at theatres and, as a consequence, production schedules were scaled down." "'B' Pictures Facing New Hurdle?" *NYT*, Mar. 27, 1949, sec. 2, 5.

116. *NYT*, May 14, 1950, sec. 2, 3.

117. The ad also specified: "There will be no increase in prices," likely since the palace size guaranteed a high gross (advertisement, *NYT*, Sept. 24, 1950, sec. 2, 4). A subsequent advertisement offered a qualification: "When we originally announced a policy of Scheduled Performances, only Loge Tickets were placed on sale in advance." This was actually a policy long in place at Radio City Music Hall, albeit with no reserved seats elsewhere. The subsequent Roxy advertisement asserted response had been so high that all seats would be available in advance (*NYT*, Oct. 8, 1950, sec. 2, 3).

118. *NYT*, Oct. 22, 1950, sec. 2, 4.

119. "Extended Runs, B'way Showcasing Make a Nat'l Release Theoretical," *Var.*, Oct. 30, 1946, 6.

120. "'B' Pictures Facing New Hurdle?" *NYT*, Mar. 27, 1949, sec. 2, 5.

121. Goldwyn, "Hollywood in the Television Age," *NYT*, Feb. 13, 1949, 47.

122. Loew's State on Broadway, which "had advertised itself as 'the nation's leading vaudeville theatre,'" closed December 23, 1947. The article announcing the closing did note, "Vaudeville is still shown in the city on the Radio-Keith-Orpheum circuit and various neighborhood theatres on a weekly or irregular basis," but that would soon end as well. "Vaudeville Bids Broadway Adieu," *NYT*, Dec. 24, 1947, 12.

## 5. Uncanny Theater

1. "Announcement," *Moving Picture News*, Sept. 27, 1913, 15.

2. "An Acknowledgment," *MPN*, Oct. 25, 1913, 14. The change was also possibly a marketing strategy to distinguish itself from its chief competitor, *Moving Picture World*.

3. Reprinted from *The Photo-Era* (Boston) in *MPN*, Dec. 13, 1913, 22 (emphasis in original).

4. Richard D. Altick, *The Shows of London* (1978), 211–20; Erik Barnouw, *The Magician and the Cinema* (1981); Musser, *The Emergence of the Cinema*, 17–27; Crary, *Techniques of the Observer*, 132–36; and Terry Castle, *The Female Thermometer* (1995), esp. "Phantasmagoria and the Metaphorics of Modern Reverie," 140–67.

5. Gunning, "An Aesthetic of Astonishment," *Art and Text* 34 (Spring 1989): 31–36.

6. "Pepper's Ghost" is described by both Castle, *The Female Thermometer* (151; illus., 153); and Altick, *Shows*, 504–5.

7. "What Is the Kineplastikon?," *MPN*, Dec. 20, 1913, 30. "Kineplastikon" was the name for the process in Germany, where it had been developed; "Photoplast" was the name given the process by its American importer. The most detailed description of how the process works may be found in F. H. Richardson, "Projection Department," *MPW*, June 19, 1915, 1938.

8. F. H. Richardson, "Photoplast," *MPW*, Oct. 24, 1914, 494 (emphasis added). The only instance I have been able to find of this "stunt" exhibited in an actual theater was as part of a very elaborate vaudeville show that also included a feature film. This show took place at the Hippodrome, the cavernous New York theater designed for elaborate stage spectacles, but just converted to film shows as a way of improving its frequently uncertain economical status: "a new variety of film, the Kineplasticon picture, illustrating operas, while the chorus and orchestra render them in actuality." "Hippodrome Succumbs to Most Popular Amusement," *MPN*, Apr. 3, 1915, 44.

9. Joseph and Barbara Anderson have detailed the unfortunate persistence of the persistence of vision as the erroneous explanation for movement in movies in "Motion Perception in Motion Pictures," in Teresa de Lauretis and Stephen Heath, eds., *The Cinematic Apparatus* (1980), 76–95.

10. Over the history of movies, there have been various attempts to perfect shutterless projectors because they offered potentially greater screen illumination and fewer opportunities for film breakage. In 1913, the same year that *Motion Picture News* changed its name, a continuous run projector, the Vanoscope, was announced. Contemporary commentary indicates an awareness that persistence of vision was not necessary for the illusion of movement, that in fact persistence of vision necessitated by intermittent projectors was a constraint on the illusion of movement:

    In the Vanoscope the picture does not move off the screen from top to bottom, but one picture is dissolved into the other directly, thus always insuring a full picture on the screen 100 per cent of the time. Travel ghost cannot exist, as it

does not become necessary to move the picture off the screen at a speed of 16 per second or greater in order to maintain the persistence of vision. The Vanoscope projects pictures at eight per second and even slower without any visual perception of change from one picture to another. (W. F. Herzberg, "Concerning the Vanoscope," *MPN*, Dec. 27, 1913, 28)

In 1986 I saw a demonstration of a shutterless projection at a local SMPTE (Society of Motion Picture and Television Engineers) meeting in New York. While the resultant image was as good as any I have seen from a conventional projector, to my knowledge no shutterless projector has ever been employed in a commercial venue.

11. Wertheimer, cited in Joseph and Barbara Anderson, "Motion Perception," 81.

12. Hugo Münsterberg, *The Photoplay: A Psychological Study* (1916; reprinted in 1970 as *The Film: A Psychological Study*, 26–27).

13. I use the term "natural magic" deliberately here for connotations that date back at least to the Renaissance. In *The Magician and the Cinema*, Erik Barnouw discusses "the old philosophical issue between 'natural' magic—supposedly used for instructive amusement and scientific enlightenment—and exploitative magic using or claiming supernatural means, akin to sorcery and witchcraft" (107–12).

Sir David Brewster used the term in *Letters on Natural Magic* (1832) specifically to signal demystification: "The human mind is at all times fond of the marvelous. . . . When knowledge was the property of only one caste, it was by no means difficult to employ it in the subjugation of the great mass of society" (Letter I). This is an approach that already had a long history behind it; see Charles Musser's consideration of "the demystification of the projected image" in the writing of seventeenth-century scientist Athanasius Kircher (*Emergence*, 17–20).

14. "The Ontology of the Photographic Image," in André Bazin, *What Is Cinema?* vol. 1 (1967), 13.

15. Bazin's invention of the "mummy complex" as a psychoanalytic explanation of the desire for realism in art does offer a way of connecting his realistic theory to the realm of magic. I think this worth lingering over here because it does oddly echo Sigmund Freud's ideas about the uncanny that I will discuss later in this chapter. For Bazin, the plastic arts may satisfy a basic human desire embodied in the "mummy complex": "by providing a defense against the passage of time it [i.e., "the continued existence of the corporeal body"] satisfied a basic need in man, for death is but the victory of time." This then grants the "first Egyptian statue . . . a mummy" a magic function, which Bazin acknowledged. But he goes on to claim that "The evolution, side by side, of art and civilization has relieved the plastic arts of their magic role." One might say

a demystification takes place similar to the demystification of the projected image discussed in note 13. But Bazin acknowledges the demystification is never complete: "Civilization cannot, however, entirely cast out the bogy of time. It can only sublimate our concern with it to the level of rational thinking." In this notion of sublimation and the inscription of the rational over the irrational, Bazin comes strikingly close to Freud's notion of the uncanny. If Bazin himself did not recognize this, it was because he was finally more concerned with the role of realism over that of magic, but we might say that his theory of realism always allows for the return of the repressed magical. Bazin, *What Is Cinema?* 1:9–10.

16. Musser, *Emergence*, 15–22. Musser's remarks on the "demystification of the projected image" (17–19) are particularly relevant to my concerns here.

17. Lise-Lone Marker, *David Belasco: Naturalism in the American Theatre* (1975), 7.

18. Ibid., 10.

19. Ibid., 62, 61.

20. Mordercai Gorelik, *New Theatres for Old* (1940), 164–65. See also Marker, *Belasco*, 63, 141–42.

21. I think it also likely that financial considerations or space limitations of the stage could dictate a *trompe l'oeil* effect like foreshortening even for constructed environments. Still, the desire to reproduce as accurately as possible seems to dominate the period.

22. Gorelik, *New Theatres for Old*, 165.

23. "What the Motion Picture Theatre Replaces," *MPN*, Dec. 20, 1913, 28.

24. Here follows a number of random examples from trade journals writers and film practitioners of the period:

"The picture parlor of to-day is nothing more than a small theater . . . and we can go further than the setting of a drama or comedy on the stage and bring in nature's own setting and background." (William M. Hamilton, "Has the Motion Picture Business Come to Stay?" *MPW*, May 9, 1908, 412)

"The moving picture play has the whole world for its stage." (Rollin Summers, "The Moving Picture Drama and the Acted Drama," *MPW*, Sept. 19, 1908, 211)

"The greatest success of motion pictures over the regular playhouse is that they show natural scenery, real water falls, trees, gardens, etc., instead of painted scenery." (J. M. B., "The Size of the Picture," *MPW*, Mar. 11, 1911)

In an article published the same year he had begun directing feature films, Cecil B. DeMille, whose father collaborated with David Belasco and for

whom DeMille acted (Vardac, 120), compared theater and film precisely in terms of realism: " 'The scope of the photoplay,' said Mr. De Mille, 'is so much wider than that of the legitimate. We do things instead of acting them. When a big effect is necessary, such as the burning of a ship, blowing up a mine shaft, wrecking a train, destroying a block of houses, we do not have to resort to trickery. We actually do it.' " "De Mille 'Talks Shop,'" *MPW*, Aug. 29, 1914, 1244.

In an interview, Adolph Zukor spoke of the cinema's advantage in producing a stage play by Denman Thompson: "we are accorded the privilege of presenting to the public the actual scenes, which even the great genius Thompson himself could only represent in painted canvas upon the stage. The same holds true of Grace Church, which formed the familiar background of the third act." "Public Is Wise: No More Are Fakes Tolerated," *EH*, Dec. 11, 1915, 3.

Finally, Sergei Eisenstein regarded the use of a real location in his attempt to stage *Gas Works* in an actual gas factory as the final and irrevocable step for him on his journey to filmmaking: "As we later realized, the real interiors of the factory had nothing to do with our theatrical fiction. At the same time the plastic charm of reality in the factory became so strong that the element of actuality rose with fresh strength—took things into its own hands—and finally had to leave an art where it could not command. Thereby bringing us to the brink of cinema." Eisenstein, "From Theater to Cinema" (1934), in Eisenstein, *Film Form*, trans. and ed. Jay Leyda (1949), 8.

25. Gunning, "Astonishment," 116.
26. When Belasco was invoked as a model or D. W. Griffith was praised as the Belasco of the screen, realism was obviously the key issue. In this context, it might seem odd that theater manager Samuel Rothapfel would be praised as the Belasco of the screen, but the comparison invokes the practice of "staging the picture," which is explained in the next section of this chapter. James S. McQuade, who made the comparison, seems to acknowledge a tension inherent in the realism of the film image by praising Rothapfel for making the image more real: "How he ... transforms what were only shadows into living sentient beings." The way he does this, however, brings him even closer to Belasco since he creates a spectacle *around* the movie image, which demonstrates his "great resourcefulness ... in the staging of his pictures." McQuade, "The Belasco of Motion Picture Presentations," *MPW*, Dec. 9, 1911, 796.
27. Although I finally want to make something very different out of this, Christian Metz focuses precisely on the distinctive play in the screen image between absence and presence as a way of distinguishing it from our experience of stage performance. Metz, *The Imaginary Signifier: Psychoanalysis and the Cinema*, trans. Celia Britton, Annwyl Williams, Ben Brewster, and Alfred Guzzetti (1982), 61–68.

28. Louis Delluc, "Beauty in the Cinema," in Richard Abel, ed., *French Film Theory and Criticism: A History/Anthology, 1907–1939*, vol. 1 (1988), 137.

29. "The Modern Moving Picture Theatre—Ch. V, Showing the Picture," *MPW*, Oct. 16, 1909, 520. This article appeared as part of a series—hence "Chapter V"—of unsigned articles on new approaches to movie theaters.

30. A 1908 article noted that "two regular playhouses . . . have been permanently given over to the moving picture shows in Brooklyn," while in 1909 F. H. Richardson already saw the nickelodeon yielding to larger theaters similar to legitimate theaters: "That the 'store room theater' will gradually disappear seems certain, but their place will be taken by especially built theaters, seating from five hundred to a thousand, most of them giving a mixed bill of motion pictures and vaudeville at ten cents admission. Many of these are already built and more are projected here in Chicago." "Moving and Talking Pictures Attract Many," *MPW*, June 27, 1908, 541; F. H. Richardson, "What Is in the Future?" *MPW*, Aug. 28, 1909, 280.

31. *MPN* Nov. 1, 1913, 38 (emphasis added). Within a year, the screen in the stage setting was a commonplace: a description of the Duplex Theater (Detroit) previously discussed in the introduction comments on "the picture screen . . . being viewed through a stage setting of scenery *of the usual type* at the sides and top of the proscenium arch." *MPW*, Sept. 12, 1914, 1525 (emphasis added).

32. The large theater was the New Willis Wood Theater in Kansas City, Missouri, a 2,000-seat theater originally built in 1900 for "the highest class of drama and musical comedy. But patronage began to wane, people were going to the picture theaters." Consequently, the owners remodeled it as a picture house: "The stage has been entirely transformed, all of the old settings have been removed and a permanent setting built instead. In front of the screen is a lattice window which draws apart, disclosing a smaller curtain which when raised shows the screen. Standing in the center of the stage is a small electric fountain which operates during the intermission. Around this are banked hundreds of ferns and flowers." "Among the Picture Theaters," *MPW*, Dec. 5, 1914, 1367.

The smaller theater was the Majestic Theatre in Cleveland, and it tried something sufficiently unusual to suggest the picture settings were still in an experimental stage: ". . . a special stage setting, the screen removed to one side so that the orchestra could be accommodated on one side. A grassy lawn-like effect was secured by laying a green drop from the stage to the auditorium incline." The off-center screen, which I have not found elsewhere, was likely necessitated by the small size of the stage. "Unique Stage Setting," *MPW*, July 25, 1914, 591.

33. *MPW*, Mar. 12, 1915, 1587.

34. *MPW*, May 1, 1915, 705.

35. *The New York Clipper*, May 21, 1919, 34.

36. *MPN*, Nov. 22, 1919, 3741.

37. *MPN*, Jan. 30, 1920, 408.

38. Raymond Fielding, ed., *A Technological History of the Motion Pictures and Television* (1967; rpt., 1983), 119.

39. *N.Y. Mail and Express*, Sept. 21, 1897, 2, cited in Musser, *Before the Nickelodeon*, 261–62.

40. *MPN*, Nov. 21, 1925, sec. 2, 63, and June 12, 1926, sec. 2, 107.

41. "Colonel Varners Opens New House in North Carolina," *MPN*, May 30, 1925, 2704; "Stage Treatments: Atmospheric Setting," *MPN*, Sept. 2, 1927, 663.

42. The last instance of an entry for "Picture Sets" occurs in *MPH*, "Better Theatres" sec., Nov. 19, 1932, 55, at which point the number of suppliers had been reduced to three. For reasons that will be discussed in the next chapter, the use of picture sets was abandoned following the introduction of sound. The 1932 date does seem very late, but it is possible that picture settings were in limited use or that the inclusion of the entry was the result of careless copy editing. The latter seems more likely to me since the supply companies themselves had ceased advertising picture sets toward the end of the 1920s. The following year, three of these companies do turn up under a new entry, "Scenic Artist Service": "Oftentimes an exhibitor is in need of someone to paint a front drop or curtain, or do some special building and painting of sets for a stage prologue. There are several reliable firms that make a specialty of this kind of work." *MPH*, "Better Theatres" sec., Oct. 21, 1933, 38.

43. *MPN*, Jan. 24, 1920, 1846.

44. *MPN*, sec. 2, June 12, 1926, 51.

45. Since Sigmund Freud's work has recently, once again, become highly contested in the academy, I would like to explain my invocation of him here. Three assumptions underlie my appropriation: (1) I do not regard Freud as the ultimate arbiter or the final word on the workings of the human mind; (2) I do not intend this chapter to serve as a validation of Freud's thought; (3) since I am not a psychiatrist, I have no illusion that anyone who is a psychiatrist could take what I am writing here as furthering psychoanalytic thought, nor do I wish that anyone who isn't a psychiatrist should. Whatever we finally make of the conceptual theories underlying Freud's observations, I do think that we humanists can find greatest value in his precise description and analysis of human emotions. This is the area where I find Freud's writing most evocative—and provocative. Most compelling to me—and of particular importance to my argument here—is his acute sense of the way in which seemingly opposed emotions may in fact be connected.

46. Sigmund Freud, "The 'Uncanny'" (1919) in *The Standard Edition of the Complete Works of Sigmund Freud*, vol. 17 (1917–1919) (1955), 249.

47. It should be noted that television does in fact work by a progression of still images and so is as dependent on the phi effect as movies. My point here is that the sense of contradicting our own rational knowledge of how the images are produced is less forceful with television. This is also not to deny that there is something uncanny in the way broadcast television at least makes visible spectral images that apparently surround us at all times in our daily lives, sending its images "on the air," but here the uncanny quality if more connected to the physical nature of the world we live in rather than the apparatus itself.

48. "While such a presentation would seem to forbid any reading of the image as reality—a real physical train—it strongly heightened the impact of the moment of movement. Rather than mistaking the image of reality, the spectator is astonished by its transformation through the new illusion of projected motion. Far from credulity, it is the incredible nature of the illusion that renders the viewer speechless." Castle, *The Female Thermometer*, 118.

49. *NYT*, June 6, 1915, sec. 2, 3.

50. Wm. A. Johnston, "A New Departure," *MPN*, Feb. 21, 1914, 13.

51. "Vitagraph Picture Theater," *MPW*, Feb. 14, 1914, 287.

52. H. M. Schoenbaum, "Screens and What to Know About Them," *MPN*, Aug. 15, 1914, 33.

53. *MPW*, June 5, 1915, 1613.

54. How common was the fountain? By late summer 1914, *Motion Picture News* declared the following about fountains "Placed in the center of the apron and just back of the footlight line": "Electric fountains have ceased to be novelties seen only in a few theatres. Managers are looking upon them as almost a necessary part of the decorative scheme of an up-to-date theatre." The article then described how colored lights could play on the water, streams could create patterns for "a good water display," and the water itself could be perfumed. It provided names of a dozen theaters that had ordered fountains, concluding "many other theatres" had as well. "The Electric Fountain," *MPN*, Aug. 14, 1914, 33.

    In spite of my opposition of fountain to waterfall, I did find one attempt at waterfalls, albeit miniaturized, which essentially made them a picturesque variation of the fountain. The Liberty Theatre in Portland, Oregon, had a stage with the usual tripartite division, the screen centered between the two watery re-creations: "On both sides of the velvet curtains of burnt orange which hide the screen are replicas of Oregon's famous water falls, Multnomah and Bridal Veil. Here water ripples in true outdoor fashion over miniature rocks and under fairy bridges." Strikingly, the waterfalls were treated as a separate show, something of an entr'acte between the film showings: "When the center curtain is down hiding the screen, the side curtains are drawn back, disclosing the cascading water falls on each side of the stage." "New Liberty Theater, Portland, Ore.," *MPW*, Sept. 22, 1917, 1840.

55. Of some interest here is Yuri Tsivian's description of the understanding of the screen in early Russian cinema: "The screen appeared as an ambiguous and elusive membrane, a boundary between 'us' and 'them' that—at the same time—insisted that no boundary existed at all." Yuri Tsivian, *Early Cinema in Russia and Its Cultural Reception*, trans. Alan Bodger (1994), 155.

56. A *Variety* review of the Los Angeles premiere states the film "was directed by Lloyd Brown and Donald Crisp," as if they deserved equal billings, but subsequent notices made clear that Brown was solely responsible for the stage performance (*Var.*, Feb. 23, 1916, 23). As with other early feature film performances, and in the manner of combination companies, the film was "staged" in New York in the same way that it had been staged in Los Angeles, with Brown supervising both performances. Vardac writes about the New York showing as an example of theater ceding its mission to motion pictures, as if, contrary to the actual performances, the staged action was kept separate from the film: "The stage, recognizing the superiority of the film in pictorial narration, was now satisfied merely to provide introductory material" (*Stage to Screen*, 83).

57. Advertisement in *NYT*, Apr. 9, 1916, sec. 10, 10. According to the *AFI Catalog*, *Ramona*, "the first film of the Clune Film Producing Co., formed by W. H. Clune after the success of *The Birth of a Nation*, which had its premiere in Clune's Auditorium, convinced Clune and his general manager Lloyd Brown that the demand for big productions had not been met by the supply of these films" (755). It is possible that Clune and Brown hoped these interpolations would surpass the prologue for *The Clansman*. Certainly surpassing the Griffith film seems to have been their ambition, as this review of the Los Angeles showing makes evident: "It is in 14 reels, the largest picture ever shown, outdistancing 'The Clansman' by more than 2,000 feet" (*Var.*, Feb. 23, 1916, 23). By the time it reached New York, it had lost two reels.

58. "Notes Written on the Screen," *NYT*, Apr. 2, 1916, sec. 10, 11.

59. "Ramona," *MPW*, Apr. 22, 1916, 640.

60. "The Screen," *NYT*, July 22, 1919, 10.

61. Advertisement for *The Fall of Babylon*, *NYT*, July 12, 1919, 12.

62. "A company of dancers and singers accompanied the film to various cities." *AFI Catalog*, 260.

63. *New York World*, July 22, 1920.

64. *New York Evening Telegram*, ca. July 22, 1920.

65. "Rothapfel Blends Music with the Picture—Langorous [*sic*] Southland Atmosphere Brought to California Theatre to Aid Picture Presentation," *MPN*, Jan. 31, 1920, 1249 (emphasis added). Ross Melnick provides the same quotation, but from a different and earlier source (*Los Angeles Evening Examiner*), so it is likely the *Motion Picture News* article was a reprint. Melnick takes the claim of innovation in the source article at face value, concluding, "By not privileging

the film more than the live performance, he [Roxy] was able to interrupt its flow with music and dance to create one (largely) harmonious whole." But since the interpolated stage number occurred only once and to suggest a transition between two distinct settings, the stage performance here does seem more subordinate to the film than in Griffith's staging five months earlier of *The Fall of Babylon*, with its constant interpolations, an impression evident in the *New York Times* review cited above. In any case, the mixing of live performance and film was not exclusive to Roxy and more common than Melnick seems to realize, going back at the least to *Ramona*. Melnick, *American Showman*, 182–83.

66. Vardac provides a description of the use of treadmills and moving panoramas in late-nineteenth-century stagings of horse races (*Stage to Screen*, 75–81). This was precisely the kind of thing that movies should have taken away from the stage, according to Vardac's argument, but other performances of *In Old Kentucky*, as will be described later, did feature a live staged horse race.

67. "Exhibitors Advertising," *EH*, Mar. 20, 1920, 69 (emphasis added). It is worth noting that *Exhibitors Herald* saw the stage performance as a kind of advertising (articles about distinctive prologues ran in the "Exhibitors Advertising" section), something that would gain distinction for the individual theater beyond the attraction of the movie itself: "The whole is very neatly done and the management of the Riviera is to be congratulated upon its perfect synchronization. It is a stunt that can be effectively staged in any house and at little expense. The word of mouth advertising the Riviera received more than paid the firm of Balaban and Katz for their enterprise."

68. J. M. B., "Motion Picture Theatre Construction Department," *MPN*, Dec. 6, 1913, 30 (emphasis added).

69. Clarke, quoted in Colby Harriman, "The Theatre of To-Day," *MPW*, Dec. 19, 1925, 706.

70. On the other hand, Crafton notes that reviews of the first Vitaphone performances, while full of praise, offered a criticism in similar terms: "The sound quality, however, was characterized by several reviewers as 'mechanical' or 'metallic.'" Crafton, *The Talkies*, 81.

71. Advertisement for *In Old Kentucky*, *Chicago Daily Tribune*, Mar. 3, 1920, 10.

72. Live performers were used in something of a similar fashion at a showing of *In Old Kentucky* in Minneapolis, which otherwise restricted the performers to a staged prologue: "in the part of the film where the horse race is shown the negro actors [from the prologue] were again called upon to lend color to the scene. In the tense excitement while Queen Bess is neck and neck with the rival pony the cheers and appeals for victory rang out from behind the stage. The audience thrilled to this novel touch and in every instance broke out with

cheers and applause." "The Tale of Some Exploitation 'What Am,'" "Exhibitor Service" section of *MPN*, Jan. 24, 1920, 1044.

73. "Directors Protest Use of Extravagant Presentations," *EH*, Dec. 17, 1921, 39. This protest was in the form of a letter sent to Martin J. Quigley, publisher of the *Herald*, likely because promoting atmospheric prologues as a way of attracting the public was a policy of the *Herald* in this period. As a result, this journal ran countless articles suggesting formulas for successful prologues. The *Herald* insistently presented prologues as a kind of "exploitation," advertising that could help promote individual films, and it continued to feature articles on notable prologues through the late 1920s.

Donald Crafton (*The Talkies*, 75) quotes from a John Ford article written in 1927 for *Film Daily*, in which Ford criticizes the live-performance aspects of film exhibition, suggesting that directors were generally opposed to presentations and prologues. A distinction needs to be made here: presentations were like vaudeville, with the Strand setting the prototype for this kind of show, while prologues were a live entertainment specifically oriented toward the feature film, intended to introduce it, and this dates to some of the earliest showings of feature films in legitimate theaters. The innovation of the 1927–1928 season was the increasing use of prologues in palaces, which was likely responsible for the directors' renewed campaign against them. Ford writes about both, with presentations seen as destructive to the mood of the film, but he does not reject prologues entirely: "Personally, I prefer a musical prologue—one that is in harmony with the feature picture—something sweet and simple, beautiful and illuminative, sublime and inspiring—just so it is in keeping with the theme of the photoplay." It is not clear from this if this musical prologue has any visual component, but Ford does add: "It is a significant thing that none of D. W. Griffith's masterpieces have been accompanied by presentations when released . . . the orchestral prelude . . . is practically the only 'prologue' to a Griffith opus. To me, that is ideal." Except for the New York showing of *Birth of a Nation*, Ford is wrong about Griffith's major films. But perhaps he does intend to differentiate between presentations and prologues, and by a preference for a "musical prologue" he had in mind the pantomimed performances on stage featured in the Griffith prologues. Ford, "Thematic Presentations a Wish for the Future," *FD*, June 12, 1927, 47. I want to thank Don Crafton for providing me with a copy of this article.

74. "Exhibitors Advertising," *EH*, June 26, 1920, 69. This article focuses on a theater in Utica, N.Y., where the owner "devised and constructed his own mechanism for the occasion." The point of the article was to demonstrate the value of live performance even in small cities: "What Mr. Lumberg can do successfully in Utica, Mr. Anybodyelse can do in any other city in the United States."

75. "Treadmill Race Prologue Precedes 'County Fair,'" *EH*, Mar. 5, 1921, 56.

76. I have come across one attempt to interpolate a stage race scene into the film itself for a performance of *In Old Kentucky* at the Madison Theatre in Detroit:

> The big stunt . . . was the real horse race which was used at the point in the picture where the heroine rides "Queen Bess" to victory.
>
> For this purpose, it is said, a great tread-mill was transported from New York and set up on the Madison stage. Jockeys were mounted upon the horses, one of them dressed to represent Anita Stewart as she appeared in the play, and when the subtitle "They're off!" was flashed upon the screen the curtain was raised and the real horses were seen in action.
>
> As is customary in stunts of this nature, a moving panorama was provided which completed the illusion. . . .
>
> When the rider costumed to represent the star drew away from the others the screen was lowered and the picture was resumed.

The article claims this "stunt" was a real boon to the box office, but that does not tell us how the contemporary audience experienced the scene, which was, after all, the most famous from the original play. And there is no way I could prove now that contemporary audiences might have felt something of a comedown in the return to the film, but it is worth pondering how that transition might have felt. In any case, there seemed agreement ultimately that it was best to limit such actions to prologues. It should perhaps be noted that this performance preceded the showing at the Riviera in Chicago by about a couple of weeks, so that the Riviera might well have had the model of the staged race at the time it decided to do everything but. "Madison Stages Real Horse Race in 'In Old Kentucky' Engagement," *EH*, Feb. 21, 1920, 87.

77. As should be evident from the various quotations in this chapter, prologues— as well as other live performance surrounding the films—were frequently reported on in the trade press throughout the silent period. My general comments on the content and form of the prologue is based upon extensive reading in *MPW*, *MPN*, and *EH*.

78. An *Exhibitors Herald* article in 1920 did take note of a filmed prologue for the feature *Sex*, but thought the primary value of the prologue was that it provided theaters with the model for a *staged* prologue: "*Those who viewed the production in the projection room were forcibly impressed with the prologue, a carefully and lavishly produced film preface in which the theme of the story was vividly set forth. . . . The producer should be given especial credit for his foresight in providing exhibitors with this excellent material for guidance in the preparation of presentation features. . . .* Under ideal circumstances it will probably be found

most advisable to use such a prologue as a guide, fashioning after it a stage presentation with human players, working into it the best musical arrangement that can be improvised. In such a case, it may be found desirable to dispense with the screen prologue when the picture is exhibited." If it is not possible to stage a prologue, the article concedes, "Certainly a film prologue is much better than no prologue at all," as if the audience *always* needed to be eased into the diegetic world of the film. " 'Sex' Prologue Provides Material for Staging Introductory Feature," *EH*, June 5, 1920, 53 (emphasis in original).

79.  In a 1926 article about movie exhibition in Berlin, Siegfried Kracauer articulates a critique that offers a different way of looking at the sense of continuity between live and filmed performance I describe here: "Rather than acknowledging the actual state of disintegration which such shows ought to represent, they glue the pieces back together after the fact and present them as organic creations. This practice takes its revenge in purely artistic terms: the integration of film into a self-contained program deprives it of any effect it might have had." Kracauer (trans. Thomas Y. Levin), "Cult of Distraction," *New German Critique* 40 (Winter 1987): 95.

Kracauer writes nothing about picture settings, but I have found one example of their use in Berlin. A 1916 article on the medium-sized Nollendorf Theater describes the beginning of a show: "The curtain rises on a replica of the ancient forum at Rome. There stands the broken columns of this once noble gathering place. In the distance, a Roman arch stands, more perfect in its preservation than the rest. The stage lights are lowered and the scene becomes enshrouded in gloom. Now, it is pitch dark. Then, between the columns of the Roman arch a picture scene unfolds itself." Edward Bernard Kinsila, "Modern Theater Construction," *MPW*, Jan. 22, 1916, 602. Since the use of presentation acts that Kracauer describes seem to take their lead from American exhibition practice, it is possible the picture settings had far more extensive use than this one example. In any case, Kracauer's final critique, a modernist view that seeks a distinctive essence for each art form, would be perfectly aimed against the theatricality of the stage set: "By its very existence film demands that the world it reflects be the only one; it should be wrested from every three-dimensional surrounding lest it fail as an illusion. . . . [Movie theaters] will not fulfill their vocation . . . until they cease to flirt with the theater, anxious to restore a bygone culture" ("Cult," 96). Kracauer's desire to wrest the screen "from every three-dimensional surrounding" suggests that picture settings might have been a common practice in Germany as well.

80.  "Novel 'Lost World' Prologue," *MPN*, Mar. 28, 1925, 1328-b.

81.  Five years before this showing, *Exhibitors Herald* was touting the "scrim drop" as a device to effect the transition from stage to movie screen: "It is the long sought device that intimately identifies the stage presentation with the motion

picture—essentially simple, as are most long-sought solutions. . . . At the Capitol theatre, New York . . . the device was used to bridge the step between stage feature and the opening scenes of 'The Heart of a Child,' Nazimova's current Screen Classics production. . . . In the Capitol presentation, lights came up on a stage set to resemble as closely as possible the first scenes of the play [i.e., the film story]. . . . Then the scrim drop was lowered, giving first the impression of London fog, lights being manipulated to further the effect, and by a careful graduation of shading the picture was permitted to strike upon the drop. Naturally, the first scene was seen but vaguely. Within moments, however, the shadings had been so deftly changed that the picture was under way upon the screen without the transition having been realized by the audience. . . . One instance, it illustrates the effectiveness with which this transition, which has puzzled showmen for so long, may be accomplished." "Screen Drop Gives Screen Effect to Interpretative Introduction," *EH*, May 22, 1920, 57. Multiple examples of the use of projected movie images on a scrim to effect a seamless transition from prologue to the beginning of the feature film may be found in Lester M. Townsend and Wm. W. Hennessy, "Some Novel Projected Motion Picture Presentations," *Transactions of SMPE* 12.34 (1928): 345–49.

82. *EHW*, "Better Theatres" sec., Nov. 23, 1929, 24.

83. To take a much later, albeit simpler, example, Radio City Music Hall, even in the 1960s and 1970s, would distinguish between its vertically cascading gold curtain and a simple curtain that parted in the middle, the latter used solely to distinguish between filmic portions of the program. The cascading curtain, however, would create a more decisive boundary between live and filmed entertainment.

84. The purpose Simon Trussler finds in the first instance of proscenium and curtain in the British theater in the early seventeenth century is of some relevance here: "the court masque . . . was to be of lasting importance in its introduction to the British theatre of the proscenium arch and its front curtain—behind which [machinist and designer Inigo] Jones would create his wonderful machines through which landscapes, mountains, castles, and artificial seas were created, or transformed one from the other, all with due attention to the illusion of perspective." Trussler, *The Cambridge Illustrated History of British Theatre* (1994), 98.

85. The screen was, of course, placed within a proscenium from 1896 on when movies appeared in vaudeville houses as an item in a series of acts. Since contemporary description gives little indication of how the shows were staged, I cannot claim here that the feature film saw the first instances of the play of film image between curtain and screen I am describing. What I think is important is how conventionalized this play becomes after the advent of the talking film when the practice of picture settings was abandoned. In this con-

text, the curtain is clearly easing the transition to film image as the picture settings and prologues once did.

86. The earliest references I have been able to find of the use of "canned" to describe movies are from 1914, the year when motion pictures are moving definitely toward features, making them seem something of an equivalent to legitimate plays: "canned drama" in "Paramount Pictures Corporation," *MPW*, July 11, 1914, 264; and "'canned' actor" in Harry L. Reichenbach, "Pictures vs. Actors," *MPW*, Nov. 28, 1914, 1221.

87. The earliest example I could find of the need for the human voice in film exhibition came in an article on the opening of the Regent, the same theater described on page 218: "At other intervals the monotony of the 'silent stage'— there is bound to be some monotony in the long picture, however inspiriting it is—was delightfully broken by the voices of trained singers from the windowed recesses above and at each side of the stage." However, it was not just the voices that enhanced the image: "Soft lights were played upon these windows [where the singers stood] and also upon the fountain which plays just in front of the orchestra platform." W. A. J., "A De Luxe Presentation," *MPN*, Dec. 6, 1913, 16.

## 6. THE ARCHITECTURAL SCREEN

1. Schoenbaum, "Screens," *MPN*, May 2, 1914, 42.

2. See, for example, Raymond Fielding, ed., *A Technological History*, an anthology of articles on different technical subjects from *The Journal of the Society of Motion Picture and Television Engineers*. None deals directly with the screen itself although screen brightness was a long-standing concern in the pages of the journal. In film studies, the screen has received most attention from John Belton in his impressively thorough *Widescreen Cinema*, but in spite of his title even Belton focuses most on the technological apparatus embodied by camera and projector. Belton, *Widescreen Cinema* (1992).

3. The most thoroughgoing example of this approach may be found in Robert Eberwein, *Film and the Dream Screen: A Sleeping and a Forgetting* (1984).

4. *NYT*, Mar. 27, 1928, 31.

5. *Los Angeles Times*, May 5, 1928, 7.

6. Perhaps because it was not so much an innovation as its promoters wanted people to think, so surprise possibly increased its effectiveness. "It is safe to say that the Magnascope is not really a new idea nor does it involve any special mechanism or optical equipment. It is merely making good use of available equipment." Lester M. Townsend and Wm. W. Hennessy, "Some Novel Projected Motion Picture Presentations," *Transactions of SMPE* 12.34 (1928): 352.

The "Supervisor of Projection" for the Rivoli and Publix theaters in New York justified claims for Magnascope in defensive terms that made progressive change in the black masking around the image its most important component and otherwise acknowledged "that no claim is made that any new engineering principle is involved or that any radical mechanical advance has been made." H. Rubin, "The Magnascope," *Transactions of SMPE* 12.34 (1928): 403. Although I have come across no evidence of oversized screens in the teens, at the time of the *Old Ironsides* premiere an article claimed a suddenly enlarged screen in the middle of *Intolerance* (1916): "It will be recalled the D. W. Griffith did this with certain of the Babylonian scenes in 'Intolerance' just ten years ago on the West Coast." Griffith himself was the source for the claim: "Mr. Griffith explained to a News representative that this was done at the time by having a large screen partly masked by drapes which could be parted." " 'Ironsides' Premiere Brilliant Event," *MPN*, Dec. 18, 1926, 2327.

7. Mordaunt Hall, "The Screen," *NYT*, Dec. 7, 1926, 21. The element of surprise was also evident in another review, by Eileen Creelman in the *New York American*, quoted in a post-premiere ad: "The majestic silhouette [of the USS *Constitution*] floating on a suddenly enlarged screen startled even the most phlegmatic theatre-goer into enthusiasm." *NYT*, Dec. 8, 1926, 25.

8. Sid., "The Trail of '98," *Var.*, Mar. 28, 1928, 30.

9. The *New York Times* review of *Old Ironsides* states that the entire second half of the film was shown on the enlarged screen, which makes it unusual in terms of later uses of Magnascope. But a *Los Angeles Times* article on the New York premiere does limit its use to two sequences: "The great ship, bearing straight down upon the audience, created a wonderful thrill. The same effect was used in the marine battle scene, so that complete details took on the size of tremendous close-ups" (Norbert Lusk, " 'Old Ironsides' Thrill Gotham," *Los Angeles Times*, Dec. 12, 1926, C27). Whichever report is accurate, limited use was always the rule in subsequent Magnascope exhibition. In light of subsequent concerns, I do want to highlight another point in the second quotation: on the greatly enlarged screen, objects in long shot could appear as if in close-ups.

10. "Screen's New Novelty," *Var.*, Mar. 21, 1928, 15. The normal screen at the Astor was 16 feet, so the enlarged image of 32 feet was smaller than the Magnascope screen at the Rivoli. On the other hand, given that the Rivoli had close to twice the seating capacity of the Astor, it's possible the enlarged image was even more startling in the space of the smaller theater.

11. "Grauman's Screen Has Odd Effect," *Los Angeles Times*, May 13, 1928, B28.

12. " 'The Trail of '98,' " *MPN*, Mar. 24, 1928, 945.

13. "Showmanship Strikes Out for Novelty in the New 'Fantom Screen,' " *MPN*, Apr, 7, 1928, 1102. Since McCarthy had handled roadshow exhibition for *The*

*Birth of a Nation* and *Way Down East,* his comment casts doubt on D. W. Griffith's claim that he used an enlarged screen for *Intolerance* (see note 4).

14. Merritt Crawford, "Sound-on-Film or Sound-on-Disc, Which Shall It Be?," *FD,* Mar. 15, 1929, 12. Identifying Crawford as "an electrical engineer and sound specialist," Donald Crafton cites this article as evidence that there was not much difference in quality between disc and film systems. In a subsequent discussion of the sound-on-film aspect ratio, he does not comment on the "inferior" image or the loss of illumination. See Crafton, *The Talkies,* 147, 233–35.

15. The journal was initially known as *Transactions of the Society of Motion Picture Engineers,* but changed its name to *The Journal of the Society of Motion Picture Engineers* in 1930.

16. Writing in *MPN,* acoustical engineer Raymond V. Parsons claimed, "there is no reason why the sounds of speech or music reproduced even in a comparatively faithful manner by a loud speaker should introduce a different acoustical problem in an auditorium than the original speech of music would in the same auditorium" ("Theatre Acoustics and the Sound Film," *MPN,* Mar. 2, 1929, 630). Four months earlier in a competing journal, engineer Parsons reported on a survey of "prominent theatre architects": "It has been suggested in this symposium [i.e., the survey] that sound-film theatres be made wider in order to bring the audience in closer proximity with the stage" (R. V. Parsons, "Some Comment on the Sound Picture Survey," *EH&MPW,* "Better Theatres" sec., Oct. 27, 1928, 131). Parsons himself did not think shape was of great acoustical importance, and most problems could be rectified by sound-absorbing material.

    Contrarily, Paul R. Heyl, "senior physicist in charge of the sound laboratory of the Bureau of Standards," stated simply, "Generally speaking, auditoriums are less likely to exhibit troublesome echo when their outlines are rectangular." Heyl also recognized a distinction in amplified sound: "In the case of theatres used for sound pictures . . . there may be employed to advantage a somewhat shorter reverberation time than is desirable for rooms of the same size used for speaking or musical performances." Heyl, "Rectangular Auditoriums with No Curves Held Acoustic Aid," *MPN,* May 3, 1930, 57, 60.

17. I am using "speakers" as a generic term. In trade writing, a distinction would be made between "horns" and "cones" that is not essential to my concerns.

18. Harry M. Paul, "Modernization of Theatre Equipment," *MPH,* "Better Theatres" sec., Apr. 11, 1931, 25 (emphasis added). In a brief discussion of screens, Crafton cites a remark from a General Electric engineer in a 1955 reminiscence that makes a similar claim: "Our sense of direction from which sounds come is too keen for us to be fooled by loudspeakers placed alongside or above the screen. Sound must come from directly behind the screen to give a good illusion." Crafton, not questioning this claim, assumes the illumination problem

was solved with the introduction of improved sound screens. Crafton, *The Talkies*, 235.

19. A 1930 article does claim two "methods . . . in widespread use," placing the "horns" behind the screen, which is "highly directional," or "around the outside of the screen," which has "less directional effect," but by 1931 the speaker behind the screen became dominant practice. Gordon S. Mitchell, "The New Motion Picture and the Public," *EHW*, "Better Theatres" sec., Nov. 22, 1930, 40.

    But practitioners could doubt dominant practice. A Colorado projectionist wrote F. H. Richardson about an experiment: "With the projector lamp not working, but with the sound on I have had regular patrons of the theatre stand at the rear and walk toward the screen, with the instruction to tell me just where the speakers were, or where some individual speaker was. Without exception they have located the speaker as being in the center of the screen vertically and about 4 feet from the edge horizontally, when in fact the horns were at that time located at the sides of the screen." He also invokes the importance of visual cues, noting that he did not project an image because "were the figures in action on the screen, the average person would locate the words as coming from the speaker's mouth, even though they came from the ceiling." Richardson, "F. H. Richardson's Comment," *MPH*, "Better Theatres" sec., Oct. 22, 1932, 21.

    I think the imagined source for sound in his final example is intended to be ridiculous, but I have personal evidence that the observation is accurate: the primary facility for our film classes at Washington University, an approximately 300-seat auditorium, does in fact have its speakers located in the ceiling, something students inevitably find hard to believe, even those sitting in the balcony, close to the sound source.

20. Crafton writes that the early Vitaphone shorts sought to bring live theater to the screen: "The models for the new sound cinema were opera, classical music, light drama, and Broadway vaudeville entertainment, with its characteristic melting-pot flavor of New York ethnicity." Crafton, *The Talkies*, 74.

21. The quote actually reads "0.050 in. in diameter," but I have corrected what is quite clearly a typo. Perforations 0.050 in. in diameter are impossible since the perforations alone would cover a space larger than a square inch, while the 0.005 inches is congruent with other dimensions in the article. Charles R. Underhill, Jr., "Practical Solution to the Screen Light Distribution Problem," *JSMPTE* 56 (June 1951): 681.

22. Richardson, "Sound Pictures," *EHW*, Apr. 5, 1930, 38.

23. Richardson, "F. H. Richardson's Comment," *MPH*, "Better Theatres" sec.: "The Case for Unperforated Screens," Sept. 24, 1932, 23–24; "The S.R.P. and Perforated Screens," Oct. 22, 1932, 20–22; "The Perforated Versus the Solid Screen," Dec. 17, 1932, 25; "Practical Approval of Solid Screens," Feb. 11, 1933,

20; "How Many Holes in a Screen?" Apr. 8, 1933; "Disadvantages in Use of Perforated Screens," June 3, 1933 (a reprint of his SMPE address), 19–22.

24. Richardson, "F. H. Richardson's Comment," *MPH*, "Better Theatres" sec.: "Variations in Screen Illumination," June 6, 1931, 52 (report on conditions in ten theaters in Los Angeles); "The Problem of Screen Illumination," Apr. 8, 1933, 22–23.

25. In the late 1980s theater chain AMC began installing an unperforated curved screen and speakers arrayed along the top; it promoted the screen with the slogan, "There is a difference." From my own experience, I can say the image in theaters with the Torus screen, as it was named, was noticeably brighter, but the screen was an odd contraption with the curve held in place via a vacuum that did not always work well, leading to a return to perforated screens within a decade.

26. H. Rubin (Supervisor of Projection, Paramount Theatre, New York City), "Some Problems in the Projection of Sound Movies," *JSMPE* 12.35 (1928): 867; Harry M. Paul, "Modernization of Theatre Equipment," *MPH*, Apr. 11, 1931, 162.

27. A. L. Raven, "Permeable Projection Screens for Sound Pictures," *Transactions of SMPE* 13.1938 (1929): 467–68.

28. "Report of the Screen-Brightness Committee," in Helen M. Stote, ed., *The Motion Picture Theater* (1948), 216.

29. Richardson, *MPH*, June 3, 1933, 20. Is it possible that complaints about John Gilbert's tenor voice came from too much compensation of the treble range?

30. "One standard practice which is followed in all cases requires that the horns and the back of the screen not occupied by the horns be completely enveloped by absorbent drapes. If the sheet [i.e., the screen] is set back from the proscenium arch, it is also usual to hang drapes in shadow box effect. This treatment eliminates back stage reflections of sound." H. B. Santee, "Surveying a Theatre Preparatory to Installation of Sound Apparatus," *MPN*, Mar. 2, 1929, 632.

31. The companies that provided picture settings no longer feature them in their ads, but they would begin to stress curtains as the proper setting for the screen since curtains could provide the kind of deadening useful for amplified sound. A 1931 article specifically recommends curtains as a screen surround (effectively a new and now required kind of picture setting) for their acoustic properties: "The source of the sound should be well surrounded with sound absorbent material to obtain the best results. Draperies should be hung at both sides of the sound screen." Harry M. Paul, "Modernization of Theatre Equipment," *MPH*, Apr. 11, 1931, 25. A late 1929 article on the move

toward wider-gauge filmmaking, which predicts "a screen 60 feet wide by 30 feet high"—overly optimistic since the largest 70mm screen used, at the Roxy, was 40 by 20—states that the larger sized would require the screen to be "placed from 20 to 25 upstage," without specifying how sound would be handled, although coauthor F. H. Richardson, as noted above, opposed the use of the perforated screen. The article does note that "the present screen . . . is usually only seven feet behind the curtain line." Since later photos generally show the screen closer to the curtain, it is not clear if this was an intermediary position or if perhaps the distance was affected by the use of multiple curtains, detailed below. Douglas Fox and F. H. Richardson, "Larger Screen—Wider Film in Architecture and Projection," *EHW*, "Better Theatres" sec., Oct. 26, 1929, 17.

32. Here is a description of a Fox theater that opened in Los Angeles in 1930: "When open to the first position, small slides, portraits, song slides—in fact, many unusual effects—can be projected. . . . The next position finds the curtain open still wider, allowing the projection of the standard-size picture. . . . The third position opens the front curtain wide, to its fullest limit of off-stage travel." Movable black masking had already been developed and was frequently advertised in the trade press, for use with Magnascope as well as the wide films that had their brief appearance around this time. The use of the curtain in this instance sounds like an attempt to provide the screen with a more decorative surrounding at the same time that it provided the proper acoustical environment. "Curtaining the Stage for Projection," *MPH*, "Better Theatres" sec., Mar. 14, 1931, 18.

33. A. Rodgers, "Lighting Auditoriums During as Well as Between Shows," *MPN*, Apr. 7, 1928, 1100.

34. "Progress in the Motion Picture Industry," *JSMPE* 15.1 (July 1930): 98.

35. A 1913 article praised a theater that did not use a picture setting, but came up with a drapery setting that functioned to much the same purpose: "Mr. Lynch knows that unless the screen is set back on the stage, the picture is too close to the front seats to be enjoyed by the patrons." *MPN*, Nov. 1, 1913, 38.

36. Starke, "The Projection of Motion Pictures," *JSMPE* 41 (Aug. 1943): 188.

37. Valentine, *The Show Starts on the Sidewalk*, 29.

38. "New Theaters for the Cinema," *Architectural Forum* 42.3 (Sept. 1932): 257.

39. Valentine was writing in a period when fewer and fewer of the palaces still existed and even those were threatened with demolition. She expresses a pervasive nostalgia about these structures, one that is found in much other writing on the palaces and effectively echoes the early enthusiasm for them, when their pretentiousness, construed positively, was thought to elevate the status of film as art. It's only in this way that how the film image was made to fit into increasingly elaborate architectural designs could be seen as unproblematic

while the projection booth needed special attention: theaters had a logical location for the screen on a stage, but there was nothing comparable to a projection booth. Valentine's primary interest, much like other writing on old theaters, is focused on the decorative elements of the architecture: consider, for example, her encomium of the Moderne theaters from the thirties and forties designed by S. Charles Lee: "Together with the light pattern on the ceiling, the walls blended the interior in shape, color, and harmony, translated as great swirling patterns that led the eye to the screen" (106). Why would patrons sitting in a darkened space need any help directing their eyes to the one brightly illuminated area? In praising the interior decoration, Valentine implicitly acknowledges one of the problems with the movie theater architecture of the period: there were in fact a lot of visual attractions to compete with what the screen had to offer! Only in this context may Lee's decoration be made of value since it first distracts, then leads you to the proper place. And it is precisely because the decoration was distracting that there was a move to cover over much of this decoration with curtains in the 1950s when a new aesthetic of theater architecture had become dominant.

40. Schlanger, "New Theaters for the Cinema," *Architectural Forum* 42.3 (Sept. 1932): 254.

41. Schlanger, "Reversing the Form and Inclination of the Motion Picture Theater Floor for Improving Vision," *JSMPE* 17.2 (Aug. 1931): 167. Schlanger most fully realized his ambition to bring theater architects and engineers together in 1960 as a founder and first vice president of the United States Institute for Theatre Technology.

42. "Ben Schlanger," *JSMPTE* 79:11 (Nov. 1970): 1030. In an article that seeks to relate changes in theater architecture of the 1930s to an increasing desire to find distinctly American forms that throw off European influences, Larry May describes Schlanger as "the dean of movie architects," although he unfortunately garbles one of Schlanger's central points on organization of space in film theaters by quoting him on the need to make design forms horizontal in opposition to the vertical orientation of the movie palaces. He then goes on to read much symbolic meaning into the horizontal form, effectively upending Schlanger's central opposition between the vertical orientation of the movie spectator versus the horizontal orientation of the stage spectator. Also, given the very insistent emphasis on functionalism and stripping away decoration in all of Schlanger's writing as well as its high level of sophistication and awareness of other architecture as a writer for *The Architectural Forum* and *The Architectural Record*, I have to question May's claim that there is no European influence in the style that Schlanger was helping to forge. May, with the assistance of Stephen Lassonde, "Making the American Way: Moderne Theatres, Audiences, and the Film Industry 1929–1945," in Jack

Salzman, ed., *Prospects: An Annual of American Cultural Studies*, vol. 12 (1987), 97–99.

43. Schlanger, "Reversing the Form," *JSMPE*, 162, 167.

44. Schlanger, "Production Methods and the Theatre," *MPH*, "Better Theatres" sec., Apr. 8, 1933, 8.

45. Schlanger, "Auditorium Floor Slopes for Motion Picture Theatres Today," *MPH*, "Better Theatres" sec., Sept. 20, 1947, 17 (emphasis in original).

46. In a 1936 article for the *JSMPE*, Louis Lumière described an enormous screen (approximately 100 feet wide by 80 feet high) used for the Paris Exposition of 1900: "As a fabric for the screen I had selected a material that reflected, when wet, as much light as it transmitted, so that one could see the projected images from any position in the big hall." Lumière, "The Lumière Cinematograph," in Fielding, *A Technological History*, 50.

47. Francis M. Falge, "The Screen—A Projectionist's Problem," *JSMPE* 19.1 (July 1932): 910–11.

48. Ben Schlanger, "Motion Picture Theaters," *The Architectural Record* 81.2 (Feb. 1937): 19–20. Later, when this formulation had been accepted as a guiding principle, Schlanger would recommend somewhat more stringent guidelines. In one 1946 article, he opted for an auditorium distance–screen width ratio of 5.2:1 for the furthest seat and at least 1:1 for the closest seat, about which he added, "It is desirable, indeed, to make this distance one and a quarter times the picture width wherever possible." Schlanger et al., "Planning the Small Motion Picture Theatre," *MPH*, "Better Theatres" sec., June 1, 1946, 19.

49. See, for example, Gio Gagliardi, "It's High Time to Give the Screen the Attention Due It!," *MPH*, "Better Theatres" sec., June 3, 1950, 27.

50. Ben Schlanger, "Sizing the Picture for 'Wide-Screen,'" *MPH*, "Better Theatres" sec., Oct. 10, 1953, 18. See also Schlanger, "The Motion Picture Theater Shape and Effective Visual Reception," *JSMPE* 26.2 (Feb. 1936): 128–35.

51. "Seat-Preference Survey," *NYT*, Oct. 22, 1941, 27; "Theater Engineering Report: Sub-Committee on Theater Design," *JSMPE* 38.1 (Jan. 1942): 78–81.

52. Gio Gagliardi, "The Needle's Eye," *MPH*, "Better Theatres" sec., July 1, 1950. Results of these surveys have been sufficiently consistent to suggest that most people know the best places to sit, even if movie theaters opt not to charge premiums. Acknowledging this is completely unscientific, I'd still like to add that I've been keeping track of where people sit ever since reading these surveys about fifteen years ago, usually at afternoon showings when audiences generally have a fairly wide choice of seats. If the theater has an exceptionally large screen or an exceptionally shallow depth, the center of gravity, so to speak, might be pushed a bit further back, but for the most part the middle-third center of the seating area seems to be the preferred choice, which leads

me to suspect it always has been, and no one ever actually believed the claim that in a movie theater as opposed to a stage theater every seat's a perfect seat.

53. Schlanger, "Sizing the Picture," *MPH*, Oct. 10, 1953, 16. This was the distance Schlanger decided was optimal in 1946 (note 49), but it is important to note that for the survey it is an *average*, not necessarily a distance found in many theaters.

54. In 1948, Ben Schlanger reported that a 1938 "survey of 500 theatres showed [a] variation [of screen sizes] to range from a width of from one-third to one-eighth of the maximum viewing distance in the auditorium." Given the size of the palaces and repeated references in the trade press to "postage stamp screens," they likely account for the high end of this range. Schlanger, "Proposing a Larger Picture for a More Effective Show," *MPH*, "Better Theatres" sec., July 31, 1948, 29.

55. Schutz, "The Screen Theatre: Bringing Architecture to the Picture House Through a Third of a Century," *MPH*, "Better Theatres" sec., Sept. 25, 1948, 4.

56. Schlanger, "Adapting Existing Auditoriums To 'Full Vision' Movies," *MPH*, "Better Theatres" sec., Dec. 1, 1951, 11. It was perhaps because sound led to the truly expansive use of black masking that Schlanger, looking back on the early days of sound, could write, "It was when sound was introduced that the exhibitor became aware that motion picture theatre design presented a series of technical problems. Soon after he began to realize that the visual problem, although not dealt with too seriously before the advent of sound, was equally, if not more important, than the acoustic problem." Schlanger, "It's Urgent Now to Put Our Modern Know-How to Work," *MPH*, "Better Theatres" sec., Oct. 23, 1948, 24.

57. A "Better Theatres" article on the maskless screen codeveloped by Schlanger directly rejected the improvement to screen brightness that had been attributed to black masking: "Contrary to the understanding of many people, the primary purpose of masking is to absorb the effect of equipment vibration. . . . The black masking was always an evil—for years a necessary one. Its value as a means of overcoming some of the deficiency of light sources has probably been exaggerated; what little it has is confined to the edges, and there it distorts the extreme tones to the detriment of the middles. With color pictures, it is twice an evil." "Mask Elimination Takes Engineering, Not Gadgeteering," *MPH*, "Better Theatres" sec., Feb. 9, 1952, 34.

58. E. G. Johnston, "Viewing a Premiere from the Booth," *MPN*, Apr. 1, 1927, 1149.

59. Richardson, "Lessons for Operators," *MPW*, Feb. 15, 1908, 112.

60. H. C. Weston and E. Stroud, "The Lighting of Cinema Auditoriums for Visibility and Safety," *Transactions of the Illuminating Engineering Society of Great Britain* (London: IESGB, 1939), cited in R. Gillespie Williams, "Dynamic Luminous Color for Film Presentation," in Stote, *The Motion Picture Theater*, 83.

61. The program is reproduced in Ben M. Hall, *The Best Remaining Seats*, 84.

62. R. Gillespie Williams, "Dynamic Luminous Color," 90. This was actually not the first time that some kind of colored surround had been used. In response to a paper at a SMPTE conference reporting on the use of a color surround system in Great Britain, a skeptical Lester B. Isaac, making the case for the continued use of black masking, gave a prehistory of the experiment with color surround at the Roxy:

> The use of color borders is nothing new in this country. It was tried many years ago, as far back as 1919, when we used red, blue, and green borders. Before that D. W. Griffith, the great picture director and producer, also thought he was an expert in lighting. In an attempt to add atmosphere to several of his pictures, and one I remember in particular was "Broken Blossoms," he introduced the use of the so-called X-ray lamp, which was on the side, top, and bottom of the screen. Through various scenes it would project either red, or a magenta, or a blue, or a green. These additional colors certainly only added to the distraction and the discomfort of the audience. (Williams, ibid., 89)

> A contemporary article on the opening of the Roxy noted that the screen "has caused so much controversy among film folk." The theater had opened with a Gloria Swanson feature, and the article quoted "Gloria Swanson to the effect that 'Roxy's' projection seriously detracted from her picture." E. G. Johnston, "Viewing a Premiere," *MPN*, Apr. 1, 1927, 1149.

63. Richardson, "F. H. Richardson's Comment," *MPH*, "Better Theatres" sec., Nov. 21, 1931, 51, and *MPH*, Sept. 24, 1932, 23.

64. The actual method might not sound very different from the black surround, but there was increasing interest in this period with finding other colors as a way of easing eye strain from looking at bright light set against a dark surround: "The screen is set forward of a full-stage black velour eye curtain, and a black ground cloth is used to cover the stage floor. A 'curtain of blue light' is projected between the screen and the black curtain giving a deep blue background and providing the necessary contrast." "Progress in the Motion Picture Industry," *Transactions of SMPE* 12.34 (1928): 277.

65. Schlanger, "Now How About Our Auditoriums?" *MPH*, "Better Theatres" sec., Jan. 7, 1950, 18.

66. Townsend and Hennessy, "Some Novel Projected Motion Picture Presentations," *Transactions of SMPE* 12.34 (1928): 352–53. This article was regarded as sufficiently significant to be reprinted in *EHW*, "Better Theatres" sec., May 12, 1928, 34–35, 63–64, where they are identified as "two projection experts of the Eastman theatre and school" (35). *Transactions* is more specific: Townsend is "Projection Engineer, Eastman Theater & School of Music, University of

Rochester," while Hennessy is simply listed as "Projection Dept., Eastman Theater, Rochester, N.Y." (345).

67. Salt, *Film Style and Technology: History and Analysis* (2d ed., 1992).

68. Nathan D. Golden, "Sound Motion Pictures in Europe," *EHW*, "Better Theatres" sec., Nov. 23, 1929, 51 (emphasis added). Given the current physical plant for exhibition in the United States, these differences might not seem as striking to us now. But when I lived in Berlin in 1964–1965, a period when the palaces still dominated American first-run exhibition, I was generally surprised by how very tiny the theatres were. For example, one downtown theater the "UFA Palast," possessed a name that had to suggest something a good deal grander to an American ear than the theater I actually saw.

69. Because I have not been able to locate a precise theater breakdown from 1929, I am using a U.S. theater census from 1948. This should still offer an apt comparison in terms of large theaters since the only significant change in the physical plant of U.S. exhibition in the intervening period was the loss of small, marginal theaters and the building of theaters in the "under 2,000 seats" category. The census listed 589 theaters operating in New York with an additional 60 in Newark and Jersey City. My claim for the higher number of large theaters is based on the fact that the average number of seats per theater was 1,228 for New York and 1,282 for the New Jersey cities. Since Manhattan and Brooklyn possessed some of the largest first-run theaters in the country, with many "neighborhood" theaters with seating capacities substantially over 2,000, it is evident that large theaters dominated first- and second-run exhibition.

The census also revealed 16,880 movie theaters "open more than three days a week and more than three months a year." Although this number is only 62 percent of the number of theaters in Europe in the 1929 survey, there is a far higher proportion of large audience theaters: 92 over 3,000 (which the survey actually breaks down further, with 17 over 3,999); 348 from 2,000 to 2,999; 2,199 from 1,000–1,999. Where two-thirds of the theaters in Europe had fewer than five hundred seats, approximately one-third of the theaters in the U.S. had fewer than 401 seats (the cutoff point in the 1948 survey). "16,880 Operating Theatres, 7,442 Buyers, Study Finds," *MPH*, May 1, 1948, 16, 18.

70. Salt, *Film Style*, 219, 221–22.

71. See Gagliardi, "It's High Time," *MPH*, June 3, 1950, 28.

72. Thalberg, "Technical Activities of the Academy of Motion Picture Arts and Sciences," *JSMPE* 15:1 (July 1930): 14.

73. Richardson, "F. H. Richardson's Comment," *MPH*, Nov. 21, 1931, 51. When *Dracula* changes to the settings of the original play and becomes more of a drawing room drama, that lighting does become flatter.

74. Underhill, Jr., "Practical Solution," *JSMPTE* 56.6 (June 1951): 680.

75. See, for example, David Bordwell, "Space in the Classical Film," in Bordwell, Staiger, and Thompson, *The Classical Hollywood Cinema*, 50–51; Stephen Heath, "Narrative Space" in *Questions of Cinema* (1981), 19–75; and Jean-Louis Comolli, "Technique and Ideology: Camera, Perspective, Depth of Field," trans. Diana Matias, in Nick Browne, ed., *Cahiers du Cinéma, 1969–72: The Politics of Representation* (1990).

76. Various attempts to deal with the drop-off provide evidence that practitioners did consider it a real problem. For example, in 1951 RCA introduced a screen, marketed as the "Snowhite Evenlite," that evened out illumination by progressively reducing the number of perforations moving outward from the center, the usual location of the speaker. Two years later this screen would be rendered obsolete because of the introduction of stereophonic sound, which demanded continuous perforations across the surface of the screen to allow for directional sound.

77. George Schutz, "The Big Picture," *MPH*, "Better Theatres" sec., May 9, 1953, 76. This was the size given for the 1.33:1 screen at the time the Music Hall began utilizing a 1.66:1 screen 50 feet wide. It is likely the Music Hall screen in 1932 was actually smaller.

78. For a firsthand account of the distortion at the Music Hall, see note 93 of chapter 1.

79. Schlanger, "New Theaters for the Cinema," *Architectural Forum* 42.3 (Sept. 1932): 254–55 (emphasis added).

80. Of course, there was a move to deep-focus styles in the 1940s, which *was* conditioned by exhibition to the extent that the improvement in carbon arc technology did make more legible the more detailed deep-focus images. But it is also possible that the renewed concern about side-view distortion in movie theaters in the postwar period was itself a consequence of changes in cinematography since deep-focus photography would make the distortion more evident.

81. Bazin, "The Evolution of the Language of Cinema," *What Is Cinema?* 1:33.

82. MGM used the same cameras as those used for Fox's Grandeur film, but dubbed the process "Realife." *The Bat Whispers* (1930), a United Artists wide-gauge film, likely used the same camera as well, although a DVD release claims 65mm in its cover copy. In addition, Warner Bros. utilized 65mm film for three features while RKO released one feature in 63mm. Paramount developed a 56mm system, but it appears to have produced only one demonstration short in this gauge. Information on early wide-gauge filmmaking may be found in Robert E. Carr and R. M. Hayes, *Wide Screen Movies: A History and Filmography of Wide Gauge Filmmaking* (1988), 1–10.

83. Carr and Hayes note Grandeur "used an oversized (literally by two) Movietone soundtrack which also rendered superior sound" (5). The advent of wide-

gauge filmmaking seemed to animate Schlanger. He writes about it more than once, likely because it had a transformative potential for him: "And now the enlarged screen threatens to render the standard theater form obsolete in more points than ever" (Schlanger, "Reversing the Form," *JSMPE*, 162). Ironically, the move to wide-gauge filmmaking was in part an attempt to make the oversized architectural spaces of the palaces work for movies, while Schlanger saw wide film as doing the opposite.

84. Nevertheless, MGM did have a limited release of *Billy the Kid* (1930) in 35mm that was a reduction print intended for projection on larger screens. The resulting reduction of the image offset the gains offered by the 70mm negative: because the image was smaller than the standard 35mm frame, the image suffered the same problems experienced with Magnascope—lower illumination and increased graininess in spite of the finer grain of the 70mm original. Although the reduced frame did anticipate the standard widescreen formats of the 1950s, the anamorphic process of the same period (initially marketed as CinemaScope) made it possible to retain more of the improved image quality of the 70mm original.

85. This would have been true at least for the grandest of the movie palaces. While the proscenium opening in the midsized palace was always sufficiently large to give a postage-stamp appearance to the screen, in many instances it may well have been too narrow to accommodate the enlarged screens that were at least feasible with wider-gauge film. In any case, individual articles on new theaters that appeared in the "Better Theatres" section of *Exhibitors Herald-World* in 1929–1930 and its successor *Motion Picture Herald* in 1931 inevitably note that the proscenium was built large enough to accommodate enlarged screens.

86. Because the frame of Grandeur is not compatible with subsequent 70mm standards, the 70mm version was restored in a 35mm anamorphic print by the Museum of Modern Art.

87. While I have seen one reel of this film projected in its widescreen aspect ratio on a screen, I have seen the Grandeur version in its entirety only on a flat panel television from a Blu-ray disc. I mention this to indicate it is possible that seeing the film projected on a properly proportioned screen might well leave a different impression, with the position of the speaker within the image more apparent.

88. "Wide Film Require New Type of Theatre," *MPN*, June 7, 1930, 97.

89. Edeson, "Wide Film Cinematography: Some Comments on 70 mm. Camerawork from a Practical Cinematographer," *American Cinematographer*, Sept. 1930, 21.

90. William Stull, A.S.C., "Seventy Millimetres: The First of the New Wide Film Processes Reaches Production," *American Cinematographer*, Feb. 1930, 42.

91. See most of all Charles Barr, "CinemaScope Before and After," *Film Quarterly* (Summer 1963): 4–24.

92. F. H. Richardson, "Wide Film: What It Is—How It Works," *EHW*, Oct. 19, 1929, 33.

93. The editor of the "Better Theatres" section of *Motion Picture Herald* saw such changes as directly responsible for a move to larger screens: "With the improvement of carbons and reflector arc lamps, plus refinement of film grain, the average picture size has been growing larger in recent years. But it is typically still small compared with the dimensions of the seating plan" (George Schutz, "The Search for Ways to Make the Theatre's Picture Newly Unique," *MPH*, "Better Theatres" sec., May 5, 1951, 13). It seems to me equally likely that the improvement also had an impact on what those screens displayed.

94. Bosley Crowther, "New Movie Projection Shown Here; Giant Wide Angle Screen Utilized," Oct. 1, 1952, 1; and "6,500 See Debut of CinemaScope, New Film Process, in 'The Robe,'" *NYT*, Sept. 17, 1953, 1.

95. "Concave Screen on Market," *MPH*, "Better Theatres" sec., July 27, 1946, 34.

96. "One for the Aisle Sitters," *Newsweek*, Apr. 21, 1947, 99. The *New York Times* also treated image distortion as a familiar phenomenon: "A new screen . . . eliminates all the distortions that have grated on the nerves of spectators seated way over on the side of the theatre." "Screen," *NYT*, May 11, 1947, sec. 2, 5.

97. Advertisement for Trans-Color Screen, *MPH*, "Better Theatres" sec., Nov. 4, 1950, 74.

98. "Observations on the Curved Type Screen," *MPH*, "Better Theatres" sec., June 28, 1947, 47. The one clear-cut difference between the Retiscope and its concave-convex successor was that the later screen had a seamless fiberglass surface as an improvement over the earlier screen fiberglass panels with very visible seams, but it was the fabric itself that supposedly increased reflectance.

99. United States Patent Office, Patent #2,346,257, Apr. 11, 1944. While fiberglass was used by a number of chains, the material was a good deal more expensive than other screen fabric, which likely limited its application: "NuScreen is somewhat more expensive ($2,500) than the standard screen, which costs roughly $600 installed." "One for the Aisle Sitters," *Newsweek*, Apr. 21, 1947, 99. It does not appear to be used in the new screens of the 1950s.

100. Another porous-material screen without perforations, the "Cycloramic," claimed an increase of 20 percent more light. (Advertisement for "Cycloramic" screen, B. F. Shearer Company, *MPH*, "Better Theatres" sec., Sept. 3, 1949.) Since the perforations accounted for 20 percent of the screen area, the boost in illumination must have derived entirely from the elimination of perforations.

101. Advertisement for Retiscope Screen Company, *MPH*, "Better Theatres" sec., Sept. 21, 1946, 35; advertisement for B. F. Shearer Company, *MPH*, "Better Theatres" sec., Aug. 5, 1950, 4. The Cycloramic screen was used for the Magnascope sequence at the end of David O. Selznick's *Portrait of Jennie* (1949).

102. United States Patent Office, Patent #2,117,857, May 17, 1938.

103. "'Blended' Screen Aids Film Realism," *NYT*, Oct. 13, 1937, 15.

104. "RCA Offers Maskless Film Screen," *MPH*, Dec. 22, 1951, 35.

105. Advertisement for RCA Synchro-Screen, *MPH*, "Better Theatres" sec., Mar. 1, 1952, 3.

106. Schlanger, "Adapting Existing Auditoriums to 'Full Vision' Movies," *MPH*, "Better Theatres" sec., Dec. 1, 1951, 11.

107. George Schulz, "The Search for Ways to Make the Theatre's Picture Newly Unique," *MPH*, "Better Theatres" sec., May 5, 1951, 13–14.

108. "On the Horizon," *MPH*, Dec. 6, 1952, 9.

109. Schlanger had been advocating for a wider screen since the 1930s: in an article on the value of a wider screen, as a demonstration he provides an image from *Grand Hotel* (1932), cropped to about a 1.6:1 aspect ratio. See Schlanger, "On the Relation Between the Shape of the Projected Picture, the Areas of Vision, and Cinematographic Technic," *JSMPE* (May 1935): 403. This makes it likely that he was involved in the decision to crop the image at the RKO 58th Street.

110. "On the House," *MPH*, "Better Theatres" sec., Jan. 10, 1953, 12. This turned out to be no joke after all: about four months later, cropping height and expanding the image along the horizontal axis did in fact become the standard procedure for achieving widescreen projection (with aspect ratios ranging from 1.66:1 to 1.85:1), and the phrase "the poor man's Cinerama" became a commonplace description for it. John Belton assigns this term to CinemaScope as well (Belton, *Widescreen Cinema*, 113–37). It seems, in this period, that everything *not* Cinerama was the poor man's version of it.

111. The homemade light surround was for a small theater in Pleasantville, N.J. On a screen "12x9 feet . . . peach-colored cheesecloth 18 inches wide is substituted for black masking, with the cheesecloth attached . . . so as to give a 45° angle. . . . Further, 4x8-foot sections of compo board are played out from the cheesecloth border, which . . . acts like the bell of a horn upon the sound" ("Methods in Management," *MPH*, "Better Theatres" sec., Sept. 1, 1951, 21). In August 1952, Raytone Screen Corporation announced it would begin marketing the "Transcenic Screen Surround" in November and promised the achievement of "wide angle vision" with it (advertisement for Raytone Screen, *MPH*, "Better Theatres" sec., Aug. 23, 1952, 43). And a 1951 article on the maskless screen reported that "one of the major television set manufacturers has announced home equipment with a 'halo' border—that is, edging the image with an effect of light instead of cutting it sharply with dark wood framing. The reason? They say the 'halo' increases visibility, reduces eye fatigue, makes the picture look larger" ("Looks Like Screen Masking Could Be on the Way Out," *MPH*, "Better Theatres" sec., Aug. 4, 1951, 23).

112. "Paramount Screen with Border Light," *MPH*, "Better Theatres" sec., June 6, 1953, 32–33.

113. In SMPTE's theater manual published in 1969, a section on screen masking notes as one possibility "a reflective boxlike structure that tends to flow into the picture and vice versa." Don V. Kloepfel, ed., *Motion Picture Projection and Theatre Presentation Manual* (1969), 88.

## Conclusion: Ontological Fade-Out

1.  "743 Drive-Ins Operating; 137 All Year, MPAA Says," *MPH*, Nov. 6, 1948.

2.  "Drive-Ins in U.S. and Canada Total 2,020," *MPH*, June 3, 1950, 15. The second number comes from John Belton, *Widescreen Cinema*, 76.

3.  S. Herbert Taylor, "Drive-In Theater," in Stote, *The Motion Picture Theater*, 42.

4.  "Chicago's Quad—A Drive-In with Dual Projection and Four Screens," *MPH*, "Better Theatres" sec., Aug. 5, 1950, 14.

5.  "Projection Light for Larger Pictures," *MPH*, "Better Theatres" sec., May 7, 1949, 18.

6.  "Terry Ramsaye Says . . . ," *MPH*, Feb. 10, 1951, 14.

7.  "Projection Light for Larger Pictures," *MPH*, May 7, 1949, 18.

8.  Spigel, *Make Room for TV: Television and the Family Ideal in Postwar America* (1992), 39–40.

9.  A 1951 article states that 88 percent of drive-ins charged by the individual, while those charging by the car wanted to attract the whole family. "Drive-In Owners Want Per Person Admission, Earlier Product Runs," *MPH*, June 10, 1951, 13. According to this survey, a similar majority, 81 percent, "indicated free children's admission in one form or another a positive must," signaling that most drive-ins regardless of admissions policy were marketing themselves to baby-boom parents. To some degree, admitting children free lessened the difference between per-individual and per-car admission, as one drive-in owner noted: "per person or per car depends on locality. We charge 60 cents at our Washington metropolitan area and people are willing to pay it. At our Newport News, Va., drive-in (industrial community) we charge $1.20 a carload and do nicely." Either admission policy, effectively minimizing the number of paying admissions, as well as the ways in which film viewing was made one of many competing activities, are likely responsible for the major studios' initial resistance to making their product available to drive-in theaters. Further, while movies might be the primary attraction, there was "a wide variety of competing attractions which may include pony rides, picnic areas, car washing, bingo, laundry service, bottle-warming service, merry-go rounds, refreshment facilities, and dance floors." Rodney Luther, "Marketing Aspects of Drive-In Theaters," *Journal of Marketing* 15.1 (July 1950): 42.

How far beyond conventional theater attractions could drive-ins go? Belton cites a Florida location, " 'The Only Drive-In Theatre in the World That Offers Lake Fishing,' [which] boasted that its patrons could fish and watch movies at the same time" (*Widescreen Cinema*, 78).

10. Belton, *Widescreen Cinema*, 92.

11. "Of Local Origin," *NYT*, Dec. 26, 1953, 11.

12. The figures are cited in Belton, *Widescreen Cinema*, 99. See also Bosley Crowther, "Cinerama Tourism," *NYT*, Sept. 29, 1957, sec. 2, 1. Crowther was writing in response to the fourth of the five travelogues.

13. Cinerama also had plans to add a third house along Broadway, although this never happened. Eugene Archer, "Cinerama Plans 2 More Theatres," *NYT*, Aug. 25, 1962, 11.

14. A year later, the Warner Theater, originally the Strand, reduced its seating capacity as well and increased its screen size to 81 by 30 feet. Eugene Archer, "Warner Theater Is Cutting Size," *NYT*, Oct. 23, 1963, 36. This article also mentions that "sections of the proscenium arch have been eliminated," so, apparently the arch was left intact when the first screen was installed.

15. Eugene Archer, "Cutting the Capitol Theatre Down to Size," *NYT*, July 29, 1962, 69.

16. "Cinerama Backs a New Theater," *NYT*, Feb. 6, 1963, 4. The futuristic quality of the dome could help promote Cinerama as the future of movies, but it was as much an imposition of an existing architecture on the movie screen as previous theater design had been. The chief advantage of the dome was not so much display of the image as cost: "such a theater would cost about $250,000 to build, or about half the cost of the conventional theater."

17. Eugene Archer, "Movie Theaters at Building Peak," *NYT*, Nov. 7, 1962, 45.

18. "Rugoff's Unique Cinema I–Cinema II," *Var.*, June 27, 1962, 4.

19. "Rugoff–Becker's 2-Level Theatre on East Side's 'New B'way' (3rd Ave.)," *Var.*, Feb. 15, 1961, 17.

20. Bosley Crowther, "New Link in Art-Theater Chain," *NYT*, June 24, 1963, 21.

21. "Of Local Origin," *NYT*, Nov. 4, 1949, 33. It is worth noting the films the *Times* reported had better records: " 'The Big Parade,' with a ninety-five-week stand . . . Roberto Rossellini's Italian-made topical drama, 'Open City,' with ninety-one weeks at the World Theatre, and 'The Ten Commandments,' with a sixty-two week engagement at the old Criterion Theatre." The top four, then, contained two recent art films; for long-running achievements in Hollywood film, on the other hand, you had to go back to the 1920s, the heyday for extended-run bookings.

22. *NYT*, Sept. 17, 1950, sec. 4.

23. Barbara Wilinsky provides an extensive analysis of the art house audience in the 1940s in *Sure Seaters*, 80–103.

24. Wilinsky (ibid., 30–31) explains how distinctions were made between which British films went into mainstream theaters and which were exhibited in art theaters.

25. The success of *Hamlet* in New York was no doubt a factor in the decision to roadshow the film in 352 U.S. cities, where the exhibition was so successful that Universal-International expected a "domestic revenue of about $5,000,000." A. H. Weiler, "Random Notes About People and Pictures," *NYT*, Sept. 25, 1949, sec. 2, 5.

26. The sixties also saw the beginnings of a move toward the mass-distribution pattern that would become the norm in the seventies, so that Broadway theaters operating in a grind mode lost their exclusivity. With the collapse of reserved-seat exhibition in the seventies, those theaters lost their final rationale, and all the palaces on Broadway would eventually be demolished. But already in the late 1960s, there was a fear that "Broadway was doomed to extinction as the moviegoing center of the city," a fear temporarily abated by multiplexing existing theaters. Vincent Canby, "Old Movie Palaces Don't Die, They Just Turn Into 2 or 3 Smaller Theaters," *NYT*, July 29, 1968, 24.

27. Eugene Archer, "2 New Theatres Due on 3rd Avenue," *NYT*, Feb. 15, 1961, 39. The *Variety* article published on the same day ("Rugoff–Becker's 2-Level Theatre . . .") also lists only Schlanger as the architect.

28. Fred A. Bernstein, "Andrew Geller, 87, Modernist Architect, Dies," *NYT*, Dec. 27, 2011, B14. This obituary focuses entirely on Geller's domestic architecture, with no mention of his contribution to Cinemas I–II. Also, I have reviewed the Andrew W. Geller architectural records and papers at the Dept. of Drawings & Archives, Avery Architectural and Fine Arts Library, Columbia University, and found no other plans for a theater.

29. The only twentieth-century theater that regularly turns up in histories of architecture is Radio City Music Hall, but that is likely because of its art deco style and its prominent status as part of Rockefeller Center.

30. "Twin Cinemas: Flexible Showcase for Films," *Architectural Forum* 117.3 (Sept. 1962): 120–23; "Piggy-Back Movie House on 3rd Avenue," *Progressive Architecture* 43 (Mar. 1962): 84; "Building Housing Two Theatres Nears Completion," *NYT*, June 17, 1962, sec. 8, 6. By contrast, when Walter Reade, Rugoff's main competitor in the New York art cinema market, opened its own piggyback theater six months later and a block away from the Cinemas I–II, its more conventional architecture went virtually unnoticed.

31. "City Art Society Honors Architects," *NYT*, May 21, 1963, 23. The other awards, held in the Geller architectural records and papers at the Avery Architectural and Fine Arts Library, are the Bard Award for Merit in Urban Architecture by the City Club of New York and a Citation from the New York State

Association of Architects. In addition, the theater was chosen as part of a Museum of Modern Art exhibition, "Architecture USA," for the United States Information Agency.

32. Indeed, "an attempt would be made to see that the buildings were architecturally related. One integrating device will be the use of long, straight colonnades. Another will be the use of multiple façade arches." Ross Parmenter, "2,400-Seat Philharmonic Hall Set for Lincoln Sq.," *NYT*, May 10, 1959, 73. An *Architectural Forum* article on the construction of Philharmonic Hall also singled out the arches, suggesting it as the source for the motif copied by the other buildings: "The Philharmonic's arch design will probably be used as a unifying motif for the whole center." "Lincoln Center Starts Building Philharmonic Hall," *Architectural Forum* (June 1959): 7.

33. The earliest rendering of Philharmonic Hall, for example, was published in the *New York Times* in 1959 (Parmenter, "2,400-Seat Philharmonic Hall," 1). Although somewhat different from the final building, the colonnaded glass façade was its most striking feature.

34. By this point in his career Schlanger had received an international reputation for his work on seating and sight lines, "a specialty he had elevated to a science." Obituary, *Architectural Forum* 110. 6 (June 1971): 64. At Lincoln Center he designed the seating for the three central buildings: Philharmonic Hall, the New York State Theater, and the Metropolitan Opera.

35. The press release may be found in the Geller architectural records and papers.

36. *NYT*, June 25, 1962, 25 (emphasis in original).

37. In a letter dated June 12, 1962, dealing with a list of all the various people who had worked on the building (and which had been requested by *Architectural Forum*), Schlanger wrote, "In accordance with our previous arrangements it seems best to start the listing with the heading: ARCHITECTS Andrew Geller Ben Schlanger." And, indeed, all of the architectural drawings held in the Geller papers list Geller and Schlanger equally. While some articles list Schlanger as a "theater consultant," the advertisement announcing the opening simply lists both as "architects," while a *New York Times* article on the day of the opening calls them "the architectural team." "Two Theatres Open with 'Boccaccio '70,'" *NYT*, June 26, 1962, 23.

How much was Geller committed to the distinctive features of this building's design? In 1988 he became the architect for a renovation to put a shoebox theater behind Cinema I by eliminating Schlanger's Synchro-Screen and removing a number of seat rows. The plan reduced total capacity from 700 to a bit over 500 and placed a conventional screen directly in front of the new first row, effectively destroying Schlanger's carefully worked out sightlines, putting a good number of viewers too close to the screen, and creating serious

side-view distortion. Geller also put conventional theater curtains over the screens in all three auditoria. In a memo prepared for the manager of the theaters, dated November 23, 1988, he wrote that "the white marble panels at the seven exterior arcade columns have been replaced with black granite panels for easier maintenance as well as for appearance," thereby erasing the connection to Lincoln Center. In this document, Geller listed himself as the sole architect of the original building.

38. The continental seating was also touted as an innovation of the New York State Theater, for which Schlanger was given credit.

39. An article on the opening of the Murray Hill considered it of note that "The stage has no curtain and the ceiling slopes downward to meet the curved walls of the proscenium. Floodlights replace the stage curtain." The design was sufficiently novel that the writer could only describe the missing curtain in terms of stage and proscenium, even though the theater had dispensed with both of these as well. "Murray Hill Gets New Movie House," *NYT*, Oct. 4, 1959, 49.

40. The piggybacking would eliminate one aspect of the Duplex Theater that was essential for the development of the multiplex: the projection booth that could access all the auditoria, which made the semi-automation of projection of the multiplex possible.

41. "Rugoff's Unique Cinema I–Cinema II," *Var.*, June 27, 1962, 4.

42. See note 78 of chapter 5.

43. *NYT*, Sept. 15, 1957, sec. 6.

44. Although the curtain moves faster than in my memory, the blu-ray disc of *This Is Cinerama* provides a nice simulation of seeing the image projected across the curtain. The first four of the five Cinerama travelogues all began with a conventional 1.33:1 image and the curtains opening just enough to reveal that image. The subsequent revelation of the full Cinerama image projected onto the curtains as the curtains pulled open to their full width became a trope to express astonishment at the image itself.

45. Belton, *Widescreen Cinema*, 93. Belton makes a point about the Cinerama narrative films that signals something new: "they never quite rid themselves of Cinerama's Original Sin—its essential affinity for the episodic and the picaresque and its fascination with journeys and various means of locomotion," and he goes on to locate the "roller coaster rides" in a number of Cinerama narrative features (92). However, one can also feel Cinerama's influence with other variations on the roller coaster in both *The Robe* (1953), with its wild chariot race, and the runaway horse-and-buggy sequence in *Oklahoma!* (1955). Both films were first in their respective technologies, CinemaScope and Todd-AO, both of which were intended to compete with Cinerama. Unlike Cinerama, however, subsequent films did not need to include this effect. How-

ever, there is still a lasting significance in this development: because of the perceived need for the roller coaster effect, the Cinerama films may fairly be described as the first "effects-driven" cinema, a term that would come into common use decades later.

46. Pry, "The Wonderful World of the Brothers Grimm," *Var.*, July 18, 1962, 6.

47. Schlanger, "On the Relation Between the Shape of the Projected Picture, the Areas of Vision, and Cinematographic Technic," *JSMPE* 14.5 (May 1935): 404–5. Schlanger did manage to see and write about one of the earliest demonstrations of Cinerama, seeing in it evidence of his claims for what a larger image could accomplish: "As a technique for regular motion picture exhibition, it may not be practicable. The demonstration supplied convincing proof, however, that dramatic impact can be greatly increased by enlargement of the area of the performance, *both* in pictorial content and in dimensions of the image." Ben Schlanger, "Sound Is Established—Now Let's Go Back to the Picture," *MPH*, "Better Theatres" sec., May 7, 1949, 17.

    When widescreen formats were firmly established as a standard for all theatrical filmmaking in 1953–54, Schlanger did see this as a realization of his aims as a theater architect: of the new " 'wide-screen' technique in its various forms," he wrote, "by virtue of its magnitude relative to the size of the audience, it gives the performance 'presence' . . . and it fills so much more of the field of vision than former practice allowed that less extraneous material . . . is included in the spectator's view to undermine the illusion which the performance is trying to produce in his mind." However, noting "a decided increase in the amount of light reflected from the larger screens on to the walls and ceiling," he still sees the need for a "synchronous" screen surround and a neutral auditorium. Schlanger, "A Functional Setting for the 'Wide-Screen' Picture," *MPH*, "Better Theatres" sec., Jan. 9, 1954, 18.

48. The opening of *The Robe* directly imitates the use of curtains from *This Is Cinerama*, but keeps it all on film: the credits appear against a dark red theatrical curtain; after the director's credit, the curtains slowly part in the middle to emphasize the width of the screen and to reveal the opening shot of spectacle, a high-angle shot of a filled Roman arena, so capacious the film image seemingly cannot contain it all.

49. In the manner of the old movie palaces, the legitimate theater would be located on the ground floor of the office building. Ironically, the earliest announcement of the plan for the theater identified Ben Schlanger as the consulting architect for the theater. Franklin Whitehouse, "Broadway to Get a Drama Theater," *NYT*, Sept. 22, 1967. Schlanger was not the architect on the final project, but he did work more and more on live-performance theaters in the last phase of his career, as if he had said everything he had to say about movie theaters.

50. But it did lose the expansiveness it had had at the Capitol: because the Warner Cinerama had recently been turned into a triplex, the screen had been reduced to 64 by 30 feet. Canby, "Old Movie Palaces Don't Die," *NYT*, July 29, 1968, 24.

51. James Naremore is more specific on these aspects of the film: "almost two-thirds of the picture has no dialogue; and only about thirty minutes involve characters who are placed in jeopardy." Naremore also identifies one source of the film's obscurity: "At some point late in the production, Kubrick also cut the extensive off-screen narration." Naremore, *On Kubrick* (2007), 142.

52. In 1999, I was teaching *Blow-Up* (1966) in a class at Washington University and was a bit surprised to learn the students really disliked it. Discussion made it evident the problems were lack of dialogue, obscurity of motivation, and the uncertainty of the ending, which prompted me to ask if any of them had ever seen *2001*. The question prompted strong reactions, all on the order of, "Oh, yeah, my parents made me watch that. What a terrible movie!"

53. Kubrick had come to the United States (via steamship because, ironically given the content of this film, he had a dread of flying) and was actively engaged in the screening, using audience reaction at a preview screening before the premiere to make additional cuts. As Vincent LoBrutto described it, "During the press screening, Kubrick walked up and down the aisle, watching the audience to determine their reactions and where the film might be dragging." At a minimum, he was aware of how the performance would work at the Capitol and was possibly instrumental in this "staging" of it. LoBrutto, *Kubrick: A Biography* (1997), 310.

    I had noted that Kubrick's next film, *A Clockwork Orange* (1971), played at Cinema I. This time Kubrick did not travel to New York for the premiere, but nonetheless had specific requirements for how the image should be handled: "Kubrick knew that Cinema I projected films onto a white cement wall (*sic*) without a matte to surround and frame the image. Kubrick insisted on having a black matte. Pressure was put on Donald Rugoff, who owned the theater, and he agreed to paint a matte on the surface" (LoBrutto, 359). Perhaps because he had begun his artistic career as a professional photographer, Kubrick, unlike Schlanger, *did* conceive of his image as a framed picture, his experience with Cinerama notwithstanding.

54. The mise-en-scène makes objects on the periphery appear sufficiently large that a pronounced sense of parallax produces something of a vertiginous quality even on a flat screen, albeit much diminished.

55. In his incisive reading of the film, James Naremore makes a point about Kubrick's style that is relevant to the impact of this moment: "notice that the first parts of the film are quite sparing in point-of-view shots. . . . The most intense subjective shots in the middle section belong to HAL" (*On Kubrick*, 146).

# SELECTED BIBLIOGRAPHY

*Note*: Except for writings by Ben Schlanger, this bibliography does not contain entries for individual newspaper and trade journal articles cited in the text.

Abel, Richard. *Americanizing the Movies and "Movie-Mad" Audiences, 1910–1914.* Berkeley: University of California Press, 2006.
———. *The Red Rooster Scare.* Berkeley: University of California Press, 1999.
Abel, Richard, ed. *French Film Theory and Criticism: A History/Anthology, 1907–1939.* Vol. 1. Princeton: Princeton University Press, 1988.
Abel, Richard and Rick Altman. *The Sounds of Early Cinema.* Bloomington: Indiana University Press, 2001.
Allen, Robert. "Motion Picture Exhibition in Manhattan, 1906–1912: Beyond the Nickelodeon." *Cinema Journal* 18.2 (Spring 1979): 2–15.

——. *Vaudeville and Film, 1895–1915: A Study in Media Interaction.* "Dissertations on Film." New York: Arno Press, 1980.

Altick, Richard D. *The Shows of London.* Cambridge: Harvard University Press, 1978.

Altman, Rick. *Film/Genre.* London: British Film Institute, 1999.

——. *Silent Film Sound.* New York: Columbia University Press, 2004.

*The American Film Institute Catalog of Motion Pictures Produced in the United States: Feature Films, 1911–1920.* Patricia King Hanson, executive editor. Vol. F1. Berkeley: University of California Press, 1988.

Anderson, Joseph and Barbara Anderson. "Motion Perception in Motion Pictures." In de Lauretis and Heath, 76–95.

Applebaum, Stanley, ed. *The New York Stage: Famous Productions in Photographs.* New York: Dover, 1976.

Arnheim, Rudolf. *Film as Art.* Berkeley: University of California Press, 1957.

Balio, Tino. *Grand Design: Hollywood as a Modern Business Enterprise, 1930–1939.* New York: Scribner's, 1993.

Balio, Tino, ed. *The American Film Industry.* Rev. ed. Madison: University of Wisconsin Press, 1985.

Barnes, John. *The Beginnings of the Cinema in England, 1894–1901.* Vol. 1 (1894–1896). Rev. ed. Exeter: University of Exeter Press, 1996.

——. *The Beginnings of the Cinema in England, 1894–1901.* Vol. 3. Exeter: University of Exeter Press, 1996.

Barnouw, Erik. *The Magician and the Cinema.* New York: Oxford University Press, 1981.

Barr, Charles. "CinemaScope: Before and After." *Film Quarterly* 16.4 (Summer 1963): 4–24.

Bauland, Peter. *The Hooded Eagle: Modern German Drama on the New York Stage.* Syracuse: Syracuse University Press, 1968.

Bazin, André. *What Is Cinema?* Vol. 1. Berkeley: University of California Press, 1967.

Beach, Edward R. "Double Features in Motion-Picture Exhibition." *Harvard Business Review* 10.4 (July 1932): 505–515.

Belasco, David. *The Theatre Through Its Stage Door.* New York: Harper, 1919.

Belton, John. *Widescreen Cinema.* Cambridge: Harvard University Press, 1992.

Bennett, Susan. *Theatre Audiences: A Theory of Production and Reception.* London: Routledge, 1990.

Berger, Robert, Anne Conset, and Stephen M. Silverman. *The Last Remaining Seats: Movie Palaces of Tinseltown.* Los Angeles: Balcony Press, 1997.

Bergman, Gösta M. *Lighting in the Theatre.* Totowa, NJ: Rowman and Littlefield, 1977.

Bernheim, Alfred L., assisted by Sara Harding. *The Business of the Theatre: An Economic History of the American Theatre, 1750–1932* (1930–1932). New York, Blom, 1964.

Bianco, Anthony. *Ghosts of 42nd Street: A History of America's Most Infamous Block.* New York: Morrow, 2004.

Bieber, Margarete. *The History of the Greek and Roman Theater.* Princeton: Princeton University Press, 1961.

Birkmire, William H. *The Planning and Construction of American Theatres.* New York: John Wiley, 1906.

Bloom, Martin. *Accommodating the Lively Arts: An Architect's View.* Lyme, NH: Smith and Kraus, 1997.

Bordwell, David. "The Classical Hollywood Style." In Bordwell, Staiger, and Thompson, 1–84.

——. *Narration in the Fiction Film.* Madison: University of Wisconsin Press, 1985.

Bordwell, David, Janet Staiger, and Kristin Thompson. *The Classical Hollywood Cinema: Film Style and Mode of Production to 1960.* New York: Columbia University Press, 1985.

Bottomore, Stephen. "The Panicking Audience? Early Cinema and the 'Train Effect.'" *Historical Journal of Film, Radio and Television* 19.2 (1999): 177–216.

Bowers, Q. David. *Nickelodeon Theatres and Their Music.* Vestal, NY: Vestal Press, 1986.

Bowers, Q. David and Kathryn Fuller-Seeley. *One Thousand Nights at the Movies: An Illustrated History of Motion Pictures.* Atlanta: Whitman, 2013.

Bowser, Eileen. *The Transformation of Cinema, 1907–1915.* New York: Scribner's, 1990.

Brewster, Ben. "Periodization of Early Cinema." In Keil and Stamp, 66–75.

Brewster, Ben and Lea Jacobs. *Theatre to Cinema: Stage Pictorialism and the Early Feature Film.* Oxford: Oxford University Press, 1997.

"The Brickbuilder Annual Architectural Terra Cotta Competition." *The Brickbuilder* 22.11 (Nov. 1913): xxxviii.

Brook, Peter. *The Empty Space.* New York: Atheneum, 1968.

Brown, T. Allston. *A History of the New York Stage: From the First Performance in 1732 to 1901.* Vol. 3. New York: Dodd, Mead, 1903.

Browne, Nick, ed. *Cahiers du Cinéma, 1969–72: The Politics of Representation.* Cambridge: Harvard University Press, 1990.

Butsch, Richard. *The Making of American Audiences: From Stage to Television, 1750–1990.* Cambridge: Cambridge University Press, 2000.

Cahn, Julius, ed., *Julius Cahn's Official Theatrical Guide.* New York: Julius Cahn, 1896.

Cameron, James and Joseph S. Cifre, eds. *Cameron's Encyclopedia Sound Motion Pictures.* 6th ed. Coral Gables, FL: Cameron, 1959.

Camp, Pannill. *The First Frame.* Cambridge: Cambridge University Press, 2014.

Carlson, Marvin. *Places of Performance.* Ithaca: Cornell University Press, 1989.

Carr, Robert E. and R. M. Hayes. *Wide Screen Movies: A History and Filmography of Wide Gauge Filmmaking*. Jefferson, NC: McFarland, 1988.

Castle, Terry. *The Female Thermometer*. New York: Oxford University Press, 1995.

Ceram, C. W. *Archaeology of the Cinema*. New York: Harcourt, Brace and World, 1965.

Chambers, Robert W. "The Double Feature as a Sales Problem." *Harvard Business Review* 16.2 (Winter 1938): 226–36.

Chandler, Alfred D., Jr. *The Visible Hand*. Cambridge: Harvard University Press, 1977.

Chansky, Dorothy. *Composing Ourselves: The Little Theatre Movement and the American Audience*. Carbondale: Southern Illinois University Press, 2004.

Cheney, Sheldon. *The Art Theatre* (1917). Rev. ed. New York: Knopf, 1925.

——. *The New Movement in the Theatre*. New York: Mitchell Kennerley, 1914.

——. *The Theatre: Three Thousand Years of Drama, Acting and Stagecraft*. New York: Longmans, Green, 1929.

Coad, Oral Sumner and Edwin Mims Jr. *The American Stage*. New Haven: Yale University Press, 1929.

Comolli, Jean-Louis, "Technique and Ideology: Camera, Perspective, Depth of Field." Trans. Diana Matias. In Browne, 213–47.

Crafton, Donald. *The Talkies: American Cinema's Transition to Sound, 1926–1931*. New York: Scribner's, 1997.

Crary, Jonathan. *Techniques of the Observer: On Vision and Modernity in the Nineteenth Century*. Cambridge: MIT Press, 1990.

de Lauretis, Teresa and Stephen Heath, eds. *The Cinematic Apparatus*. New York: St. Martin's, 1980.

Delluc, Louis. "Beauty in the Cinema." In Abel (1988), 137–39.

Dimmick, Ruth Crosby. *Our Theatres To-day and Yesterday*. New York: H. K. Fly, 1913.

Eberwein, Robert. *Film and the Dream Screen: A Sleeping and a Forgetting*. Princeton: Princeton University Press, 1984.

Eisenstein, Sergei. *Film Form*. Trans. and ed. Jay Leyda. New York: Harcourt Brace Jovanovich, 1949.

Fell, John, ed. *Film Before Griffith*. Berkeley: University of California Press, 1983.

Ferguson, Otis. *The Film Criticism of Otis Ferguson*. Edited and with a preface by Robert Wilson. Philadelphia: Temple University Press, 1971.

Fielding, Raymond, ed. *A Technological History of the Motion Pictures and Television* (1967). Rpt., Berkeley: University of California Press, 1983.

Flagg, Edwin H. "The Planning of Theatres and Auditoriums." *Architect and Engineer* (Oct. 1920): 71–80.

Forsher, James. *The Community of Cinema: How Cinema and Spectacle Transformed the American Downtown*. Westport, CT: Praeger, 2003.

Frary, I. T. "The Allen Theatre." *The Architectural Record* 50.5 (Nov. 1921): 359.

Freud, Sigmund. "The 'Uncanny'" (1919). In *The Standard Edition of the Complete Works of Sigmund Freud*. Translated from the German under the General Editorship of James Strachey. Vol. 17 (*1917–1919*): 219–56. London: Hogarth Press, 1955.

Frick, John. "A Changing Theatre: New York and Beyond." In Wilmeth and Bigsby, 2:196–232.

Fried, Michael. *Absorption and Theatricality: Painting and Beholder in the Age of Diderot*. Berkeley: University of California Press, 1980.

Frohman, Daniel. "Movies and the Theatre." *Women's Home Companion* (Nov. 1912): 5.

——. "The Moving Picture and Its Place in American Drama." *The Brickbuilder* 23.2, "The Moving Picture Theatre Special Number" Supplement (Feb. 1914): 4.

Fuller, Kathryn H. *At the Picture Show: Small-Town Audiences and the Creation of Movie Fan Culture*. Washington: Smithsonian Institution Press, 1996.

Fuller-Seeley, Kathryn H. *Hollywood in the Neighborhood: Historical Case Studies of Local Moviegoing*. Berkeley: University of California Press, 2008.

Gassner, John. *Directions in Modern Theatre and Drama*. New York: Holt, Rinehart, and Winston, 1965.

Glazer, Irvin R. *Philadelphia Theaters: A Pictorial Architectural History*. New York: Dover, with The Athenaeum of Philadelphia, 1994.

——. *Philadelphia Theaters, A–Z: A Comprehensive Record of 813 Theatres Constructed Since 1724*. New York: Greenwood Press, 1986.

Goffman, Erving. *Frame Analysis: An Essay on the Organization of Experience*. Cambridge: Harvard University Press, 1974.

Gohr, Siegfried and Gunda Luyken, eds. *Frederick J. Kiesler, Selected Writings*. Ostfieldern bei Stuttgart: Verlag Gerd Hatje, 1996.

Goldwyn, Samuel. "Hollywood Is Sick." *Saturday Evening Post*, July 13, 1940: 18–19, 44, 48–49.

Gomery, Douglas. "The Movies Become Big Business: Publix Theatres and the Chain Store Strategy." *Cinema Journal* 18.2 (Spring 1979): 26–40.

——. *Shared Pleasures: A History of Movie Presentation in the United States*. Madison: University of Wisconsin Press, 1992.

Gorelik, Mordercai. *New Theatres for Old*. New York: Samuel French, 1940.

Grau, Robert. *The Business Man in the Amusement World: A Volume of Progress in the Field of the Theatre*. New York: Broadway Publishing, 1910.

Grieveson, Lee and Peter Krämer, eds. *The Silent Film Reader*. London: Routledge, 2004.

Griffiths, Allison. *Shivers Down Your Spine: Cinema, Museums, and the Immersive View*. New York: Columbia University Press, 2008.

Gunning, Tom. "An Aesthetic of Astonishment: Early Film and the (In)Credulous Spectator." *Art and Text* 34 (Spring 1989): 31–45.

——. *D. W. Griffith and the Origins of American Narrative Film.* Urbana: University of Illinois Press, 1991.

Guzman, Tony. "The Little Theater Movement: The Institutionalization of the European Art Film in America." *Film History* 17.2/3 (2005): 261–84.

Hall, Ben M. *The Best Remaining Seats: The Golden Age of the Movie Palace* (1961). Rpt., New York: Da Capo Press, 1988.

Hall, Sheldon and Steve Neale. *Epics, Spectacles, and Blockbusters: A Hollywood History.* Detroit: Wayne State University Press, 2010.

Heath, Stephen. *Questions of Cinema.* Bloomington: Indiana UP, 1981.

Held, R. L. *Endless Innovation: Frederick Kiesler's Theory and Scenic Design.* Ann Arbor: UMI Research Press, 1982.

Henderson, Mary C. "Scenography, Stagecraft, and Architecture." In Wilmeth and Bigsby, 2:487–513.

——. *Theater in America: 200 Years of Plays, Players, and Productions.* New York: Abrams, 1986.

Herne, James A. *The Rise of Realism in the American Drama.* Orono: University of Maine Press, 1964.

Herzog, Charlotte. "The Archaeology of Cinema Architecture: The Origins of the Movie Theater." *Quarterly Review of Film Studies* 9.1 (Winter 1984): 11–32.

Hewitt, Barnard. *Theater U.S.A.: 1665 to 1957.* New York: McGraw-Hill, 1959.

Hill, Gus, ed., *Gus Hill's National Theater Directory.* New York: N.p., 1914.

Hulfish, David. *Motion Picture Work.* Chicago: American Technical Society, 1915; rpt., New York: Arno Press, 1970.

Hyde, Ralph. *Panoramania! The Art and Entertainment of the 'All-Embracing' View.* London: Trefoil, 1988.

Izenour, George C. *Theater Design.* 2d ed. New Haven: Yale University Press, 1996.

Izod, John. *Hollywood and the Box Office, 1895–1986.* New York: Columbia University Press, 1988.

Jones, Margo. *Theatre-in-the-Round.* New York: Rinehart, 1951.

Keil, Charlie and Shelley Stamp, eds. *American Cinema's Transitional Era: Audiences, Institutions, Practices.* Berkeley: University of California Press, 2004.

Kernodle, George R. *From Art to Theatre: Form and Convention in the Renaissance.* Chicago: University of Chicago Press, 1944.

Kessler, Frank and Nanna Verhoeff. *Networks of Entertainment: Early Film Distribution, 1895–1915.* Eastleigh, UK: John Libbey, 2007.

Kiesler, Frederick. "Building a Cinema Theatre." In Gohr and Luyken, 16–18.

——. *Inside the Endless House.* New York: Simon and Schuster, 1966.

Kinsila, Edward Bernard. *Modern Theatre Construction.* New York: Chalmers, 1917.

Kloepfel, Don V., ed. *Motion Picture Projection and Theatre Presentation Manual.* New York: Society of Motion Picture and Television Engineers, 1969.

Knudsen, Vern. "Acoustical Design of Multiple-Use Auditoria." In Izenour, 460–78.

Koss, Juliet. *Modernism After Wagner*. Minneapolis: University of Minnesota Press, 2009.

Koszarski, Richard. *An Evening's Entertainment: The Age of the Silent Feature Picture, 1921–1928*. New York: Scribner's, 1990.

Kracauer, Siegfried. "Cult of Distraction." Trans. Thomas Y. Levin. *New German Critique* 40 (Winter 1987): 91–96.

Larkin, John, Jr. "The Guild Movie Is Here." *Theatre Magazine* (May 1926): 32, 62.

Laurie, Joe, Jr. *Vaudeville: From the Honky-Tonks to the Palace*. New York: Holt, 1953.

Leacroft, Richard. *The Development of the English Playhouse*. Ithaca: Cornell University Press, 1973.

Leacroft, Richard and Helen Leacroft. *Theatre and Playhouse*. London: Methuen, 1984.

Leyda, Jay and Charles Musser, curators. *Before Hollywood: Turn-of-the-Century Film from American Archives*. New York: American Federation of the Arts, 1986.

Lewis, Howard T. *The Motion Picture Industry*. New York: D. Van Nostrand, 1933.

"Lincoln Center Starts Building Philharmonic Hall." *Architectural Forum* 110.6 (June 1959): 7.

LoBrutto, Vincent. *Kubrick: A Biography*. New York: D. I. Fine Books, 1997.

Londré, Felicia Hardison and Daniel J. Watermeier. *The History of North American Theater: The United States, Canada, and Mexico: From Pre-Columbian Times to the Present*. New York: Continuum, 2000.

Luther, Rodney. "Marketing Aspects of Drive-In Theaters." *Journal of Marketing* (July 1950): 41–47.

Macgowan, Kenneth. *Footlights Across America, Towards a National Theater*. New York: Harcourt, Brace, 1929.

——. *The Theatre of Tomorrow*. New York: Boni and Liveright, 1921.

Mackay, Constance Darcy. *The Little Theatre in the United States*. New York: Holt, 1917.

Mackintosh, Iain. *Architecture, Actor and Audience*. London: Routledge, 1993.

Marker, Lise-Lone. *David Belasco: Naturalism in the American Theatre*. Princeton: Princeton University Press, 1975.

May, Larry, with the assistance of Stephen Lassonde. "Making the American Way: Moderne Theatres, Audiences, and the Film Industry, 1929–1945." In Jack Salzman, ed., *Prospects: An Annual of American Cultural Studies*, vol. 12. New York: Cambridge University Press, 1987, 89–124.

McCullough, Jack W. "Edward Kilanyi and American Tableaux Vivants." *Theatre Survey* 16. Pittsburgh: American Society for Theatre Research, 1975, 25–41.

McNamara, Brooks. *The American Playhouse in the Eighteenth Century*. Cambridge: Harvard University Press, 1969.

——. "Scene Design and the Early Film." In Leyda and Musser, 51–56.

——. "The Scenography of Popular Entertainment." *The Drama Review: TDR* 18.1 (Mar. 1974): 16–24.

McNamara, Brooks, Jerry Rojo, Richard Schechner. *Theatres, Spaces, Environments: Eighteen Projects*. New York: Drama Book Specialists, 1974.

Meisel, Martin. *Realizations: Narrative, Pictorial, and Theatrical Arts in Nineteenth-Century England*. Princeton: Princeton University Press, 1983.

Melnick, Ross. *American Showman: Samuel "Roxy" Rothafel and the Birth of the Entertainment Industry, 1908–1915*. New York, Columbia University Press, 2012.

Melnick, Ross and Andreas Fuchs. *Cinema Treasures: A New Look at Classic Movie Theatres*. St. Paul: MBI, 2004.

Meloy, Arthur S. *Theatres and Motion Picture Houses: A Practical Treatise on the Proper Planning and Construction of Such Buildings and Containing Useful Suggestions, Rules and Data for the Benefit of Architects, Prospective Owners, Etc.* New York: Architects' Supply & Publishing, 1916.

Metz, Christian. *The Imaginary Signifier: Psychoanalysis and the Cinema*. Trans. Celia Britton, Annwyl Williams, Ben Brewster, and Alfred Guzzetti. Bloomington: Indiana University Press, 1982.

Meusy, Jean-Jacques. "Palaces and Holes in the Wall: Conditions of Exhibition in Paris on the Eve of World War I." *The Velvet Light Trap* 37 (Spring 1996): 81–98.

Moderwell, Hiram Kelly. *The Theatre of To-day*. Rev. ed. New York: Dodd, Mead, 1928.

Morrison, Craig. *Theaters*. New York: Norton, 2006.

Morrison, William. *Broadway Theatres: History and Architecture*. Mineola, NY: Dover, 1999.

"The Moving Picture Theatre." *Architect's and Builder's Magazine* 42.8 (1910–1911): 319–22.

——. *Architecture and Building* 43.8 (May 1911): 319.

Mullin, Donald C. *The Development of the Playhouse: A Survey of Theatre Architecture from the Renaissance to the Present*. Berkeley: University of California Press, 1970.

Münsterberg, Hugo. *The Film: A Psychological Study*. New York: Dover, 1970; a reprint of *The Photoplay: A Psychological Study* (New York: Appleton, 1916).

Murphy, Brenda. *American Realism and American Drama, 1880–1940*. Cambridge: Cambridge University Press, 1987.

Musser, Charles. *Before the Nickelodeon: Edwin S. Porter and the Edison Manufacturing Company*. Berkeley: University of California Press, 1991.

——. *The Emergence of the Cinema: The American Screen to 1907*. New York: Scribner's, 1990.

——. "Moving Towards Fictional Narratives: Story Films Become the Dominant Product, 1903–1904." In Grieveson and Krämer, 87–102.

Musser, Charles, with Carol Nelson. *High-Class Motion Pictures: Lyman H. Howe and the Forgotten Era of Traveling Exhibition, 1880–1920*. Princeton: Princeton University Press, 1991.

Naremore, James. *On Kubrick*. London: British Film Institute, 2007.

Naylor, David. *American Picture Palaces: The Architecture of Fantasy*. New York: Van Nostrand Reinhold, 1981.

Nicoll, Allardyce. *The Theatre and Dramatic Theory*. London: George C. Harrap, 1962.

Niver, Kemp. *American Biograph Bulletins*. Los Angeles: Locare Research Group, 1971.

Odell, George C. D. *Annals of the New York Stage*. Vol. 15. New York: Columbia University Press, 1949.

Oettermann, Stephan. *The Panorama: History of a Mass Medium*. New York: Zone Books, 1970.

Ohmer, Susan. *George Gallup in Hollywood*. New York: Columbia University Press, 2006.

Orgel, Stephen. *The Illusion of Power: Political Theater in the English Renaissance*. Berkeley: University of California Press, 1975.

Paul, William. "The K-Mart Audience at the Mall Movies." *Film History* 6.4 (Winter 1994): 487–501.

Philips, Lisa. *Frederick Kiesler*. New York: Whitney Museum of American Art, 1989.

Pichel, Irving. *Modern Theatres*. New York: Harcourt, Brace, 1925.

Poggi, Jack. *Theater in America: The Impact of Economic Forces, 1870–1967*. Ithaca: Cornell University Press, 1968.

Postlewait, Thomas. "The Hieroglyphic Stage: American Theatre and Society, Post–Civil War to 1945." In Wilmeth and Bigsby, 2:107–195.

Quinn, Michael Joseph. "Distribution, the Transient Audience, and the Transition to the Feature Film," *Cinema Journal* 40.2 (Winter 2001): 35–56.

———. "Early Feature Distribution and the Development of the Motion Picture Industry: Famous Players and Paramount, 1912–1921." PhD diss., University of Wisconsin–Madison, 1998.

Ramsaye, Terry. *A Million and One Nights*. New York: Simon and Schuster, 1926.

"Report of Jury Award." *The Brickbuilder* 23.2, "The Moving Picture Theatre Special Number" Supplement (Feb. 1914): 6.

Richardson, F. H. *Bluebook of Projection*. 6th ed. New York: Quigley, 1937.

———. *Motion Picture Handbook: A Guide for Managers and Operators of Motion Picture Theatres*. New York: Moving Picture World, 1910; 2d ed., 1912.

Robinson, David. *From Peep Show to Palace: The Birth of American Film*. New York: Columbia University Press, 1996.

Rossell, Deac. *Living Pictures: The Origins of the Movies*. Albany: SUNY Press, 1998.

Sachs, Edwin O. *Modern Opera Houses and Theatres* (1896). 2 vols. Reissued, New York: Blom, 1968.

Salt, Barry. *Film Style and Technology: History and Analysis*. 2d ed. London: Starword, 1992.

Sayler, Oliver M. *Max Reinhardt and His Theatre*. New York: Blom, 1968.

Schatz, Thomas, ed. *Boom and Bust: The American Cinema in the 1940s*. New York: Scribner's, 1997.

Schivelbusch, Wolfgang. *Disenchanted Night: The Industrialization of Light in the Nineteenth Century*. Trans. Angela Davies. Berkeley: University of California Press, 1988.

Schlanger, Ben. "Adapting Existing Auditoriums to 'Full Vision' Movies." *MPH*, "Better Theatres" sec., Dec. 1, 1951, 11–12, 26.

——. "Advancement of Motion Picture Theater Design." *JSMPE* 50.4 (Apr. 1948): 303–313.

——. "Architecture and the Engineer." *MPH*, "Better Theatres" sec., Sept. 26, 1931, 20–21.

——. "Auditorium Floor Slopes for Motion Picture Theatres Today." *MPH*, "Better Theatres" sec., Sept. 20, 1947, 17, 48–49.

——. "First a Larger Picture." *MPH*, "Better Theatres" sec., Mar. 5, 1949, 17, 33–34.

——. "A Functional Setting for the 'Wide-Screen' Picture." *MPH*, "Better Theatres" sec., Jan. 9, 1954, 18, 20–21.

——. "Increasing the Effectiveness of Motion Picture Presentation." *JSMPE* 50.4 (Apr. 1948): 367–73.

——. "It's Urgent Now to Put Our Modern Know-How to Work." *MPH*, "Better Theatres" sec., Oct. 23, 1948, 24, 34.

——. "Making Motion Pictures Better in the Theatre Than at Home." *MPH*, "Better Theatres" sec., Sept. 25, 1948, 23–24.

——. "Measuring Obsolescence and Determining What to Do About It." *MPH*, "Better Theatres" sec., July 21, 1945, 13–14, 21.

——. "A Method for Enlarging the Visual Field of the Motion Picture." *JSMPE* 30.5 (May 1938): 503–10.

——. "Modern Seating and Chair Maintenance: VIII—An Architectural Point of View." *MPH*, "Better Theatres" sec., June 4, 1932, 16, 42.

——. "Motion Picture Auditorium Lighting." *JSMPE* 34.3 (Mar. 1940): 259–64.

——. "The Motion Picture Theater Shape and Effective Visual Reception." *JSMPE* 26.2 (Feb. 1936): 128–35.

——. "Motion Picture Theaters." *The Architectural Record* 81.2 (Feb. 1937): 16–24.

——. "Motion Picture Theatres of Tomorrow." *MPH*, "Better Theatres" sec., Feb. 14, 1931, 12–13, 56–57.

——. "New Theaters for the Cinema." *The Architectural Forum* 57.3 (Sept. 1932): 253–60.

——. "Now How About Our Auditoriums?" *MPH*, "Better Theatres" sec., Jan. 7, 1950, 11, 18.

——. "On the Relation Between the Shape of the Projected Picture, the Areas of Vision, and Cinematographic Technic." *JSMPE* (May 1935): 402–9.

——. "Planning Today's Simplified Cinema." *MPH*, "Better Theatres" sec., Nov. 21, 1931, 18–21, 138.

——. "Production Methods and the Theatre." *MPH*, "Better Theatres" sec., Apr. 8, 1933, 8–10, 61.

——. "Proposing a Larger Picture for a More Effective Show." *MPH*, "Better Theatres" sec., July 31, 1948, 22, 29.

——. "Reversing the Form and Inclination of the Motion Picture Theater Floor for Improving Vision," *JSMPE* 17.2 (Aug. 1931): 161–71.

——. "The Rising Revolution in Motion Picture Technique." *MPH*, "Better Theatres" sec., Jan. 10, 1953, 13–14, 28.

——. "The Screen: A Problem in Exhibition." *MPH*, "Better Theatres" sec., Oct. 24, 1931, 14, 66.

——. "Sizing the Picture for 'Wide-Screen,'" *MPH*, "Better Theatres" sec., Oct. 10, 1953, 16, 18–19, 65–66.

——. "Sound Is Established—Now Let's Go Back to the Picture." *MPH*, "Better Theatres" sec., May 7, 1949, 17–18.

——. "The Theatre of Tomorrow." In Sexton, vol. 2 (1930), 51–56.

——. "Use of the Full Screen Area Today." *MPH*, "Better Theatres" sec., June 3, 1933, 11–13.

——. "Utilization of Desirable Seating Areas in Relation to Screen Shapes and Sizes and Theater Floor Inclinations." *JSMPE* 18.2 (Feb. 1932): 189–98.

——. "Vision in the Motion Picture Theatre." *MPH*, "Better Theatres" sec., July 30, 1932, 8–9.

Schlanger, Ben and William A. Hoffberg. "Effects of Television on the Motion Picture Theater." *JSMPE* 56.1 (Jan. 1951): 39–43.

——. "How Theatres Can Be Revised for 'Full Vision.'" *MPH*, "Better Theatres" sec., Jan. 5, 1952, 8–10.

——. "New Approaches Developed by Relating Film Production Techniques to Theater Exhitibion." *JSMPE* 57.9 (Sept. 1951): 231–37.

Schlanger, Ben, William A. Hoffberg, and Charles R. Underhill Jr. "The Synchro-Screen as a Stage Setting for Motion Picture Presentation." *JSMPTE* 58.6 (June 1952): 522–28.

Schlanger, Ben, in collaboration with Jedd Stow Reisner, Architect; Max O. Urbahn, Consultant; William A. Hoffberg, Engineer; Daniel W. B. Warner, Architect; Edward Content, Acoustics Engineer; Frederic E. Sutton, Mechanical Engineer. "Planning the Small Motion Picture Theatre." *MPH*, "Better Theatres" sec., June 1, 1946, 13–16, 18–19, 22–24, 26, 28.

Schroeder, Richard. *Lone Star Picture Shows*. College Station: Texas A&M University Press, 2001.

Sexton, R. W., ed. *American Theatres of Today*. Vol. 2. New York: Architectural Book Publishing, 1930.

Sexton, R. W. and B. F. Betts, eds. *American Theatres of Today*. New York: Architectural Book Publishing, 1927.

Sharp, Dennis. *The Picture Palace and Other Buildings for the Movies*. New York: Praeger, 1969.

Simonson, Lee. *The Stage Is Set*. Rev. ed. New York: Theatre Arts Books, 1963.

Singer, Ben. "Feature Films, Variety Programs and the Crisis of the Small Exhibitor." In Keil and Stamp, 79–100.

——. "Manhattan Nickelodeons: New Data on Audiences and Exhibitors." *Cinema Journal* 34.3 (Spring 1995): 5–35.

Siry, Joseph M. *The Chicago Auditorium Building: Adler and Sullivan's Architecture and the City*. Chicago: University of Chicago Press, 2002.

Sklar, Robert. "Hub of the System: New York's Strand Theater and the Paramount Case." *Film History* 6.2 (Summer 1994): 197–205.

Slide, Anthony. *Early American Cinema*. Metuchen, NJ: Scarecrow Press, 1994.

Southern, Richard. *The Open Stage*. London: Faber and Faber, 1953.

——. "The Picture-Frame Proscenium of 1880." *Theatre Notebook* 5.3 (Apr.–June 1951): 59–61.

——. *Proscenium and Sight-Lines*. London: Faber and Faber, 1939.

——. *The Seven Ages of Theatre*. New York: Hill and Wang, 1961.

Spehr, Paul C. "Politics, Steam and Scopes; Marketing the Biograph." In Kessler and Verheoff, 147–56.

Spigel, Lynn. *Make Room for TV: Television and the Family Ideal in Postwar America*. Chicago: University of Chicago Press, 1992.

Staiger, Janet. "Duals, B's, and the Industry Discourse About Its Audience." In Schatz, 72–78.

Stokes, Melvyn and Richard Maltby. *American Movie Audiences: From the Turn of the Century to the Early Sound Era*. London: British Film Institute, 1999.

Stote, Helen M., ed. *The Motion Picture Theater*. New York: Society of Motion Picture Engineers, 1948.

"The Strand." *American Architect* 106.2022 (Sept. 23, 1914): 177–83.

Szarkowski, John. *The Idea of Louis Sullivan*. Boston: Bullfinch Press, 2000.

Tidworth, Simon. *Theatres: An Architectural and Cultural History*. New York: Praeger, 1973.

Traub, James. *The Devil's Playground: A Century of Pleasure and Profit in Times Square*. New York: Random House, 2004.

Trussler, Simon. *The Cambridge Illustrated History of British Theatre*. Cambridge: Cambridge University Press, 1994.

Tsivian, Yuri. *Early Cinema in Russia and Its Cultural Reception*. Trans. Alan Bodger. London: Routledge, 1994.

Valentine, Maggie. *The Show Starts on the Sidewalk: An Architectural History of the Movie Theatre, Starring S. Charles Lee*. New Haven: Yale University Press, 1994.

Van Hoogstraten, Nicholas. *Lost Broadway Theatres*. Rev. ed. New York: Princeton Architectural Press, 1997.

Vardac, A. Nicholas. *Stage to Screen: Theatrical Method from Garrick to Griffith*. Cambridge: Harvard University Press, 1949.

Vidor, King. *King Vidor: A Tree Is a Tree*. New York: Harcourt Brace, 1953.

Wagner, W. Sidney. "The Stillman Theatre, Cleaveland, Ohio." *The Architectural Record* 43.4 (Apr. 1918): 307–310.

Waller, Gregory A. *Main Street Amusements*. Washington: Smithsonian Institution Press, 1995.

Waller, Gregory A., ed. *Moviegoing in America: A Sourcebook in the History of Film Exhibition*. Malden, MA: Blackwell, 2002.

Whittemore, Charles A. "The Motion Picture Theater: I. Comparison of Two Types of Plan." *Architectural Forum* 26.6 (June 1917): 170–76.

——. "The Motion Picture Theater: IV. Heating and Ventilating and Type of Plan" *Architectural Forum* 28.3 (Sept. 1917): 67–72.

——. "The Moving Picture Theatre." *The Brickbuilder* 23.2, "The Moving Picture Theatre Special Number" Supplement (Feb. 1914): 41–45.

Wilinsky, Barbara. *Sure Seaters: The Emergence of Art House Cinema*. Minneapolis: University of Minnesota Press, 2001.

Williams, Alan. "The Lumière Organization and 'Documentary Realism.'" In Fell, 153–61.

Wilmeth, Don B. and Christopher Bigsby, eds. *The Cambridge History of American Theatre*. Vol. 2. Cambridge: Cambridge University Press, 1999.

Wilson, J. Victor. "Strand Theatre, New York." *American Architect* 106.2022 (Sept. 23, 1914): 184–86.

Young, William C. *Documents of American Theater History*. 2 vols.: *Famous American Playhouses, 1716–1899* and *Famous American Playhouses, 1900–1971*. Chicago: American Library Association, 1973.

Zukor, Adolph, with Dale Kramer. *The Public Is Never Wrong*. New York: Putnam's, 1953.

Academy of Motion Picture Arts and Sciences, Producers-Technicians Committee, 252
Academy of Music (New York), 101–2
acoustics, 234, 379n16
Adler, Dankmar, 23–24, 37, 102, 104
*Alien* (1979), 297
*All About Eve* (1950), 184
Allen, Robert, 65, 96
*American Cinematographer*, 267
American Theatre (Salt Lake City), 90–91, 100
"Annabella Serpentine Dance" (1895), 50

*Annie Get Your Gun* (1950), 182–84
Antoine, André, 192
*Antony and Cleopatra* (1913), 140–41
architectural form, 4–5, 18–19; cantilevered balcony, 104–8, 347n32; democratizing public space, 109–10; democratizing theatrical space, 101–10; elimination of galleries, 134; form and function, 21–28, 95; frontal seating and the proscenium stage, 44, 47, 48, 49; hierarchical organization of space, 39–40, 78–82, 94; hierarchical space and race,

architectural form (*continued*)
347–48n34; in ancient Greek theater, 24; in Elizabethan theater, 24–25; in store theater, 67–69, 71–74, 80, 85–90; in tiered horseshoe theater, 37–41, 44–47, 52, 102; tiered horseshoe used for feature film, 134; in Times Square theaters, 44; multiplicity of forms, 95–98
*Architectural Forum*, 283
Armat, Thomas, 28
"Arrival of a Train at La Ciotat" (1895), 53
art theaters/art cinema, 93, 174, 292–93
Astor Theatre (New York), 140, 146–48, 155, 165, 181
atmospheric theaters, 204–6, 227
Auditorium Theatre (Chicago), 23–24, 33, 38, 45, 47, 84, 101–4, 108, 140

Bancroft, Squire and Marie Bancroft, 47–50
Barrymore, John, 177
Bayreuth Festspielhaus, 23, 45–49, 346n12; democratizing of space, 102–3; influence on the Auditorium Theatre, 329n56
Bazin, André, 190–91, 242, 254, 365–66n15
*Beau Geste* (1926), 153
Belasco, David, 127, 130, 191–93, 210, 367n26
Bel Geddes, Norman, 16, 18
*Ben-Hur* (1925), 156, 169
Bergman, Gösta M., 48–49
Bernheim, Alfred, 123–28, 133
Bial, Alfred, 43
bifurcation: in exhibition, 145–55, 174–76; in production, 155–56, 165, 169, 171–72, 174
"big head," 57, 267, 335n98

*Big Parade, The* (1925), 129, 147–48, 165, 170, 231
*Big Trail, The* (1930), 255; comparison of 35mm and 70mm versions, 256–69
*Billy the Kid* (1930), 389n84
Biograph Company, 52–54, 127–28
*Birds, The* (Aristophanes), 3–4
*Birth of a Nation, The* (1915), 118, 196, 214
black masking, 237–38, 246–50, 270–72; alternatives to, 247, 249, 271–73, 386nn62,64; and screen brightness, 87; problems caused by, 247
*Black Pirate, The* (1926), 251
Blackton, J. Stuart, 145, 210
Bloom, Martin, 21–22
"B" movies, 184
*Bocaccio 70* (1962), 288
Bordwell, David, 171
Bottomore, Stephen, 54–55
box set, 47–48, 331nn76,78
Bradlet, John M., 68, 72–74
Brady, William, 133
Braun, W. T., 68
*Brickbuilder* design competition, 67, 75–80
*Broken Blossoms* (1919), 199–200
Brook, Peter, 324n13
Bush, W. Stephen, 81, 83, 120–21
Butterfly Theater (Milwaukee), 68

Candler, Asa, 140
Candler Theatre (New York), 140–41, 146
"canned theater," 229
canvas as synonym for screen, 58–59
Capitol Theatre/Loew's Capitol/ Loew's Cinerama (New York), 105, 146, 155, 165, 169, 177, 181–82, 279–80, 292–93, 375–76n81
carbon arc, and film style, 253, 269

Carlson, Marvin, 69

Carnegie Hall, 149

Castle, Terry, 206–8

Cavell, Stanley, 242

Churchill, Marguerite, 257

Cinema I-Cinema II (New York), 280, 282–89, 293; echoing Lincoln Center, 283–86; function of duplex, 288

CinemaScope, 2, 268, 270, 276

cinematograph, 29

Cinerama, 5–7, 270, 273–74, 278–80, 289–95, 297; "Cinerama effect," 290, 292, 294, 396n45; reception of, 1–2; Super Cinerama, 279

Cinerama Dome (Los Angeles), 279

*Citizen Kane* (1941), 172

*Clansman, The* (1915), 198–200, 221

Clarke, Eric, 218

classical style, departures from, 171–72, 174

Close, Charles A., 326n24

Clune's Auditorium (Los Angeles), 198–99, 371n57

Coca-Cola, 140

*Cockeyed World, The* (1929), 169

Cohan, George M., 140

Coliseum Theater (Seattle), 84

Consent Decree of 1941, limiting extended-run exhibition, 182

coup de theatre, 233, 294–97

Craft, Pliny P., 122–23, 129

Crane C. Howard, 100

Crary, Jonathan, 324–25n14

Crisp, Donald, 214

Criterion Theatre (New York), 142, 150, 152–53, 209

*Crowd, The* (1928), 165–69

curtain, 5, 7, 14, 34, 292; as feature in Cinerama exhibition, 290, 292, 396n44; as synonym for screen, 36, 58, 60; curtains to improve acoustics, 278; eliminated by Ben

Schlanger, 287, 289–90, 396n39; function in live performance theater, 227, 376n84; function in movie theater, 226–28, 237–38; in *2001* performances, 295–97

*Dante's Inferno* (1911), 122

*Days of Heaven* (1978), 288

deep focus, 271

Delluc, Louis, 193

DeMille, Cecil B., 66, 127, 150

DeMille, William, 71, 78, 108

*Design for Living* (1933), 150, 156, 169

*Diabolique* (1955), 282

*Don Juan* (1926), 177–78, 233

double bill exhibition, 176–79, 185; in New York City, 362n110

Doyle, Arthur Conan, 224

D'Oyly Carte English Opera House (London), 104

*Dracula* (1931), 253

drive-in theaters, 276–78, 392–93n9

"Drunkard's Reformation, The" (1909), 60

Dullea, Keir, 293

Duplex Theater (Detroit), 7–13

Dwan, Allan, 216

Eastman Theatre (Rochester), 218, 250–51, 266–67

Ebbett's Field, 96

Eberson, John, 206

Eden Muséem, 29

Edeson, Arthur, 267

Edison, Thomas, 28–29

Edison films, 30, 34, 42, 50–51, 115, 128, 326n29, 332n83

"effects-driven" cinema, 291–92, 297, 396–97n45

Egyptian (Boston), 226–27

Embassy Theatre (New York), 146, 148–50, 155, 221, 281

"Empire State Express" (1896), 52–55, 57–58, 61, 333–34n91

*Exhibitor's Herald*, 204

exploitation exhibition, 153

extended run theaters ("run house"), 152–55, 176, 182, 202, 208; and art cinema, 281–82, 393n21

*Fall of Babylon, The* (1919), interpolating live performance, 214–16

feature film (feature-length film), 11–12, 94, 181–82; adaptation of plays, 122; as part of movie palace program, 111, 114–17; class appeal and dignity discourse, 141–42, 186–87, 356nn50,52; classifications, 155–56, 359n80; combination companies for, 129–32, 357n62; decline in plays as source material, 289; differentiating by venue, 137–41; hierarchization of audience by, 135; origins of, 127–39; palace program affecting length, 117–19, 138, 349n56; quality-quantity conflict, 111–12, 156, 345n6, 348n42

Federal Communications Commission (FCC), 277

figure-ground opposition, 50–51

Film Guild Cinema (New York), 13–19, 93; and multiple projections, 15–18

First National Pictures, 221

floor slope, 79–80

*Footlight Parade* (133), 247–48

Ford, John, on prologues and presentations, 373n73

fourth wall convention, 58–61, 86, 174, 194; and Cinerama, 291–93

Fox, William, 127

Fox Film/Twentieth Century-Fox, 154, 182, 255

Freud, Sigmund, 213, 369n45; and "The 'Uncanny,'" 206–8; continuity between opposites, 224

Frohman, Charles, 42–44, 51, 69, 124, 127

Frohman Daniel, 81, 127, 132–33

Fuller, Buckminster, 279

Gable, Clark, 181

Geller, Andrew, 282–83, 286; contribution to Cinema I-II, 395–96n37; redesign of Cinema I-II, 395–96n37

George M. Cohan Theatre (New York), 199

Gilsten, Jacob, 271

*Girl of the Golden West, The* (play), 192

Glyptorama, *see* living pictures (*tableaux vivants*)

Goldwyn, Samuel, 180–81, 184–85

Gomery, Douglas, chain store analogy, 351–52n6

*Gone with the Wind* (1939), 181; releasing strategy, 362n111

*Good Little Devil, A* (1914), 130

Gould, Gloria, 148–49, 281

Gould, Stephen Jay, 149

*Governor's Lady, The* (play), 192

Grandeur (70mm), 256–69, 388–89n83, 389n84

*Grand Hotel* (1932), 391n109

Grand Opera House (Pueblo, Colorado), 104

Grau, Robert, 63

Grauman's Chinese Theatre (Los Angeles), 231–32

Great Depression, impact on exhibition, 177

*Great Dictator, The*, 362n111

*Great Expectations* (1946), 281

Grierson, John, 156

Griffith, D. W., 60, 196; combining live performance and film, 214–15

grind theater, 152

Gunning, Tom, 65, 188; on realism and the uncanny, 192–93

Hal Roach Studios, 179–80
*Hamlet* (1948), 281; roadshow exhibition, 394n25
Hammerstein, Oscar, 31, 52, 98, 152
*Happy Days* (1930), 269–70
Harris, Marcia, 256
Harris, Sam H., 140
Haymarket Theatre (London), 48, 50
*Heart of a Child, The* (1920), use of scrim in prologue, 375–76n81
Henderson, Mary C., 21–22
*Henry V* (1946), 281
Herzog, Charlotte, 68
Hippodrome (Buffalo), 204
Hippodrome (New York), 105
Hitchcock, Alfred, 252
Hollywood Theatre (New York), 182
Horsley, David, 118
Hutton, Betty, 271

Ibsen, Henrik, 45
Illinois, State of, restricts movie running times, 180
Illuminating Engineering Society of Great Britain, 247
illusionism, 192, 227
*Il Posto* (1963), 288
*In Old Kentucky* (1920), interpolating live performance, 217–22, 372–73n72, 374n76
*Intolerance* (1916), 215
*It's a Wonderful Life* (1946), 362–63n112

Jannings, Emil, 150
Jenkins, C. Frances, 28–29

Keith, Ian, 258
Kiesler, Frederick, 13–19, 322n22; connection to Eugene O'Neill, 323n25

Kilyani, Edward, 31
Kineplastikon (Photoplast), 188
kinetoscope, 28–30
Kinsila, Edward Bernard, 67, 113
Klaw and Erlanger theaters, 124, 126–28, 143
Kleine, George, 123, 139–40, 179, 195
Koster and Bial's Music Hall (New York), 30–34, 40, 42–43, 188
Kracauer, Siegfried, 242, 288–89; critique of presentation theaters, 375n79
Kubrick, Stanley, 292–94, 297; involvement in premiere showing of *2001*, 398n53

*Ladies' Home Journal*, 113
*La dolce vita* (1961), 282
Laemmle, Carl, 116
Lamb, Thomas, 103–9, 140, 146
Landmark Theatres, 174
Lang, Fritz, 252
Langlois, Jean Charles, 27
*Last Days of Pompeii, The* (1913), 208
Leacroft, Richard, 38
Lee, S. Charles, 382–83n39
legitimate theater, 96–97, 120–21, 142, 176, 187, 191, 208, 239; as business model for motion pictures, 123–28, 142; combination companies, 123–24, 127–29, 133, 196; feature films in, 122, 133–34, 152; impact of feature film on touring companies, 132–33, 354–55n27; movie theaters replacing in Times Square, 141; oversupply of theaters, 133; Syndicate-Shubert battle, 125–27; the road, 122; theater circuits, 124–26
Lehar, Franz, 149
Liberty Theatre (New York), 196–97
*Life Begins* (1932), 160, 162–64, 169

lighting: stage lighting, 48–50, 332–33n86; in the auditorium, 49, 83–87

Lincoln Center, 282–86

Little Theater movement, 17, 92–93, 344–45n116; and the Little Film Theater movement, 17, 93

living pictures (*tableaux vivants*), 30, 239; and the Glyptorama, 31–36, 188, 194; influence on Vitascope presentation, 34–35

Lockwood, Gary, 294

Loew, Marcus, 98, 118, 127, 130

Loew's State (New York), 146, 155

Loew's Theaters, 146, 271, 279

long runs: in legitimate theaters, 147; in movie theaters, 147–48, 153, 184

Los Angeles Theatre, 216

*Lost World, The* (1924), prologue for, 224–26, 228

Lubin, Sig, 97–98

Lubitsch, Ernst, 149–51, 156, 158–59, 169

Lumière films, 29, 32–33, 42, 208, 326n24

Lyric Theatre (New York), 143

Macgowan, Kenneth, 21–23, 60

Mackintosh, Iain, 102

Madison Square Garden, 96, 208

magic lantern, 187–88, 191, 207, 230

Magnascope, 232, 238, 266–67, 377–78n6, 378n9, 382n32, 389n84

Majestic Theater (Cleveland), 197, 368n32

*Mare Nostrum* (1926), 156

Marowitz, Charles, 21–22

McCarthy, J. J., 233

"McKinley" (1896), 53, 58, 61

*Me and My Gal* (1931), 172, 174

*Mean Streets* (1973), 288

Meisel, Martin, 27–28, 50

Meloy, Arthur, 38–39, 67

*Merry Widow, The* (1925), 149

Metro-Goldwyn-Mayer (MGM), 146–48, 155, 165, 172, 181, 231, 255, 279, 296

Metropolitan Opera House (New York), 102, 283

Metropolitan Opera House (Philadelphia), 98

Meusy, Jean-Jacques, 89

*Million Dollar Mermaid* (1952), 232

Moderwell, Hiram Kelly, 44–46

"Monroe Doctrine, The" (1896), 34

Moore, Colleen, 174

Morgan, Ralph, 174

Morosco, Oliver, 127

Motion Picture Directors Association/ Directors Guild of America (DGA), 219, 221

*Motion Picture Herald*, 2, 19, 204, 278, 293

*Motion Picture News*, 186–87, 196, 207–8

Motion Picture Producers and Distributors of America (MPPDA)/Motion Picture Association of America (MPPA), 181; and the Women's Better Picture Movement, 179

movie palace, 2, 4–5, 23, 37, 39–40, 67, 71–72, 79, 81, 94–99, 103–9, 113, 116–21, 133–37, 143, 145, 147, 152–54, 170; as pre-release theaters, 182–84, 280; decline of stages shows in, 177, 179; influence on film style, 250–52, 254; variety programming in, 65, 114–21; program restricting film length, 118–19

Movietone (Fox), 233

Municipal Arts Society of New York, 283

Münsterberg, Hugo, 190

Murnau, F. W., 158, 161

Murray Hill Theatre (New York), 282, 286

Musser, Charles, 191, 201, 230

Mussolini, Benito, 158

mutoscope, 28
Mutual Film Corporation, 118, 138
Myers, Nathan, 68, 99
myth of democratized viewing, 108, 244, 245

"narratage," 174–75
naturalism, 191–92, 194
natural magic, 190, 208, 365n13
New Amsterdam (New York), 104
Newsweek, 270–71
New Willis Wood Theatre (Kansas City), 196, 368n32
New York Model, 128–45; market power of, 131; New York showing as advertising, 131, 142–45, 184; decline of Broadway for first-run exhibition, 280, 394n26; East Side as Off Broadway, 282
New York Philharmonic, 177
New York State Theater, 283
New York Times, 270–71, 283
nickelodeon, 66–67, 194, 337–38n21
Novelty Scenic Studios, 202

object scale, 56–57
O'Brien, Willis, 224
Old Heidelberg (play), 192
Old Ironsides (1926), 153, 232
Oliver, Edna Mae, 271
Olivier, Laurence, 281
Olympia Music Hall (New York), 52, 55–57, 143
Olympia Theatre (Miami), 206
O'Neill, Eugene, 172–73; and the Theatre Guild, 17
Orpheum Theater (Chicago), 76
Orpheum Theater (St. Joseph), 84

Palace of Delight (Philadelphia), 96–97
panorama painting, 26–28, 297; moving panoramas used in stage

productions, 27, 32, 192, 372n66, 374n76
Paramount Pictures (Famous Players), 113–14, 126–28, 136, 150–54, 156, 182, 232, 274
Paramount Theatre (Times Square Paramount) (New York), 152
Patriot, The (1928), 149–53
Peck, Ferdinand, 102–3
"Pepper's Ghost," 186
persistence of vision, 189, 207–8
Philharmonic Hall (New York), 283–84, 395nn32–33
phi phenomenon, 190; in television, 370n47
Photophone (RCA), 233
Pickford, Mary, 130
picture settings, 194–213, 369n42; picture settings in Germany, 375n79
Plimpton, Horace G., 117–18
Poggi, Jack, 133–34
Postlewait, Thomas, 48
Poverty Row, 179
Power, Tyrone, Sr., 262
Power and the Glory, The (1932), 174
Powers, Pat, 138
pre-release exhibition, 154–55, 182–84, 359n78; palaces become pre-release theaters, 184
presentation theater, 136–37, 152, 154, 169, 289
programmers, 118, 152, 172, 174
projection booth, location of, 88–90
prologues, 154, 221–26; contrasted with presentations, 373n73; filmed, 374–75n78; transition from stage to screen, 224–26; treadmill, 221–22
proscenium stage, 194, 212, 223, 227, 272–74, 286; attacks on, 17–18; and the stage picture, 17, 323n29; eliminated by Cinerama, 278, 393n14

Provincetown Players, 92–93

Publix Theatres, 152–53

Quigley, Martin, 139

Quinn, Michael, 126

*Quo Vadis* (1913), 123, 129, 140

Radio City Music Hall (New York), 116, 232, 247, 249–50, 254, 276

*Ramona* (1915), interpolating live performance, 214, 371n57

Rapp (C. W.) and Rapp (G. L.), 108–9

Raven Screen Corp., 236

RCA, 272

realism, 41–45, 47–50, 57–61, 71, 191–94, 209–10; and the reality effect of motion pictures, 42–43, 51–54, 192, 366–67n24; as a function of architectural space, 51–57

*Red Shoes, The* (1948), 281

Regent Theatre (New York), 104, 146

Reinhardt, Max, 16–17; and the New York production of *The Miracle* (1924), 16–18, 204, 206, 291, 322n23

Rialto Theatre (New York), 117, 152

Rice, Elmer, x; and the Theatre Guild, 16

*Richard III*, 38

Richardson, F. H., 69, 77, 86–87, 246–47, 253, 271; battle against screen perforations, 235–37

Riviera (Chicago), 217, 219, 221

Rivoli Theatre (New York), 117, 153, 182, 232

RKO 58th Street (New York), 273

roadshow exhibition, 153–54, 184, 280–82, 292, 360n92; and Consent Decree of 1941, 182; in legitimate theater, 129–32

Rothapfel, Samuel "Roxy," 63–65, 84–85, 111–13, 115–17, 146, 152, 169, 218; combining live performance and film, 216–18, 371–72n65; comparison to David Belasco, 367n26; on secondary importance of feature film, 136–37; predicts end of stage shows, 177, 179

"Rough Sea at Dover" (1896), 42–43, 50–51, 57

Roxy Theatre (New York), 97, 154, 174, 184, 247, 250

Rugoff-Becker Theatres, 280, 282, 286

runs-zones-clearances, 135–36, 154, 169

*Saboteur* (1942), 247, 249

Sachs, Edwin O., 37, 45

Salt, Barry, 251–52

*Saturday Evening Post*, 113, 180

Schiller Theater (Chicago), 104

Schlanger, Ben, 239–47, 249–50, 255, 270, 291, 297; and Cinema I-Cinema II, 282–87; correlation between architecture and film style, 242–45, 250–54; developing SynchroScreen, 271–74; "shapeless shape" film image, 292; statistical analysis of film images, 243; views on Cinerama and widescreen, 397n47

screen: as architectural object, 94, 239–44; curved to improve sight lines, 74–75; "Cycloramic," 270–71, 390n101; Fantom Screen, 231–33, 243, 295; fiberglass, 271, 390n98; gilt frame for, 34–35, 86–87; impact of sound on, 236–37; increasing size post-World War II, 272–73; location on stage, 36, 112–13, 233, 235–39; perforations, 235–37; rear-screen projection, 89; "Retiscope Concave Screen," 270–71; as window, 210–11; brightness (reflectance), 87–88; brightness and centering of film

image, 253–54, 388n76; size and camera distance, 251; size and object scale, 268–70; size for Cinerama, 278–79, 393n14; size formulas, 244–45; size in drive-ins, 276; size in palaces, 245–46; size in store theater, 75–78; size in vaudeville theater, 35, 52; specular vs. diffusive, 353; "Trans-Color Convex Screen System," 271

Search for Paradise (1957), 290

seating, 78–80; continental seating, 286, 396n38; seating capacity, 99–100

seat preference surveys, 245, 384–85n52

Selig, William H., 116, 120–21

Selznick, David O., 181

Shubert, Lee, 127

Shubert Organization, 125–27, 133, 143, 155

side-view distortion, 101, 238–39, 244–45, 271, 388n80; and 60° arc, 244–46; curved screen to eliminate, 270–71; in store theater, 73–75; in tiered horseshoe theater, 54

sight lines, 36–37, 78–80, 91, 98–99, 101–2, 324n5; and upstage position of screen, 113; differences between stage and movie theaters, 243; problems created by screen at curtain line, 237–39

Siry, Joseph M., 101–3

Society of Motion Picture (and Television) Engineers [SMP(T)E], 236, 241, 245, 250, 252, 277; Projection Practice Committee, 236; Theater Design Subcommittee, 245

sound film (talkies), 177; competing systems, 233–34; limitations of sound-on-film, 234; placement of loud speakers, 235–37; unity of

sound and image, 235; wide gauge film improving quality, 255

Soldier of Fortune (1920), interpolating live performance, 216–17

Southern, Richard, 47–48

Spartacus (1913), 140

specials, 152–76

Spoilers, The (1914), 112, 114–15, 118

Spoor, George K., 117

Stewart, Anita, 217

store theaters, 174; differentiated from nickelodeon, 66–67, 337–38n21; facades of, 68–69, 71; growth of, 63; impact on film production, 65–66, 76–77

Strand Theatre (New Jersey), picture setting in, 211

Strand Theatre/Warner Cinerama (New York), 5–7, 100–117, 136, 146, 162, 177, 182; cantilevered balcony as defining feature, 104–8; mezzanine rotunda, 108–10; orchestra on stage, 112–13; picture setting in, 211–12; vaudeville influence, 113

Strange Interlude (film, 1931), 172–74

Strange Interlude (play), 16, 172

Student Prince, The (1927), 158–59

Sullivan, Louis, 23–24, 37, 102, 104

Sunrise (1928), 156–58, 160–61, 169, 359–60n83

Synchro-Screen (screen synchrofield), 271–74, 286–87, 289, 291; as stage setting, 272

Syndicate, The, 124–28

television, 184–85, 207, 270, 272; and the uncanny, 370n47; defined by domestic space, 277–78; as competition to theatrical movies, 2; variety shows as competition to vaudeville, 185

Ten Commandments, The (1923), 147

Thalberg, Irving, 146, 252–54
theater building boom: 1905–1932, 65;
    post-World War II, 280; art theater
    construction, 280
theater capacities, in Europe and U.S.,
    251–52, 387n69
Theatre Guild, 16–17
This Is Cinerama (152), 273, 278–79,
    290; as travelogue, 279
Thomas, Lowell, 290
Tiffin Scenic Studios, 202–3
Tiger Rose (play), 192
Todd-AO, 182
To Have and Have Not (1944), 182
Tom Jones (1963), 288
Tracy, Spencer, 174
Trail of '98 (1928), 231–33
Trouble in Paradise (1932), 169, 171–72
2001: A Space Odyssey (1968), 280,
    292–97

"Umbrella Dance" (1895), 50–51
Uncle Tom's Cabin (play), 147
United Artists, 154, 182, 255, 279
Universal Pictures (Universal-Interna-
    tional), 154–55, 281
uplifting the audience, 110, 139,
    141–42

Valentine, Maggie, 240, 382–83n39
Vardac, Nicholas, 217, 222, 372n66
Variety, 280
variety debate, 114–21, 179–85
vaudeville, 29–31, 38, 130–34, 137, 141,
    145–47, 152, 176–77, 179, 187, 189,
    221, 239; end of, 185, 363n122;
    influence on store theater, 64–65,

84–85; small-time, 74, 96–98;
    tabloid (tab shows), 137
ventillation, 83
Victoria Theatre (New York), 152
Vidor, King, 146–47, 165, 169–70
Vitagraph Company, 142–45, 209–10
Vitagraph Theatre (New York), 143–45,
    153; programming compared to
    Strand, 144; picture setting in,
    209–10
Vitaphone (Warner Bros.), 177–78, 233
Vitascope, 31, 33–36, 40–43, 49–51,
    58–59, 69, 188, 194
von Stroheim, Erich, 149

Wagner, Richard, 46–48, 102–3,
    330n73
Walsh, Raoul, 255
Warner Bros. (Warner's Features), 138,
    154, 160, 169, 172, 182, 233
Wayne, John, 256
Wertheimer, Max, 189
Why Change Your Wife? (1920), 150
widescreen, 271, 391n111; used with
    SynchroScreen, 273–74
Wilinsky, Barbara, 93
Wings (1927), 150
Wonderful World of the Brothers Grimm,
    The (1962), 279; and special effects,
    291
Woods, Frank, 132
World Film Company, 133
Wreck, The (1913), 145, 357n60

Yankee Doodle Dandy (1942), 182

Zukor, Adolph, 136, 141–42

FILM AND CULTURE

*A series of Columbia University Press*

EDITED BY JOHN BELTON

*What Made Pistachio Nuts? Early Sound Comedy and the Vaudeville Aesthetic*
Henry Jenkins

*Showstoppers: Busby Berkeley and the Tradition of Spectacle*
Martin Rubin

*Projections of War: Hollywood, American Culture, and World War II*
Thomas Doherty

*Laughing Screaming: Modern Hollywood Horror and Comedy*
William Paul

*Laughing Hysterically: American Screen Comedy of the 1950s*
Ed Sikov

*Primitive Passions: Visuality, Sexuality, Ethnography, and Contemporary Chinese Cinema*
Rey Chow

*The Cinema of Max Ophuls: Magisterial Vision and the Figure of Woman*
Susan M. White

*Black Women as Cultural Readers*
Jacqueline Bobo

*Picturing Japaneseness: Monumental Style, National Identity, Japanese Film*
Darrell William Davis

*Attack of the Leading Ladies: Gender, Sexuality, and Spectatorship in Classic Horror Cinema*
Rhona J. Berenstein

*This Mad Masquerade: Stardom and Masculinity in the Jazz Age*
Gaylyn Studlar

*Sexual Politics and Narrative Film: Hollywood and Beyond*
Robin Wood

*The Sounds of Commerce: Marketing Popular Film Music*
Jeff Smith

*Orson Welles, Shakespeare, and Popular Culture*
Michael Anderegg

*Pre-Code Hollywood: Sex, Immorality, and Insurrection in American Cinema, 1930–1934*
Thomas Doherty

*Sound Technology and the American Cinema: Perception, Representation, Modernity*
James Lastra

*Melodrama and Modernity: Early Sensational Cinema and Its Contexts*
Ben Singer

*Wondrous Difference: Cinema, Anthropology, and Turn-of-the-Century Visual Culture*
Alison Griffiths

*Hearst Over Hollywood: Power, Passion, and Propaganda in the Movies*
Louis Pizzitola

*Masculine Interests: Homoerotics in Hollywood Film*
Robert Lang

*Special Effects: Still in Search of Wonder*
Michele Pierson

*Designing Women: Cinema, Art Deco, and the Female Form*
Lucy Fischer

*Cold War, Cool Medium: Television, McCarthyism, and American Culture*
Thomas Doherty

*Katharine Hepburn: Star as Feminist*
Andrew Britton

*Silent Film Sound*
Rick Altman

*Home in Hollywood: The Imaginary Geography of Hollywood*
Elisabeth Bronfen

*Hollywood and the Culture Elite: How the Movies Became American*
Peter Decherney

*Taiwan Film Directors: A Treasure Island*
Emilie Yueh-yu Yeh and Darrell William Davis

*Shocking Representation: Historical Trauma, National Cinema, and the Modern Horror Film*
Adam Lowenstein

*China on Screen: Cinema and Nation*
Chris Berry and Mary Farquhar

*The New European Cinema: Redrawing the Map*
Rosalind Galt

*George Gallup in Hollywood*
Susan Ohmer

*Electric Sounds: Technological Change and the Rise of Corporate Mass Media*
Steve J. Wurtzler

*The Impossible David Lynch*
Todd McGowan

*Sentimental Fabulations, Contemporary Chinese Films: Attachment in the Age of Global Visibility*
Rey Chow

*Hitchcock's Romantic Irony*
Richard Allen

*Intelligence Work: The Politics of American Documentary*
Jonathan Kahana

*Eye of the Century: Film, Experience, Modernity*
Francesco Casetti

*Shivers Down Your Spine: Cinema, Museums, and the Immersive View*
Alison Griffiths

*Weimar Cinema: An Essential Guide to Classic Films of the Era*
Edited by Noah Isenberg

*African Film and Literature: Adapting Violence to the Screen*
Lindiwe Dovey

*Film, A Sound Art*
Michel Chion

*Film Studies: An Introduction*
Ed Sikov

*Hollywood Lighting from the Silent Era to Film Noir*
Patrick Keating

*Levinas and the Cinema of Redemption: Time, Ethics, and the Feminine*
Sam B. Girgus

*Counter-Archive: Film, the Everyday, and Albert Kahn's Archives de la Planète*
Paula Amad

*Indie: An American Film Culture*
Michael Z. Newman

*Pretty: Film and the Decorative Image*
Rosalind Galt

*Film and Stereotype: A Challenge for Cinema and Theory*
Jörg Schweinitz

*Chinese Women's Cinema: Transnational Contexts*
Edited by Lingzhen Wang

*Hideous Progeny: Disability, Eugenics, and Classic Horror Cinema*
Angela M. Smith

*Hollywood's Copyright Wars: From Edison to the Internet*
Peter Decherney

*Electric Dreamland: Amusement Parks, Movies, and American Modernity*
Lauren Rabinovitz

*Where Film Meets Philosophy: Godard, Resnais, and Experiments in Cinematic Thinking*
Hunter Vaughan

*The Utopia of Film: Cinema and Its Futures in Godard, Kluge, and Tahimik*
Christopher Pavsek

*Hollywood and Hitler, 1933–1939*
Thomas Doherty

*Cinematic Appeals: The Experience of New Movie Technologies*
Ariel Rogers

*Continental Strangers: German Exile Cinema, 1933–1951*
Gerd Gemünden

*Deathwatch: American Film, Technology, and the End of Life*
C. Scott Combs

*After the Silents: Hollywood Film Music in the Early Sound Era, 1926–1934*
Michael Slowik

*"It's the Pictures That Got Small": Charles Brackett on Billy Wilder and Hollywood's Golden Age*
Edited by Anthony Slide

*Plastic Reality: Special Effects, Technology, and the Emergence of 1970s Blockbuster Aesthetics*
Julie A. Turnock

*Maya Deren: Incomplete Control*
Sarah Keller

*Dreaming of Cinema: Spectatorship, Surrealism, and the Age of Digital Media*
Adam Lowenstein

*Motion(less) Pictures: The Cinema of Stasis*
Justin Remes

*The Lumière Galaxy: Seven Key Words for the Cinema to Come*
Francesco Casetti

*The End of Cinema? A Medium in Crisis in the Digital Age*
André Gaudreault and Philippe Marion

*Studios Before the System: Architecture, Technology, and the Emergence of Cinematic Space*
Brian R. Jacobson

*Impersonal Enunciation, or the Place of Film*
Christian Metz